l Bracewell

MNESIA CLUB
GATE
EPTS OF PHYSICAL BEAUTY
E

SE

Th

THE NINETIES

when surface was depth

Michael Bracewell

Flamingo

An Imprint of HarperCollinsPublishers

Flamingo
An Imprint of HarperCollins*Publishers*
77–85 Fulham Palace Road,
Hammersmith, London W6 8JB

www.**fire**and**water**.com

Flamingo is a registered trademark
of HarperCollins Publishers Ltd.

Published by Flamingo 2002
1 3 5 7 9 8 6 4 2

Copyright © Michael Bracewell 2002

The Author asserts the moral right to
be identified as the author of this work

A catalogue record for this book is
available from the British Library

ISBN 0 00 712801 0

Set in Fairfield Light by
Rowland Phototypesetting Ltd,
Bury St Edmunds, Suffolk

Printed and bound in Great Britain by
Clays Ltd, St Ives plc

Contents

Acknowledgments

Some of the material used in this book has appeared in a previous form in the following publications: the *Guardian*, *The Times*, the *Independent*, the *Independent on Sunday*, *Frieze*, *Nest* magazine, the *Sunday Telegraph*, the *New Statesman*, *Tate*, a Royal Academy of Art catalogue and a Waddington Galleries catalogue.

The author and publishers of this work would like to express their gratitude to Barry Adamson and Mute Song Ltd for permission to quote from the lyrics of 'Split' by Barry Adamson.

'Try writing what you have written in the past tense in the present tense and you will see what I mean. What we have to do is to give back to the past we are writing about its own present tense. We give back to the past its own possibilities, its own ambiguities, its own incapacity to see the consequences of its action. It is only then that we represent what actually happened.'

Professor Greg Dening
http://www.nla.gov.au/events/history/papers/Greg_Dening.html

Culture-vulturing City Slickers

It was back in the winter of 1988 – a dark, wet, spiteful afternoon, with the thin rain blown in sudden gusts. Looking down from the penthouse of some mansion flats in Warrington Crescent – it was a real penthouse: there was a roof terrace, and a spiral staircase and everything – you could just make out, in the failing light, the dripping shrubs and sandy little paths of the big private garden that ran behind the length of the entire block. This elegant oblong of trees and lawn – a Central Park in miniature, transplanted to west London – looked desolate now, with drifts of sodden leaves rising up like sullen brown waves towards the damp-blackened timbers of a trellis. In summer, the same lawn had been scorched white, and peopled throughout the long afternoons by squads of charging, tumbling toddlers, running riot in the dusty sunshine. But now it was early December, and, against the gathering dusk, the tree-tops looked like crooked black fingers, clawing at the lowering sky.

The window panes held darkness. Probably, somewhere down there, forgotten and forlorn, there would be a child's abandoned tricycle, or a brightly coloured ball, begrimed by weeks in a flower-bed. Something or other, at any rate, to send you one of those

sudden jabs of melancholy that quickly casts a shadow across your hopes; some trite but troubling symbol of lost innocence, reminding you, in abstract, of youth and opportunities thrown away (a whole summertime, it seems, of opportunities squandered) – wasted in a mess of jobs and plans and relationships, which had seemed, at the time, to put the kick in life's chutney.

Beyond the twilit barrier reef of the facing houses, you were aware of the rush-hour traffic, inching ill-tempered towards Marylebone and Marble Arch – the dreary scraping of the windscreen wipers, the black cabs shuddering in an endless jam. Here we were at the tail end of the 1980s, children of the late Fifties and early Sixties, beginning to feel the odd twinge of the thickening process of early middle age, but still young enough to want to carry the fight to the enemy; to emulate the Balzacian hero, staring down on the city of Paris, to declaim, 'And now you and I come to grips!'

But what, exactly, right now, was there down in the city to come to grips with? The heroism of the war-cry had been replaced by a kind of Mock Heroism, which had declared itself (out of nowhere, too – a sudden hesitancy in the voice, skidding a few tones from manly authority to punctured confidence) only at the moment of announcing the challenge.

Or were the vocal cords simply learning the cadences of irony? Everything had gone all slippery, like spilt mercury; and when the tweezers of criticism tried to pick up a trend or a product or an event it seemed to split up into cunning little sub-sections of itself, scattering hither and thither with a wanton disregard for any singularity of purpose – any one meaning. And this was because everything, it seemed – all the bits and pieces of contemporary culture, from architecture to mineral water – had become semiotic Phenomena; the seismic impact of which, rippling across the surface of the culture, could be placed under the niftily scientific label of Epiphenomena. In the lab of semiotics (you could imagine that it looked like the Clinique counter in a big department store)

everything was significant, busily signifying something – it was all signage.

By the end of the 1980s, small things seemed to articulate big things (fascism, fast food and Madonna, for instance, could be studied and assessed within the same academic language – at times within the same sentence); while big things (the burgeoning processes of globalization, for example) were almost too big to see, like those patterns in the desert you can make out only at 37,000 feet.

The penthouse had a main living room that was maybe the size of one and a half tennis courts. The walls were painted a matt shade of pale dove grey, as was the surround of the fireplace, which didn't imitate Georgian classicism (the style of choice for the Eighties make-over of Edwardiana) so much as pun on it, and then cross out the pun – like making a painting that looked like a painting and then painting over the painting, frame and all, with one colour that was the same shade as the wall.

The lighting, too, was subdued. It came from a neat constellation of dimmer bulbs set into the ceiling, and conveyed – what? A submarine light that made distances difficult to gauge; it made the vast room appear cosy and cold, simultaneously. If you were feeling the jab of melancholy it could seem like the twilight of indecision.

And then, there they were, the two of them: a pair – a brace – of Culture-vulturing City Slickers.

With his back to the big sash window, seated in a grey vinyl cube of a chair, sipping his tea without looking up from the cup, and frowning – a trick he had learned during his brief stint as a chartered surveyor, working in Carlos Place opposite the Connaught Hotel – a critic and curator of high seriousness, Andrew Renton (one of the first – if not the first – art-spotters to identify the gathering nestlings of Young British Art), had just made the statement that 'culture is wound on an ever-tightening coil'.

He was speaking with reference to the peroxide crew-cutted

female vocalist Yazz, who – solely on the strength of her summer Number One, 'The Only Way is Up' – had just earned herself an hour-long documentary entitled 'The Year of Yazz'. And his point was that culture – mass-market popular culture, in particular, as the latest delectable truffle of the age – was being assessed and assimilated into the various strands of media with increasing speed. The brainy end of the fashionable media, especially, were being swift to set their hounds on the trail of the Gilded Truffle: that signifier, punctum, bull's-eye that changed weekly – sometimes even hourly – but that seemed to sum up the age in one bite . . .

'Would You Like to Swing on a Star?' or A Short History of Cultural Commodification in the 1990s

Picture, if you will, the slack-jawed derision with which Little Richard or Elvis Presley might have greeted an announcement, in 1959, that comedy or cooking was 'the new rock and roll'. 'No suh! Ah don' like it!' With pianos to straddle and trousers to split, neither of these great architects of the Pop Age would have deigned so much as to give the idea a second thought. That any rival phenomenon could pinch the mantle of rock and roll, or parade around in its borrowed crown, would simply have been unthinkable. Rock and roll defined the modern age, and nothing else would do.

This happy state of affairs managed to last, in Britain, until the start of the current decade. Then, in 1990, when the country was still watery-eyed and winded from being punched below the intellect by the Recession of the late Eighties, the great surge of public fervour for England's chances in the World Cup of Italia 90 gave birth to the latest catchphrase in analytical shorthand: football, we decreed, was 'the new rock and roll'.

And the media were swift to authorize this radical shift in value

judgements. Unlikely celebrity pundits such as Salman Rushdie and Michael Ignatieff were wheeled out from behind their hitherto bookish identities, to dabble in populism and turn the tears of a pre-lapsarian Gazza into a kind of weeping effigy for the burgeoning church of Laddism Nouveau. That soccer should be 'the new rock and roll' was a triumph for the zeitgeist surfers, providing as it did a sinewy little label that could be easily adapted to a whole succession of ensuing phenomena that appeared to define the state of the nation.

Barely had rock and roll itself had time to acknowledge this sneaky jab to its noble jaw, when the success of Luciano Pavarotti, whose rendition of 'Nessum Dorma' as the ''ere We Go' of Italia 90 had brought Puccini to the High Street, inspired the heretical suggestion that opera, in fact, was the new rock and roll. And, as the latest speculation on what brand of cultural activity might best reflect the national temper, kept buoyant in the ether of popular enthusiasm by various combinations of tenors through the early 1990s, opera might well have been the new rock and roll had it not been usurped by the reinvention of stand-up comedy.

Comedy became the new rock and roll when Vic Reeves and Bob Mortimer took the trappings of psychedelic dandyism and applied them to what seemed like an imagining of Morecambe and Wise on helium. Suddenly, released from the humour of political correctitude that had kept many young comics on the raised awareness cabaret circuit, British comedy exchanged jokes about Margaret Thatcher for cartoon surrealism and an infantilist nostalgia for the popular culture of the early 1970s. All too soon, by way of Vic and Bob, Harry Enfield, Sean Hughes and Frank Skinner, comedy's claim to being the new rock and roll seemed assured when Newman and Baddiel, of 'The Mary Whitehouse Experience', played sell-out shows at Wembley Arena – thus conquering the ultimate venue of rock and roll itself. This triumph of comedy over pop and football – as the new rock and roll – would be compounded by the fact that many young comedians

would discover secondary careers as celebrity panellists on TV quiz shows about pop and football.

But no sooner had the new generation of young British comics settled down to a collective reign over the national mood, than out of the comparative obscurity of Goldsmiths College and warehouse exhibitions in London's East End came the pronouncement that contemporary art, festooned with ironic chutzpah by the youthful practitioners of neo-conceptualism, had in fact taken over from comedy as the new rock and roll. There was even the suggestion, as young British artists became famous for making sex- and death-obsessed conceptual jokes with ironic punchlines, that art had become the new rock and roll by being the new comedy.

But if BritArt was a cultural co-product of BritPop, as suggested by *Arena* magazine, then the international success of Oasis would remind the nation that rock and roll, actually, was the new rock and roll and always had been. And that would have been the end of it – except for the fact that 'BritCulture' had inspired the media to reinvent Swinging London, and with it a restaurant and gastronomy boom that made cooking, in fact, the new rock and roll. (Other than a faint flurry of excitement around the contractual arrangements of Zoe Ball and Andy Peters, which had threatened to suggest that being a children's television presenter was the new rock and roll, the issue had never been clearer.)

By the autumn of 1996, with new expensive restaurants opening all over London, each one a tribute to the luxurious styling revealed on the pages of *Elle Decoration* magazine, and with braised artichoke hearts on wilted rocket being concocted nightly on British television, anyone who could poach an egg in a minimalist interior was on the cutting edge of culture.

So what might be the next rock and roll, in 1999? Answer: Designer Witchcraft. It was only a short step from the luxurious mediation of herbs, olive oil and shaved truffle, which typified the cult of the neo-Foodie, to the cleverly styled photographs of natural

ingredients and state-of-the-art spells that appeared in the velvet-covered publishing sensation of winter '97, *Hocus Pocus: Titania's Book of Spells*.

In a stroke of sheer brilliance, in terms of marketing, at least, *Hocus Pocus* took the visual language of *Elle Decoration* and 'Alastair Little's Italian Kitchen' and applied it to a practical guide to white magic for the New Women of the urban cognoscenti. With spells for wealth, health and a happy love life, this was New Age sorcery for the Bibendum generation, as though Titania herself were sprung from the womb of the Conran Shop, tutored in the Aveda school of minimalist aromatherapy and sent on her mystic way to heal the hearts and guide the heads of high achievers bored with Prozac and the *Marie Claire* problem page.

With a rival publication, *How to Turn Your Ex-boyfriend into a Toad*, selling equally well, the cult sensation was building up to a juicily media-friendly phenomenon. And this latest challenge to the increasingly materialistic and somewhat chauvinistic procession of phenomena that had comprised the new rock and roll – each one describing a further return to the demonized and elitist values of the 1980s, only dressing down now in the name of populism – brought about the triumph of female spell-weaving which conjured up the Spice Girls. Bred in the magic test-tubes of advanced marketing, the Spice Girls are a comma in the history of cultural commodification: they bridge the gap between virtual reality and legalized cloning. Both of which might yet be the new rock and roll.

The brief December twilight gave way to the hostile blackness of a winter's night. Even the sodium orange of the streetlights seemed to be sucked into the darkness, leaving just a gleam of a tangerine mist, hanging in the trees. Inside the apartment, barely audible, came the sound of some difficult modern music – sudden, pedal-dampened piano chords, a jagged crescendo . . . On the low black

coffee table, which was varnished and polished to such a sheen that it looked as though it was lacquered, was the box of the CD – some pieces by Pierre Boulez.

'. . . plunk.'

This was anxious music – culture-vulturing city slicker music. It sounded as if someone were trying very carefully to extract a snooker ball that had become stuck beneath the strings in a grand piano. But how to describe a culture-vulturing city slicker? Well, it was all based on a drawing. This is what you got.

In the first place, this winter's dusk, it felt like the end of something. Like the Russian play where the collapse of an entire social order is announced by the snapping of a violin string. Perhaps the Eighties were exhausted, too, the pneumatic self-confidence of the decade's rhetoric slowly beginning to deflate. (And these are observations about a certain, single aspect of an era – that aspect being the effervescent mist that shivered and tingled just above the fizzy bits of the zeitgeist.)

The latter half of the 1980s had seen the beginnings of de-stabilizing cultural status and blurring aesthetic boundaries. Terms such as 'accelerated', 'fragmented' and 'dystopic' were in currency, conveying the sense of a new, volatile, high-speed culture – the future was beginning with the ruination of history. From the Alessi kettle to your average maroon and turquoise balustraded business park office building, the Three Ps of post-modernism were making their presence felt: punning, plagiarism and parody. What larks Pip, old chap, what larks.

As if to mark the moment, the 'semiotext(e)' booklets by or on the principal cast and chorus of post-modern thinking (and that little bracketed 'e' said it all, somehow) from Baudrillard, through Foucault to Virilio, had neat, uniform, black covers – were aesthet-ically exquisite handbooks of the avant-garde – and somehow seemed emblematic of the sheer fashionability, at that time, of critical theory. They had frankly funky titles such as *Pure War* or *Foucault Live*, and generally sexed up the dusty world of critical

theory in much the same way that business publishing would get down and groovy a decade later – in fact, the two facelifts would be linked.

Here, also, was the idea of the city itself becoming a critical theoretical text: a sort of moodily lit, sci-fi urban landscape, articulating the semantics of cultural meltdown. And the language (jargon, jive talk, call it what you will) of this latest criticism was very romantic, in a New Romantic sort of way, as it seemed to conflate the rhetoric of science with the imagery of dandyism, positing the critic as a kind of chic urban guerrilla über-technician, carrying out missions of anthropological field work.

This seemed also to echo – be a consequence of, in terms of image – that era of the late 1970s which the singer with the Human League, Philip Oakey, would describe in 2001 as 'the alienated synthesist period' – the chisel-faced romantic, playing musique modern(e) in a grey room. Urban infrastructure and information theory to the critical theorists (they were *landscape poets*, by temperament) of the middle to late 1980s, was what the Lake District had been to Victorian Romantics, the mountains of Nepal to a traveller on the Magic Bus, or the peaks of Bavaria to Pantheist seekers of the Sublime.

(The 1980s would also see the menus of fashionable restaurants employ a kind of lyric poetry, further Sublime, in the descriptions of dishes: '*shards of baby halibut wrapped in a fluffy cardigan of raspberry coulis, dancing on a mist of chives . . .*' In the Nineties, he-man chefs like Marco Pierre White (think Kirk Douglas as Van Gogh in *Lust for Life*, shouting at crows and kicking over easels) and the rugged snappiness of *cucina rustica* would be a neat indicator of the general push towards Authenticity – the triumph of ingredients over adjectives. But the list-based poetry of food description would endure, largely on the packaging of supermarket premium-range thermodestabilized theme snacks.)

As the Nineties arrived, the sites for this critical theoretical romanticism would expand outwards, across the decade, from the

city (from the capital, in fact) to engage first with ideas of suburbia, then provincial urban hinterland, and ultimately the nowhere-zones of service-area Britain – the edges of motorways and mirror-glassed retail parks. By the start of the twenty-first century (as the novelist Jeff Noon would assert about the regeneration of Manchester) entire cities would seem like one big shop: a mono-environment of white-laminated MDF shelving, brushed-metal light fittings and natural-effect bleached oak floors – the whole thing defined by the total consumer experience. Subsequently, the school of romantic critical theory would become fixated on a whole new landscape, of brands and logos and commerce: the poetical Sublime of business culture, corporations and the Internet.

But that was all ten years around the corner. What about the culture-vulturing city slickers, where did they come in? From a schism, in fact. The contortions of critical theory towards the end of the Eighties – as ideas, as fashion, as informants of advertising, arts education and retail culture – could be said to have divided a generational sensibility.

On the one hand, applied post-modernism in culture and commerce would come to seem like one of the voodoo arts carried out by the Demon Kings of yuppiedom – a grand denial of Content, grating and dicing the sanctity of Meaning into little more than a bucketful of marketable pixels, hand-sorted by media-sodden focus groups. A grand liberation, perhaps. On the other, there was the sense in which the cultural climate that had allowed post-modernism to flourish – a sudden explosion of media, technology and image making – was also, somehow, more than anything, well . . . like the end of something: a realization on that dreary December evening, those pedal-dampened, difficult chords, that snapped violin string . . .

These opposed opinions were well illustrated in the world of contemporary art.

Through the middle to late 1980s, the rise to prominence of young Scottish painters from Glasgow School of Art – most notably

Steven Campbell and Adrian Wiszniewski – had delivered a muscular, enigmatic body of deeply literary painting that seemed to articulate – literally depict – the anxiety, doubt and confusion of a twilit, pre-post-modern generation. The aesthetic and philosophical agenda of these painters could seem like an update of that concerning the Neo-Romantic artists of the 1940s (John Minton et al.), which has been aptly labelled by the historian Dr David Mellor to include 'nostalgia and anxiety, myth-making, organic fantasies'.

As such, these young Scottish artists were also the last gasp (for a while, at least) of a particular artistic sensibility, honed and empowered through atelier skills, responsive to the history of painting. In their different styles, both Campbell and Wiszniewski seemed to focus on the character, or type, that Peter York might once have described as 'the neurotic boy outsider': the romantic, aesthetic, self-questioning young man, existentially challenged and a teensy bit self-obsessed. Campbell's stock character at the time was a kind of lost rambler – dressed somewhat in the clothes (grouse-moor tweeds at a glance) that ex-Skid turned model and TV presenter, Richard Jobson, had worn during his 'Armory Show' poet phase – and crossing a landscape of self-contradicting signposts and strange, semi-mystical features. Wiszniewski – in his paintings from the mid-Eighties, at any rate – depicted limp-fringed, sensual-mouthed, pretty-eyed young men wearing white shirts and tie, collar loosened, like Rupert Brookes or Rupert Everetts of the modern city. As with Campbell's ramblers, these romantic, alienated young men appeared caught in a cat's cradle of contradictory, entropic states. (Both painters looked remarkably like their chosen characters – archaically handsome in a Georgian kind of way.)

A powerfully atmospheric colour drawing by Wiszniewski from 1986, 'Culture Vulturing City Slickers' might be said to sum up this particular era: two of the painter's urbane, entranced young men, immobile and strangely allegorical (one of them is clasping an

affectionate alligator) against a dowdy, bronze-coloured twilight, which settles like sediment on Town Hall architecture and period streetlamps. But allegorical of what?

The young men are caught in the sunset of anxiety perhaps – as Damien Hirst's massively influential 'Freeze' exhibition (one of the starting whistles for the 1990s) with its deft and super-self-assured rearranging of intentionality, was barely a couple of years away. For with 'Freeze' (not to mention its epiphenomenal seismic impact) the artist would seem to *lose the right to fail*. No more anxiety, no more lost young men. Wiszniewski's City Slickers have an air, if not of doomed youth, then of youth in a kind of psychological transit camp of the emotions, stuck between Either and Or – rigidity or flux, spirituality or nihilism.

In the catalogue for Wiszniewski's exhibition at the Walker Art Gallery, Liverpool, held in the winter of 1987, the artist is described as a part of 'the New Image Glasgow phenomenon'; it is also suggested 'that a condition of ambiguity is more appropriate to the spirit in which' Stephen Campbell's pictures are painted. Here, then, was the phenomenon of a condition of ambiguity – the culture-vulturing city slicker position.

Represented by the Marlborough Gallery and Nicola Jacobs Gallery, respectively (Albemarle Street and Cork Street), Campbell and Wiszniewski both caught the Eighties art prices boom. It was one of the ironies of the period – during the Ascent of the Demon Kings of Yuppiedom – that paintings depicting states of anxiety, stasis or confusion should have made big money off the enterprise economy. But neurotic art tends to sell well during times of Boom Economy, cf. the cost of a Warhol during Reagan's presidency.

So then what? The phenomenon of 'New Image Glasgow' more or less disappeared, its ethos in decline. The painters didn't sink without a bubble, but almost: they became Newly Marginalized as Reactionary, or whimsical, which would become the stock Nineties way of dealing with cultural opposition.

From this point on, to the closing years of the Nineties, Tom Wolfe's phrase about the art scene of the late Sixties, and 'Cultureburg's' need to be 'cosily anti-bourgeois' would seldom seem more relevant. For throughout the Nineties, as the margins became the mainstream – typified by television comedy and the mediation of Young British Art (the latter, in fact, being a complex and eclectic generational grouping of artists, who happened to comprise, as a phenomenon, a good story) – so the newly perceived Reactionary (for instance, a certain kind of painting itself being considered reactionary) would become the New Margins – the anxiety dumps, the unfashionably alcoholic, the not Post Anxiety . . .

When you saw those culture-vulturing city slickers, sitting there in the submarine twilight, you could have had the feeling that they'd been there for ever, and would just stay in one place, immobile, entranced . . . Would anything – as Pierre, with a slight, upward twitch of his right hand, summons up another staccato, slippery snooker ball, clunky chord – ever disturb them?

BritPop Revisited

To anyone over thirty, drifting with a faintly puzzled expression towards the reflectiveness of early middle age, the phenomenon of BritPop and its expansion into the BritCulture of neo-Swinging London could be tantamount to discovering a premature liver spot and being seized with a sense of one's own mortality. Suddenly, popular culture, as the freewheeling go-kart of carefree youth, seemed to be pronouncing its disaffection with even those members of the older generation who had cut their teeth on Bowie's glam angst, rallied to the energizing bloody-mindedness of punk and pursued the vertiginous mutations of ambient dance music with something more than casual interest. BritPop, as a vivacious new player in popular culture, seemed to source from

13

past pop in a way that could bring on a chronic attack of déjà vu in anyone who could remember, however vaguely, the originals.

This was youth flaunting the shock of the old, and they did it with style and wit. True, there were going to be some other diversions on this magical mystery tour down memory's dual carriageway, from the cul-de-sac of 'nouveau romo's' reawakening of New Romantic synth-pop to the lay-by of Easy Listening revivalism, but BritPop was the real picnic at the end of the journey. And it was strictly for the kids – even if the adults tried to join in.

But the liberty of youth, as Elizabethan sonneteers never tired of mentioning, is a short-lived condition. The transatlantic triumph of the Spice Girls repositioned the banner of youth supremacy yet again. Liam and Patsy, as the John and Yoko of the National Lottery generation, might well be officializing the triumph of Brit-Culture on the cover of *Vanity Fair*, but it's the navel-pierced girl power of Spice Girls that is really calling to the pocket-money. *Spice* was the fastest selling CD of 1996, and America had already fallen to the charms of its performers. The younger sisters of TopShopPop seem poised to oust the elder brothers of BritPop, thus marking yet another revolution of pop's indefatigable loop, in which the prayers and protests of one generation are translated into the language of the next. Sally might wait – to paraphrase Oasis – but the Spice Girls won't. And BritPop, in retrospect, for all its dismissive swagger, might prove to have been more subtle than we thought.

The story of BritPop all began, really, with Suede's suburban urchin poetry of love, lust and loneliness on the streets of contemporary London. Suede were from Haywards Heath, and their mixture of limp-wristed petulance and deeply depressed meditation owed as much to the musical style of David Bowie as it did to the poetic anatomizing of Britain that had been put forward by Morrissey. They were like a pink marble mezzanine, generationally, between the melancholy notions of Britishness delivered

by late indie groups, and the boyish exuberance that took off with BritPop proper. Suede, sexually ambiguous and dead clever, were the end of one pop sensibility and the launchpad for the next. And they wrote some great songs: *'On a high wire, dressed in a leotard, there wobbles one hell of a retard . . .'* The oldies, at a pinch, could relate to that.

But by the time that the BritPop princelings Supergrass, with a rubber-mouthed assurance that touched on the brattish self-confidence of the adolescent Mick Jagger, had rocketed up the pop charts with the simple slogan 'We are young! We are free!', it seemed as though a historic marker had been planted with jaunty arrogance in the massive sandbank of sensibility that separated the consumers of pop who were born in the early 1960s, from those who had first blinked into the light towards the middle of the 1970s. What was being proclaimed was a kind of heritage pop, in which the styling and values of an earlier England – the England of the Beatles and brand-new Wimpy Bars – was evoked by Thatcher's grown-up children to offer a cultural database of re-ceived ideas of Britishness, from which a response to the realities of Major's classless Britain could be impishly composed. For the kids, it was rather like running riot in an interactive museum of English popular culture. BritPop, importantly, seemed to lack the anxiety and self-referring irony of the pop that had come just before it. It seemed, somehow, deeply materialistic.

But pop provides an unofficial cartography of its host culture, charting the landscape of the national mood and marking those points where the major trade routes of social trends are traversed by the underground tunnels of the zeitgeist. In the case of BritPop, the phenomenon as a whole could be seen to combine an infantil-ist nostalgia for the popular culture of its practitioners' adoles-cence, with the born-again maleness of laddism nouveau.

This was demonstrated by Oasis, who just missed literalizing, by a single letter, their justifiable claim to enjoying yet another annus mirabilis in 1996, when a Gallagher brother mimed the

insertion of his Brit Award into his backside. The maleness of BritPop took the healthy irreverence of the young Beatles and mixed it with a dollop of *Viz* comic's reactionary humour. And, once again, both BritPop and the laddism of *Viz* – or *Loaded* – seemed to be yearning for the freedom of a second adolescence in a younger and less complicated Britain.

In their vastly differing ways, the superstar groups of BritPops – Oasis, Blur, Supergrass and Pulp – were reworking the pop heritage they had inherited as teenagers. Fairly soon, it would be claimed that if Oasis were inspired by the Beatles, then Pulp were impersonating the Kinks, Supergrass were doing a passable imitation of the Spencer Davis Group and Blur were somewhere between the Small Faces and Georgie Fame. Small wonder that the movement should rally to a reinvented Paul Weller as the godfather of Mod revivalism. As Tony Parsons remarked in his review for *Prospect* magazine of Martha Bayles's *Hole in Our Soul: The Loss of Beauty and Meaning in American Popular Music*: 'BritPop is traditional rock. Its appeal is that it is at once shiny and new while also replete with nostalgia – pop music is coming home.'

And BritPop was coming home at a time, during the slow recovery from the Recession of 1990, which had seen the end of designer elitism and the fetishing of new technology as a viable chassis for the pop and Fleet Street style press. As the adult heirs of Thatcher's Britain, more or less force-fed the reality and consequences of rampant cultural materialism, it seemed as though the BritPop kids could only look back to an England before Prozac and a pop before post-modernism. As their one-word names suggested, these groups were half in love with the simplicity of a Sixties childhood or Seventies rites of passage, when the colours on colour TV were too hot to watch without eye-strain, and the tank-topped dolly birds of situation comedy were bubbling with suggestiveness to the damp innuendo of their mutton-chop-sideburned suitors. Hence the assertion by Simon Reynolds, in his essay on BritPop for *Frieze* magazine, that the movement could

not justify its label as 'the new Mod' because it was based almost entirely on personal and cultural nostalgia. The original Mods would sooner have handed back their button-down shirts than admit to a nostalgia for anything.

Partly an infantilist comedy of recognition, and partly a defiant rejection of cultural anxiety, BritPop put forward a pop ethos that Blur summed up in the title of their CD, *Modern Life is Rubbish*. With a founding theology of apolitical infantilism, the movement had distanced itself from both the multiculturalism of dance music and the white nihilism of grunge's screamed de profundis from the teenage bedrooms of middle-class America. What BritPop promised, with a disingenuous simplicity that belied its subtle protest, were some catchy tunes and a rattling good time.

As such, amid the fiscal neurasthenia of the early 1990s, in a pop cultural climate that revived archaic notions of gender and sexuality by turning young men into lads and young women into 'babes', BritPop was attempting to reclaim a lost innocence on the one hand, but indulging a new hedonism on – or with – the other. Or, to quote Blur, the complexities of sexual politics could be reduced to the seemingly infinite chant of 'Boys who like girls who like boys', and so on. And so BritPop, in many ways, was like a suburban teenage party as it might be reconstructed by today's young adults from their memories of youth.

But despite its seeming espousal of a wanton dumbness, a few BritPop tracks were both musically accomplished and lyrically clever.

For all its opacity and pouting, the movement produced some glorious pop moments, from Pulp's 'I Want to Live Like Common People' to the thunderous title track of Oasis's second CD, *(What's the Story) Morning Glory*, which confounded its detractors with their impassioned articulations of defiance in the face of modern life's rubbish. At their best, these were serious and sincere pop songs, which used archaic formats and styling to pass comment on society as they found it. The message, in BritPop, was subordinate to the

medium – a neat reversal of the up-front conscience raising of traditional protest songs.

This mixing of intentions was much in evidence on Pulp's controversial *Sorted for Es and Whizz*, which was seized upon by anti-drugs lobbyists to represent a massive misjudgement on the part of the group with regards to its ambiguous handling of a sensitive subject. It might have been one small step for Jarvis Cocker on to Michael Jackson's heavily defended stage at 'that' awards ceremony, but it was a mighty leap for BritPop as the scourge and cartoon folk devils of the transatlantic pop establishment. Rooted in the past but sniping at the present, BritPop made its political points by never referring to politics. Noel or Damon might offer a cursory nod to New Labour, but there was none of the community knees-up and flag-waving which had typified the politicized pop events laid on by Red Wedge or Rock Against Racism during the early years of the 1980s. Rather, the politics of BritPop were summed up in the lyrics of Oasis's ground-breaking single 'Whatever' (1994), with its demand for personal freedom – 'I'm free, to do whatever I, whatever I choose,' – being snarled by Liam over Noel's evocative homage to the reversed orchestration on the Beatles' psychedelic nursery rhyme of 1967, 'I am the Walrus'. And, ironically, this plea for individualism would breed a new breed of conformism within BritPop's massive fan base. In the end, the democracy between the performers and fans that punk had attempted to instigate, and that dance music simply took for granted, was wholly dismantled by BritPop's reawakening of an earlier rock and roll orthodoxy. Jarvis and Co. might have been the Citizen Smiths of modern Britain, but their triumph lay in a powerful coalition between media and marketing.

As BritPop spilt over into the 'BritCulture' of BritArt and the heavily over-mediated 'neo-Swinging London', as championed by British glossy magazines from *GQ* to the *Telegraph Magazine* and *Elle*, so a new aristocracy of wholly metropolitan socialites, art dealers, PR gurus and restaurateurs would benefit from the

mini-boom. For Noel and Liam Gallagher, from the depressed suburb of Burnage, south Manchester, there must have been a delicious sense of victory in realizing that the old escape route from working-class drudgery through football or pop was still open – and it could still make the toffs dance to their tune. As is traditional in English popular culture, from Mick Jagger's charming of the British aristocracy, the yobs were calling the shots to the snobs. Hence Noel Gallagher, on the television programme 'TFI Friday', displaying his neatly shoed foot to a fawning Chris Evans and barking the one word, 'Gucci'. BritPop had not merely come home, it was thinking of buying the house. Which was rather why Liam Gallagher cancelled an American tour.

What did become evident, however, was that by invoking both the sound and sensibility of English popular culture of earlier eras – be that the High Psychedelia of Sixties opulence or the cheerful cheesiness of Seventies kitsch – the ultimate destination of Brit-Pop's targeted revivalism was a kind of 'virtual' pop, in which the stars and the fans appeared like holograms of their distant and mutated originals. And, ironically, the Beatles themselves would release what amounted to a 'virtual' single, 'Free as a Bird', with Lennon's vocals collaged into new material, just as Oasismania was nearing its peak. With a sigh of relief and a power surge on the National Grid, the country was once more united in its traditional twin obsession with northern working-class pop and the Royal Family – Princess Diana having screened her 'Panorama' special just minutes after the world première of the Beatles' virtual video. This, if ever there was one, was a triumph for Sixties revivalism, and the Beatles had descended as though from Pop Heaven to anoint Noel and Liam – within air-space of Royalty – as the successors to the original BritPop throne.

BritPop, as a media phenomenon attendant on the supposed rivalry between Blur and Oasis, had arrived at a time when years of Conservative government had all but conditioned several generations of young people into believing that politics were irrelevant

– save as a distant force of despotism, reflexively acknowledged in a half-hearted way to challenge the legality of raves or keep homeless people in the streets. Now, it would seem as though the maturing establishment of BritPop can either follow the formulaic patterns of rock orthodoxy – the 'difficult' new album, solo projects, rumours of overdose, and, to quote Blur, 'a big house in the country' – or batten down the hatches in the face of the Spice Girls and the pre-teen pop parade.

Like Boyzone and Take That before them, the Spice Girls are an arch-conservative construct whose media-friendly sex appeal is shot through with the commonsensical philosophies traditionally ascribed to well-behaved but fun-loving teenagers. The Spice Girls are naughty but nice, with a vote-winning dash of cosmetic militancy. Need we look any further than the coy chorus of, 'If you wanna be my luvah, first you gotta be my friend' to realize that they follow in a long line of safe pop phenomena that stretches all the way back to Cliff Richard and his pals in *Summer Holiday*? If BritPop plundered from pop's past, in the name of Prog Mod revivalism, then the Spice Girls look back to the Mop Top era of Beatlemania, before the music turned weird, and the youthful Fab Four were cheeky professionals on the stage of the Royal Variety Show.

And so this latest phenomenon in British pop is retreating yet again, in terms of its ethos, from the psychedelic garden of 1968 to the positive Eden of 1964. After all, the Spice Girls approached Richard Lester, who directed the Beatles in *A Hard Day's Night*, to create their first full-length feature film. Who knows, if BritPop gives way to girl power then Britain might need the Spice Girls like Russia needed a communist Elvis. They could yet become the official state pop of advanced democratic consumerism – the sound of a bright new Britain.

'. . . on an ever tightening coil . . .'

In the big grey apartment, the submarine light seemed to turn moss-green. The grey-painted frame of one of the tall sash windows rattled suddenly, buffeted by the wind. There were going to be some changes around here. During the next ten years, certain . . . ideas would emerge from the culture, pretty much organically, the sheer brute force of which would take some getting used to. The list would run something like this:

1. Throughout the 1990s, many of the very qualities being demonized as evil Thatcherite 1980s acquisitive competitive cultural bullishness – the whole yuppie arrogance of 'greed is good', for instance, or 'second is nowhere' – would be simultaneously rehabilitated by popular culture, media and advertising as 'Attitude'.
2. Pop, for the most part, would cease to be a venue for new ideas and become a site for recycling old ideas.
3. Anxiety and doubt, as an energizing force within cultural practice, would be domesticated and disarmed by a) the comedy of recognition and b) market-formatted cultural production. The effect of these factors produced a culture that appeared to have been *designed*, by media, retail and advertising. Contemporary art would become fixated on issues of pre-mediation and mediation itself.
4. Brute Authenticity would replace Brute Irony as the temper of the zeitgeist.
5. A consequence of the above would be a pan-media return to gender stereotyping.
6. As the 1990s became fixated on brands and retail culture, so the Trojan Horse of cultural materialism would be Infantilism – seducing the consumer with cosy treats: the caffe latte and the loft conversion. By the year 2000, frothy coffee would appear to be the multi-purpose signifier of urban, credit-based consumer society – the Death by Cappuccino effect.

7. In the 1990s, the cross-cultural pursuit of Authenticity would also provide the 'bread and circuses' (most importantly, Popular Factual Programming – 'reality' and 'conflict' TV – an obsession with 'celebrity' and confessional journalism) with which to distract the consumer from the sheer fragility (as demonstrated by the near civic panic during the petrol shortages) of consumer society.

8. This obsession with Authenticity would declare realism to be synonymous with dysfunctionalism.

9. As a site for cultural production, all aspects of the middle classes would be deemed toxic, if not radioactive.

10. By the year 2000, Call Centre Britain would be firmly established. The rhetoric of advertising and retail – the slogans of the Benign Corporation ('Because Life's Complicated Enough!', 'Every Little Helps!', 'What Can We Do to Make It Happen?') would be based on an idea of intimacy, empathy and personal contact with the customer. The reality behind the rhetoric would be a culture of endlessly deferred accountability, in which there was no one, ultimately, whom the consumer could challenge as responsible for the fair running of The System. Translated into the dynamics of a family, the consumers became children (remember the Trojan Horse of Infantilism a little earlier on?) to the parents of the Benign Corporation, who promised comfort but handed out abandonment.

11. The end result of these ideas would be the feeling that, we, the consumer democracy, were in fact *post-political* – and afflicted with a Fear of Subjectivity.

The lost young men of Campbell and Wisniewski just didn't seem hip to the Attitude of the Nineties – they were too awkward, too obscure, too strait-laced, too fey. As culture-vulturing city slickers, all they could do was carry on sitting there. Sighing, perhaps. Fairly soon, all the elitist smarty-pants twiddly bits of Eighties post-

modernism – Style Culture, atria, nouvelle cuisine, Jeff Koons – would be declared (in public, at any rate) An Enemy of the People.

The culture of self-conscious artifice had been replaced by a culture of self-conscious authenticity. And as the margins of culture were fed into the conservative, market-dictated flow of the mainstream, it would take some fancy footwork to remain oppositional. But oppositional to what? What did the term mean nowadays? In many cases, the only way to become culturally confrontational was to make a choice to cease your cultural pro-duction – to culture strike, as the writer, punk historian and activist Stewart Home would declare and demonstrate.

Howard Devoto

Of all the icons assembled in the pantheon of punk, Howard Devoto could most probably lay claim to being the most enig-matic and the most revered. He was described by Pete Frame (the creator of the *Rock Family Trees*) as 'the Orson Welles of punk', and pronounced in a tribute song by Momus to be 'The Most Important Man Alive'. Morrissey stated that it was Devoto whom he had in mind when he wrote 'The Last Of the Famous International Playboys', while Paul Morley claimed that Devoto introduced a 'new literacy not just into punk, but into rock as a whole'. He has also been cited as an influence by novelists as different in style as D. J. Taylor and Jeff Noon.

And yet Devoto himself remains mysterious. His guru-like status has been all the more respected for the dignified manner in which he has allowed his body of recorded work and published lyrics to represent him. Having co-founded and founded, respect-ively, two of the most influential groups of the punk period, the Buzzcocks and Magazine, he then went on to record a solo album, *Jerky Versions of the Dream*, before forming his third and final group, Luxuria, in 1986.

He ceased recording professionally in 1990, preferring the anonymity of a day job to some kind of honorary position in the music business as an elder statesman of cultural revolution. He could therefore also claim to be 'the T. E. Lawrence of punk'. With regard to his current employment, Devoto has little to say. 'I am the manager of the archive at a leading photographic agency in central London. I also receive royalties from my recordings.' He is neither open nor defensive about his working life beyond music, except to say that his work with Luxuria did not deliver the support he required to proceed.

'There was something very limiting about punk,' he states, in a tone that is both assertive and measured – Alan Bennett without the soft edges – 'and in the early days that was punk's strength. You knew your themes, you knew how to look and you knew your musical style. And there you were, for a while. But I'd loved all kinds of other music up to that point. There was some big elemental thing that happened with the Sex Pistols, but in terms of music there was a whole gamut of other stuff which I had liked, and which, in the realm of ideas, were not totally different tins of biscuits – Leonard Cohen, Dylan, David Bowie. With the Pistols and Iggy Pop, it was the anger and poetry which hooked me in, really.'

In the spring of 1976, in Manchester, Devoto co-founded Buzzcocks with guitarist Pete Shelley. They recorded the massively influential *Spiral Scratch* EP, and a highly collectable official boot-leg, *Time's Up*. Heard now, these recordings have lost none of their fizzed-up, self-aware energy, driven by Shelley's sublime re-invention of jagged, high-speed pop guitar playing. On machine-gun-tempo songs such as 'Friends of Mine', 'Boredom' and 'Orgasm Addict', Devoto delivers his smarter-than-smart lyrics with an edgy petulance that disguises their wit and biting acuity as a kind of pantomime of dumbness. 'You're making out with schoolkids, winos and heads of state,' he lashes out on 'Orgasm Addict', 'You're making out with the lady who puts the little plastic robins on the Christmas cake.'

Artistically, the young Devoto was responding to influences from Alice Cooper to Camus. Having studied philosophy as a student, and having been interested in meditation, his lyrics on *Spiral Scratch* and *Time's Up* were fully intended to be carefully posed, self-questioning philosophical statements about the problems of existence. Interviewing himself, when *Spiral Scratch* was originally released in 1977, Devoto wrote of the song 'Breakdown', '"Breakdown"'s hero is in the position of Camus' Sisyphus – "To will is to stir up paradoxes."' Punk rock had thus been a personal and creative catalyst for Devoto, offering him a means to conduct nothing less than a biopsy on his own soul.

'I think that punk rock was a new version of trouble-shooting modern forms of unhappiness,' he says, 'and I think that a lot of our cultural activity is concerned with that process, particularly in our more privileged world, with time on our hands – in a world, most probably, after religion. My life changed at the point I saw the Sex Pistols, and became involved in trying to set up those concerts for them. Suddenly I was drawn into something which really engaged me. Punk was nihilistic anger, not overtly political anger. Political anger could have been the radical Sixties.

But going back to what I was going through, personally, and all of the stuff that you do go through as a student, I remember – before punk even – pursuing Artaud's Theatre of Cruelty; I had pictures of the Baader Meinhof on my wall, and all of that hunger strike stuff was going on. It was that struggle for commitment which you have as a young person. And where did you put all that when you're a young person like me, who wanted to play a "Yes, but –" game with everything?'

Since 1990, Devoto has given the whole punk reunions circuit an extremely wide berth, as well as being highly reluctant to offer up his recollections to what has become the major academic industry of 'Punk Studies'. An example of this reticence could be seen in his contribution to the commemorative documentary, which was made in 1996, about the two Sex Pistols concerts held

at Manchester's Lesser Free Trade Hall in the summer of 1976. Despite being the man who actually arranged these concerts – with his own first group, the Buzzcocks, supporting at the second – Devoto chose to be represented on the programme by a reel-to-reel tape-recorder, playing a recording of his few comments about the occasion.

Person to person, he can give a meticulous account of his involvement in punk, often using factual information and chronology as a means of avoiding generalized statements about punk's 'attitude'.

'Can I just say,' he states, 'that what I don't buy are things like a piece which I read by Caroline Coon about punk a few years ago, which said how desolate the mid-Seventies were, culturally and politically. And I don't buy John Lydon's line, either, in this new film *The Filth and the Fury*, where he's going on about "the system being really oppressive in Britain, and that's why punk rock happened". I just don't accept this stuff, really. In myself, I can't say that I was feeling particularly great at that time – but what's new?'

Having left the Buzzcocks almost as soon as they released their first record, Devoto formed Magazine as a way of expanding the possibilities that had been opened by punk. In a leaving statement issued on 21 February 1977, he wrote: 'I don't like most of this new wave music. I don't like music. I don't like movements. Despite all that, things still have to be said. But I am not confident of Buzzcocks' intention to get out of the dry land of new waveness to a place from which these things could be said. What was once unhealthily fresh is now a clean old hat.'

As ever, Devoto's stance was one of disaffection and dissatisfaction – rejecting the early complacency into which punk rock so readily dropped, prior to becoming little more than a picture postcard parody of itself. With Magazine, he explored the causes of this stance through lyrics and performance at once disturbing and playful, self-aware and endlessly self-questioning.

Musically, Magazine comprised the formidable teaming up of Dave Formula, John McGeoch and the legendary Barry Adamson, whose own solo work would pursue the idea of attempting to solve the case of oneself. In hindsight, Magazine would have found their place in the history of music on the strength of just one of their early recordings, 'Shot by Both Sides'.

'Magazine was its own particular blend of trying to contain a certain sort of intelligence in that sort of music. One of my partners of those years, asking about a Magazine lyric, said, "Is that about you and me?" And I said, "You'll never know because I swap them around." But also in Magazine there was the idea of me addressing the audience and making ambiguous pronouncements about our respective roles – your idea of me, and my idea of you. And I was really playing with that during the period of the first two Magazine LPs – when I was in the prime of my ambition. I'm still proud of Magazine. Half a lifetime of feeling went into it.

'And I'm sure that I tried to rant on about the importance, to me, of paradox and contradiction. That there is some state of grace or point of ultimate knowledge in trying to come to an aesthetic understanding of these things. I'm trying to explain the Magazine song, "Shot by Both Sides", I suppose, and this is the area which I've explored in everything I've done since the Buzzcocks.'

In many ways, Devoto's life since adolescence, when he first started to write, has been an epic of self-portraiture. Even now, he is writing his autobiography and recording it as a spoken word document, to be left to the National Sound Archive after his death. He has barely reached the middle Seventies and the work is already twenty chapters – ten hours – long, including one hundred and fifty samples of music. Not surprisingly, one of his favourite authors is Marcel Proust. His own writing, as a lyricist, has articulated his personal position with an eloquence and originality that rivals much of the best contemporary fiction and drama.

But at the heart of his constant enquiry – as revealed with brooding poignancy on his final LP with Luxuria, *Beast Box* – seems to lie a fear of what he might discover if he could actually answer his own questions about himself. 'They've opened the Beast Box haven't they?' he concludes the title track of that LP, and even on the haunting crescendo of 'Railings', which he recorded in 1998, for the rock group Mansun, his distinctive voice appeared to croon from its own grave, 'Don't burn your hand on the window, if you just want to take in the view . . .'

'Life is hell,' says Devoto during this interview, neither joking nor seeking to shock, 'I don't think I've ever strayed very far from that idea since I was about twenty. Now, in the last ten years, since I've essentially quit music, I've come to some kind of accommodation with that. But at a blood and brain level, that's really how I feel, and it's one big reason why so far I don't have kids.

'From where I was, in 1990, I suppose that most people in my position would try to find another niche for themselves in the music business. But I have too much damaging, damaging pride. And if you take my lack of confidence, and you take my pride – well, there you really are shot by both sides.'

Contemporary Interventionism

In the Whitechapel Art Gallery's survey of British experimental art from 1965 to 1975, 'Live in Your Head', there was a work by Keith Arnatt from 1972 in which the artist had been photographed standing on a busy street, wearing a placard which proclaimed, 'I'm a Real Artist'.

Dour and faintly absurd, yet with a confrontational edge that flits between threat and polemic, Arnatt's street sloganeering seems particularly relevant to a new sensibility that has emerged in contemporary British art, and that seeks to rearrange or dismantle the purpose and cultural status of current artistic activity.

In 'Live in Your Head' the foregrounding of documentation over aesthetics, for example, and of politics over individualism, could be seen as a direct rehearsal of the ICA's 'Crash!' exhibition, or the 'democracy!' show curated by students on the Visual Arts Administration MA at the Royal College of Art. Taken as a gear-change in the zeitgeist, these shows and a host of lesser-known pamphleteers, activists, interventionists and ideologues, comprise a distinct reaction – or response – to the agenda set within the visual arts throughout the 1990s.

On the one hand, there is a sense in which dissident, confrontational or otherwise socially engaged artistic practice would seem to become disqualified the moment that it has any relation with the 'elite' white cube of the gallery, or the social systems of the art world. On the other, within the gradations of artistic dissent – from artists engaged in direct street action, through to those who are actively reinventing the notion of art in the community – there still seems to be room for such work to be curated without losing its integrity.

'Many of the major new galleries have engaged artists to work with communities in imaginative education and outreach programmes,' says Teresa Gleadowe, the Course Director of the Visual Arts Administration MA at the Royal College of Art; 'Such activities have little relation with traditional studio-based practice – they involve public participation, research, conversation, exploration, shared interests and causes. Social engagement is a common concern. Most of these projects do not result in the production of art objects, and some may not easily be recognized as art at all.

'The "democracy!" exhibition took on the job of representing some aspects of this activity and of finding ways of presenting it in a gallery situation. This is a difficult and even paradoxical endeavour, which demands from the visitor a level of deep engagement – reading, listening, forensic investigation. As an exhibition subject it is a risky enterprise, and one which might not easily be

undertaken by an established institution. It seems appropriate that young curators, working within the research environment of a curatorial course, should give themselves the task of making manifest practices of this kind.'

Evidence that such socially engaged art practice is swiftly gaining in significance, raising a host of issues related to venue, craft, distribution and commodity, can be seen at a glance from some of the artists involved in 'democracy!'. Sarah Tripp's documentary project, for example, interviewed a network of people about their faith and belief; Group Material – best known for their 'AIDS Timeline' – were an artists' collective based in New York's Lower East Side, 'committed to art's potential to effect social political change'. Also for 'democracy!' Jeremy Deller worked with elderly people, 'opening the doors of the Royal College's Senior Common Room to the members of a local drop-in centre'.

Taken point for point, a freshly politicized approach to making art can be seen to exchange the sexual, nihilistic, aesthetically exquisite and pop culturally individualist agenda of last decade's 'Sensation' generation, and replace it with a virtually existentialist reassessment of art's capacity and function. Where the lucrative visceral shock tactics of Emin, Hirst or the Chapman brothers could be seen as the convulsions of outraged romanticism, so the various practitioners and collectives of the latest sensibility appear to be based in a kind of philosophical ethnography, questioning social and cultural power structures from the outside, and developing an art that is largely impossible to own, display or accord a financial value.

For the novelist, pamphleteer and founder of the Neoist Alliance, Stewart Home – who famously went on 'Culture Strike' between 1990 and 1993, refusing to make any new work at all – this relationship between culture, commodity and distribution is central to both his writing and its publication. He regards both Tracey Emin, with whom he once exhibited, and Damien Hirst as artists who have 'recouped' on his ideas (his 'Culture Strike'

bed, and his 'Necrocard', respectively) by turning them into com-
modified objects.

'I guess that in some ways I've worked with self-publishing and
small presses in order to enable different discussions to go on
outside of the commodified business exchange. The Tate have
been collecting my pamphlets and leaflets since the 1980s, so you
can criticize these institutions, but their archivists and librarians
are really on the ball. Basically, if you get an A3 sheet of paper,
and fill it with whatever polemic you want, then those ideas are
going to get around and get a response.'

A further collective devoted to such practice is Inventory,
formed in 1995 as a group committed to exploring the possibilities
of anthropological research as text-based art. Through their
Inventory journal – with the slogan, 'Losing, Finding and Col-
lecting' – and a succession of activities based on street inter-
ventions, Inventory could be seen to represent a determinedly
outsider stance, while seeking new, cheap ways to disseminate
their thinking.

'We all abandoned individual practice at the start of the 1990s,'
says an Inventory spokesperson, 'primarily because we found the
whole new British art scene, which had originated around Hirst's
"Freeze" exhibition, to be utterly alienating. We saw ourselves as
more connected to surrealism, Dada, Walter Benjamin or Bataille,
and we wanted to talk about ideas through a journal which could
be slightly academic, mad, and shocking.

'But that wasn't enough; we wanted to explore the various
economies of social life through social situations, and so our work
is political inasmuch as it's occurring at a time when even the
word "socialism" appears to be taboo. We regard nihilism in a
pro-active, Nietzschean sense, as something to be worked through,
and empowered by. By investigating the nature of field work, we
turn the anthropological gaze back on ourselves. This could be
translated into politics – through the surrealist notion of a perman-
ent state of revolution.

'I don't think that anyone in the London contemporary art scene trusts us enough to represent us; they like us to be a bit of a cult. But we've survived for five years without them, and so we can easily do another five. We're quite happy representing ourselves.'

One of Inventory's better-known 'interventions' was a fly-posting project in Hanway Street, in London's West End, called 'Smash This Puny Existence'. Braving foul weather, local hostility and the approaches of bored prostitutes, the group fly-posted this dark cut-through between Oxford Street and Tottenham Court Road with a series of newsprint posters proclaiming such announcements as 'The Puerilification of Culture' and surrealist texts on the experience of walking through a city. The group also discovered that a loophole in public by-laws made it possible for a person to stand on Oxford Street holding a large placard (of the sort usually seen advertising closing-down sales) which blared 'Smash This Puny Existence'.

This project was also disseminated by Matthew Higgs (the curator of this year's British Art Show) through the long-established art books publishers, Book Works, as part of their Open House series of guest-curated projects. Book Works was founded in the mid-1980s as 'an attempt to reposition the book in the context of visual arts', and in recent years their role as enablers of documentative, interventionist and pamphleteering artworks has become increasingly significant. Above all, many of their publications create affordable artworks, which can have whatever collectable status the buyer decides.

'Over the years, this has produced an eclectic range of works,' says one of Book Works' founders and directors, Jane Rolo, 'from early collaborations with activist groups like the Guerilla Girls, or Adrian Piper's book *Colored People* – a visual commentary on preconceived ideas about race. More recently, Czech artist Pavel Buchler's project involved projecting a red light from Chetham's Library in Manchester – where Marx and Engels studied – on to the Saint George's flag of Manchester cathedral. With the Open

House project, we've been able to work with talented young curators like Matthew Higgs and Stefan Kalmar, and to commission books by artists like Janice Kerbel and Nils Norman: to invest in ideas, rather than the cult of artist as celebrity'

Stefan Kalmar has introduced his commissions for the Book Works Open House project – under the umbrella title 'access/excess' – with a quotation from the *Communist Manifesto*: 'All that is solid melts into air, all that is holy is profaned, and man is at last compelled to face with sober senses his real condition of life and his relations with his kind.'

As though to illustrate this supposed disruption of systems and orders, Kalmar has commissioned four artists to create what are in essence handbooks for social or anti-social activity. Janice Kerbel's '15 Lombard Street' gives precise instructions on how to rob the branch of Coutts & Co. bank at that address, for example, while Nils Norman's 'The Contemporary Picturesque' considers protest culture tactics in relation to 'the development of a repressive form of urban architecture and design – such as surface studs, trash cages and anti-poster surfaces'.

Ultimately, events such as the recent 'Reclaim the Streets' demonstrations in London can be seen as a potentially volatile summation of the burgeoning relationship between marginalized artistic activity and direct political action. For Stewart Home, however, as a veteran of many interventionist, hoaxing and direct action campaigns, the political significance of anarchic demonstrations should not become too intimate with art. 'The danger is that you begin to brand such street actions as "art", and thereby dampen their political directives. It's always easy for them to try and control us by treating us as a cult.'

Freezing cold in Cavendish Square, shadows in the doorways of John Lewis – the clear night sky, promising frost, above the ornate

red brick of Marylebone's rooftops ... In a nasty little pub, a knot of cumbersome figures accumulate: unironic anorak wearers, plump young men with pudding-basin fringes and bottle-end glasses, dandyfied smoothies reeking of scent, Dadaist-looking spiv types with loudly checked tweed lop-sided motoring caps such as Mr Toad might have worn, a few greying punks wearing old men's suits ... These people may look like potatoes, but they're the forces of Opposition; like Wyndham Lewis's Enemy, clan-gathering round the back of Oxford Street, W1.

Shortly before half-past eleven the whole rag-bag assortment creeps and shuffles, grey and hunched against the frost-whitened streets, where sounds are growing softer, along the shadow of the buildings, to a back mews, and a big black garage door, behind the uppermost panes of which a feeble yellow light is dimly gleam-ing. The little crowd – fifteen or so, maybe twenty – huddle forward in the silence, as the big black door opens just a few inches and a hand so white and frail as to seem luminescent slides out to greet them with a single beckoning finger. Heads lowered, they all shuffle in ...

The vast auditorium, smelling of brass polish and dust, is barely lit. But you can just make out a couple of ... grand pianos ... on the stage. To a murmur of *exceedingly well-mannered applause*, two casually dressed young men seem pretty much to sprint from the darkness of the wings, hurl themselves down on the pair of adjusted piano stools, fling their hands to the keyboard and ... play a Morton Feldman minimalist piano duet for the best part of the forty minutes. Welcome to the 'Wigmore Alternative', the Anti-Rave! – where the music doesn't pound in beats per minute, it echoes in beats per hour ...

The enigmatic composer Lawrence Crane (England's unack-nowledged Satie, a joker in the pack) and founder of the Wigmore Alternative – part pastoralist, part humorist, part über-archivist, part punk rocker – would demonstrate, in the twilight of the 1980s, the importance of *Organization* ... The artistic application

of the aesthetics of librarianship or proofreading. Cranesque order and neatness was a rout to the sublime.

Pet Shop Boys

For a pop duo who had their first Number One hit – 'West End Girls' – back in 1985, Chris Lowe and Neil Tennant, better known as Pet Shop Boys, have a knack of remaining constantly modern. Like the artists Gilbert & George, they have developed a creative partnership that seems to operate beyond the boundaries of fashionability, and yet remains permanently in fashion. From such memorable occasions as Chris Lowe wearing an Issey Miyake inflatable suit when they performed on 'Saturday Night at the London Palladium' – and refused to wave at the end of the show with the rest of the acts and Jimmy Tarbuck – to their later collaborations with artist film-makers such as Derek Jarman and Sam Taylor-Wood, they have always managed to mirror the zeitgeist while retaining their cultural independence.

To some extent, the enduring relevance of the Pet Shop Boys could be due to the fact that they seemed to find their perfect musical identity right at the very beginning of their career. By mixing the sensory rush of luxuriously orchestrated dance music with an image and lyrical style that was almost its direct opposite, foregrounding isolation and social commentary, they achieved an originality and acquired a stance that has simply intensified over the years. With the Pet Shop Boys, there is nearly always a hidden, sharp edge of critique – critique of society, of pop, and of themselves – just beneath the lustrous sheen on the surface of their image. After all, they even managed to cover Village People's 'Go West' with a Russian constructivist spin.

The Pet Shop Boys are holding a series of interviews in a semi-derelict suite of rooms just beneath the highly ornate, neo-Gothic eaves of the old Saint Pancras Station Hotel. The hotel

has been empty for nearly a decade – although the Spice Girls filmed their video for 'Wannabe' here – and this interview has been presented as a kind of eerie performance piece with touches of science-fiction. Summoned up the five dusty flights of the abandoned ceremonial staircase, a tape-recording of barking dogs breaks out high above you. So far, so New Romantic.

Greeted at the top by Dainton, the Pet Shop Boys' friend and bodyguard, you are then led through a further suite of darkened rooms, at the end of which, booming away, there is a projection of the Pet Shop Boys' latest video. When you finally get to Tennant and Lowe, they are sitting on an illuminated glass floor inspired by Kubrick's *2001 – a Space Odyssey*, and wearing matching Versace bomber jackets made out of a gold metallic fabric designed to retain every crease and wrinkle. They look like off-duty astronauts.

'If you had this floor in your house,' announces Tennant, suddenly domestic in the midst of Goth-Futurist ambience, 'and it was taken away, you'd really miss it. Everything would look really drab, because it gives off a lovely light. It's actually quite warm and contemplative.' He looks around the floor again, for all the world like a customer in Habitat on the Conran Shop, choosing interior lighting.

Tennant and Lowe are there to promote their new single, with its classically Pet Shop Boys title, 'I Don't Know What You Want but I Can't Give It Anymore'. This single is a mesmerically spooky disco stomper, which has a lyric about paranoia, surveillance and infidelity, but a snare-drum and hi-hat back-beat that sounds as though it was lifted off a track by Barry White and the Love Unlimited Orchestra. In fact, it is one of those potent configurations of opposites that the Pet Shop Boys have made their speciality. In addition to this, they have developed a new image for the video you could call 'Boot Boy Samurai Chic'.

As a look, this new image just manages to ride that perilously tight back-curve of style that Eddie Izzard identified as connecting 'fantastically hip' with 'totally naff'. What makes it succeed, ulti-

mately, is the fact that the Pet Shop Boys have pushed it to the very limit: scary gold-haired wigs that show the dark roots of dyed hair, heavy black eyebrows of the kind last seen on Siousxie Sioux in about 1981, spider-thin dark glasses that lend an air of complete blankness to the features, and striped culottes that hang like ankle-length skirts. Gothic interiors, men in skirts and synthesizers – it has to be New Romantic.

'I do think that the video's quite New Romantic,' says Neil, 'but New Romanticism worked for such a short period of time, didn't it? And needless to say David Bowie had the best moment in it by leaping in about two hours after it all started with the video for "Ashes to Ashes". That really is the ultimate New Romantic video, although there's probably some good ones by Steve Strange and Visage – "Fade to Grey" perhaps?

'I remember when I used to live in a flat in the Kings Road, just above a Chinese restaurant, and I happened to open the door one day just as Steve Strange walked past. He was wearing "Look Number Three", which was when he had a beard and sat on cushions. It was his "Cushions Period", but I always remember it as quite exciting.'

'There's not enough of all that, these days, is there?' adds Chris Lowe, as though remarking on the demise of corner shops. 'The Kings Road used to be fantastic.'

'If I had the nerve,' Neil confides, 'I'd walk up and down the Kings Road dressed like we are in our video. Secretly, I'd quite like to do that. But it takes too long to put the wig on . . .'

'But that was the whole point!' exclaims Chris. 'The whole point of New Romanticism was that it took such a long time to get ready. That was what you did – get ready.'

'I have to say that I like the bit in the video with the whole ritual of putting on the costumes. The costumes are a distancing technique – a way of saying that we're nothing to do with anything else that's happening in pop,' says Neil. 'Pop music, these days, is either cheesily sincere – as in your boy bands – or it's effectively

natural-looking, and we wanted to do something with a level of artifice in it. I always liked pop that has a sense of wonder about it. I mean, would you rather see David Bowie on roller skates – like he was in his "Day In, Day Out" video – or would you rather see David Bowie dressed as a clown, walking along the beach at Hastings with a bunch of New Romantics? I imagine you'd rather see him dressed as a clown in Hastings – I know I would.

Also, the Pet Shop Boys have always been obsessed with not being real, because we think that's more interesting. I have always thought that the idea, for a pop star, is to not be able to believe that they're real. Which is why I think it was brilliant that Elvis never performed in Britain. Actually, to their credit, the pop gossip columnist of *The Sun* suggested that all the interviewers should be dressed like we are in the video.'

'But it can also look grotesque,' Chris points out.

'No. It really wasn't designed for daily wear,' agrees Neil. 'It was designed like our "Pointy Hats" look a few years ago, to be seen through an electronic medium. That way you can smooth things out. We did the "Pointy Hats" in real life, just once, when we launched MTV in Russia. When we came out to do the press conference we discovered that the ceiling of the room was too low for the hats, and then when I sat down the collar of my jacket rode up, so I had to kind of bend forward. An English audience would have found this hilarious, and we'd all have had a good laugh. But the Russians just sat there and stared at us, and then asked all the usual questions as though nothing was odd. You've got to have a nerve to do this kind of thing, you know. But when you look at our "Pointy Hats" video, it's a classic video. It's an attempt to move away from all the supposed naturalism in pop . . .'

With their new image, record and forthcoming tour, the Pet Shop Boys are presenting, as usual, an entire theatrical package. This time, they have pulled off the considerable coup of collaborating with the visionary architect, Zaha Hadid, some of whose buildings have been considered too radical to be constructed. In the

light of this latest collaboration, one can see how the Pet Shop Boys – Lowe is a trained architect himself – are continuing their fascination with presenting artificial environments in which to perform their songs.

'Actually, the idea came about because Janet Street Porter had been walking with Zaha Hadid for her television programme,' says Neil. 'And she said, "Why don't you get Zaha Hadid to design your new musical?" and we said, "Because she's an architect and it's a completely different discipline to designing for the theatre." But then we were in New York and I was flicking through a book of Zaha's designs in the Rizzoli bookshop, and I suddenly saw all of her architectural models as stage sets – wonderful shapes to walk across while holding a microphone, wearing a ludicrous costume and having a wind-machine on you maybe.

'So we approached her, and I have to say that she and her operation have been inspiring to work with. They take all the practicalities of a rock show on board, and they are the only people we have ever worked with who take the budget seriously. They are working on a modular set which can evolve during the show and be adapted to different sizes of venue. Which means that the backing singers are going to be doing some heavy lifting, only they don't know that yet . . .'

So what does all this new look mean? Or does it mean anything? To judge from the exterior shots of the video, and the extreme styling of their new image, they are positioning themselves in a vision of the future in which the architectural brutalism of the Seventies has become as weathered as the Victorian neo-Gothicism of Sir George Gilbert Scott's Saint Pancras Hotel. It is, perhaps, the idea of the future itself appearing antique and old-fashioned, with every adult and child dressed, as revealed at the end of the video, in the extraordinary Samurai chic which we had assumed was a sub-cult gang costume – like the Droogs in *A Clockwork Orange* – rather than the mark of complete social conformity.

'There is a comment about conformity,' says Neil. 'But I think that if our previous shows were paintings, then they would have been figurative. Whereas this one is definitely abstract. Unlike our other shows, this doesn't have a narrative, however loose. I think that it is possible for pop music to get over-intellectualized, but on the other hand it probably isn't intellectualized enough. In the late Seventies and early Eighties pop was definitely intellectualized, and interestingly enough there was a lot of good music around at the same time. These days, you'd get embarrassed to start talking about art or writing in pop because people might think you're being pretentious, which is a really sad pay-off of the whole laddish thing in the Nineties.'

'Like Bowie gets ridiculed for wanting to be interested in new things,' says Chris. 'But we're always looking for a new underground . . .'

But the problem of how to be confrontational would still obsess a new generation of cultural practitioners during the 1990s. How the hell did you catch anyone's attention, what with the whole more-in-your-face-than-you thing going on? To some pundits, the age would seem obsessed by sex and death, centring on what Professor Eric Northey would define as 'the nectothon' of the mass mediation of Diana, Princess of Wales's death and funeral. Culturally, in many ways, this was a post-modern re-run of the aestheticism and morbidity of the nineteenth-century 'fin-de-siècle' – the cartoon decadence of a neo-grunge demi-monde, with yobs and snobs united in the flashlight of high fashion.

And how did you deal with the phenomenon-seeking inverted commas of free-floating irony? That would become another problem.

Irony (as understatement, overstatement, the conflation of opposites and a general fiddling about, in the name of critique,

with context and intentionality), within the cultural practice of the early 1990s, would turn out to be the growing pains of the New Authenticity – the phase before the social realism kicked in. But back in the winter of 1988, there was a feeling abroad about irony that was touchingly innocent; it could remind you, in hindsight, of Truman Capote's wistful recollections, as an alcoholic, of how he used to get drunk: 'In Harry's Bar it just seemed such fun,' he said.

Likewise Irony. Looking back on it now, and seeing the two culture-vulturing city slickers, thinking out ways to sidestep the obvious, outwit the trend-waves, and play a tune on the bleeps and squeaks of the zeitgeist, there is the realization that the fluffy end of the arts and cultural media during the late 1980s and early 1990s (the swift dissolve between Cult Studies and Lifestyle journalism) had become set to being hyper-cynically arch, or 'arch'.

On the one hand, Irony could be regarded as a means of responding to, and co-existing with, the conversion of all things socio-cultural into a post-modern bombardment of culturally destabilized, aesthetically blurred, ultimately unauthored and free-floating signifiers – the Phenomena of things. Irony, in this respect, was a kind of 'two can play at that game', or 'I'll be your mirror' means of critique.

But the Ironists of the early 1990s had also honed the pursuit of Style Watching (the refraction of the post-punk style press through aspirational high bourgeois print media) to such a degree, that their commentaries became increasingly reliant on the instant translation of trends and phenomena into a code of social satire. This was a mixture of wit and anthropology that could end up dissolving in the acid bath of its own chemistry. For there was a faintly psychopathic edge to all of this, in the sense of cold-blooded style watching, however astute, needing to lack almost any kind of empathy – or even emotional awareness – with its subjects, but simply looking for the most precise emblem of their Type. In

many ways, this was the point where Naturalism met Marketing – on an island off the coast of Camp.

At the time this seemed like the weaponry of applied dandyism, and wide open to the perils of terminal ennui: where dandies articulate their philosophy of life through Mock Heroic fashion (the world expressed in a tie-pin, for instance), so the culmination of Irony would be a search for the tiniest detail in other people's dress and behaviour, which would say the most about them. A noble enough enterprise, in keeping with the naturalism of nineteenth-century fiction (cf. Tom Wolfe's literary and journalistic homage to Balzac and Dickens), but also open to abuse as the reduction of all things to nothing more than a periodic table of status.

Needless to say, by the middle 1990s, the sheer surfeit of Irony in the zeitgeist was like some kind of cultural vitamin imbalance. We were gorged on Irony, sickened and bloated and cramped with snooty cleverness. Irony was our trapped wind. The critic Robert Hughes – somewhat brutally – even described the art of Jeff Koons as 'the last of the methane in the cow of post-modernism'.

But then a miracle occurred, and Irony turned into the Pursuit of Authenticity. This was partly a cyclical reaction to the trend, but also because a new generation of Ironists had realized that the only way of becoming Irony-proof themselves was to proclaim yourself one hundred per cent Authentic: a no-nonsense, bit-of-a-laugh, see-you-down-the-pub kind of person. Enter the massed armies of Mockney, the Lads, Ladettes and Babes – the football's coming home, none-of-that-low-fat-malarkey, 'trainspotting', fever-pitching, text-messaging, wap-phoning, Girlie Show and two smoking barrels. Enter, Attitude! A breath of fresh air, perhaps, or the fashionable face of anti-intellectualism.

Robert Hughes, needless to say, would now become Newly Marginalized and wheeled out as a Reactionary for his trouble – partly because of his book, *The Culture of Complaint* – which was held up as a proto-typical, disgusted-of-Manhattan, 'everything's

dumbing down', anti-political-correctness kind of book (the same thing would happen to Harold Bloom, with his 'School of Resentment' comments about the dangers of politicized -isms to literary criticism, in his massive book, *The Western Canon*), but also because the top froth of the culture – television, advertising, various chunks of the visual arts, pop and literary worlds – had been hanging on to irony for dear life, even as they were beginning to feel the pull of New Authenticity.

Robert and Harold, therefore, were shut up faster than a pair of dotty old men who had wandered into a rave – they just didn't get it, did they, and in the neo-Swinging Nineties, if you weren't hip to the Attitude!, you were . . . almost definitely . . . hopelessly . . . *middle-class and toxic*.

And this was strange: in a broad-band of culture which was being maintained, administered, mediated and consumed almost entirely by the middle classes, for an actual cultural practitioner to be regarded in any way as 'middle-class' was pretty much the end of the line. It usually implied that you were anti-modern, and, worse, anti-multicultural. Cultural-type people, therefore, were falling over one another to become bourgeois-proof. Regional culture (for example), and dialect in particular, was seized upon to provide the new morality comedies of Authenticity – from *Trainspotting* to *The Full Monty*; but at the same time there had seldom been such a pan-media boom in essentially bourgeois lifestyle subjects, from funky cooking to interior design and urban gardening.

'So why,' – as Quentin Crisp once remarked – 'was there such a racket?'

'The 'dumbing down' ticket was a waste of time: a debased and pointless phrase which, along with the equally pointless 'politically correct' and 'Middle England', simply denoted some vague idea of an armed confrontation between, on the one hand, tweedy intellectuals from the Home Counties with maths-teacher haircuts and a passion for opera, and on the other wantonly extravagant,

taxpayer-paid-for, brand-new Faculties of Hip-Hop Studies. It was simply the old High and Low culture debate, but now with added Bitterness.

Rather, the 1990s, perhaps, were acting out their version of the cultural identity crisis that occurred towards the end of most eras, and which the critics of the time can never quite agree upon. And as a fin-de-millennium, as well as fin-de-siècle, the Nineties got a triple whammy of crisis.

With regard to the trend for such crises, writing in 1939 about the 1930s, for instance, Malcolm Muggeridge had stated: 'The present is always chaos, its prophets always charlatans, its values always false. When it has become the past, and may be looked back on, only then is it possible to detect order underlying the chaos, truth underlying the charlatanry, inexorable justice underlying the false values.'

And here was Blake Morrison, in 1999, beginning a polemical essay for the *Independent on Sunday* newspaper – headlined: 'All Plugs and No Shocks: PR Driven, 'accessible', bland, 'self-congratulatory'. That's today's art scene' – with a quotation from T. S. Eliot: '"We can assert with some confidence," Eliot wrote in 1948, "that our own period is one of decline [and] that the standards of culture are lower than they were fifty years ago . . . I see no reason why the decay of culture should not proceed much further, and why we may not even have to anticipate a period [of] no culture."' Morrison adds: 'It's not that we've got no culture, but something almost as bad is infecting the patient: Blandness, capital B. Not just the quiet, inoffensive kind. No, something more shrill and happy-clappy. A relentlessly cheerful, end-of-millennium, let's-make-everyone-feel-comfortable blanket of good taste.'

Such doubt and pessimism about the state of culture, therefore, why It's All Over or has never been worse, would appear to be a traditional sub-strand of culture itself – a homoeopathic dose of fatalism, to keep the arteries of progress clean. It had occurred

in Pope's 'Dunciad', back in 1728, and Theophile de Gautier's Preface to his novel, *Mademoiselle de Maupin*, at the start of the nineteenth century, through nearly every cultural configuration by way of Wilde, Pound, Auden, Shaw and Orwell, to the disillusionment with the idealism of the 1960s shown by Sixties people like Christopher Booker (*The Neophiliacs*) and even Jonathan Green (*All Dressed Up*). And so when the end-of-civilization-as-we-know-it is announced, one can only really think, 'Well, no change there, then.'

But as the shutters came down (the moss-green submarine light in the grey penthouse apartment, the pedal-dampened difficult chords, the snapped violin string) and the culture-vulturing city slickers experienced the gathering loss of sympathy between a particular generation and the times they are living in (pondering Muggeridge and Morrison perhaps), there was suddenly the nagging doubt, '*What if they're right?*' . . . That what was now required, maybe, was the exchange (to judge from the shorter history of disillusionment) of a secular for a spiritual path.

For the 1990s seemed to be a decade of dichotomous thinking, which pointed out more sharply than usual the limits of generational sympathy. Within the culture, there were few gradations of points of view – little anxiety of oscillation between Either and Or. Beyond the increasingly important world of visual art – because visual art, in the 1990s, would become a multi-purpose emblem of modernity and regeneration, rather like London's Docklands had been in the Eighties – the rest of us would simply become aware of subtle, or not so subtle, massaging shifts in the presentation of things . . . You just got the feeling that you were usually being sold something, and that, as cultural commodification appeared to be approaching critical mass, most of it simply wasn't worth the price. 'So much of everything!', as Peter York has refined the moment into a four-word statement.

Britain, TV and Art

It was Mike Myers, the American star and creator of the spoof nerd cable TV show, *Wayne's World*, who really addressed the recent British obsession with searching for expressions of its national identity in the ironic remodelling of its popular culture. For it was Myers, in an unexpected piece of comic shape-shifting, who discarded the definitively American character of Wayne – all gleaming white teeth and cap-sleeve t-shirt – for the amplified Britishness of Austin Powers: psychedelic secret agent and International Man of Mystery.

The cinema release of *Austin Powers* coincided with the attempt to revive 'Swinging London', as an emblem of Britishness for the late 1990s, heralding the official rise of Cool Britannia. So when the fashionable alliance of New British restaurants, BritCulture and a myriad PR companies was suggesting that a return to the colourful optimism of the mid-1960s was just around the corner, Austin Powers marched round the other corner on our cinema screens, leading a parade of sequence-dancing Beefeaters and hand-springing policemen to a waiting E-type Jaguar painted in the colours of the Union Jack. 'Hello Mrs Kensington . . .' he drooled to the leather-clad agent sitting at the wheel, and the mirror held up to Britain's latest image of itself as neo-Swinging retro-kitsch was showing a perfect reflection – New Irony and all.

As Britain is described by cult American television, so the affectionate satire of *Austin Powers* can be seen to have sharpened into downright derision on some of the latest imports to British small screens. In a recent re-run of an episode of Mike Judge's cult cartoon of teenage nihilism, *Beavis and Butthead*, the sniggering duo were sitting on their ripped sofa as usual, watching a video by the British band the Verve. 'Aren't these dudes from that country where everything sucks?' remarked Beavis, eventually. Similarly, in the adult cartoon *South Park*, with its accounts of the

goings-on in a small boring town in Colorado, the foul-mouthed children of South Park Elementary would sooner sit next to the red-eyed son of Satan in class, than the British kid Pip – 'because you're British, ass-wipe'. Pip, dressed in the cap and jacket of the boy hero of *Great Expectations*, accepts all abuse with a generous good humour that somehow makes him even more pathetic.

What seems to give these American comments on Britishness their comic edge is the manner in which they identify that strand of cultural self-consciousness that has provided Britain with some of the best, as well as the worst, of its national self-expression. Since Vic Reeves and Bob Mortimer wed Pop to absurdism in their ground-breaking television show, 'Vic Reeves' Big Night Out', in the early 1990s, the cultural fetishizing of Britishness by way of ironic nostalgia and post-modern caricature has been approaching critical mass. The inevitable response to the burn-out of irony would be the rise of the post-Prozac public confessional – the New Sincerity, aided by its sidekick of New Sincerity with street-credibility – the New Authenticity.

An attempt at self-defence at a time of cultural insecurity, the cry of 'Any old irony' had been echoing around the studios of British television for some years, and would seem to have authorized a situation in which – as W. H. Auden once suggested in his poem about the perils of trying to reach Atlantis – it had become impossible to tell the true from the false in terms of articulate statements about Britishness. What had come into relief was a raised tracery of distinguishing national characteristics, from the archaic comedies of British manners acted out by Harry Enfield or Paul Whitehouse, to the baggy British groups with their trademark nasal whine of post-Oasis BritRock. And these are the enduring traits of Britishness that the cutting edge of American comedy has found so easy to lampoon. In addition to the targeted sarcasm of *South Park* and *Beavis and Butthead*, who could forget *Frasier*'s temporary obsession with a horrible English pub? Or the time that a thinly disguised Mary Poppins came to help out *The*

Simpsons, and wound up on the sofa with her stockings rolled down to her ankles and a fag in her mouth?

As the advertising industry has the most calculated interest in reflecting versions of Britain back to itself on television, so it has taken the trend for ironic retro-kitsch – itself an infantilist reflex of nostalgia for our pop-cultural youth – and applied it to articulations of national identity. The TV advert for Mercury 'One 2 One' cellular phones, is a computer-generated montage of Vic Reeves interacting with the great British comedian Terry-Thomas, in scenes from the 1960 classic, *School for Scoundrels*. Beyond the product message, what emerges from this advertisement is a working definition of the way in which 'Englishness', as a contemporary concept, is terminally stylized in order to be culturally rehabilitated from any reputation for nationalism or anti-multiculturalism.

This notion is compounded by the latest television advertisement for Rover cars, in which suppositions of Britishness are visually punned into a new, fashionably acceptable vision of Britishness. To an immaculate early-Seventies soundtrack, sourced from vintage Roxy Music and Sparks, the Rover commercial 're-makes and re-models' (to borrow from the title of another early Roxy Music number) a British landscape in which the Edinburgh Tattoo becomes the tattooed arm of a young woman at a rave, and a kid munching fast food on a skateboard becomes an arch reference to Meals on Wheels. With a knowing catchphrase, 'It's nice to know that things haven't changed a bit', Rover's heavily pushed advertisement is selling New Britain as a state of mind by effectively suggesting that Old Britain is dead and buried.

This trend for montaging laundered notions of British popular culture into a commodified vision of New Britain has been matched – in this age of fetishized Newness – by the search for the New Authenticity. Rather like a short story by Chekhov dramatized by old clips from police surveillance videos, perhaps the function of the New Authenticity is to suggest a social conscience in the lingering dusk if post-modern chaos, and to provide

a new cast of everyday heroes to people moral fables. As the national media report the case of a twelve-year-old mother who had sex with her thirteen-year-old boyfriend because they were bored with watching the coverage of Princess Diana's funeral, there is a sense that the layers of irony attendant on mediating definitions of contemporary Britain have gone beyond critical mass, and finally imploded.

In a blistering editorial in the May 1998 issue of *Living Marxism*, Mick Hume described the conversion of 'Cool Britannia' into what he terms 'Ghoul Britannia'. Having identified a parading of dysfunctionality, death and despair in many aspects of British culture, from the lyrics of Radiohead and the pathological end of BritArt, to films such as *Nil by Mouth* and *Gummo*, he suggested that the dangerously self-defeating miserabilism of 'Ghoul Britannia' is 'symptomatic of a society which has lost faith in itself, one which sees humanity drowning in a bloody gut-bucket of its own making'.

Such a conclusion, in many ways, could be the ultimate destination of the British search for cultural authenticity: the belief, mistaken or otherwise, that the only aspects of ordinary life worth recording are those which reflect dysfunctional behaviour. And this could be seen as a repetition of the trend for problem films, in the early 1960s, that exhausted the true artistic potential of British 'kitchen sink' cinema by merely cloning the various 'problems' into a threadbare formula. Writing in the *Spectator*, in 1962, one exasperated critic remarked: 'We've seen the brooding terrace, we've heard the moaning factory whistle and frankly we don't care any more.' This was not, one feels, indifference to social issues; rather it was impatience with the idea that the whole of British realism could be seen through one, increasingly self-parodic, point of focus.

As though to address this aspect of New Authenticity, there is now a new middle ground to Britain's pop cultural reflection of itself. The success of *Men Behaving Badly*, as the grand manifesto

of Laddism Nouveau, has been succeeded by the televisual equivalent of a 'call to all cars' to find something – anything, pretty much – that will bring the success of Helen Fielding's *Bridget Jones's Diary* to the television screen. And this New Comedy of Recognition has a twin in what could be called the New Tragedy of Recognition: more than a decade after *thirtysomething* turned middle-class American domestic trivia into the stuff of epic theatre, the patrician classes of the British media have hatched a robust cult for public confession, which is now demanding a home on television. And, doubtless, will get one.

Between the vogue for ironic retro-kitsch and the drift towards New Authenticity, a situation has arisen in the articulation of Britishness that could be said to demand the exchange of cleverly honed trends for a return to old-fashioned – some might say reactionary – statements of intent. There is a feeling of slight relief when one comes across one of those brightly coloured adverts that announce, with no further ado, 'It does exactly what it says on the tin!' After the succession of dizzyingly jump-cut, defiantly conceptual and ultra-fashionable blipverts, there is something faintly endearing about the straightforward hard sell. And the same, perhaps, can be said of those works of art or cultural interventions that make no attempt to lubricate the wheels of their conceptual thinking with self-advertisement, irony, pastiche or high-minded punning.

As part of the 'artranspennine 98' exhibition, which used the whole of the trans-Pennine region from Liverpool to Hull as a venue for showing contemporary art, there was a work by Joseph Beuys, situated in the Victoria Gardens beside the Henry Moore Institute, in Leeds. As an artist, icon and shaman, Beuys can be ranked with Warhol and Duchamp as a figure who managed to harness the energy of his century, and translate his personal experience of that energy into monolithic statements about humanity.

The piece by Beuys in Victoria Gardens is part of a work called '7,000 Oaks', which the artist initiated in 1982 for the international

exhibition Documenta 8, and which has subsequently spread around the world. It comprises a young tree, planted beside a basalt marker. The basalt was mined from volcanic vents near Kassel. The catalogue note for the piece explains the epic intentions of the seemingly simple work: 'The combination of a living, growing tree with the immutable presence of stone is one individual's response to the vulnerability of nature in the face of destructive progress.'

'7,000 Oaks' does exactly what it says on the tin, and is all the better for it.

Every view upon an age is bound to be a portrait of the viewer – a vista seen through the eyes of generational prejudice. Looking down from the apartment in Warrington Crescent, there was a feeling of being momentarily absent from one's body, neither lost in thought nor quietly meditational, but drawn, somehow, down into the gusting rain and the darkness – a kind of emotional hypothermia, with memories taking the place of sleep.

Ian Devine, the former guitarist with punk progressives Ludus, hit mid-middle age towards the end of the Nineties, extolling both the *Saga* senior citizens' magazine and the writings of the Australian historian, Greg Dening. It was Dening who wrote, 'We make sense of the present in our consciousness of the past,' and who advocated the writing of history in the present tense. Divine's ultimate aim was 'cultural disengagement' – 'I want to not know,' he says, 'who Hugh Grant is . . .'

The Barbarism of the Self-reflecting Sign

The surface of the water in the plastic cup had been
perfectly still just a second ago. Now, though, was it
your imagination or tired eyes, or had the faintest ripple,
a tiny freak outbreak of miniature choppiness, disturbed
its earlier calm? In this light – iron-grey storm clouds
pressing down, dusk falling fast – it was difficult to tell.
No – look! There it is again! That sudden shimmer on the surface
of the water, as if someone were gently tapping the cup from
underneath. A distinct jolt, like a kind of sonic boom reaction to
some . . .

With claw prints the size of parking spaces, the Tyrannosaurus
Rex slammed his way through the tense, electrical air of the
lowering tropical storm. Hard in his sights was that gleaming
symbol of contemporary urban person's assertion of the back-
woods-roaming, paragliding, authenticity-boosting, camp fire, free
spirit, white-water lifestyle: an off-road 4×4 land cruiser – of the
sort that could be seen almost any day of the week, being loaded
with ciabatta croutons, bagged salad and Chilean Merlot outside
any number of edge-city retail park, twenty-four-hour, thirty-two-
checkout, Mothership supermarkets.

Back in the early 1990s, dinosaurs loved the Mothership. The

blockbusting success of the raised-awareness action movie *Jurassic Park* had let loose its computer-generated cast of prehistoric monsters to endorse any number of pre-teen products with their rearing, charging, hissy-fit forms, as well as the film's eye-catching dinosaur skeleton logo. Which was about as popular as popular culture can get. Cereals and lunch boxes, birthday cakes and pasta shapes – along the shining aisles of the Mothership the dinosaurs ruled again.

And, somehow, dinosaurs were right for the early 1990s. A creature whose brain was its smallest part was unlikely to be wounded by irony. Also, the movie considered the needs of its audience from every angle, thus pre-empting a confusion of intentionality: here, for instance, was a guy being plucked out of a portaloo and having his legs ripped off; on the other hand, here were lots of he-might-be-right-you-know Chaos Theory pronouncements, delivered with seductive fox-like elegance by leather-jacketed sexy scientist Jeff Goldblum. And then there was the eco-message, summed up in breathtaking long-shots of peaceful, pro-organic, Natural Shoe Store, liberal bourgeois vegetarian dinosaurs, grazing en famille on prairies of willowy waving prehistoric pampas grasses.

By the by, the film had introduced the hitherto underused term 'cloning' into the broader cultural discourse, which turned out to be absolutely on-the-button to define a general trend. As the dinosaurs in *Jurassic Park* had been cloned from preserved DNA to provide sensational infotainment – reactivating a history in suspension, so to speak – so many of the cultural products of the 1990s, from TV programmes to graphic design, would turn out to be cloned from, as it were, cultural DNA. Here was classic post-modernism in action – authorless signs transmitted through filters of meaning, brought to life in the labs of logo and cultural production.

Cultural cloning . . . now there was a thought. If you could just identify the most efficient little gobbets of an image or an idea –

well, you could simply think of it as sampling, taking out the best bits and doing them like mad. Fads such as these were as old as the hills, of course (Hollywood cloning its stars, England its Beat groups) but the sheer extent of media in the 1990s – when the 'mass' in 'mass media' appeared to amplify a thousandfold on endlessly replicating channels, added to a burgeoning cultural conservatism – would make for an especially arid monoculture, based largely on promotability and marketing. The trick, for cultural practitioners, was to identify which of the principal species they were cloned from, and not try anything surprising. Culture could be led by market research, and very often was.

(Also, in the Nineties, the culture of superlatives demanded the most popular bits – the fondant centres, the strawberry cream, garlic butter – were simply lifted out of their context, so they became little more than a gooey mass. A diet of fondant centre . . .)

An example would be the extraordinary success of Helen Fielding's romantic comedy, *Bridget Jones's Diary*: the success of her idea was multi-cloned across fiction, film, advertising and print media, established as an *entire demographic model* and then used to sell the idea of Bridget Jonesness back to people who'd bought it in the first place. At the wallet end of marketing the proof of the cloning would be found in a multi-million-pound cosmetics promotion which offered 'a Bridget Jones-style Diary'.

On terms such as these the idea of originality per se had become subordinate to the cloning process, and the baby dinosaurs crept out of their broken shells to rule the Earth again.

Cloned Media

Prior to the latest cloning boom in 'zoo media' (Chris Evans et al. to 'The Girlie Show') and 'reality TV', the process has perhaps reached its apotheosis with the phenomenal, pan-media, super-cloned success of Irvine Welsh's novel *Trainspotting*. What began

as a neo-realistic account of life and living death among Edinburgh drug addicts – couched in the vernacular tradition of James Kelman's Booker Prize-winning novel, *How Late It was, How Late* – has become, by way of the movie, the soundtrack CD, the t-shirt and the advertising campaign, a form of media shorthand to signify Youth in general.

The greatest irony, perhaps, of this conversion of a novel into a free-floating logo for youthfulness was the appropriation of the orange and white graphics, made famous by the film of *Trainspotting*, to advertise the winter sale in French Connection's chain of high street boutiques. There is a somewhat spooky connection between the desire to buy a ribbed brown cardigan and the need to identify, as a consumer, with the desperation of a heroin addict. And the proof of the cloning process would be inadvertently sealed by Sarah Champion, in her introduction to *Disco Biscuits: New Fictions for the Chemical Generation*, where she wrote, 'we now have *Trainspotting*, the attitude'.

The cloning process, by converting issues and substance into the short-term safe harbour of provenly marketable 'attitude', has created a tendency within contemporary media – and even the broader span of contemporary culture – to fear any innovation that does not correspond to whatever attitude happens to be riding high. And at this point, cultural phenomena become merely vessels – the medium is the message, after all. Too true, Marshall!

Similarly, our decade-long love affair with mass retro-culture within the poppier packaging of just about everything (the cloning of suspended styles) would prompt the suggestion (with more than just a pulse of real panic in there) that at this rate we would 'run out past' by 2005 – that culture was faced with a chronic 'retro shortage'. (A further Jeff Noonism would be the idea of 'Post-Future', a point at which the Future – as a thing, concept, temporal

or descriptive – no longer existed. Thus there would also be 'post-future kids', for whom the idea of fashionability, modernity or keeping-up-to-speed would be utterly – and, you imagined, bliss-fully – meaningless.)

The endless cycles of pop cultural revivalism – the imagery of modern culture as a database and dressing-up box – describe the extent of retro-culture. You could also throw in the importance to Interior Design in the 1990s of Mid-century Modern styling (the Fifties coming up in price), which was morphed with the brushed-metal and bleached-oak effect of shop-fitting chic to create the basic Loft Look. Out of this came a kind of 'Pod and Spike' approach to Lifestyle – Pod being the cocooning impulse to feed on infantilism, and Spike being the exquisite good taste of the tamed avant-garde.

At its most expensive, styling went the whole way to Minim-alism: this required lots and lots of open floor space to turn your loft into a gallery (Pod) – one science-fiction exotic cut stem of some spiky flora (Spike), a couple of Whitefriars vases perhaps, and the rest was whiteness. Hence the irony of the urban very rich seeking to define their Lifestyle by vast areas of emptiness – they and their possessions becoming exhibits, an aubergine or a Diptyque perfumed candle (Pod) taking on the aura of sculpture. More often than not, any actual art in a minimalist barn would be screaming how fucked-up it and everything around it was (Spike), or, at the very least, pronouncing an exquisite conundrum of neurotic self-concept.

Tim Noble and Sue Webster

Visceral yet lumpen, lurid yet delicate, the art of Tim Noble and Sue Webster is filled with contradictions. Encountering their work for the first time, a viewer will be struck by its mixture of vivacity and savagery. Mixed messages of love and death, ambition and

nihilism, are carried on a style that alternates between cartoon delinquency and a kind of modern baroque.

Sue Webster was born in Leicester, in 1967, and Tim Noble in Gloucester, in 1966. The couple first met at Nottingham Poly-technic, in 1986, where they were both studying Fine Art. Their personal relationship, from this initial meeting, has become a major informant of their creative partnership as artists. The couple do not claim to be two people working as one artist; rather, the direction of their work is dictated and considered by the conflation of their separate ideas, enthusiasms and acquired skills. As Tim Noble remarks, 'We are consistently inconsistent; that's one of our greatest strengths.'

Over the course of their career, Tim Noble and Sue Webster have worked in many different artistic media: they make paintings, sculptures and assemblages of lights and neon. The couple have also turned their hands to fly-posting montaged pictures of them-selves, and once held their own street tattoo parlour during the 'Livestock Market' art fair held in Rivington Street, east London, in 1997.

Above all, however, Tim Noble and Sue Webster have worked with the idea of themselves, as artists who are making works within the somewhat febrile climate of contemporary British cul-ture. Their intentions are maybe explained by a work they made in 1998, called 'Dirty White Trash (with gulls)'. In this piece, 'six months' worth of artists' rubbish' has been meticulously assembled and crafted – itself a contradictory act – in such a way that when light is projected upon the seemingly chaotic heap, it casts the shadow of the artists in perfect profile.

Caught with the accuracy of a silhouette, this shadow piece shows the couple relaxing back to back, the one sipping a glass of wine, the other enjoying a cigarette. Meanwhile, two stuffed seagulls are picking at a few discarded chips on the edge of the dumped rubbish. What could this tell the viewer about Tim Noble and Sue Webster as both a couple – they live together as well as

work together, and they have an uncanny physical similarity, which makes them look like brother and sister – and as artists?

One answer might be that they regard themselves as determinedly careerist, within a line of work – the art world – that they regard as a complex game, and one in which cheats, short cuts or open ridicule of the prevailing mainstream can all be taken as valid moves. Following hard on the heels of this assessment of the pair, however, is the fact that their work can be divided into that which is extremely simple to make – little more than the cut-and-paste techniques of ersatz punk montage – and that which is painstakingly crafted. Taken all together, the different strands of their art entwine to make a coded polemical commentary on cycles of life and decay – the mortality of species and the deliquescence of cultural movements or individual careers. In this sense, Noble and Webster could be described, with accuracy, as 'decadent' artists.

On leaving Nottingham, the couple took up a residency, in 1989, in the sculpture studios at Dean Clough, in Halifax. It might be taken as eloquent of their artistic temperament – or of the recurring motifs within their later work, suggesting a desire to keep themselves at arm's length from their peers – that Noble and Webster headed north just as the movement that would become mediated as Young British Art was beginning to gather momentum in London.

As Damien Hirst had curated his influential 'Freeze' show at the PLA building in London's Docklands the previous year, so within two years the mere idea of 'young British art' would have become a usefully malleable phenomenon. Taken up by the media, as much as the patrons, galleries and collectors, this new direction in British art – as it merged with other pop cultural strands – would be taken to represent the temper of the zeitgeist.

In 1992, Tim Noble came to London to study on the sculpture MA course at the Royal College of Art. By this time, the whole phenomenon of Young British Art was following, point for point, the route between a fledgling metropolitan bohemia (those former

urban badlands, colonized by artists) and 'uptown patronage' which the American cultural commentator, Tom Wolfe, had defined in his book *The Painted Word* nearly two decades earlier.

Cutting-edge contemporary art, 'warm and wet from the Loft' – as Wolfe describes it – can enjoy a relationship with its patrons that benefits both parties. The ensuing social and cultural milieu created by this relationship – and as seen, in Britain, to have been achieved through the mediated phenomenon of 'yBa' – becomes a new kind of orthodoxy, influential in taste-making, and provoking inevitable response.

The translation of young British art into a social phenomenon, with its own cast of characters and social types, and its particular topography around the Hoxton and Shoreditch districts of east London, seems central to an understanding of the earlier work of Tim Noble and Sue Webster. As the couple moved to Hoxton in 1996, holding their first solo exhibition, 'British Rubbish', at the Independent Art Space, they arrived on the 'YBA' scene as the partying of that movement was already approaching its second wind. For Noble and Webster, the appropriation of 'YBA''s own idea of itself – as an oven-ready phenomenon, as it were – became their point of intervention.

In terms of their style, Noble and Webster have been claimed by some critics to revive the aesthetics – and tactics – that were set in place by the first wave of British punk rock between 1976 and 1978. Too young to have participated in this movement as anything other than youthful observers, Noble and Webster can be seen to have taken a received idea of punk – the strategies, the baggage and the healthy bloody-mindedness – and applied it to their own generation's attempts to re-route popular culture through the media of contemporary art.

Prior to 'British Rubbish', Noble and Webster had already made works that centred on the sloganeering, fly-posting and do-it-yourself ethos of punk pamphleteering. Tim Noble had usurped a billboard poster competition run by *Time Out* magazine in 1993,

with his work 'Big Ego'. The competition was open to people who had been resident in London for twenty-five years (which Noble had not) and to this extent Noble's design – a crudely assembled poster, featuring his face and the statement, 'Tim Noble Born London 1968' – was revelling in its own falsehood. Noble, after all, was born in Gloucester in 1966.

Similarly, in 1994, Noble and Webster doctored an image of the legendary artists Gilbert & George, by simply sticking their own faces over those of the original. They called this work 'The Simple Solution', and it followed the same thinking – in terms of making a creative virtue of hijacking an existing graphical device – as Noble's disruption of the *Time Out* poster competition.

If one of the distinguishing characteristics of the 'Young British Artists' – as a mediated, social type – was to own or affect an image of 'dumbed down' rebelliousness (the 'Boho Dance' in Tom Wolfe's definition of the type), then Noble and Webster were amplifying this tactic to the point of caricature.

More than one critic has remarked how their street tattoo parlour, with its amateurish, felt-tip-pen 'tattoos', exposed the way in which a previously working-class, light industrial area of London had become colonized in the name of art from the power-base of a bourgeois economy and lifestyle. This was Wolfe's 'Boho Dance' made visible. As David Barrett was to write of the event: 'Young artists finally had the hardcore tattoo they'd always wanted, and they strutted up and down Charlotte Road like a bad actor doing the LA Bloods.'

By the middle of the 1990s, however, Noble and Webster were beginning to plan intensely crafted pieces. Inspired by a trip to Las Vegas – although they say that watching videos of films about Las Vegas inspired them more – the couple began to work with light pieces. Exuberant, vivacious and redolent of the perverse glamour of British travelling fun-fairs, these light pieces took the 'trash aesthetic' of rockabilly gothicism and turned it into free-floating emblems of desire and sensory overload.

The visual joyousness of these pieces – simplistic promises of glamour, carnival and success – were matched by two further developments in the work of Noble and Webster. In many ways, their do-it-yourself aesthetic had become the signature of their vision: that despite themselves, almost, they were honing a view of contemporary culture based on the imminent implosion of cultural materialism itself.

What was emerging in their work, through their monolithic model of themselves as a quasi-neanderthal couple – 'The New Barbarians' (1997) – and their gruesome projections of themselves off the contours of garbage, was a targeted celebration of aimless nihilism. This was not the pro-active nihilism preached by Nietzsche, as a phase of spiritual empowerment. Rather, in the imagery of decay, violent death and destruction, honed with wit and tempered with sentimentality, this was the imagery of romantic nihilism: tribal, insular and dancing on the imagined grave of a society that might one day choke to death on the sheer waste of its own consumer products. The triumph of terminally dumbed-down culture.

In one of their most recent works, 'British Wildlife' (2000), Noble and Webster have consolidated the themes and techniques of their 'shadow' pieces. As with their obsessive involvement in crafting the 'trash' of their 'white trash' pieces, the couple have assembled a quantity of inherited stuffed animals – themselves reminiscent of a forlorn, morbid notion of Britishness – which will cast a monumental shadow of their combined profiles.

Through working with the legacy of taxidermy, in which they can describe the nuances and cruelties of the natural world, Noble and Webster present the viewer with a compelling tableau of morbidity and ghoulishness. If 'Dirty White Trash (with gulls)' put forward the idea that Noble and Webster saw themselves as trash, trashing in turn a rubbished society, then 'British Wildlife', with its poetically archaic assemblage of stuffed animals, seems to amplify the themes of mortality. In all of this, however, they

celebrate their relationship with one another, reversing the sentiments of the classical 'Et in Arcadia Ego', to suggest that in the midst of death there is life.

For 'Apocalypse', Noble and Webster have expanded their aesthetic to encompass an epic notion of the sublime – re-routed through the now established signature of their own vivid style. 'The Undesirables' (itself reminiscent of the title of a pulp exploitation novella from the late Fifties) takes the form of a mountain of garbage-filled bin-liners with a scattering of litter on its peak. The projected shadow of this crowning litter shows Noble and Webster – no longer in profile but now with their backs to viewer, and to scale – as observers on the summit.

Inspired, in part, by their drive to this summer's Glastonbury music festival, and their wait upon a hillside, as the sun was setting, to watch David Bowie's superb performance, the couple also cite the cover of Gary Numan's *Warriors* LP as an influence on this work. 'We've ascended above the trash,' says Sue Webster, of 'The Undesirables' – thus completing (in the tradition of nihilism) a classic circuit of Western romanticism.

The white neanderthal couple in Webster and Noble's 'New Barbarians' – coarse, territorially hostile, but embodying an attitude and expression at once suspicious, narrow-minded and assertive (a kind of ultra-conservatism, in the sense of protecting self-interest) – could also take their place in the Jurassic Park of post-modernism. They seem like a couple from some point in the future when the world is about to end – a post-historic, as opposed to pre-historic pair.

In such a fantasy, the world would not be coming to an end in a dramatic, *Terminator*-style apocalypse of infra-red night scopes, killing machines and rebels in the ruins; rather it would simply – dully, even – have ground to a dirty, multiple food-allergic, worn-

out, hyper-polluted inevitable halt because of humankind's insatiable greed. The New Barbarians could be strolling through the last days of the biggest shopping centre on Earth, still complaining, still greedy, still defensive of their self-interest above all. As an artwork, however, 'The New Barbarians' is owned by a wealthy private collector, for whom its message, wit and undeniably disturbing presence must perform the task once undertaken by classical allegorical painting to seventeenth-century aristocrats.

By the middle of the Nineties, the slipstream of the zeitgeist was pretty much dominated by a steady cross-cultural cloning of the two principal Attitudes: Irony and Authenticity, conflating mid-decade to breed the cult of Confession and the mediation of the formerly private and personal as mass public spectacle – another attraction in the Jurassic Park of post-modernism (with the writings of Theodor Adorno standing in for the Jeff Goldblum character's warnings about fiddling around with evolution).

[Subsequently, a web-site would be launched at www.theory. org.uk which 'packaged' leading cultural figures as though they were children's poseable action figures and bubble-gum trading cards (infantilism strikes again!) The theory.org.uk Trading Card for Theodor Adorno summarized his biography, strengths and weaknesses as follows: 'German Thinker, 1903–69. Member of the Frankfurt School. Argued that popular media is the product of a "culture industry" which keeps the population passive, preserving dominance of capitalism at the expense of true happiness. Mass media is standardized, and the pleasures it offers are illusory – the result of "false needs" which the culture industry creates. Argument is elitist, but that doesn't mean it's wrong necessarily.

'Strengths: Saw culture to be as important as economics.

'Weaknesses: Shows no understanding of popular tastes.

'Special Skills: Extreme anti-capitalist argument.']

Like the cloned dinosaurs, cloned media were reasonably single-minded about their message, and now the public were the new stars – so long as they were offering sex, violence, sentimentality or

converting their back bedroom into a nursery. As the writer Michael Collins put the case, rephrasing Warhol's maxim on fame, 'In the future everybody will be ordinary for fifteen minutes.'

The Moment of Truth

On the evening of 1 December 1976, at around 6.25 p.m., a lorry driver by the names of James Holmes kicked in the screen of his '£380 colour television' – as he later told the *Daily Mirror* – because he did not want his eight-year-old son, Lee, to hear 'the kind of muck' that Steve Jones of the Sex Pistols had just been coerced into speaking, live in the 'Today' studio, by presenter Bill Grundy. The following day, the exchange between Jones and Grundy was reported with some outrage by most of the British newspapers, providing punk rock with one of its more iconic labels: a banner headline in the *Daily Mirror* which exclaimed 'The Filth and the Fury'.

Viewed now, the spoken dialogue between Jones and Grundy sounds curiously quaint, but the episode as a whole is still engaging. The actual swearing – 'the muck' that prompted Mr Holmes to put his boot through the tube – seems almost as weighed down by self-consciousness as Bill Grundy's attempts to rise above his cheeky guests with a touch of schoolmasterly sarcasm. 'What a clever boy!' he purrs, with thinly veiled rage, as Jones responds to his challenge to 'say something outrageous' by calling him first a 'dirty fucker' and then a 'fucking rotter'.

Leaving aside the early-evening transmission time – which was the overriding factor that got 'Today' into trouble and Grundy suspended – what remains compelling is the all too apparent manner in which the presenter loses control of his guests, and, as a consequence, reveals the speed with which television itself can lose its assumed authority. Throughout the shambolic interview, during which it becomes clear that the Sex Pistols are not

going to submit to the role of 'studio guests', there is a gradual accumulation of tension – part embarrassment and part threat – that derives less from the inevitability of a conflict, than from the sense that we are witnessing an authentic breakdown in the power of television to contain its subject. As Grundy attempts to return to the autocue – his only lifeline to safety – we see a moment of extreme vulnerability in a medium that relies (or used to rely) on the illusion of control.

There is a common social impulse to witness spectacle, and, equally importantly, a desire to experience that frisson of excitement, shock or fear that accompanies the moment when the predictable passage of daily events is suddenly converted into drama by the occurrence of extreme behaviour. From a scuffle in the street to a major disaster, these moments of transition disrupt our sense of security and our perception of the world. To be present in the vicinity of such a disruption is to experience the adrenaline rush of confusion and fear we instinctively generate to protect ourselves. And to witness those same occasions in their mediated form is to experience all of their drama, but with none of the personal danger. We absorb the atmosphere of spectacle as a kind of narrative – a fact that has been well illustrated, in photographic terms, by Weegee's stark images of life and death 'as it happened' on the streets of New York.

Through modern media we can pick out the soft centres, as it were, of heightened emotions and volatile situations. We can all become members of an invisible audience, the legitimacy of whose presence is morally and ethnically ambiguous. But whether we authorize our consumption of mediated events in the name of public interest and reportage, or whether we argue the fine line between voyeurism and documentary, we require, above all, that the occasions of disruption that comprise our sense of spectacle are authentic – 'authenticity' is the hallmark of truth, and hence the gauge of social value.

Today, authenticity as spectacle has become the Holy Grail of

contemporary culture, the unifying style by which the zeitgeist is seen to be made articulate. From the gritty pop realism and boiled-beef brutalism of geezer fiction and Britflicks, to the interactive scenarios of third-person video games such as 'Metal Gear Solid' or 'Silent Hill' – in which media techniques of truthfulness are used to heighten action, control and suspense – there is now the sense that authenticity itself can be sculpted to suggest veracity as an image, in which truth remains ambiguous. This is not a marginalized creative form: the reshaping of current affairs pro-gramming to convey immediacy has been matched by the rise of broadsheet columnists recounting their personal lives as contem-porary fables, embracing the breadth of the human condition.

But nowhere has this trend been more pervasive, and the issue of veracity more contested, than within the wake of 'popular fac-tual programming': a genre which links the 'authenticity' of docu-soap and docu-drama to the studio-based spectacle of conflict of 'The Jerry Springer Show' or 'Vanessa'. As a cultural phenomenon, popular factual programme-making – and its impact on television, advertising and commentary – can be seen as the defining spirit of the 1990s: how do we mediate ourselves and who defines the mediation?

Back in the mid-1970s, television barely understood that pro-grammes could be made by simply filming volatile 'real life' dom-estic and civic situations, and rely entirely on flashpoints of confrontation to hold the attention of the viewers. Televised con-flict, beyond the sphere of current affairs, was a rarity, and the occasions on which the medium had been challenged by circum-stances beyond its control – as it had with the Sex Pistols – were regarded as memorable. When the dramatist and critic Kenneth Tynan became the first man to say 'fuck' on television, during a debate over censorship on Ned Sherrin's 'BBC3', on 13 November 1965, he remarked that he would probably be remembered only for that incident. And the (now forgotten) fact that he had used the word within a dry academic discussion about an audience's

relationship with language was an irony that failed to save him from being branded, immediately, as 'the man who said "fuck" on television'. What sealed his reputation was the objectivity of the medium: we actually saw him say it – our sense of stability had been challenged, and an evolutionary stage in the potency of television had been defined.

In 1974, a further defining moment in the evolution of TV took place when the BBC made a successful excursion into filming a factual series – regarded at the time as a radical experiment – about the daily life of a British family. In so doing, they discovered not only the power of the hand-held camera and the fly-on-the-wall point of view to convey tension and intimacy, but also the allure of authenticity. Paul Watson's series 'The Family' was greeted by some critics with incredulity and distaste – how could a film about daily domestic routine, with no specific subject or story, possibly hold anyone's attention? But the public proved the pundits wrong, and tuned in by the million to watch the volatility of a low-income, working family. Thus a template was established – already sketched out by the soft sociology of 'kitchen-sink' cinema – that authenticity was synonymous with dysfunctionalism.

The route to authenticity – or, more cynically, the allure of mass-voyeurism – lay in the simple televisual device of apparently removing the fourth wall of a person's room and thus laying bare his or her privacy. By this means, a compelling sense of risk – absent in scripted soaps – was written into the TV format, answering our need for authenticity and spectacle.

Previously, such subject matter – ordinary British life – had been the highly politicized terrain of ground-breaking documentary directors like Humphrey Jennings, whose films, such as *Listen to Britain* (1942), would prompt the young left-wing film director Lindsay Anderson to pass an assessment of British cinema in 1957 which predicted the vogue for today's popular factual television but assumed, wrongly, that social conscience and the rights of the individual would take priority over mere sensationalism and

ritual humiliation: 'I want to make people – ordinary people, not just top people – feel their dignity and their importance. The cinema is an industry, but it is something else as well: it is a means of making connections. Now this makes it peculiarly relevant to the problem of community – the need for a sense of belonging together. I want a Britain in which the cinema can be respected and understood by everybody, as an essential part of the creative life of the community.

What Anderson regarded as the ordinary person's right to importance and significance as a subject for documentary – 'the creative treatment of actuality', as he cited from documentarist John Grierson – has now become what the Sex Pistols once described as 'a cheap holiday in other people's misery'. In the Nineties, following on from the success of such docu-soap series as 'Hotel', 'Airport', 'Pleasure Beach' and 'The Cruise', TV companies fell over themselves to combine the phenomenal appeal of 'real' characters (Jane McDonald from 'The Cruise' has now presented 'The National Lottery Live', published her autobiography and played at the London Palladium) with the moments of conflict that typify the format of daytime-TV studio debates (or 'studio rage' as it has been called). Fact, not only stranger than fiction, was perceived to be stronger, even if one ITC report opined that popular factual programming was pandering to 'the worst of human behaviour'.

As docu-soap and conflict television both scored impressive ratings, the fusion of the two forms has come to revolutionize the programming schedules: one Friday evening's viewing on ITV in April 1999 ran as follows: 'Parking Wars', 'Motorway Life', 'Family Feud' and 'Neighbours from Hell'. Even the BBC's Business Unit got sexy with a docu-soap drama about company merge, 'Blood on the Carpet'. On cable, Sky TV has given us the hugely successful 'Ibiza Uncovered' and myriad half-hour shows – 'Tango Tango', 'Police, Action, Camera' and 'America's Dumbest Criminals' – which edits chunks of CCTV and surveillance video into a kind of 'You've been Framed' (or 'You've been Arrested') by the emergency services.

As a format, popular factual programming can be seen as a reinvention of social realism, but one that replaces the heightened objectivity of the naturalistic style with a heavily coerced core of subjective values. Other than being cheap, the key to PFP's success is its manipulation of public curiosity, placing viewers in the centre of a situation which is bound to test their tolerance and arouse their sense of vulnerability. In this way, the reality which such programmes mediate is being massaged by various formal devices to appear more real than real: the surface of the images is lacklustre and flattened, drawing attention to the immediate prompts of the situation – litter, clutter or any evidence of the subject being unprepared for being famous for being ordinary; long, unedited shots (sometimes running for minutes) that create a sense of portentous tension, while the new technology of small, digital cameras can convey a sense of immediacy or claustrophobia.

Thus the medium is so stretched that the slightest word or gesture becomes amplified. The traditional role of voice-over narration – to suggest authority, time line or commentary – has been either removed or replaced by a kind of disembodied Chorus, which hints at off-camera action, the consequences of which we are about to see. On programmes that deal with such volatile areas as, for instance, debt collection, environmental health and the RSPCA, there is the sense of being suddenly dragged back to safety at the ultimate moment of conflict – when someone throws a punch – or allowed to linger for as long as possible – when someone bursts into tears.

In most cases, the 'authenticity' of popular factual programming has been used to promote its treatment of the subject matter as being, to some degree, in the public interest. But in many ways such a claim for the genre is nothing more than the old device of positing pornography as sociology – 'Look at these photographs, aren't they disgusting?' This also puts any critique of authenticity into the kind of moral headlock common in debates over contemporary art: to

condemn contested material as sensationalist or prurient is construed as merely reactionary or elitist. What remains, beyond an unwinnable contest of value judgements, is the seismic shifts of audience share and ratings that will dictate the direction of the programme-making.

From the point of view of the programme-makers, the genre is an inexhaustible as the collective index of social situations and professions. But such a position is endemic within the genre of social realism. Robert Baldick, describing the cultural circumstances in which J. K. Huysmans came to write against *Against Nature* (1884) refers to the disillusionment of social realist writers in France in the latter half of the nineteenth century: 'the novel of adultery had been worked to death by writers great and small; and as for the social documentary, they saw little point in plodding through every trade and profession, one by one, from rat-catcher to stockbroker . . .'

Television's answer to such a cyclical problem has been both to up the sensationalism in its wares and spread the techniques of PFP – the span of social realism – into other strands of the medium: celebrities such as Geri Halliwell and Martine McCutcheon are presented in a carefully edited form of stylized 'docu-drama' – thus satisfying the public's need to be shown behind the scenes of fame and offered a sniff of intimacy with the stars. Similarly the fact that traditional situation comedies were based on the very professions and areas of human interest that now comprise docu-drama – corner shops, department stores, hospitals, police stations, holiday camps – has prompted, for instance, Carlton to commission a situation comedy – 'Pay and Display' – which replicates the look of a docu-soap.

And herein lies the notion that veracity has become synonymous with confusion and dysfunctionalism – through our depictions of ourselves as vulnerable, damaged, volatile, matched by our fetishizing of realism. And this, perhaps, is an accurate reflection of contemporary society, revealing a truth about the way in

which we live through our very attempts to come to terms with authenticity.

<center>◇</center>

Or was it just that the networks were looking for ways of keeping vast, profitable ratings by teasing their audience with the suggestion that they might get to see people being beaten up, losing control or fucking? Or maybe it was all just a bit of fun. One argument about Reality TV was that it taught people how to empathize with one another; that as the age was ruled by territorial hostility and depersonalizing information technology systems, watching people interact with one another on TV (*'Look at those dinosaurs ripping one another apart!!!'*) could somehow be edifying.

Championed by its creators as either a) an important breakthrough in television as a social medium, or b) honest-to-goodness, forward-with-the People soap 'n' tabloid populism (which could also, in certain circles, mean a High Camp, how-deliciously-vulgar, semi-ironic exercise in slumming it in populism), the drift of such cloning in television would seem by the end of the decade to have reached critical mass. The walls of Jurassic Park were beginning to show cracks – the dinosaurs were head-butting the concrete as the viewers voted on who gets eaten next.

In other areas of cultural practice, the cult of the personal and the autobiographical had replaced Style Watching as the mainspring of self-expression and self-promotion. Never had there been a better time to declare yourself a one-person Bloomsbury Group. But where had this obsession with the personal, the confessional and a kind of omni-vision voyeurism actually come from? One answer might be that this was a generational neurasthenia, picking up on the Flaubertian notion (as picked up by his posthumous analyst-biographer Sartre) of art and creativity being the result of 'the ever hidden wound'. So did we all feel wounded in some way?

Another answer to the question, though, might be boredom

<center>71</center>

and a craving for one-shot celebrity, prompting a culture of 'to the max', which was spun to keep raising the pitch of its own superlatives. ('*Ultimate Terror! Ultimate Destruction! Look-at-those-dinosaurs!*')

From the early to late 1990s, across the temper of the times, the 'ever hidden wound' was being exposed, and made public. Could this disarm its artistic effect? For rather than undergoing the translation into a (Flaubertian – or even Warholian) model of art and creativity, in which the presence of the artist was converted wholly into art itself, the wound was being offered up, raw and direct, as a kind of celebration or cult of actuality in relation to the personal. Just what would people be prepared to do to get their little nugget of celebrity – to do their circuit of the dinosaur park? Throughout the second half of the 1990s, the answer to this – not surprisingly, perhaps – would be 'absolutely anything'.

From the mutation and conflation of confessional culture and mediated 'real life' had emerged the broader trend of the barbarism of the self-reflecting sign – every bit as threatening, in its own way, as the gradually mutating dinosaurs unleashed by the founder of Jurassic Park's blasphemous fiddling about with natural evolution. Shame on such grandiosity! We should have remembered the testament of Pee Wee Herman, returning from Texas with his beloved bicycle: 'I've learned something on the road, you know – Humility!'

Tracey Emin

Sitting with the posture of an obedient child, Tracey Emin lights another Marlboro, inhales deeply, ponders for a few more seconds, and then pronounces: 'Fundamentally fucked, but ideologically sound, that's me.' She concludes this definition of herself with one of those laughs you usually hear coming out of a phone box when three teenage girls are in there daring one another to ring up

boys. And somehow this laugh speaks volumes about the woman.

For in her rapid ascent from the legions of Young British Art to being nominated for the Turner Prize, the whole point about Tracey Emin has been the fact that she expresses herself as the original precinct kid and disco girl: 'Mad Tracey from Margate' – as she described herself on a banner being towed behind a plane above the seafront of her home town.

As an example of myth-making within the history of art, you could say that Emin has used her perceived 'ordinariness' to much the same effect that Salvador Dali used his eccentricity, converting herself into a modern icon. In Britain, the yobs and the snobs have always had a soft spot for one another, and even the street-trader twang of Mad Tracey's Thames Estuary accent has caused a shiver of delight down the spines of the male metropolitan gentry who tend to be in charge of the art world. For within the marble halls of the cultural establishment, a woman like Tracey Emin is wholly exotic.

But now Emin's fame has splashed way over the edges of the enclosed, confusing world of contemporary art. In Tracey Emin – and the woman and her work are completely indistinguishable – the zeitgeist surfers of the late 1990s have identified the perfect mascot for contemporary Britain's twin obsessions with real-life drama and public confession. Her art is entirely autobiographical, presenting only Tracey Emin's highly visceral account of Tracey Emin, across a whole range of media from films and neon sculptures to writing and embroidery. And as it is a depressing fact that most women experience verbal abuse from male strangers, so much of Emin's art is a direct response to all of the men who have called her a slut or a slag. Similarly, she explores her own relationship with those degrading labels, using a kind of child-like sincerity as her torch to see by.

Emin's source material for the agony, confession and sexual memoirs that comprise the written pronouncements in her art begin with her birth. She describes the conception of herself and

her twin brother, Paul, to be the result of a passionate affair 'when my Mum and Dad got a crate of gin and a crate of scotch and fucked on the carpet in front of the fire – that's how we came about'. With her distinguishing frankness, Emin has made no secret of the fact that her Turkish Cypriot father, a chef, was maintaining one household in London and another, with her mother, in Margate. Tragically, at the age of thirteen, Tracey was raped. Subsequent to this, she became sexually promiscuous 'between the ages of thirteen and fifteen', and more or less gave up attending school. Next stop would be art college.

By foregrounding sexual confession, accounts of her own despair and the innermost secrets of her relationships with friends, lovers and family, Emin has slipped into the whole current cultural climate which puts forward soft-core sociology as a subtle form of authorized, and highly ambiguous pornography: the daytime-TV studio debates that cleverly mingle sex with violence, the broad-sheet columnists who offer up every last detail of their private lives as insights into the way we live now, and the docu-soap television programmes that derive their power from zooming in on the breakdown of their subjects.

'That's the whole reason why I'm popular,' she says. 'It's the way the psyche of the nation is right now. Ten years ago, in terms of art, there was no room for me anywhere. No galleries would show my work or listen to my ideas. They'd presume me to be pathetic, and self-indulgent . . .'

Then Emin gives another of those laughs, and makes a kind of 'yes, I know what you're thinking', eyes-raised-to-Heaven ex-pression of self-criticism, before adding, 'And there's a lot of people who still think that I am pathetic and self-indulgent . . .' When you meet her, Emin seems fragile to the point of bird-like: a petite, slender woman wearing embroidered mules and an elegantly simple dress, with a pink cashmere cardigan loosely knotted around her waist. She looks much younger than her thirty-seven years. The force of her personality seems to reside in her almond-

shaped, coffee-coloured eyes – the strongest evidence of her Turkish Cypriot background – which can shift their expression from mean suspicion to melting vulnerability from one second to the next. She seems too small for the large red sofa on which she is sitting, in her vast, top-floor studio loft in the heart of Whitechapel – the district of London's East End that is enjoying renewed fashionability due to its increasing population of young artists, and their accompanying galleries and cafes.

'During Thatcherism,' Emin continues, 'if you didn't fit in with the crowd, you were on the outside, and if you were on the outside then you were a nobody. And that was the general feeling for everything, no matter what your place was in the hierarchy: you had to fucking fit in, and if you didn't – forget it. And the whole culture was built on that. But get rid of Thatcherism, and everything was turned around. Then, it became the cult of the individual, the loser and the outsider – because those were the types who had been ignored for fifteen years.

'So suddenly we've got everything from "The Jerry Springer Show" to Princess Diana's confessions on TV, or Paula Yates saying all those things the other night that – well, I didn't find them difficult to listen to, but I did find them surprising. That your husband died from this auto-wanking thing rather than committing suicide. But that's how much things have changed: there's an audience who want to listen to these things now, whereas before there wouldn't have been. It's like people want to watch "East-Enders" because they don't want to think about their own lives; then you've got this other thing where you home in on real people's tragedies, lives and stories. And people feel that they can relate to that.

'But that's also why a lot of people don't like my work – they're sick of me. But the fact that I'm there is because of the psyche of the way that people are thinking now. And of course, that's all going to change – I know that. But I've always done self-portraits, anyway. It's like I read Julie Burchill's autobiography, *I Knew that*

I was Right All Along, and I read her column, too, and there are loads of cross-over things with my work in that.'

Kneeling on the floor behind her, an assistant is working on one of Emin's famous embroidered textiles: a large square montage of fabrics that shouts out its witty slogans ('Planet Thanet', for instance) in what look like letters made of fuzzy felt, as part of a vivid, visual cacophony of accusations, confessions and emblematic signage. At a glance, it looks like a multicoloured version of the graffiti in a bus shelter, but it is a strand of Emin's work that is compelling, somehow managing to coerce the reader into studying every last centimetre of its public announcement of private feelings.

In terms of its artistic lineage, it brings to mind the feminist reinvention of embroidery samplers made by women artists in 'The Subversive Stitch' exhibition, or the 'Fun City Bikini' pieces made back in 1970 for the 'Cunt Power' issue of *Oz* magazine. Similarly, the famous poster campaign developed by the Madeley Young Women's Group in the early 1980s, using slogans to educate boys in their social treatment of girls – 'We hate you when you call girls slags' for example, or, 'What You Staring At?' – rehearsed aspects of the sentiments and tactics that can be found in Emin's embroideries.

But where the artistic precursors of Tracey Emin's aesthetic were usually defining the political position of women's collective experience, Emin articulates her personal experience as a wholly autobiographical, multimedia epic. Her drawings have an expressionistic intensity that has earned them comparisons with sexually charged and neurotically taut works by Egon Schiele.

Expressing the experience of loneliness and pain arising from violation – or a sense of having colluded with acts of violation – and the inevitable, accompanying self-hatred, Emin's art could be seen as both a calling to account of the people who have shaped her life, and as a purgative ritual through which she attempts to regain her innocence. In this way, she claims her accounts of personal experience have a political validity.

And in this there is a kind of Napoleonic ambition. Emin presents herself through her art in grand, self-enshrining gestures, which somehow manage to mingle supreme arrogance with an endearing and courageous streak of pure heroism. Having presented her work in 'The Tracey Emin Museum', she then called her first one-person show, at Jay Jopling's powerful White Cube gallery, 'My Major Retrospective' (on the grounds that she thought that this would be her first and last 'proper' exhibition). In one particular work, 'Montenegro' (1997) she has made a small army of tanks out of matchboxes and matches, each bearing a tiny flag with 'Emin' written on it, making their way across a classroom map of the world.

'When I was at Maidstone College of Art, what I liked was that everything had a Marxist bent. So instead of just hearing lecturers, they'd get in the women from Greenham Common, or the striking miners. We even had a lecture from Sinn Fein, although they had to hold it after five o'clock, as opposed to within the college hours. But we were all interested to hear what they had to say. So people were bringing living history into the college, so we weren't just studying in this little bubble of art school; they were trying to make us aware of what was happening politically and socially, and I'll always be grateful for that. By going to Maidstone, I learned that art can be bigger and broader than just art.

'There is a politics behind what I do, but that's not my priority. So, for example, when I published a first-hand account of my abortion in a national newspaper, that was going to be pretty fucking political – particularly when you've got fucking Blair suddenly saying that he doesn't really agree with abortion. So that's going beyond art, that's bigger than art. I got a load of letters from the Pro-Life, Pro-Choice people, and from women who had had a termination and felt that they'd made a mistake. They were people who felt that I'd actually said what it was like to have an abortion, rather than simply giving an opinion about it.'

While she was at Maidstone College of Art, prior to attending

the Royal College of Art, Emin began to develop the personal and artistic stance for which she has become famous. The college's social secretary for two years, she organized such events as the 'Ideologically Unsound Talent Show' – as a riposte to the Marxist leanings of the college – and also became something of a local legend. She recalls how a banner in the main hall, proclaiming 'Smash Racism', was doctored by a student to read 'Smash Tracism'.

And there is an element in this anecdote that seems to hint at the darker side of her ambivalent yet addictive relationship to being known as a vivacious character. In her film and text, 'Why I Never Became a Dancer' (1995), she recounts how she ran out of a disco dancing competition in 1978 because what she thought were the cheers of a supportive crowd were in fact the jeers of a group of men – some of whom she had had casual sex with – chanting, 'Slag, slag, slag'. Similarly, in her paintings of having anal sex, there is an ambiguous mingling of self-hatred, accusatory polemic and sensationalist shock tactic. There is a strong sense, conveyed by the memoirs related in her art, that in desperately wanting to be popular, or loved, Emin has either debased herself or been exploited. In one of her text pieces she writes, 'Happy to die for love, that's me and it's sad.'

'If I was comprised of lots of different people, and I had to list them, I know that Silly Cow would be one of the first on my list, and Spoiled Brat would be another. Then there would be, Compassionate and Caring, Loyal and Lap-dog. I'm like one of those dogs who would walk across a whole continent to see my master again. It's a bit pathetic, but it's true. A lot of my friends, who are quite critical of me, say that I have standards and that I get into trouble when I try to make them apply to other people. I don't lie, for instance – try that one out – and I'm a faithful person. In fact, I have been unfaithful twice in my life – once was just a kiss with another person – but I wouldn't go through that hell again.'

Emin increasingly uses writing and text as the most direct means of communication within her work. She has given public readings of her work, and has self-published two collections of her writings, *Always Glad to See You* and *Exploration of the Soul*. Her style wanders between a stream-of-consciousness outpouring of her personal feelings, to a form of vernacular, anecdotal story-telling that reads rather like letters to herself or to the subject of the piece. In this, her literary ambitions follow in a tradition of female confessional writers, from Anne Sexton or Sylvia Plath, through to the writings of Kathy Acker. And, in many ways, she adapts the notion of confessional writing to that broader culture of confession that she sees as currently supporting her reputation.

Subsequent to her drunken appearance on a TV debate about the Turner Prize, Emin is turning to writing – or the idea of writing – more and more, as a retreat from what she regards as the mounting pressures of her celebrity. Most importantly, she wants to devote herself to writing a book, which her agent, Jay Jopling, is already proposing to publishers.

'There haven't been many people drunk on television: there was Oliver Reed, George Best and myself. I think that the nation likes it because it shows the vulnerability within us all. I mean everyone gets pissed and makes an arsehole of themselves, but not in front of four million people. I was told that the viewing figures for that programme went from one and a half million to four million in the time it took me to walk off.

'I want my life to quieten down, and I have quite a few personal problems that I can't sort out because I'm on the run all the time, in my head. I drink too much. I've cut down my drinking by sixty per cent, but I still have a very bad problem when I go out socially. If I do the book thing, it means that I can solve things by being peaceful and quiet. I could go on trains to places I haven't been before. There are loads of Holiday Inns which are built on by-passes and things, and some of them have got swimming pools; I could go there and just write for four days.

'When I start my book I'm going to be writing two thousand words a day, every day. That'll take me a couple of hours. I write really fast, stream of consciousness, and while there might be a few things which don't make any sense when I read them back, at least I've got the ideas down. It'll be a book of short stories, and the fiction will come in where I change some names and places. I've written one book about my life from the moment of my conception to losing my virginity when I was thirteen; this'll be the follow-up – my life from age thirteen to twenty-one.'

Ultimately, people's opinion of Tracey Emin – as a current phenomenon – is based and divided on whether they perceive her brand of autobiographical art, and her promotion of it, to be a sincere and socially edifying act of personal catharsis or simply an exercise in self-publicity. And this is an argument that can run and run, without ever reaching a useful conclusion. For every critic who finds Emin's art to be courageous and liberating, there will be another who denounces its provoking of controversy, or the questions that it raises about the role of fame within the constitution of contemporary art.

While it is easy to find people who might offer spiteful or envious comments about Emin, and even easier to find people who cannot sing her praises too loudly, she appears to possess the ability to discourage simple objective critique about her practice and the phenomenon of her current success. And if the direct polarization of opinion about an artist is a test of his or her significance, then Emin is clearly significant.

'She is a very significant presence within Young British Art,' says the critic and art historian, Richard Cork. 'There is a strong sense of vulnerability in her work, and the feeling that the only way for her to proceed is to try and exorcize some trauma from her past. She doesn't seem to exclude anything from this process of self-disclosure, and while this could quite easily degenerate into a fairly unbearable form of narcissism, she does get away

with it. And I think that this is because she is not trying to raise herself above criticism or self-criticism; she is clearly trying to deal honestly with her past, but there is no suggestion that she has achieved serenity.'

'I was talking to someone the other night, and why the hell should I still be an outsider when I'm sixty?' says Emin, with regard to her position in the cultural establishment. 'There's no reason for it. I'd be like the really interesting, funny guy who you meet in the pub when you're fifteen, and then when you're thirty-six he's still in there – only now he's fifty-eight and still sitting in the same fucking pub in the same corner. I'm not interested in becoming like that. I haven't had to change what I do; I haven't had to bow down to the system. I mean I didn't get any O-levels or A-levels, and people said, "You can't go to art school." So I just got my own form and filled it in.'

Today, Emin's detractors serve her cause to as great an effect as her supporters. Her former boyfriend, for instance, the poet and painter Billy Childish, has recently gained a good deal of reciprocal publicity off the back of his old flame by launching his 'Stuckist' movement – a loose-knit group of painters who have published a twenty-point manifesto, 'Against conceptualism, hedonism and the cult of the ego-artist'. On the front of this manifesto is a quote from Tracey, supposedly made about Billy: 'Your paintings are stuck, you are stuck! Stuck! Stuck! Stuck!'

'Well, his paintings are stuck,' says Emin, with disarming frankness, but genuine affection for Childish and his enterprise. 'This is just one of Billy's pamphlets – he's done loads of them, and it's a good, healthy thing – and a newspapers got hold of it and they know that it'll make a good story.'

But when Childish published his stories and poems about his relationship with Emin, she found them 'hateful and hurtful – particularly reading about all of his sexual conquests – it used to do my head in. But now I see that they're not about me, they're about him and his take on life, and he doesn't come across as

81

particularly admirable.' And in this, perhaps, one can see the reverse side of Emin's own artistic practice.

In a recent television documentary about Emin, the only critical voice in the programme – as the gents of the art world vied with one another to mingle faux-laddish candour with quasi-ironic hyperbole – came from her twin brother, Paul, who claimed to have lost his business contract in Margate because of the controversy generated by his sister's work. 'I want to use this occasion to state that I, Paul Emin, have no connection whatsoever with Tracey Emin's art,' he stated. And Emin herself, from her Whitechapel loft, admitted that her work back in Margate might find a reception very different from its current fashionability within the art world.

'I would like to show some of my work down in Margate,' she says, 'but there isn't really anywhere to show it. There's the library I suppose. But it would mean hiring a space and organizing it, and I'm too busy to do that. But it would be interesting, because a lot of my work is about growing up in that locality, and it would be quite interesting to hear the responses from other people growing up there. But it wouldn't really serve my purpose. What really serves my purpose is having a great big fuck-off show in New York. That's what serves my purpose.'

Confession as public spectacle was woven in to the burgeoning obsession with any form of celebrity. As the decade progressed, it appeared that the values traditionally, and even sneeringly, ascribed solely to the tabloid press – voyeurism, sensationalism, knee-jerk morality – were becoming all-pervasive as the temper of the times.

Applied post-modernism as a sophisticated parlour game had authorized no end of super-whizzy look-Mum-no-hands ways of flirting with tabloid culture, but the principal readership of the

endlessly cloning celebrity magazines – as much as the audiences of daytime confession 'n' conflict TV 'debates' – seemed to be drawn, demographically, from the lower-income end of the scale. Thus, the new aristocrats of celebrity culture (as well as the old aristocrats who were just aristocrats, but still got loads of celebrity-space) were kept in place largely by a particular public need for a kind of epic, ongoing soap opera of people who seemed to have more teeth than them and nicer houses than theirs. The celebrities, perhaps, were just another of the Compensatory Pleasures (like extended credit facilities or deli-style sandwich fillings) that people in the Nineties needed to compensate for . . . living in the Nineties. But one fundamental result of the cultural equation between confession and celebrity would be that the poor, quite literally, were supporting the wealthy.

Ulrika Jonsson

Just type 'Ulrika Jonsson' into the subject window of your Internet search engine, and you'll be sent back a lengthy list of sites, all of which promise 'Ulrika Nude!' Trawled up from the murkier depths of the web, these sites specialize in computer-manipulated images of celebrities. It's a kind of cyber-harem that doubles as a somewhat sordid gauge of modern fame. You get the feeling that if you were a celebrity, checking out your virtual profile, you'd probably be pretty miffed to find yourself pornographically pixilated in this way. That said, when you saw the sheer number of people whom these sites have fiddled around with, you'd maybe feel strangely hurt if you weren't included.

At thirty-two, Ulrika Jonsson was both defined and misrepresented as a sex symbol. Meeting her outside one of the smarter Windsor commuter stations, sitting behind the wheel of a soft-top Saab, dressed in casual black with Gucci sunglasses, she looks like any off-duty career woman. Neither her image, nor her voice –

slightly 'county', with the odd dead-drop into New Labour Mockney – seems to hint at media celebrity and part-time wild child.

Saab lend her the car in exchange for the occasional personal appearance. She wants the estate version so there'll be room for her five-year-old son's bike in the back. 'I drove a Fiat Panda until a couple of years ago,' she explains, as a dashboard slightly more complicated than the flightdeck of the Starship *Enterprise* winks lazily into life. And this little fact says a lot about the woman: Ulrika embodies the point where tabloid-hounded TV personality – flashy cars, the Met bar and lots of foreign holidays – meets Home Counties mum: the school run, early nights and swimming lessons.

On the one hand, you could say that Ulrika's entire career as a TV presenter and national pin-up has been driven by the juggernaut of her sex appeal. On the other, she has never promoted herself as anything other than 'ordinary'. The trouble is, Ulrika emits that particular kind of ordinariness that many people also find sexy. She is probably the only prime-time television star to have been photographed wearing an Agent Provocateur négligée while leaning at a jaunty angle against the extension hose of an Electrolux dust-buster. She shares with Felicity Kendal – the star of the terminally domestic Seventies sit-com, *The Good Life* – the fact that she has been voted 'Rear of The Year' in a national poll.

Ulrika uses the word 'ordinary' to describe herself, as though it is the one card in her hand that can't be beaten. 'People like me because . . . Well, they like me, if they like me at all, because I'm ordinary. I suppose that when I started out, nearly twelve years ago, there weren't a lot of young female presenters. There wasn't the amount of satellite channels that there are now, and even Sky was only just starting. Now, there are millions of young girls who are TV presenters and they're on the cover of just about everything. But I do think that I'm just ordinary. And I don't mind laughing at myself. So maybe I just make people feel comfortable. People don't really know what pigeon-hole to put me in, because

I keep changing my course and I don't seem to fit into any pattern.

'I'm not quite sure how it all happened for me. I didn't mind messing around in a crowd, but if there was a serious audience I'd probably walk the other way. Even now, when I do stand on a stage, I tend to be very self-deprecating and take the piss out of myself. Because I feel that I'm almost not worthy to be there, I think that if they can see me laughing at myself, then they won't laugh at me. We can just laugh at me together.'

Even as she's saying this, in the wholly ordinary surroundings of a National Trust tea room in the Home Counties, on a perfectly straightforward Thursday afternoon, another nice woman (middle-aged, mumsy, terribly polite) comes up and asks her for a pair of autographs. 'We've been having a debate,' the woman explains, 'and we want to know if you're Ulrika Jonsson?' 'I was this morning,' Ulrika replies, signing the proffered menus, and then she's worrying whether the recipients of these autographs will spot that she's written 'lots of love' on one of them and only 'love' on the other.

And that's another thing that you begin to notice about Ulrika – she seems as though she is constantly having to monitor her every slightest move, as though anything that she says or does, however trivial, could be seized upon and used against her. Again, she seems to use her ordinariness as both weapon and shield in her constant fight with what she sees as her misrepresentation within the press. It's as if she's trying to shy away from something, these days, even as she's still on the celebrity roller-coaster.

But with the media feeding frenzy that attended the 'discovery' that Ulrika is pregnant with her second child, you begin to see the reasoning behind her paranoia. Despite the fact that, by her own admission, she has taken a deliberate step back from the limelight, taking on very little new work, the news of her pregnancy dominated no fewer than five newspaper covers over a weekend when there were plenty of other important news stories – the little matter of major rioting in central London, for instance.

'The pregnancy was never announced – it didn't come from me

or from any of the people who work with me. But I've been forced to admit it, unhappily, when I'm just a woman who has become pregnant and would like to be enjoying the pregnancy. I can't describe the feeling of panic which all this attention and prying has caused for me. Not least because I'm only just pregnant, and any woman will tell you that the first three months of a pregnancy can be very problematic. This ridiculous media circus doesn't make me feel important, it makes me feel ridiculous. None of it has any relevance to my job, or what I'm known for, and the stress is enormous.'

From the very beginnings of her career as a TV AM weather girl, who went on to present the snappily athletic series 'Gladiators', the fact that Ulrika was partially sold to the public as a bouncy 'Swedish blonde' has made her natural tabloid fodder. Even when she made the jump from mainstream to cult, by appearing as a kind of ironic version of herself on 'Shooting Stars' – the send-up of a quiz show hosted by Vic Reeves and Bob Mortimer – Ulrika's private life was always made pretty public by the press. Married, separated, and now a single parent, her every holiday and dinner date (she once went out with Prince Edward) seemed to prompt another frenzied whoop of glee from the paparazzi. Now, you can hear the mounting anger in her tone the moment she touches on the subject of the tabloids.

'What they're basically saying is, "Because you earn all this fucking money, and because you get all the fucking glory, you can take some of the shit as well. Because we're going to dig, and we're going to chase, and we won't be happy until we're burying you." And I just think that's wrong. I think that because I'm in the entertainment business, that's considered egotistical and they just want to shatter it or bring it down.

'There are certain people in the business who will give the press exactly what they want. They'll turn up to everything and they'll pose and do anything. I've never been like that, but I've still managed to attract that kind of attention. Whether I burp or

fart it's in the papers. But then when I was pregnant, for instance, I was chased in a car.'

Beyond the tabloids, one of the difficulties facing Ulrika, professionally, is her lack of a coherent role. Over the course of her career, she has, for instance, swung from singing in a musical to interviewing the Chancellor of the Exchequer about macro-economics. Similarly, as the presenter of 'Gladiators' – which was hugely successful as a prime-time series, reaching the mega-millions figures in terms of ratings – she was placed in a position where she could spend the rest of her career being known for just one programme. Her popularity on 'Shooting Stars' went some way to reinventing her for a new audience. But once again, with Ulrika, you are faced with a mass of contradictions beneath the 'sexy but jolly good fun' public image.

'It was about six months ago that I discovered I had a real crisis of persona, to so speak. I really did have no idea of who I was. There's always been two people in my personality. One is very calm, and in need of security and a solid home life. The other can be completely hedonistic – in a fairly mild, but still wild way. Now I'm feeling the need to explore new areas – things that are nothing to do with TV or public life. I'd like to pursue my interest in painting and writing for instance.

'I'm developing the idea for a novel – it would sound too grand to say I'm actually writing a novel, because that's a big enterprise. But I have read some complete shit, and thought, "I could do better than that!" This is me boasting, but I'd read about all these young people writing the stories of their lives – I just finished Geri Halliwell's autobiography – and I'd always thought that I'd write the story of my life, if only as a form of therapy. So I've started trying to write it down in a couple of different styles, but I haven't worked out which style to follow yet. It's not necessarily going to be for publication, but it would be for my own benefit.

'The other thing that I've been doing for years is writing poetry, and that, I think, would be really interesting to publish. But it is

so terribly personal, coming from all kinds of experiences that I've been through – good and bad, but predominantly bad.' The contradictions in Ulrika resurface once again; here's a woman whose bedside reading, she says, is Joanna Trollope's aga-sagas and Dostoevsky's epic description of insanity and despair, *The Idiot*.

In many ways, it would seem to make sense for her to follow the path of 'Shooting Stars', and take advantage of the high fashionability that type of 'ironic' TV now commands. It has become a feature of post-modern comedians, such as Vic and Bob, or Harry Hill, to showcase essentially conservative media personalities within the surreal, volatile set-up of their pro-grammes. Similarly, *Absolutely Fabulous*, as a hip sit-com, brought new audiences and brilliant new roles for both June Whitfield and Joanna Lumley. But are these 'guest stars' being asked, to some extent, to become stooges?

'Bob went too far on "Shooting Stars" once – with a gag about my son during my divorce – but I laughed along with it and he apologized later so it was all OK. I don't know why they thought of me for "Shooting Stars" in the first place. But I was a great fan of Vic and Bob so they didn't have to ask twice. I remember doing the first series and just enjoying myself, but having no real sense of achievement. And then suddenly everyone was saying how brilliant it was to have me on the programme, and how clever I was. And I was thinking, "But I'm not doing anything – I'm just being me." I'm really good at word association, and that kind of fits in with the way Vic and Bob tend to work. It was really just repositioning people's perception of me, after seeing me reading the weather or presenting "Gladiators".'

With this in mind, you feel that Ulrika ought to be appearing at Glastonbury with the Beastie Boys, or doing a collaboration with Damien Hirst. Contemporary culture thrives on such unlikely combinations, merging the radical and the populist in a way that seems to sum up the quirks of the zeitgeist.

'I'd do anything with Bruce Springsteen like a shot,' says Ulrika, laughing. 'But this is all really new for me. "Shooting Stars" was a cult show, but does that make me a cult figure, or simply a member of a cult show? It's interesting how things have changed for me, after feeling the pull, so to speak, of "Shooting Stars", but I'd prefer to wait and see how things develop.

'Age doesn't bother me. Turning thirty was great, and turning forty just reminds me that I'm mortal! I'm quite enjoying maturity. With the programmes I get offered, I've tried to be true to myself and only do the things which I think are worthwhile. But increasingly I've found that I'm not being offered anything I particularly want to do. I certainly don't do this for the money, and I have never been dependent on anyone financially. I'm not being negative, I'm simply saying that I'd like to step outside the circle, so to speak, and consider new things.'

Ultimately, Ulrika Jonsson would seem to be at that crossroads in her life that comes to us all with the approach of middle age. On the one hand, there's a career to pursue, and all the pleasures of success. On the other, particularly with raising young children, a whole new set of priorities comes into play. One can't help thinking of the way in which Zoe Ball, also, has made a fairly public attempt to use domesticity to distance herself from her image as a good-time girl who's one of the boys. It's probably a common feature of early middle age, simply to want the best of both worlds, and that's where Ulrika seems to be at. Also, you get the feeling that she's pretty sick of the 'girly' image.

'I've had countless boyfriends in the past who've said "You're a fucking feminist" – and I just laughed at them because they feel so threatened by that. I think that some things are very clear-cut and simple, and so I say them. Then they're like, "Oh you'll be burning your bra next" and I'll say, "I fucking would if my tits weren't so big."

'In a lot of ways I do feel like I want to turn the tables, and turn everything upside down,' she says, unexpectedly. 'There's

maybe an amount of anger in the way I feel – not directed at anyone or anything in particular. But I can really say that the only thing I get genuine, unconditional satisfaction from is my child.'

... not that you could put your finger on exactly why, of course, but the arcade leading out of the Underground station, and even the street beyond seemed darker than usual. The shopfronts and entrances, normally slabs of white light, as though the luminescence itself was plasticized and high gloss, appeared dull, and somehow smaller. Perhaps it was the crowds. The crowds! You just hadn't reckoned on this. It was that kind of inch, inch, inch, it will never end shuffle, of the sort that leaves you looking at your shoes, as you, too, inch, inch, inch in the same direction as everyone else.

There was an impression of darkness overhead – darkness in a low cloud, like the smoke inside a lamp, actually hanging just beneath the ceiling of the arcade. Of course, you looked up, and – nothing. Just London grime; the black dust gathered on the raised plaster ridges of an arch, which can send a romantic turn of mind back to thoughts of the capital in the 1930s, for instance, and the ghosts of other commuters and shop workers, other crowds. Maybe this was what the Blitz was like. Those Henry Moore drawings of people sleeping in the Underground: sleeping figures in the lamplight, done in greys and reds and spider-thin lines of black ink.

Lots of children around, young mums and double buggies. They were slowing up the usual rush-hour crush, and their whole ambience of mint-coloured plastic juice containers and bags filled with toddler stuff just didn't seem to fit with this time – late afternoon – and this place, a central London tube station; because this time and place were for the world of work: the ultimate

affirmation of the absolutely usual. The theatre of sameness, where you could turn up every day and simply know that everything was in its proper place: the universe safe on its axis – because of that flower stall, those refrigerated displays of sandwiches, the general feel of a day just getting on.

Then you saw the mums and the double buggies and felt the darkness pressing down on the shuffling crowd. The affirmation of normality had been cancelled out; everything felt unusual, dividing the crowd into those who hated the change and those for whom it was like some kind of holiday carnival – some spree. Gore Vidal had just been over, and he'd said, about our current national situation, 'I never knew you people were so sorry for yourselves.' Which was a point of view, of course, but somehow, looking around, most of these people – inch, inch, inch, double buggy, double buggy – well, they actually seemed to be enjoying themselves.

During the mobilization for World War One, the artist and writer Percy Wyndham Lewis had written in his periodical *Blast* about the London crowd; a crowd on the threshold of war in that case, but similarly a national event, just wandering around the London streets: 'For some hours he moved forward at a snail's pace. The night came on. He allowed himself to be carried by the crowd. He offered himself to its emotion, which saturated him at length. When it had sunk in, he examined it. Apparently it was sluggish electricity. That was all.'

That seemed about right – updated. The crush was enormous. The crowds, the mums, the double buggies, the toddlers, and then the torpid surge of pushing forward another few inches. And the silly thing is, you didn't even want to be here. An arrangement made, thoughtlessly, completely forgetting that this, this . . . thing, would be going on. There was the sense of having been ousted from one's usual habitat; that, hold-on-just-one-little-minute-but-some-of-us-actually-live-here – and now this crowd were making it impossible to operate. Oh, it was easy to start feeling superior

about it all – but that didn't work for long. You were up against
. . . the dynamics of the family – a family of millions.

The American was only half right, because he missed the bit
about this being like the whole country turning into a daytime-
television studio. With an audience of some vast number, every
one of whom it seems was pushing through this arcade in order
to get their chance to be seen to emote, to confess, to have their
very own thirty seconds of Reality TV-style, lingering-camera-on-
brimming-eyes-and-innocent-toddler-wobbling-along-with-a-couple-
of-gladioli-essence-of-public-emotion. And there in conscientious
primary school felt-tip, written over a thousand times: 'Princess
of All Our Hearts'.

Behold, the Necrothon!

Not that one wanted to seem unkind. And yet the mood was
unreal; times of day seemed to swap around, with twilights in
mid-afternoon and a sense of midnight at dusk. It was all very . . .
fin-de-siècle. That was the phrase, right down to the overtones
of Victorian Aestheticism and Decadence. That here, right slap-
bang in the middle of modern working London – the cafes,
refrigerated displays, perfume counters, compilation CDs – there
was suddenly this folded black velvet and white lilies mood; this
Imperial ceremonial, like those arcane rituals where Officers from
Knightsbridge Barracks walk riderless horses down the centre of
the Mall, a pair of shining black boots reversed in the silver
stirrups.

The fin-de-siècle mood had been growing, in many ways. Weird
modern art, reeking of sex and death and a kind of nerveless,
godless, abandonment to sensuality. Philip Hoare had caught the
moment perfectly in an essay for the *Spectator* – sewing together
the art at 'Sensation' – and check out a Joker in the pack, Adam
Chodzko, with his 'God Lookalike Competition' piece – with
another exhibition down the road, of 'Symbolism in the Age of
Rossetti, Watts, and Burne-Jones'. He showed how the two were
like mirrors of each other, both feeling the quickening 'sense of

an ending' – (and Hoare was the man who rehabilitated that phrase, too, from Frank Kermode).

Now here we were in this crowd. Claustrophobia in crowds and jams re-enacts the primal fear of the birth canal – no exit terror. But then there was this . . . situation, in which one literally felt that one was turning against the crowd, pushing in the opposite direction, alone . . . (Where, oh where were the people from the Anti-Rave who looked like potatoes, now that you really needed them?) Against the overwhelming current of toddlers and double buggies and paper twists of gladioli all heading off towards the gates of Kensington Palace – like the crowds who witnessed alien phenomena in *Close Encounters of the Third Kind*, all being summoned to the flat-topped mountain in the middle of nowhere. (They don't know why; they've been freaking out their families by making models of this damned mountain out of sand in the back yard and piles of mashed potato on their supper plates.)

The mood of unreality seemed unhealthy, volatile, as though unsure of its own direction or purpose. Truth to tell, there was something of the lynch-mob about it – the force of a collective that might possibly not tolerate any questioning of its chosen banner. It was that studio audience feeling, that now's-your-chance-to-let-it-all-out mood. The sluggish electricity could suddenly overload, short-circuit. But here was a certain sickliness; the conversion of tragedy, refracted through media, into a fusion of celebrity and confession and salaciousness and voyeurism that exceeded the wildest hungers of a mood already ravenous for real-life drama as public spectacle. It was like a sacrifice to Decadence; and here were the worshippers, in this inching crowd, shuffling out towards Kensington High Street as a darkness like dust and oily smoke seemed to hover just over their heads . . .

From Fairy Tale Wedding to public confession on 'Panorama', Diana had alternately enchanted her times and embodied them. In her violent death, there was a terrible sense of self-scripted drama – existence on an allegorical level. Many felt she'd had a bad deal from what Michael Collins described as 'the black crows' of the Royal Family. To others she was less the Princess of All Our Hearts than the Patron Saint of Shopping.

In the midst of all this spectacle, culminating in the Necrothon, the barbarism of the self-reflecting sign had held forth with a certain thuggish self-assurance. There was little conception of the architecture of the ego, it seemed, save as monolith. The idea of the self's fragility, caught up in its twinning with the soul, seemed pretty much eccentric. One twenty-one-year-old zeitgeist surfer – he was called Rory McCarskill – made the pronouncement in 1996, 'Everything's just another look nowadays', and the fin-de-siècle flavour of the times, epicurean in its serving and sampling of image, seemed to use its every pronouncement on the self, paradoxically, as a means of avoiding any real engagement with issues of subjectivity. The texture of public confession and sensation made an excellent form of displacement therapy and intimacy regulator – it removed (like the mobile phone) the greater difficulties of trying to be alone with the self.

As the Necrothon seemed to blend with the Royal Academy's controversial exhibition of 'Young British Art' owned by Charles Saatchi, 'Sensation', the wider fin-de-siècle mood took on its most pervasive reach within the culture. The traditional tenets of fin-de-siècle Decadence all seemed to be in place, more or less replaying, move for move, the Decadence at the end of the nineteenth century. Metrocentric, its spores carried by media and new media, this idea of Decadence had a common denominator of spectacle: visceral morbidity and sexuality, coupled to a public hunger, or so it seemed, for views into private worlds – the more extreme the better. And as all eras of Decadence seem to re-run the lurid range of the Roman originator, the *Satyricon*, so the

1990s seem to need a Petronius to comment and record – but the decade never delivered. Right across the popular media, it was the loudest voices – the post-modern Trimalchio – which seemed to win: the 'Me! Me! Me!' barbarism of the self-reflecting sign.

As though to compensate for this, virtually woven into the allure of a fin-de-siècle Decadence, a vogue for the rhetoric of spirituality and complementary therapy joined the cafe latte and the loft conversion as a major part of Lifestyle – all those esoteric scents and bath oils, for instance, targeting 'Equipoise', 'Calm' and 'Seren-dipity', all those chakras and mood enhancers. The language of the weekend Retreat had found its way to the perfume counter; here was a mainstream manifestation of Aestheticism – the actual immersion and anointing of the self in cosmetic treatments of the soul. The whole billion-dollar cult of commercial perfumery had gone Meaningful, as though Joris-Karl Huysmans had done the marketing for Elizabeth Arden.

In the absence of an Oscar Wilde of the 1990s, we rediscovered the Oscar Wilde of the 1890s, and found his philosophies (like Warhol's) had always been prophetic. As a wit, dandy, popular socialist and homosexual martyr, Oscar Wilde would have been the perfect chat-show guest for the late 1990s – somewhere between Sir Elton John and Eddie Izzard. 'To cure the soul by the means of the senses,' Wilde had pronounced through Dorian Gray, 'and the sense by means of the soul . . .' Well, now you could get it in a shower-gel too; and You-Know-Who would prob-ably have found it too absurd. On the other hand, 'Our Oscar' knew more about being alone with the self than most people. The centenary of his incarceration, in 1995, had been a prompt to examine his example: the template for modern tabloid sensation, the self-reflecting sign as self-destructive celebrity and genius.

Art and Fashion

Oscar Wilde, lecturing on 'Dress' in the autumn of 1884, had laid the foundations of his belief that the relationship between art and fashion was a truly modern conflation of forms, the correct understanding of which – 'One should either be a work of art or wear a work of art', as he would later explain – could be the credo of a new kind of metaphysical dandyism. For Wilde, the late-nineteenth-century fashions of seasonal 'modes' comprised an old tyrant to be destroyed: 'A fashion is merely a form of ugliness so unbearable that we are compelled to alter it every six months,' he pronounced in his lecture on 'Dress'; and his wife, Constance, would take a noted interest – as a feminist and social celebrity – in the women's meetings on 'Rational Dress', which aimed to reform the heavy Victorian fashions which the Rational Dress Society considered both cumbersome and unhygienic.

There is a case for claiming Oscar and Constance Wilde to be the first modernist couple, alternately amusing, instructing and shocking London society in their few years together as a fashionable husband and wife. And much of their prophetic modernism – which could be reduced, as a mission, to the practice of aesthetic reform – was made articulate on a social level by their appearance. Richard Ellmann, in his biography of Wilde, reports the effect of the young couple's stroll through Chelsea to visit their acquaintance, the artist Louise Jopling: '"As we came along the Kings Road," Wilde reported, "a number of rude little boys surrounded and followed us. One boy, after staring at us, said, ''Amlet and Ophelia out for a walk, I suppose!' I answered, 'My little fellow, you are quite right. We are!'"'

Dressed in 'a brown suit with innumerable little buttons that gave it the appearance of a glorified page's costume', with Constance beside him wearing 'a large white picture hat, with white feathers, and a dress of equal flourish', Oscar Wilde's promenade

down the Kings Road could be taken as a piece of self-conscious performance art. As a display of constructed identity on parade, this performance had its roots in the pseudo-official Dandyism of Balzac's *Traite de la vie élégante*, published in the 1830s – which made a stylized fetish of mannered idleness. The Kings Road would also become a public cat-walk for poseurs in 1977, with the weekly procession of first-wave punk rockers performing their lager-drenched promenade from shopping at BOY to shop-lifting from Beaufort Market – just a spit or two from the former chez Wilde in Tite Street.

But the Wildean influence of art upon fashion had also extended to his proto-Surrealist 'cello coat' – which had been modelled for him 'by a ghostly figure in a dream'. With more earthly ambitions, Wilde had worn the cello coat to a Private View at the new Grosvenor Gallery in May 1877, on the occasion of his first appearance as an Oxonian art critic. His mission as an aesthete, in this respect, would be to authorize a dialogue between art and fashion by uniting those two subjects – then hopelessly beyond one another's reach in terms of their respective cultural status – within his single and levelling critical language of dandified aesthetic philosophy.

Similarly, as Wilde revealed how the surface of a society's tastes and values could be used to describe their hidden indices of aspirations, fears and desire – in a manner that would be repeated in the films and paintings of Andy Warhol in the 1960s – so he more or less invented the psychology of modern advertising as the dominant force in contemporary popular culture. By reducing, with scientific genius, the wordy prose of aesthetic philosophy to the well-turned aphorism, sugar-coated with paradoxical wit, Wilde invented the dynamics of the pack-shot catchphrase and the mind-catching slogan. If you think about it, a Wildean maxim such as 'Cultivated leisure is the aim of man' (from 'The Soul of Man Under Socialism', 1891), would be the perfect slogan for Saab, Ford or Hilton.

As Peter Wollen demonstrates in his selection of works and objects for 'Addressing the Century: 100 Years of Art and Fashion', the widening of artistic boundaries and the acceleration of consumer society that coincided with European modernism would do much to extend the Wildean pronouncement of either being or wearing a work of art. Towards the outbreak of World War One, a new sense of urbanity would have opened up, which demanded, as Ezra Pound pronounced, 'the accelerated image of its own grimace'. By 1913, Sonia and Robert Delaunay – both artists, both caught up in the avant-garde society attendant on the development of Cubism – appeared to be following in the footsteps of Oscar and Constance Wilde, as social celebrities with a self-consciously pronounced and unmissable personal style. As a by-product of their artistic experiments, the Delaunays' appearance was an aesthetic manifesto to wear around the streets, salons and dance halls of modernist Paris.

The Delaunays' shared creation of the 'simultaneist' aesthetic, based on light as a unifying force among contrasting colours, would find expression in their paintings and writings, but more specifically through Sonia's 'simultaneous' dresses and fabrics. As wearable modernism, and subtly erotic, these pieces became a direct informant on Giacomo Balla's futurist manifesto, 'The Anti-Neutral Dress' – despite the vehement anti-feminism of the Italian futurists – and would also be an influence on the Omega Workshop wing of London's Bloomsbury Group. And as their reputation spread, Sonia Delaunay's use of dress-making and textile designs as a medium for artistic expression would lead her, by way of her 'Future of Fashion' show at Claridge's Hotel, London, to some contact with the world of commercial fashion.

In her profile of Sonia and Robert Delaunay, *Living Simultaneously* (1993), Whitney Chadwick identifies the couple's modernist assault, initially, through their clothes: 'Their frequent companion, the poet and art critic Guillaume Apollinaire, spoke admiringly of Robert Delaunay's red coat with its blue collar, his

red socks, yellow and black shoes, black pants, green jacket, sky-blue vest, and tiny red tie. Sonia was no less resplendent in a purple dress with a wide purple and green belt. Under the dress's jacket, she wore a large corsage divided into brightly coloured zones of fabric in which antique rose, yellow-orange, Nattier blue and scarlet appeared on different materials, juxtaposing wool, taffeta, tulle, watered silk and peau de soie. So much variety, Apollinaire concluded, could not escape notice and must surely transform fantasy into elegance.'

This phrase of Apollinaire's, to 'transform fantasy into elegance', could be taken to describe the revolt into style which the Wildes and the Delaunays represented in their respective eras, and which made their appearance articulate of their amplified, crusading personalities. Indeed, from Apollinaire's description of the Delaunays, and his identification of the slide of fantasy into elegance, a contemporary reader could be reminded of the young Vivienne Westwood and Malcolm McLaren – in the days of their retro-trash 'Let It Rock' boutique. For the architects of punk, expressing a cartoon of Teddy Boy styling by way of McLaren's schooling in Situationist interventions, and Westwood's progressive translation of fetish-wear into street-wear, there was a similar declamation of personal style as targeted trouble-making as there was for the Delaunays' journey to the heart of Parisian Dada. Similarly, the hyper-conventional appearance of Gilbert & George – bespoke suited by their south London tailor – has been the principal focus and emblem for their art and their lives as 'living sculptures'.

The theory and practice of becoming a 'self-creating artwork' is a process that Quentin Crisp has identified, with regard to his own constructed self, as becoming an 'autofact'. And Crisp, born in suburban Sutton, Surrey, in 1908, could be the twentieth century's unofficial High Priest of amplified style. Baffled by fashion proper, and bored by art, Crisp embodied an extreme sense of style that was based on the supremacy of one's own sense of self. This

individualistic sense of style has less to do with the world of couture and fashion houses than it does with a kind of performance folk art, in which the Wildean boundaries between art and life are intentionally blurred – or beyond one's control as a result of one's temperament.

In his biography of the Honourable Stephen Tennant, *Serious Pleasures*, Philip Hoare reports Tom Driberg's account for the 'William Hickey' column of 23 April 1928, of the young aesthete's arrival at a social function. Defining a personality for whom self-creation stood on the slender cusp between high fashion and eccentricity, the description of Tennant's appearance is all the more powerful for its brevity: 'The Honourable Stephen Tennant arrived in an electric brougham, wearing a football jersey and earrings.' Beyond the fashion house and beyond the authorizing space of the studio or gallery, Tennant's flippant subversion of male appearance can be seen as an act of self-creation and self-advertisement; his raison d'être – as a living artwork – was to become a beautifully pointless icon to his own vanity. Tennant's dandyism, obsessed with androgyny and modernity, was like a Cocteauesque premonition of David Bowie's appearance in 1970, photographed reclining on a sofa in a dress for the album sleeve of *The Man Who Sold the World* – which was suppressed in the USA because of its perceived effeminacy.

Both David Bowie and Marc Bolan, as futuristic pop pantomime wrapped in tin foil, were ultimate products of the English Mod obsession with creating unique and exclusive styles. The Space Age and Op Art designer fashions of the 1960s, which had included such major collections as Paco Rabanne's 'Twelve Unwearable Dresses', was matched by the 'art school' styling of Mod. John Entwistle, of the Who, could be seen on the cover of *My Generation* in 1966, wearing a 'Union Jacket', which was based on the work of Geoff Reeve at the Textiles Department of the Royal College of Art. As the historian David Mellor has pointed out in his *Sixties Art Scene in London*, the Union Jack had been

given a 'serial meaninglessness' through its appropriation by Pop Art, and as a consequence Entwistle's jacket could be seen as a highly ambiguous statement about national and personal politics – laden with nihilism and irony. A reworking of this situation, in which questions of 'artistic status' were raised by the relation-ship between art, design and fashion, would also be seen in the 1960s when Bridget Riley strenuously – and successfully – opposed the use of her black and white Op-art paintings within fashion design. Needless to say, 'Richard Shops' appropriated Riley's aesthetic in the mid-1960s, under the banner of 'Such Pretty Clothes!'

But in the early 1960s, the mainstream of Mod fashion – an English working-class appropriation of Italian styling – had been foreshadowed by an extremist faction in the little-known cult of 'Individualism'. Mark Paytress, in his biography of Marc Bolan, *Twentieth Century Boy* (1992), gives a definition of the proto-Mod Individualist movement, which could double to describe the unofficial relationship between art and fashion that emerged in popular culture from Stephen Tennant, through Glam rock and punk to the exuberance of New Romanticism: 'There has always been an uncomfortable contradiction between the avowed per-sonal expression of a subcultural style, and the fact of belonging to a subculture . . . An Individualist would take the straight Mod gear as a starting point, then throw in something completely at odds with the rest of the outfit.'

For Bolan's involvement with the early Mods, this amplification of a subcultural fashion was simply sculpted by the desire for total originality, in terms of styling, to create a look that was abandoned the moment it was copied – on even a local basis among the Mod fraternity. Boy George and his early associate Marilyn would espouse similar thinking in the twilight of New Romanticism in the early 1980s, when George declared that he wouldn't be seen dead in any outfit that could actually be bought. Similarly, in 1978, when the punk model Jordan – who would appear as Britannia on

the poster for Derek Jarman's uneasy film fantasy, *Jubilee* – was offered a show at a gallery in New York, to simply 'be herself', she gave an interview to the *NME* in which she stated that 'dressing up is for me what painting was to Picasso'. The entire point of Individualism, in both a historical and a pop cultural sense, is to value one's originality as an 'autofact' far more highly than the vigorous glamour that can be borrowed, to shape one's identify, from the most exclusive of actual fashion designers.

If the radical exclusivity of Individualism can be taken as the ultimate expression of personal styling in the Pop age, then the potential of that movement had been rehearsed in part in the 1930s, when Elsa Schiaparelli worked with Surrealists such as Man Ray, Meret Oppenheim and Salvador Dali. As Peter Wollen states in his catalogue essay for 'Addressing the Century': 'Schiaparelli also experimented with new materials – cellophane, glass, plastic, parachute silk – and deliberately gave exaggerated prominence to accessories. Fantasy in design always gravitates towards the bodily extremes, towards hats, gloves and shoes, which can be extravagantly shaped without affecting the basic form.'

Contemporary fashion design has seen the legacy of Schiaparelli's dalliance with Surrealism in the works of designers as different as Rei Kawakubo at Comme des Garçons and Hussein Chalayan, both of whom have extended the boundaries of fashion to address conceptual and dream-like areas. In the work of Shiaparelli – as in the work of Kawakubo and Chalayan – elegance is ever present as a controlling force, no matter how extreme the aesthetic or concept of a garment. But the unofficial, 'street version' of surreal clothing and 'auto-faction' is less concerned with elegance than it is with disruption.

The extreme cult of Individualism could be seen to have reached some kind of apotheosis in the self-creation of the late Leigh Bowery, whose existential 'point' was to make a nonsense of having any point. In a philosophical line of descent from Wilde's pronouncement that one should either be or wear a work of art,

Bowery shared with the 'body-artist' 'Veruschka' the notion that one's reconstructed self should not have to mean anything, artistic or otherwise. The Wildean debate about the 'usefulness' of art, in relation to the functional status of fashion, reached critical mass with Leigh Bowery.

Rebuilding himself with masks, meshes, prosthetics, make-up and paints, Bowery could become a lurid cartoon or a diaphanous sculpture; as an autofact, he reversed not only the status of art over fashion – or vice versa – but also the very meaning of those terms. In effect, his intention was that paradoxical notion of 'creative nihilism' which Malcolm McLaren had identified as a component of punk rock. In Bowery's case, the heroic absurdism of his appearance could be taken as a persuasive mockery of 'meaning' itself – a claim that was strengthened by his residency as a living artwork at the Anthony d'Offay Gallery, in which he merely – or as Wilde might have said, 'strenuously' – reclined.

. . . people happening to look upwards in the vast ceremonial lobby of the old Berners Hotel, just north of Oxford Street in the West End of London, tended always to comment on the extravagance of the raised tracery on the ceiling: a rococo fantasy that looked as though it were made of wedding cake icing; in its time it has been ignored, bombed and painted candy-floss pink.

Now, in a hotel that caters for bourgeois northern Europeans, middle-management Japanese and the lower to middling strata of the music and entertainment business, the curlicues and ornate vertebrae of this ceiling are a carefully restored pattern of ivory white; beneath, and under the slightly unfocused gaze of the carved hunch-shouldered heroic figures who appear to support the corners of the room, an arrangement of silk-covered sofas and wing-backed armchairs spread out on either side of the lobby, a circular table in their centre, bearing a sturdy vase from which a

controlled explosion of freshly cut flowers burst forth – lilies, irises, eucalyptus leaves and the odd palm frond.

Being a hotel of the pre-Boutique hotel era, the bouquet boasts no spikes; just as there are no lime-green floodlit spaces in the lobby, where snippets of surrealism – an etiolated silver chaise longue, for instance, cushioned in pub-wallpaper flock – play up the perfection of minimalism. No; this hotel – neither a Grand hotel nor a featureless business-class barracks – has stayed beyond the reach of dominant styling. Rather, it is staid: reliably middle-aged and middle-class in an increasingly up-beat and rehabilitated maze of streets – just on the edges of the studios, workshops and showrooms of the garment and millinery district.

These days, mobile phones ring every two minutes in the cere-monial lobby, and just two minutes' walk away the shabby pro-cession of Oxford Street, both urgent and meandering, makes its way past electrical goods stores and short-lease shops selling cheap leather jackets. All the telephone boxes in these streets set to the north of the main thoroughfare are covered in a patchwork of sex-worker adverts, from a telephone number scrawled in biro, to a glossy four-colour calling card. Meanwhile, back at the hotel, beneath the extravagance of the ceiling, on silk-covered cushions worn slippery with use, sipping tea that has that dry, slightly paperish taste, the resting bourgeois of at least four continents have an air of somewhat self-conscious relaxation.

One afternoon during the early autumn of 1994, Leigh Bowery came into this lobby for an interview. He was its opposite, yet a composite himself of all that seemed to surround it. Big-framed, heavy-set and boyishly shabby in a tweedy, dust-coloured trousers kind of way, his round face bore the puncture marks of artificial dimples – the result of primitive piercing. He seemed bored and slightly bewildered, as though always on the point of asking some question, but not interested enough in the reply to bother. You were either of his world or you weren't. And even some of the people in it said he 'was a little bit panto – an arriviste . . .' Bowery

said that he wanted to present private sexual or bodily rituals as entertainment. So what else was new?

His investigation of the self had always been conducted in the language of a kind of absurd über drag, in which his rebuilding of himself through cosmetics, prosthetics and fabrics created a sealed mask of unknowability – he became a creature of potential further masks. Bowery had a new band called Minty – who weren't particularly good or even original – but who had captured the attention of the culture-vultures because it all seemed to hint at a kind of late-Eighties Decadence revival in a new host culture. Minty had played at Factual Nonsense's 'Fete Worse than Death' in what was then the still relatively obscure district of Hoxton Square, between Old Street and Shoreditch.

The performance had become legendary for Bowery's act of 'giving birth' – from the ripped gusset of a pair of white tights – to a bald-headed, paint-smeared, naked woman (his wife, as it turned out). Somehow, this just seemed like tacky drag reaching critical mass – most of the audience thought that it was quite funny though. Minty were going for an idea of draggy druggy punk cabaret that was left over from the middle of the 1980s, and the heyday of gay clubs such as the Mud Club and Taboo.

Just around the corner from the old Berners Hotel, a post-punk Bohemian couple – a film-maker and an art dealer – had once held court and open house to a whole tribe of druggy, draggy, occultist, fashion terrorist, art music types, including Bowery, the collective personality of whom was so volatile that they often seemed like petulant teenagers throwing lighted matches across trays of petrol.

Some of them craved centrality – addicts attracted to sobriety; others were classic aesthetes, quite possibly brilliant personalities; but caught up in a dank labyrinth of gossip and conflict that appeared to constrict and stifle, weekly. It was the kind of place where, under the blank white light of a merciless weekday lunch hour, you would find a cadaver-faced German wearing field-grey

camouflage battle fatigues, and trying to mend a Tibetan thigh-bone trumpet, or a young Japanese woman dressed in a brown gym-slip, ringing home for hours from the dust and cables beneath the table.

Back in 1986, members of this unofficial group (arguably the last stop before Young British Art) had staged the now forgotten 'Anti-Art' fair on the top floor of an old factory in Camden Town (this was when there were still old factories in Camden Town) a whole two years before Damien Hirst had played the same card to international interest at the Port of London Authority building. The 'Anti-Art' fair had a lurid, fluorescent poster, the slogan on which began, 'to spark out now would be . . .' Drugs were everywhere in this particular milieu, stalked by sex and suicide.

This was a grouping of people – some of whom would achieve a broader acclaim, working in fashion, art, video and styling – who seemed to dwell in partially prettified squalor, at once modern and archaic, halfway between the blackened dust and rotting window frames of bedsit London and an orgy of insecure fashion models. They appeared saturated by an experience of London that was both heady and futile – hours of time-killing seemed to have seeped into their pores, despite the endless talk of plans and projects. Like the inmates of Warhol's first Silver Factory mixed with a dollop of slightly diluted Quentin Crisp – 'I breathe and I blink.'

Bowery's art seemed to be the art of getting ready to go out – the process of preparation in all five modalities, from shower-gel to mini-cab. His refusal to explain his witty, meticulous self-assemblage – from tatty and vulgar to disturbing and mesmeric – maintained its nihilistic purpose. Would it have been possible for Bowery's image-making to be co-opted as a 'brand' – in the way that corporations look to semiotically well-placed phenomena to define their aura? Perhaps, but only the biggest corporations would have risked the sheer Dada of Bowery – a man who could dress

as a Spanish conquistador – with clothes pegs clipped to his jowls for a ruff, and a helmet made of an anatomically perfect model of the gland of an erect penis? Dickhead. Some mobile phone outfit, possibly.

But sitting in the lobby of the old Berners Hotel, he seemed to bring with him – just behind his faintly puzzled air – the sense of an era – a generation of burned-out cases – which had had its day, which was worn out but still going. Bowery seemed like the embodiment of a social life that was so intense that it could be managed only as a cast of mocking and self-mocking characters – eccentric, vulgar, melancholy and absurd. He died a few months later, iconic and almost legendary, but still unknowable.

In the Prozac nation, confession as spectacle, Jurassic Park barbarism of the self-reflecting sign, certain questions emerged. Could it really be true that the idea of the soul had become eccentric – that the deep core of subjectivity had been corroded by the practice of a debased form of catharsis? An abandonment of the soul as the mirror of conscience, the moral battleground, the centre of identity, the passport to the other side . . . All that stuff.

Culture had still cradled and hot-housed these notions, of course, just as we all did. But contemporary cultural articulations of the soul became heavily codified, entangled and obscure in the 1990s. Its truest pioneers, therefore, those – were they old-fashioned in some way? – with no option but to mine their own being, seemed all the more intense.

Barry Adamson

'Question: Who did it?
 Answer: Me!' (Barry Adamson, 'Split')

Manchester, approached through the southern inner suburbs of Hulme and Moss Side, presents its urban skyline with a sudden drama that is at once cinematic and apparently one-dimensional. Riding in on this reddish surf of century-old terraces, there is no high-rise obstruction to the view of clustered modernist towers, former warehousing and ornate Victorian offices that comprise the city centre; Manchester intimidates from a distance, as though transmitting a subsonic pulse of anticipation. And the musician Barry Adamson, it could be argued, composes narrative sound-tracks for the urban view, which double as self-portraits, and are as shot through with the neurasthenia of fearful apprehension as they are held in place by wit.

Now, decked out with post-modern fairy lights that define the span of the tramway at G Mex, the height of the CIS Tower and the acid-green illuminated hull of the new Halle Hall – warmed to orange at the whim of a circuit – the city looks more than ever like an architectural fait accompli: a monolithic film set, silently set down to await investigation in the open-ended acoustic basin that rises up to the northern moors. And, if cities can be likened to books or films, then Manchester would be a psychological thriller, with layers of intrigue and suspense behind the moodily lit flats of its opaque façade. It seems, like Las Vegas, to be a city of the plains, surrounded by darkness.

Moss Side, where Barry Adamson was born of a white mother and black father, and raised within an education system, during the 1960s and early 1970s, that was indifferent at best and damaging at worst, was an uneasy community of whites and blacks who were united solely by deliquescing rituals of northern working-

class society. In the late 1970s this cocktail of urban deprivation, attendant crime and legitimate protest would turn volatile, eventually explode into rioting and prompt a long-term programme of inner-city regeneration. And, as with the riots in Bristol and Brixton, this messy blaze of unrest would seem to coincide with the fall-out of punk rock and its dialogue with the musical blackness of heavily dubbed reggae and mutant funk. The young Barry Adamson, however (despite being a Stockport Art College punk) had grown up racially and emotionally with a strong sense of belonging to neither black society nor white subculture; as described by the title of a cult hit by the first band he ever played in, Magazine, he was 'Shot by Both Sides'. Being outside of the outsiders, and different among different, would be the crucial informant of his development as a musician and composer.

For Barry Adamson, the urban topography of south Manchester would double as a map of his own memories, leaving an indelible imprint on his imagination as the arranger of soundtracks for the imaginary films of his life – *Moss Side Story* (1989), *Soul Murder* (1992) and *Oedipus Schmoedipus* (1996) being the principal trilogy, punctuated by the EPs *The Taming of the Shrewd* (1989) and *The Negro Inside Me* (1993). Luxurious, erotic, tense and self-aware, Barry Adamson's musical range can score the themes of classical tragedy or dirty realism to the sound of Count Basie or an avant-garde fusion of Scott Walker and Can.

These scores to Adamson's imagined role as a character within his own fictional world – a film noir on the edge – endlessly revisit the struggle of sensibility between black and white, acceptance and rejection, love and sexuality. And, as such, his artistic project is as much literary as musical, casting himself as the private detective within his own experience, or the secret agent investigating opposed factions; he is both the cop and the criminal, tracking himself down in the urban landscape of his memories. Like the sleuth victim hero of Alan Parker's film *Angel Heart* (1987), Adamson is on his own trail in a darkly Faustian allegory.

In keeping with the ambience of this filmic narrative, the Adamson sound is an epic and eclectic collage of musical styles, creating the effect of sound-stage lighting on the 'scenes' that are being played out. On his first solo LP, *Moss Side Story* ('In a black and white world, murder brings a touch of colour') with its obvious punning on Bernstein and Sondheim's *West Side Story*, the listener is drawn not only into the soundtrack of a film – created by a mixture of movie melodrama and industrial atmospherics – but also into the sense of being surrounded by the expanded sound within a cinema auditorium. Similarly, on *The Negro Inside Me*, Adamson would convey the echoing acoustics of a 1940s dance hall, or, on *Soul Murder*, the penetrating intimacy of a wireless broadcast. Whether adopting jazz, gospel, funk, soundtrack string synthesizer chords or big-band swing, Adamson scores arrangements in which sound itself becomes a 'character' contextualized within an imaginary environment, as consciously created as his own fictional role.

Artists will create new identities for themselves, often in childhood, that are primarily survival techniques based on psychic self-defence. For Sartre, in his philosophical biographies of the novelist Flaubert (*L'Idiot de la famille*) and of the petty-criminal aesthete and writer Jean Genet (*Saint Genet*), this process gave birth to the 'becoming of' a new mask. Thus, in Sartre's analysis, Genet's being an unwanted ward of the state demanded in him the reinvention of his being as both the author and hero of his fictional worlds. Alienated by his mixed-race parentage, but more importantly by the 'ever hidden wound' – unknowable but fundamental – Adamson's first portal to reinvention was a gift for mimicry that earned him protection. This process was a necessity, unconnected to the elevated thinking of the purely artistic process.

An avid consumer in childhood of television series such as 'Man in a Suitcase', 'The Invaders', 'The Fugitive' and 'Randall & Hopkirk (Deceased)', Adamson became the hero of those teledramas within the streets and playgrounds of Moss Side, revelling

in an ambience of new glamour that could project him as the romantic hero or existential victim within the real world of class-room boredom, pregnant thirteen-year-olds and boys who came to school with black eyes. Like Genet, pursuing a dreamscape through the imagined lives of cat burglars and pimps, Adamson could find in the wounds and bravado of his peers the beginnings of the cast for his imaginary worlds – with himself, withdrawn by nature, assuming the starring role in what turns out to be, in a narrative loop, the pursuit of his own case. The self, as defined by Proust, becomes 'the many gentlemen of whom I am comprised'.

Hence, in *Soul Murder*, Adamson's proclamation of his mixed identity in the tellingly titled 'Split':

Allow me to impose myself upon ya.
I'm El Deludo
Oscar de la Soundtrack
Mr Moss Side Gory
From Rusholme with Blood!
That's me, H.P.
Harry Pendulum, the last of the big-time swingers
I'm living' off a theme.

Here are the elements of Adamson's founding theology of his new self as glamorous sleuth: 'El Deludo' (mixed up), 'Oscar de la Soundtrack' (the self as composer of one's own psychic soundtrack), 'Mr Moss Side Gory' and 'Harry Pendulum' – swinging between the roles of the cartoon cop and the pantomime gangster, touched by the vernacular of northern comedy and attempting to solve an oxy-moronic crime in which the only culprit can be Adamson's own sense of difference. Within this passing through roles in a film noir of the self, the walls of the mind begin to collapse; perceptive cer-tainty is lost, in a manner akin to the baroque complexities of plot in Howard Hawks's film *The Big Sleep* – of which even its author, Raymond Chandler, claimed he did not know 'who done it'.

The identity that Adamson has composed for himself on his solo records, from *Moss Side Story* to the critically acclaimed *Oedipus Schmoedipus*, with its guest appearances by Jarvis Cocker and Nick Cave, has been hard won as a process of reinvention in the wake of his vital roles in Howard Devoto's group Magazine, and Nick Cave's *The Birthday Party* and *Bad Seeds*. As a self-taught musician, who bought a two-stringed second-hand bass guitar and two extra strings, learning to play through the vibration of the neck on a wooden bedhead during the night before his audition for Magazine, Adamson was first Bootsy Collins to Howard Devoto's James Brown, and later the crucial architect for the echoing, swamp-fevered soundscapes of Nick Cave's terrifying rituals of self-hatred. As Cave acted out his own tragedy of heroin addiction and obsessive relationship to Anita Lane, so Adamson, no session player or second fiddle, discovered his own need to escape from the destructive psychosis that Cave's enacted drama had bred, and star in his own imaginary movie. His first single, released in 1988, was a reinvention of Elmer Bernstein's 'The Man with the Golden Arm'.

From the beginnings of this solo career, Adamson's project has mingled the sonic ambience of the TV tele-dramas that he appropriated as a child, with the desperado gothicism of early Alice Cooper – whose 'Halo of Flies' on *Killer* seems to rehearse much of the Adamson aesthetic. But this formula of formative influences was set in motion by a literary and cinematic turn of mind that provided a narrative framework, as he proclaims on *Soul Murder*, to be 'steering the wheels of this tired old jalopy onward and upward into desire'. The voice of Adamson's music, whether sung, spoken or articulated through musical composition, is the voice of Chandler's Philip Marlowe or his black equivalent, Easy Rawlins, created in Walter Mosley's contemporary crime novels of 1940s Los Angeles.

Rawlins, in particular, parallels Adamson's musical alter ego as the mordant-humoured black man in a white underworld; indeed,

for both Adamson and Rawlins the term 'black comedy' becomes a racial pun upon itself. Their characters are less concerned with the morality of crime-busting than their own safe passage – itself a journey of self-discovery – through an urban labyrinth where double identity, convoluted twists of fear and smiling treachery look on at the amoral and the absurd.

When Easy Rawlins gets caught in the maze of mayhem around the whit gangster Mr DeWitt Albright, he wakes with night sweats of dread and a yearning for the comfort of a woman, in which the desire for a lover is ambiguously linked to the infantilist or Oedipal longing for his mother: 'I woke up sweating in the middle of the night. Every sound I heard was someone coming after me. Either it was the police or DeWitt Albright or Frank Green. I couldn't throw off the smell of blood that I'd picked up in Richard's room . . . I was shivering but I wasn't cold. And I wanted to run to my mother or someone to love me, but then I imagined Frank Green pulling me from a loving woman's arms; he had his knife poised to press into my heart.'

Such a mixture of fear, desire and the sense of abandonment is also central to Adamson's *Oedipus Schmoedipus*, with its musical interpretation of the distance between love and lust, and its revealing inner sleeve of artwork of the Virgin Mary, a nude pin-up starlet and a colour-tinted, archaic photograph of a benign maternal woman. But the sound of *Oedipus Schmoedipus* continues to foreground tension, even within its more soulful arrangements, and the work as a whole – completing the trilogy comprised of *Moss Side Story* and *Soul Murder* – seems to investigate further the ambiguity of desire and the inevitability of alienation. Jarvis Cocker's vocal on 'Set the Controls for the Heart of the Pelvis' delivers the lyric, 'Save me from these glossy photographs; save me from my mother's laugh', while Nick Cave's co-authorship and Scott Walkeresque rendition of 'The Sweetest Embrace' concludes with the paradox: 'I just don't want you no more, and that's the sweetest embrace of all.'

Above all, Adamson's music articulates the moment of apprehension – the turn in the poorly lit corridor, the door to the room that might not have a floor. And as such he has remained faithful to his formative experience of eerily glamorous or fantastical teledramas, identifying within his own experience the transplanted ethos of fugitives, secret agents and alien infiltrators. Only the emotional status of these fictional ciphers has been up-graded to describe the no man's lands of gender and sexuality, where nerves – in keeping with Chandleresque scepticism, snap more easily than pencils.

It is small wonder that Adamson has recently enjoyed the supremely ironic triumph of being asked to score the additional music for David Lynch's forthcoming film, *Lost Highway*. Now completed, these pieces mark an inspired partnership between two great anatomists of anxiety; Adamson and Lynch both play in an emotional fourth dimension where fear and comedy combine to shed light into the oubliettes of human frailty. Their mutual project is the fateful constitution of curiosity. Adamson, however, has been a veteran traveller on his own lost highway, which stretches all the way back to Moss Side.

Morrissey

As a lyricist, singer and performer, Morrissey has created a mythology that is unrivalled in popular music. In fact, you have to go back to the legends of American cinema or British theatre to find an artist whose creative identity – whose public presentation of himself – is so sealed within one particular sense of constancy. Examples would be Noel Coward, or Montgomery Clift. And, increasingly, when one thinks about the conversion of Morrissey as a pop star into an entire cultural brand, it is tempting to make comparisons with Andy Warhol.

The early 1990s saw Morrissey selling out US stadium venues

faster than the Beatles. They saw Bill Cosby, on the red-blooded Johnny Carson show, having to use his spot as lead guest to entertain an audience of fans who had come to the show solely to see Morrissey perform two numbers. Cosby was saying, 'Morrissey says you have to pay attention to me . . .' Needless to say, Morrissey himself chose not to be interviewed.

But the late 1990s saw Morrissey wrap his seclusion around himself – living in Los Angeles, refusing to join in, becoming the stuff of probing biography – Salingeresque, perhaps. Morrissey's withdrawal from the main stage of music seemed to shine a bright light on all that had become torpid and uninteresting about modern pop – the tyranny of pre-teen dance acts and sludge-thick guitar rock; the perkily over-sexed and the boorishly lad-mag-friendly. When Morrissey appeared live in New York, the NYC *Time Out* called it a 'rarer than sushi' performance; in the UK, even his fiercest critics used the event to point out that music now lacked all those qualities Morrissey had embodied: wit, glamour, muscle and meaning, all on one stage. Popular culture in the Nineties, it could be said, saw its own reflection in the increasingly Warholesque surface of Morrissey's image.

The world of rock and popular music has had ample time to grow bored of stars who pose as outsiders or rebels, yet conform wholeheartedly to whatever format of behaviour will most benefit their careers. In the case of Morrissey, however, he has summed up his own position in an interview with *The Times* – 'I don't have another life. I don't exist as another person, somewhere else, doing something else with other people. There is no other me. There is no clocking off.'

From the days of his earliest recordings with the Smiths, there has been a refusal to compromise with either sentiment or sensibility in Morrissey's writing and performance. As a consequence of this, he is one of the very few pop lyricists whose writing is judged by the highest standards of contemporary literature – a feat unrivalled since Dylan and the Beatles – thus prompting the

journalist Paul Morley to say (with reference to Britain's most prestigious literary award), 'You could swap every winner of the Booker Prize for one song by Morrissey.'

This is a grand claim, and one that might be written off as mere journalistic hyperbole were it not for the evidence of the sheer extent of praise and interest in Morrissey as a cultural practitioner. In many ways, Morrissey represents what is known in modern European philosophy as 'the will to self-create'; another term for this would be 'auto-fact'. What both of these mean is the ability within individuals to realize themselves as a mythology: people who embody an entire perception of life, made articulate by a precise and utterly original combination of resources and inspiration.

One day there will most probably be a Faculty of Morrissey Studies in more than one distinguished seat of learning. And, more than probably, Morrissey himself will make especially sure that he has nothing whatsoever to do with the proceedings of their research. And this is precisely because of Morrissey's own understanding of both the anatomy of glamour (which refers us to Warhol once again) and, more importantly, the importance of mystery and elusiveness within his own creative spirit. For Morrissey suddenly to turn around and make himself the amiable interviewee on a thousand chat shows and as many newspaper supplements, or personally pass comment on some doctoral thesis that includes an assessment of his writing, would be nothing less than an abnegation of all that he has achieved.

Once again, if such a claim for Morrissey's importance as an artist seems overstated, we need only look at that first test of contemporary cultural significance – an individual artist's ability to influence other media. At the moment, in the UK and America, Morrissey occupies a position unrivalled in terms of its represen-tation of an attitude. Unlike mainstream pop performers – from Eminem to Oasis – who can be seen, in their different ways, simply to up-date traditional rebellion within rock culture (for

Eminem think Alice Cooper, for Oasis think the Who), Morrissey has actually created an emblem of opposition – you could call it a confrontational stance – which is greater than his own collected works.

This can be seen in the way he has been appropriated as a cultural brand: the Canadian novelist Doug Coupland, for example, wrote his best-selling fourth novel under the title of a song written by Morrissey, 'Girlfriend in a Coma'; likewise in Britain an entire generation of contemporary visual artists have made reference to Morrissey's writing and performance in their paintings, installations and videos. Indeed, two of the artists short-listed for the Turner Prize, Glenn Brown and Douglas Gordon, have made works inspired by and named after Morrissey songs, which have subsequently been sold to major museum collections. Thus, without raising so much as an eyebrow, Morrissey has created himself through popular music into an actual, fluid aspect of contemporary culture. The painter George Shaw even made a performance piece entitled 'Morrissey versus Francis Bacon'.

Once again, one can guess that Morrissey himself would make no comment or journey to assess the weight of his recordings and legend upon the broader waveband of contemporary culture. If we look back to his days with the Smiths, we can see the beginnings – the laying of strong foundations – of Morrissey's own sense of his relationship with both the world, and, you suspect, the celebrity which he knew would attend his contributions.

Early video footage of the Smiths surviving an ecstatic audience in Durham, northern England, for example, shows Morrissey making the simple pronouncement to the crowd, 'The eyes of the world are upon you.' In a swift reversal of syntax and semantics that is so deft and so neat you hardly spot it, Morrissey has made a statement about his own entrance into the mythology of popular culture, by addressing not himself but his audience.

The conflation of opposites and the use of paradox is a funda-mental aspect of Morrissey's writing. He shares, with writers as

117

different as Henry James and Alan Bennett, a supreme under-
standing of concealed wit and barbed praise. He also shares with
those writers a precise understanding of vernacular – and in
Morrissey's case this understanding is revealed as a brilliance at
using the language of his subject matter as a weapon against itself.
Like James could write with the stifling formalism of Bostonian
drawing-room manners, so Morrissey, anticipating his own Anglo-
Irish background in a northern English city, can hoax with idio-
matic phrasing, 'Make no mistake my friend your pointless life
will end,' he proclaims on 'Sing Your Life', and then offers faux
consolation in the rejoinder, 'You have a lovely singing voice . . .'
It is typical of the dynamics of a Morrissey song that the narrator
of its story (Morrissey himself? Unlikely, but possible) is cast as
either a comic victim of fate, or so far from the main current of
acceptance or sociability that all they can do is observe the ebbing
of the tide. Thinking back to 'Sing Your Life', you feel that the
addressee of the song's sense is in the position of the unmarried
daughter in James's novella *Washington Square* – summing up her
achievements in a sentence of such cruelty it seems unlikely she
would ever crawl out from underneath it, her father says: 'You
embroider. Neatly.' To which, in The World of Morrissey, we
might think, 'When your profession is humiliation . . .'

In terms of the gradual accretion of mythology around
Morrissey, both his songwriting and performance play endless,
self-referring games with the idea of region and territory. One
might think of Jean Genet's relationship with the Arab culture of
north Africa, or Hemingway's obsession with Spain. In merely
chronological terms, you can see how Morrissey's act of self-
creation has made use of the geography and culture of both
Manchester and London; he takes the existing histories of these
cities, and reworks them as theatres for the presentation of his
own emotions, or the characters to whom he sub-contracts those
emotions.

Certain of these lines then weave their ways into the broader

canvas of culture. At the time of writing these notes, for example, there is the supreme irony of a gleaming post-modern shopping complex in the heart of Manchester's rebuilt city centre displaying a slogan lifted from a song by Morrissey about the Moors child murderers, 'Manchester – so much to answer for'; while other early lines such as 'A rented room in Whalley Range', or 'Panic on the streets of London', have become recognizable as cultural catchphrase.

In his later references to London, there is a wider sense in which Morrissey allows the local to become the universal (in terms of truth, suffering and feeling), which also, by extension, recasts the account of his own condition as somehow representative of a sign of the times. For Morrissey, the mythology of London provided a new cast and a new stage, fixating on the skinhead culture which sociologist Dick Hebdige summed up as 'a race stricken Jobs, modern wanderers cast into a cheerless world'. Linked to Morrissey's poetics around the whole idea of the failed or failing boxer, his explorations into skinhead culture were also exercises in nostalgia for a vanished society – namely, the indigenous working-class culture of Britain, such as he had also described through his appropriation of English 'kitchen-sink' cinema in relation to the northern cities. Those with an eye for detail might like to look up Peter Ackroyd's account, in his *London: The Biography*, of a quasi-supernatural cut-throat called 'Spring-heeled Jack', and compare it to Morrissey's song 'Spring-Heeled Jim'. The real point of this comparison comes from the fact that Morrissey wrote and recorded his song a whole five years before Ackroyd published his book. It might be a mere coincidence, or, equally, it might prove Morrissey's supreme eclectism and diligence in terms of researching the inspiration of his own writing.

As a writer, Morrissey creates love affairs with a succession of characters who are as much types as personalities. And the love involved itself is far from simple – coming close, in fact, to mirroring the 'love' his fanatical audiences have always turned into joyous

ritual at his concerts. (Again, these observations are proven as fact rather than hyperbole: the photo and film documentation of Morrissey's live concerts show a phenomenon unrivalled in popular music; even the notorious 'boy-bands' with their adoring pre-teen audiences come nowhere close to the collective triumphalism of a Morrissey show. What is being experienced is an act of mutual identification, based on Morrissey's presentation of himself as a living contradiction – terminally romantic yet hopelessly unlovable. Try that on for size.)

Similarly, the elected 'cast' in Morrissey's writings – the skinhead, the hapless hitch-hiker, the suburban misfit, the petty criminal, the failing boxer – are all refracted through a voice and a performance that is entirely and utterly one hundred per cent Heroic. Here again, therefore, is Morrissey's extraordinary understanding of the artistic power of paradox: if you describe alienation in the voice of the conquering hero ('Maladjusted, maladjusted!') or the comedy of hopelessness in the soaring refrain of a love song ('Patrick Doonan raised to wait, I tried again, I'm tired again') you create a dynamic of romanticism that triggers immediate empathy through a comic reversal of comedy itself.

This latest compilation of recordings by Morrisey demonstrates not simply the artistic and musical achievement of his songwriting, but also describes the landscape of his own mythology. In many ways, Morrissey's best songs define the consolation of a harsh place; that within the stifling oppression of loneliness or exile there can be the back-handed gift of insight, and that through the struggles of love to triumph there you can find the grace of self-knowledge.

<div align="center">◄◦►</div>

. . . the Chaos Theory scientist in the black leather jacket, appalled by the prospect of cloning from suspended DNA, knowing you can't hatch safe dinosaurs, says, 'Nature will still find a way . . .'

And there goes the sun-roof! Crushed like paper. Steam of hot breath – litres of it – snorted out like air breaks, on the windows of the gleaming 4×4. One glinting eye the size of a tennis ball, pressed up close! And in the back, very still . . .

■ ■ ■ THREE

Exquisite: The Gentrification of the Avant-garde

. . . back to New York.

A ridge of blackened snow ran down the centre of Fifth Avenue, mean and dirty-looking in the freezing cold. High overhead there were bright blue skies, but the low winter sun put the street into shadow.

Earlier, waking in a small, white room (a matt white, like chalk dust) at the Paramount Hotel on West 46th Street, where the staring, slightly bovine face of Vermeer's 'Lacemaker' was silk-screened on to the headboard of the low square bed, and the perfume from the neroli-scented candles in the lobby – like the smell inside an Italian church – had been carried up in the lifts (along with the comforting aroma of the warm cinnamon dough-nuts from the in-house Dean & Deluca deli) it had seemed as though you were cocooned from all of the city's discomfort, hostil-ity or craziness – from bad taste and vulgarity, even: a womb with a view of rooftop water butts and fifty-storey office blocks.

In the middle distance, watched through the angled white slats of the blind, steam had drifted from a cooling duct, slow and silent. Rising on a thermal current of warm air, it was turned by a reflection of the sun off mirror glass into saffron mist – a late Turner oil of Venice, up-dated to the West Fifties.

Of course, you were starring in your own video; and this elegant retreat, caressing you with hidden hands, translated the volatile bustle of mid-town Manhattan into scenes of sleak, minimalist poetry, in which your best idea of yourself was instantly framed by the imagery and syntax. How thrilling to be safe and pampered and steeped in glamour, tethered to luxury by a golden thread when you set out to explore the city just beyond the heavy double sets of glass swing doors.

This was the Lifestyle, rather than the Life. The parallel universe of a costly few days in the style – the clichés, even – of a high-gloss magazine article; where attention to detail – the cinnamon doughnuts, the neroli candles, the long-stemmed crimson roses posted into slots in a wall of polished grey marble (bringing to mind the tomb of Marilyn Monroe), the Philippe Starck staircase like the ceremonial centrepiece of an expressionist mise en scène (as though a hunk off the side of a German frigate from the 1920s were flanking the broad flight of steps that narrowed as they ascended, throwing out your sense of proportion) – conjured up ambience like home-cooked loganberry jam, delivering this cloister-dim refuge from a duller or more dangerous world, extravagant, expensive, theatrical and cosy. And we, the guests, like excited children let loose in a prosperous department store at Christmas: Bergdorf Goodman by way of the Emerald City of Oz; they could even dye your eyes to match your gown – jolly old town!

Throughout the 1990s, a vivid strain of infantilism had entered the current of contemporary culture, its presence as bright and alluring as the stripe of chemical flavour in a block of raspberry ripple ice cream. It seemed to begin as an act of recoil, bang on cue, some time around the Black Monday stockmarket crash of 1987, with a yearning for small, comforting things: reassuring little treats from the August of childhood or the springtime of adolescence. From guilt, necessity or neurasthenia, it seemed as though we needed to comfort ourselves. A little while later, we

would start to sweeten the sharp, bitter taste of culture's equivalent of absinthe – the underground, the margins, the extreme and the radical – and, in making those more potent draughts more palatable, somehow rob them of their punch.

Dumbing Up

Back in the 1980s, when television adverts for personal financial services would feature grim, hawk-faced yuppies who could walk through the walls of their loft conversions in order to prove that they controlled their cash, the idea of linking the modern adult lifestyle to a nostalgia for childhood was out of the frame. Now, since the designer consciousness of the late 1980s has given way to the quest for spiritual hygiene and social responsibility that pumps the heart of New Labour's New Britain, the nurturing of our inner child by any means possible has achieved a new fashionableness – at the expense, perhaps, of our inner adult. In their search to counter the chaos of post-modern stresses and strains, it would seem as though a whole generation of consumers have toddled into early middle age with the infantilist reflex to surround themselves with small, safe and simple things that remind them of their childhood – toys are us.

Over in Europe – where France's contribution to the cultural upheaval of punk rock had been a minor cult hit from the aptly titled 'Stinky Toys' – there was a powdery scent of the metropolitan adult's desire to down-size in the arrival, in the early 1990s, of Renault's little runabout, the 'Twingo'. As a means of personal transport, the Twingo was not so much a car as a pod on four small wheels, with every straight line in its design carefully rounded to a nice smooth edge upon which it was impossible for either the driver or passengers to hurt themselves.

Available in a range of pastel shades, with an interior styling which brought to mind the Early Learning Centre, the Twingo

took the concept of inner-city driving – the need for something nippy and zippy for popping to les magasins – and replaced the urban chic of the sporty Peugeot with the child-like requirement for a kind of cartoon car, which denied the paranoia of big-city living by suggesting Toy Town in its very shape and name. After all, to the uninitiated, a Twingo sounded like a bar of chocolate.

Given that the Twingo was never launched in the UK, and that a case could be made for it simply continuing the line of European fun cars that kicked off with the Volkswagen Beetle, one could have been forgiven for assuming that its statement about adult regression was simply a one-off squeak in the zeitgeist. But the idea that some adults were responding to the economic insecurity of life in the 1990s by going for small in their choice of runabout has been maintained in the recent widespread advertising campaign for the equally dinky Fiat Seicento.

In a nifty montage of films to convey the sense of past and present, the television advert for Fiat begins with a bored little girl – presumably in the 1970s – being told by her carefully retro-styled teacher that she would do herself a favour by paying attention in class. Indurate to this common sense, our goldie-locked heroine sprints from the prison of school, to emerge on a contemporary city street at the wheel of her tiny Fiat Seicento. We can tell by the futuristic urban environment that the little girl has grown up to be a successful, carefree metropolitan adult, but rather than conveying her status in a sexed-up sports saloon car – or even on an eco-friendly bicycle – she is enjoying Fiat's product slogan to 'be small again'. Hip to her inner child, Miss Fiat runs home from the adult school of the working day in a Twingoist pod. And the only fly in the ideological ointment of this advert would seem to be that it still has to be a woman who exemplifies the joys of a little runabout, rather than a man.

But before anyone suggests that one advert does not a trend make, it should be recalled that the mighty Volkswagen image of tough reliability – remember the advert where they dropped a

Volkswagen off a crane to prove how tough it was? – has been replaced by an advertising campaign in which people in terrifying situations are shown curling up into the foetal position. Once again, the commentary of the advert reminds us that our response to fear is an instinctive attempt to make ourselves small. This advert, with its sourcing of pseudo-current affairs imagery, from a street demonstrator being truncheoned to a person ducking a back-draught fireball, suggests that our response to the hostile adult world must be to regress. For Volkswagen, this is a neat reversal of their award-winning advert of the late 1980s, in which a vulnerable, pre-Raphaelite little girl on a New York street full of crazy people and screaming cops, is ushered to the safety of daddy's VW to the soundtrack of 'Bless the Child'. More recently, Hyundai have cut out the advertising narrative and gone straight to the point: 'Baby Hyundai'.

The American trend analyst Faith Popcorn has identified this current drift towards designer infantilism in a pair of catchy catchphrases. She described the adult desire to snuggle up in a comforting lifestyle as 'cocooning', and then marked an advance on this wholesale return to a state of rediscovered innocence by suggesting the new response of 'Pleasure Revenge'. Taken as a brace of social symptoms, 'cocooning' can be seen as the adult consumer's return to the security of childhood, and 'Pleasure Revenge' as the child's lashing out against constraint by being naughty. In other words, having constructed our simple, health-conscious and innocent adult cocoons, we suddenly break down from the boredom of it all and eat a load of chocolate, smoke a packet of fags and get blind drunk. Which is a state of 'naughty but nice' that can be seen in the phenomenal success of Helen Fielding's *Bridget Jones's Diary*, as a portrait of a young urban woman who is comically caught between her conscience and her desires.

A generational response to the problems of growing up in a society that is presumed to be increasingly complex and dangerous

has been to treat the perks of childhood – fizzy pop, cartoons, taste treats, sweets, funny socks and toys – as a source of inspiration for its own amusement, and, some people might argue, its own displacement therapy. In domestic terms, one can see how the classic post-modern design statement of the Alessi kettle – an assemblage of industrial reference points and a little red bird in flight to stopper the spout – has 'childed down' to that same designer's chirpy range of kitchen knick-knacks, all of which are brightly coloured and knowingly coy. The infantilist's revenge against matt black and brushed steel, the 'cartoon kitchen' has also been enhanced by a vogue for retro-kitsch that sources from the childhood and early adolescence of current thirtysomethings, and reveals itself in such accessories as adult fridge magnets (for pin-ups or poetry), soap that smells of bubblegum, collections of Japanese robots and Thunderbirds models that double as pop-cultural antiques. All of which can be enjoyed while swigging down a bottle of alcoholic raspberryade. The claret and stilton, in many an adult household, has been replaced by alcopops and butterscotch popcorn.

There is an inevitable strand of irony running through the adult desire for the cartoon world of childhood. As grown men queue up at the Disney Store to buy Mickey Mouse boxer shorts or a Buzz Lightyear coffee mug, one can see how even the most conservative form of entertainment on the planet, Disney, has achieved a genius for making animated films that can entertain adults and children on entirely different levels. Partly a hook to get the kids into the cinema, this simultaneous translation of children's cinema into adult humour has provided some of the supreme moments of modern camp. In *Toy Story*, for example, the acerbic Mr Potato Head had only to rearrange his movable features down one side of his face and shout, 'Hey look everybody! I'm Picasso!'

Children's products and entertainments can be equivalently 'dumbed up' to an adult level. Beginning with the rise to power

of *Viz* comic, in the late 1980s, the appropriation of cartoons by adults, to serve as both a satire and an easily digestible form of entertainment – you could call it visual comfort food – has been demonstrated in the new wave of American cartoons that have acquired a cult audience in the UK. As *RugRats* is both popular entertainment for children and a comedy of recognition for adults, so the solely adult cartoons such as *King of the Hill* and *South Park* are deriving much of their comic power from the serving up of a traditionally children's form of entertainment as a kind of last gasp of punk nihilism for adults who grew up with the Sex Pistols and the Ramones.

Foul-mouthed, surreal and championing anti-social outsider-dom, these adult cartoons allow us to laugh at our own rage at the adult predicament. From Eric Cartman, on *South Park*, telling his celebrity-trivia-obsessed gay teacher Mr Garrison that he hasn't been given an anal probe by visiting aliens, to the red-neck attitudes of Hank Hill, in which pregnant women colleagues are referred to as 'disabled'; there is an anti-political correctness edge to these cartoons, which one feels is taking Faith Popcorn's notion of 'Pleasure Revenge' as a form of ideological catharsis. Under the disguise of a cartoon world – rather like the medieval literary disguise of a politically satirical 'dream' poem – adults can say what they feel and get away with it. Serviced by adult cartoons, alcoholic pop, grown-up toys and pod-shaped cars, the traditional nostalgia for childhood can now be replaced by something infinitely more appealing – the chance to have another one on your own terms.

At Dean & Deluca, the almond syrup in the cafe latte grande was sweet but not too sweet, chosen from a list that included – beyond the hunched shoulders and pristine, fresh-from-the-shrink-wrap paper cap of our boy-band handsome barrista (the gentrification

of the Gaggia operator) – vanilla, hazelnut and . . . *fraise des bois*; you could see its luscious swirl in the foamed milk, silvery and sugary, hinting at butterscotch but then – inhale! – that little back curve of almondy sophistication. Sweet warm milk and a Seville orange with Morello cherries lo-fat hi-bran (can't be too careful these days) muffin; while outside, freezing February made a brief bright tunnel of daylight between mid-morning and mid-afternoon. Imagine the cold on your face; imagine not having this sweet, warm milk. Imagine no possessions.

Yoko Ono 1996 (extracts)

Security at the Dakota building, where Yoko Ono lives on Central Park West, is so tight that you hardly know it's there. Pulling up at the enshrined but unmarked spot where her husband John Lennon was murdered in 1980, you are met by a liveried doorman whose bland friendliness puts you in mind of the imperturbable sagacity of the policemen on duty outside Buckingham Palace.

This makes perfect sense, because if America has a royal family, comprising the exceptionally wealthy, then they probably live in the Dakota. You just have time to glimpse the heavily Gothic edifice of lintelled windows and sharp-gabled casements (as though conceived by Tim Burton for his *Batman* films), a mono-lithic arch leading through to a dim quadrangle (the White Witch's palace) and then, if your name checks out, you are suddenly beyond the simple sign that says 'No Unauthorized People Beyond This Point' and standing in a tiny ante-chamber whose doors are suggestive of tungsten kick-locks and bullet-proof glass. You get the feeling, in fact, that you've been a dot on somebody's radar since the moment your cab pulled up.

Once inside, you are faced with a labyrinth of empty, high-ceilinged corridors. This is where John and Yoko's original Studio One can be found, now occupied by Yoko's office staff. Studio One

is the only non-residential suite of rooms in the Dakota, protected as such under the terms of the Lennons' original lease. As you make your way from Studio One to the small panelled lift that takes you up to Yoko's private apartments, you feel that you could be in some uncharted region of the Natural History Museum. There is the ponderous silence of Old Money, and the air is rich with the dense, institutional smell of wax floor polish. A nineteenth-century barometer of the type that Henry James might have tapped hangs on the wall. This feels like the Old New York of the Carnegies and the Stuyvesants and the Morgans – the kind of people that Andy Warhol and F. Scott Fitzgerald found so endlessly fascinating.

When Yoko opens her front door (a heavily polished mahogany affair, on the scale of something from Blenheim Palace) she seems as petite and unobtrusive as her setting is imperial and pro-nounced. She is dressed in a black pullover and black leggings; her feet are bare. In the embarrassed confusion of greeting, she gives off warmth, suspicion and faint boredom in more or less equal parts. She moves with the faintly cramped gestures of a person who has had the eyes of the world on her for too long.

This being a Japanese household, you leave your shoes by the door. A pair of glittering ruby-red pumps and a pair of old black boots are already lying there. Your eye is caught by a flotilla of sculpted cats, Egyptian in their inscrutability, that are a piece by Yoko called 'Bastet'. There used to be just one of these cats, looking down from the windows of the white drawing room across the hall into Strawberry Fields in Central Park. After a moment in the white drawing room – and look, there's John's white piano from the 'Imagine' recordings – perched on the edge of vast white sofas, aware of a Warhol here and a Haring there, we go into the big sunny kitchen.

Marble and modern art give way to brick-red sofas and directors' chairs. A small sculpture of a revolver with a knotted barrel stands high on the shelves where the DAT, CD and widescreen TV are

housed. And there, framed by a window that is filled with winter sunshine, Yoko begins: 'Is it going to be "Why did you break up the Beatles?"' There is a note of resignation in her voice . . .

Arguably, Yoko Ono is one of the most famous women in the world. She's famous for being John Lennon's widow, famous for being a strident feminist, famous for being a misunderstood artist, famous for things she never even did. Her fame is organic. But most of all, for some reason, she has become a psychic lightning conductor for other people's hostility. Which, arguably, is the fate of the true rebel.

But Yoko, without stretching the point too far, can also be seen as suffering on behalf of all women artists. From her partnership in peace protests with her male rock-star husband, through to the radical experiments in her solo albums such as *Fly* and *Approximately Infinite Universe*, she has stood for a feminism that people try to disregard. And, in the way that bigotry permits (Britain's rejection and ridicule of Yoko was partly a racist reflex against a Japanese intellectual pinching one of our lovable Mop Tops) it has become almost impossible for her to get a fair hearing – despite or because of her fame and wealth. *Rising*, her new album, may suffer from this same prejudice.

'When John and I got together and it seemed as though if we coughed they were going to write about it, I thought that it was sad that space in the newspaper should be used for something like that when we should be commenting on what's happening in the world. So I thought it was a great idea to do something. But even before that, before I met John, I was in a bag in Trafalgar Square using the press for peace. Bed In was a natural result of that.

'I was brought up to think Van Gogh was great; all the artists I admire, like Kafka, were fringe artists in their lifetime. I always thought that if you're a true artist you're only going to be appreciated after you go. They were all persecuted in one way or another. So my challenge is a bit strange. That was another thing in the

early Sixties; I'd be doing a gallery show of my paintings and they'd say, "Oh, she's a composer – they're the dabblings of a composer." And then if I did a music concert they'd say, "Oh, she's just a painter." So that's another challenge. I just have to be myself, and being myself is creating in different media without censoring myself; I'm a Jack of all trades ... Which is not a good label, and I know it's not supposed to be effective professionally, but that's OK.'

Yoko was born in 1933 of a Buddhist mother and a Christian father, and, while she and John were famous for repudiating organized religion and politics, there is a creed within Yoko's personal philosophy that seems to echo both Christianity and Buddhism: 'In a way, none of us can be truly happy unless all the sadness and destruction in the world is healed. Why should the world hate so much when it's just two people in love? One unhappy person can destroy your life.'

Having survived the war in Japan, Yoko arrived in New York at a time in the early Sixties when the neo-Dadaist art movement, Fluxus, was just beginning to grow out of a group of disaffected avant-garde artists. Yoko held performances in her loft in Chambers Street, with collaborators such as John Cage and La Monte Young. This was a scene that would bleed directly into Warhol's Factory; it would also inform the work of composers such as Laurie Anderson and Philip Glass. As such, Fluxus was more important as a catalyst than a group, and its ethos was more a shared attitude than a formal school of thought. Yoko, however, was to find herself an outsider even in this group of outsiders.

'Because of the audience being friends it was such an in-scene, you know? And that was simply because nobody else was interested in it, probably. So, yes, they liked what we did there, but at the same time, me being a woman and also an Oriental, there was a certain stigma attached to that. So basically it was not what I did that was accepted, even in the avant-garde world ... I think there was a kind of chauvinistic attitude from the male artists

maybe. But then again, among the male artists they all had a very combative attitude. I did some performance, but I didn't get much response. The Chambers Street series itself was very successful though, in the sense that they started off with twenty-five people coming to see it and then it went up to 200 people – which wasn't bad in a loft. And I think these were the first loft concerts in New York and then it became kind of fashionable . . .'

The point of Fluxus was to suggest creative anarchy by using absurd or light-hearted aesthetics; punk in its sympathy with DIY culture, Fluxus offered a creative home to artists such as Yoko who wanted to make conceptual or minimalist statements about the mysticism of art and existence. A world away from the macho studios of abstract expressionism, or the buzzing salons of apprentice pop artists, Fluxus, for Yoko, was an accidentally acquired creative environment in which she could rehearse her notions of nature and feminism. Prophetically, in 'Wall Piece for Orchestra' (1962) she knelt on a stage and repeatedly banged her head upon the floor. Humour, in Fluxus, could often be the vehicle for protest.

'The Chambers Street series started before Fluxus. George Macunias – the major co-ordinator of Fluxus – came to one of the concerts and that's where he got the idea of getting a gallery in mid-town. I think they called my work "too dramatic", because in those days, in the New York art scene, you weren't supposed to be too animated. Basically, when John and I found each other it wasn't because of what he was or what I was but because of this rebellious streak in both of us. And even in the avant-garde I was rebellious about it all. It's not just being a woman. If you're a good girl, so to speak, and kind of following the tradition of the avant-garde and using their vocabulary, then I think they'll allow you to exist. So that's why I don't really know if it was the woman in me that offended them – it's all a mixture of things; but women, especially, are not supposed to rebel. I mean it's "How dare you!" or "You should just be with us!", reflecting their ways . . .'

One of Yoko's most eloquent performances, prior to her meeting John Lennon, was a piece performed at Carnegie Hall in 1964 called 'Cut'. In this work, Yoko ventriloquized the specifically Oriental image of passive femininity by kneeling motionless on the stage while members of the audience were invited to cut off her clothes with a pair of scissors. It was works such as these that marked her out for recognition, even at that stage in the Women's Movement, as an articulate and forceful figure.

The process of labelling Yoko, which turned into demonization when she met John Lennon, was already well under way. Yoko has always tried to ignore hostile readings of her work while believing that they carry prophetic messages for her. Whether one sees this process as occult – Albert Goldman, in his infamous biography of John Lennon, saw the couple as involved in negative forms of magic – or psychologically astute, is of less importance than the way in which this system of belief has informed Yoko's whole outlook.

'If you even think about something in the corner of the world, that affects the whole world – just thinking about it! Or writing something and putting it in a drawer – you'll find your thought fulfilled. So, talking of answered prayers, you have to be very careful what you ask for; thought-form is a very strong power.

'For me it can work like magic. My previous marriage was falling apart and I did a show in the Lisson Gallery called "Half the Wind". There was a room full of everything halved; the bed was halved and the chair was halved; it was making a point that every-thing visible is just the tip of the iceberg and we don't really know the other half. And I had kept the other half of the space empty, and John, of course, immediately filled it. That is my life story: what I create affects my life immediately, for some reason. And I started to see that more and more. Sometimes it works in a negative way; for instance, I wrote a song called "Walking on Thin Ice", and since then I was walking on thin ice, because right after that John passed away. So I thought, I have to write a song called "Standing on Firm Ground" or something.

'So when I make music or artworks I'm not really in control, because I'm just passing on messages in my mind. And sometimes I get frightened because I think, "What did I say?" But you know the "Yes" painting? It's a ceiling painting and you have to climb up a ladder to read it with a magnifying glass, and it says "Yes". I never knew that I was saying "Yes" to John; John, of course, took it like it was a message for him, and it was.'

'I think that the power of journalism is incredible, and that in those days I was an easy target and a scapegoat; they just wrote about me in a very unflattering way. They did it to John, too. But you get used to that, and people get to think, "She's just a punch bag." I was the safest bet. Also, it's very interesting to make a woman into a kind of evil person who has strong evil powers or something. It's a dichotomy in a way in their minds – a strength even. It's a very interesting twist, and that's what people loved about it.'

Photographs from the late Sixties and early Seventies show John and Yoko at the height of their Hair Peace protests – a kind of new, bolshy Adam and Eve in a far from peaceful Eden. Lennon's piercing stare was the perfect blueprint for every antagonism between father and son, while Yoko's constant presence showed either a screaming performance artist or an unknowable feminist. She wasn't from Essex or Texas; she wrote songs with titles like 'What a Bastard the World is' or 'I Felt Like Smashing My Face in a Clear Glass Window'; most of all, she was always with John, thus depriving the world of their ownership of the Beatles.

Sooner or later, Yoko was accused of everything, from being unattractive to being some kind of Red infiltrator of wholesome entertainment. It was rumoured that she had considerable finan- cial clout, and that all of John and Yoko's talk about peace and charity was hypocritical in the light of the millions they were

somehow spiriting out of Apple. But as their former assistant Anthony Fawcett records, in his biography of John and Yoko's relationship, the couple were losing £20,000 a week to hippy freeloaders, primarily because they were trying to back up their promise to support struggling artists who had radical projects.

'The hippy movement was shot down by many factors, but drugs – naïvely taking drugs – was a big factor. The hippy movement seemed like a worldwide movement in concept, but still the establishment was bigger. The only criticism I have of that movement was that, although we were talking about freedom, women still got a very raw deal. It was a very chauvinistic revolution.'

. . . Yoko remains a controversial figure, marginalized as an artist. Opposed at nearly every turn by her wealth or her fame, it is difficult for her to get an unbiased interpretation of her work.

'Just recently, I did a whole art show, called "The Family Album" – meaning family of man or human race. But I had all these blood objects; there were high-heeled shoes with blood running, and a hairbrush with blood and so on. It was all putting a case about abused women and children, and I thought, well, men suffer from this too and I have to make a piece that shows men as victims of violence. So I did a jean shirt with gunshot wounds and blood coming out. And somebody started writing that "the Black Widow is selling John's blood-stained shirt", and that really hurt. They didn't really appreciate the show as an entity; it became a scandal, and of course I wasn't selling John's shirt . . .'

Yoko Ono (1999) (extract)

'I really think that we will have world peace, to the point where "peace" won't be used as a word any more, because it will just be the normal situation. There are really only two industries in the world: the Peace industry and the War industry. And if the Peace

industry becomes more viable than the War industry then we will not have war any more. The Peace industry means all of us who are not directly involved in the production of weapons and making war – but we have to change our attitude.

'Within the War industry, the people are totally unified – they just want to kill. Whereas the people in the Peace industry – we are so critical of one another. We just have to learn to be more forgiving, more caring and more understanding of each other. The old idea of love and peace really does work. And if we can come together in the Peace industry, then peace will happen. It's just so logical. And so I'll bet on that.'

In the year 2000, after a decade of prolific, computer-assisted image-making – *'Everything's just another look nowadays'* – one of the most striking pieces of communication design to hit the billboards might still be Richard Avedon's psychedelic portraits of the Beatles, made back in 1967. Solarized, hand-tinted, reversed-out and painted over, these photographs were the nearest a tube station hoarding came to a kind of benign psychic photography. George, in particular, with his palm pushed forward and his upward karmic gaze; Ringo in Yves Klein blue and Bournville brown, a dove on his finger. This is what semi-divine superheroes must actually look like. The Beatles had dominated the Nineties; and as Jon Savage, the Sex Pistols' biographer, would remark about media approaches to Apple: 'Don't fuck with the Fabs.'

The monolithic radicalism of Fabdom and Yoko Ono (look no further than 'Tomorrow Never Knows' and 'Fly', respectively), that generation of artists, at any rate (from New York, you could add a writer such as Lynne Tillman, or an artist such as Dan Graham – the people who gave the cutting edge its edge), was appropriated by cultural practitioners in the Nineties to produce a kind of exquisite version of itself, in which image was substance and that

was all – a crystalline tracery, a Technicolor cartoon, a pixellated abstract . . . And in Manhattan, in the mid- to late 1990s, a look seemed to emerge that might well be called the uniform of *the gentrification of the avant-garde* – it was a downtown-hippy postmodern Tokyo glam hip-hop punk look that read like an abridged history of popular culture refined to its most subtle yet most articulate elements.

(Look! There goes one – a girl who looks like a beautiful boy or vice versa. Not a potato person. An exquisite androgyne. The hair, shoulder-length, but worn in a bun – zen grunge, the mystical acolyte; Granny glasses circa the first Cream LP, with blue-tinted lenses; the t-shirt, with inlaid plastic panels looking somehow sci-fi Japanese with a hip-hop twist; the standard-issue Nirvana-era baggy army trousers; blue nail polish; the whole thing fitting together in a way that achieves real Style rather than mere fashion. This here is an index of Underground exotica, only prettified, somehow, and assured. As Tillman once remarked, in a classically Tillmanesque aphorism, 'History should never be written by narcissists.')

The exquisite look popped up in all reports of Soho and East Village gilded youth where money and a slightly nineteenth-century idea of Society (family, land and property ownership) were stirred together with the history and lineage – *the stylized idea* – of the Underground Cutting Edge. The children of *Interview* magazine. As filtered through pop one of the biggest new groups in 2001 would be the Strokes – a quintet of exquisitely punky-looking young men who played a perfect simulacrum of a New York downtown club punk, yet were all reasonably well-off, middle-class, and – according to one broadsheet newspaper – 'eligible Manhattan bachelors'.

Vital to the gentrification of the avant-garde was its appropriation of the iconography, the baggage, of mid-century Beat and Pop and Punk outsiderdom: Burroughs, Ginsberg, Patti Smith, north Manchester punk iconoclasts the Fall, John Giorno, Iggy

Pop, anything whatsoever remotely linked to the Warhol Factory or the Velvet Underground, CBGBs – downtown super-cool Authenticity refined to such a pitch that it became, ultimately, Style Mag contrived bland: the almost-had-a-punk-haircut-just-pulled-on-any-old-grey-jumper Nothing to Prove look. The *everything's-just-another-look-nowadays* look; the self-assurance of moneyed tourism in the fringes of cult outsiderdom.

The gentrification of the avant-garde therefore required ready-made emblems of druggy draggy androgyny – of the *real thing*, that is: genuine downtown fucked-up punk transvestite Bohemian glamour. This was the Laura Ashley of neo-punk High Society, to go with the Helmut Lang pre-dirtied denims and La Tocca perfumed candles: comprising the irresistibly Exquisite setting in which a touch of the genuine Cutting Edge gave that thrilling little bat-squeak of edgy danger . . .

Nan Goldin

Nan Goldin was born in 1953, in Washington, DC. When she was eleven years old, her sister committed suicide. Her sister's psychiatrist predicted the same fate for her. Goldin ran away from home at fourteen, and started taking photographs when she was eighteen – the same age that her sister committed suicide. Initially, Goldin took Polaroids, then she shot movies on Super 8 and finally she started taking regular photographs. She went to the New England School of Photography, ostensibly to learn about fashion photography. Describing herself as 'too confused, technically' to shoot fashion, she ended up taking a straight 35mm photography course.

Emotionally and visually, Goldin's early influences were Boston transvestites, Hollywood movies from the Thirties and Forties, early Warhol films and European cinema. She was introduced by Henry Hornstein to the work of Arbus, Weegee and Sander. In the

mid-Seventies, Goldin began her photographic diary, *The Ballad of Sexual Dependency* – the audio-visual work that was later published in book form. Goldin had travelled between America, the UK, Germany and the Far East. She took a lot of drugs and was treated for alcoholism. She recorded the life and death of her best friend, the writer and John Waters's star, Cookie Mueller. Most recently, Goldin has published a book of photographs of her extended family of transvestites and transsexuals – 'the third gender' – which is entitled *The Other Side*. Over the last two decades her body of work has made articulate, with terrifying eloquence, a vivid element of the human condition.

Read back, Goldin's life has all the qualities of exposure and suffering traditionally ascribed to the mythic character of the romantic artist. Her temperament and her love have taken her into the half-world of a genuine bohemia; she has seen many of her friends and fellow-travellers die from drug abuse and AIDS-related illnesses. She has recorded, photographically, that portion of society that is divorced from the usual restraints and support systems that service and control contemporary urban life. She would be a Rimbaud, a Genet, a Pasolini or a Hubert Selby Junior – ripe for early death and a place in immortality as a 'cult' artist.

Cult artists, more often than not, end up as mounted specimens of exotica in the museum of cultural history. We marvel at their romanticism and their endurance; we study them as pioneers sent out to the extreme edges of experience, in the hope that they will bring us back – and come to embody – reports from the depths and heights of existence. We expect cult romantics to do the whole movie – to pay the ultimate price for their art. But Goldin, to my mind, is neither a cult artist nor a romantic – despite the evidence of her subject matter. Her aesthetic runs too deep to localize her work to one specific, lurid milieu. If Goldin was a writer, she would be closer to Chekhov than to Kathy Acker or William Burroughs.

This is because Goldin's photographs, individually and collec-

tively, tell stories drawn from her lived experience. Their lucidity, simplicity and honesty grants their narrative a universal signifi- cance. Like Chekhov (or even Dickens) Goldin investigates joy and suffering in a way – story-telling in scenes – that holds up a mirror to her times. And, as her photography is almost the equiva- lent of first-person narrative, Goldin manages to be – like Flau- bert's definition of the artist – both everywhere and invisible in the landscape of her work. She has expressed herself and her world through a precise translation of her feelings into art.

Goldin's subjects, particularly in *The Ballad of Sexual Depen- dency*, are personal and domestic; her friends and loved ones are photographed in contexts and moments of extreme intimacy: the viewer is placed in the immediate environment of the photograph, yet never as a voyeur – the composition, colour and lighting of Goldin's photographs enclose the viewer on the subject's terms, yet with the stillness and archival sense of a family album.

The Ballad of Sexual Dependency describes directly, as a book or a slide presentation, the lives and loves of a group of young people. The work comprises over seven hundred images and a soundtrack, which make the viewer a witness to their events. It is not a comfortable journey because it exposes our frailties and our affectations, our hopelessness and cruelty, as well as our hopes and desires. In her Introduction, Goldin writes: 'I don't select people in order to photograph them; I photograph directly from life. These pictures come out of relationships, not observation.' There is an absence of self-consciousness in *Ballad* that makes some of the photographs almost embarrassing to look at, like watching a drunk at a party; there are moments when you are both shocked and intrigued to see how close to the surface of everyday life the more violent expressions of emotion can be. It is the empathetic quality of Goldin's photographs, resolute, refus- ing to condescend, that gives them their moral centre and hence their vitality of meaning and significance.

Looking at Goldin's photographs, it's possible to believe that

her life is realized for her only when it is being photographed. It is as though the themes of addiction and co-dependency that run through her work are equally apparent in her own addiction to recording her life on film. In *The Ballad of Sexual Dependency* we are made privy to what Max Kozloff has described as 'the common pleasure site and private hell' of many different sorts of addict: drug addicts, pain addicts, emotional addicts, couples who are addicted to one another (both joyously and destructively). Thus, the work runs like a lexicon of extreme emotional states, in which couples and individuals attempt to realize their desires or are caught in moments of bewilderment and perplexity, trying to calculate the temper of their situations.

As such, *The Ballad of Sexual Dependency* can be seen to document the unconscious processes of spiritual and physical sickness. Goldin photographs the body in such a way as to reveal both its corporeality (in the manner of Stanley Spencer's paintings or Egon Schiele's drawings) and its vulnerability. Whether a person is photographed washing, dancing, hugging or masturbating, there is an openness to the image that suggests the wounds and illnesses that lifestyles can inflict. The effects of drugs, batterings, and AIDS-related illness hang over these photographs like the exorbitant bill for a ten-year party at which nobody had much fun in the first place. In the early 1990s, there is the sense that we are all in recovery or denial; that while our metaphors used to be financial, they are now drawn from illness, treatment and survival to convalescence.

If Nan Goldin's photographs are essentially de-politicized then they reinvent the need for viewers to face their own emotional responses to the individual images. In *The Ballad*, the men often appear chauvinistic and self-obsessed; in the portraits of Brian, in particular, Goldin seems to have created two texts within the photographs: the first is a study of affection (love, even) and desire; the second is a sense of pity at the ultimate infantilism of the rugged male. The men in Goldin's *Ballad* look like clichéd charac-

ters from a Tom Waits song: they draw moodily on filterless cigarettes, they swig from the bottle, they lie naked and defenceless in shabby hotel rooms: there is an animal quality to these studies.

One of Goldin's most powerful images is 'Nan after being battered' (1984). In this horrific self-portrait, Goldin confronts her own camera with bloodied eyes and a swollen face; her expression accuses her boyfriend (who beat her up) by simply offering itself up for inspection. It seems as though the relationships between men and women in Goldin's photographs – as distinct from the relationships between women or gay men – are documented as volatile, oblivious or obsessive. During an interview in 1990, Goldin said, 'People cling together. It's a bio-chemical reaction. It stimulates that part of your brain that is only satisfied by love, heroin or chocolate.' Clinging together can create either comfort or claustrophobia; once more, the theme of sickness, and the desire for recovery, is raised in Goldin's work.

If *The Ballad of Sexual Dependency* is a photographic diary that documents the emotional spectrum of living and surviving, and takes on board the presence of death, *The Other Side* is a heroic celebration of identity realignment.

Goldin wrote: 'After years of experiencing and photographing the struggle of the two genders with their codes and definitions, and their difficulties in relating to each other, it was liberating to meet people who had crossed these gender boundaries. Most people get scared when they can't categorize others – by race, by age, and most of all by gender. It takes nerve to walk down the street when you fall between the cracks. Some of my friends shift genders daily from boy to girl and back again.'

Goldin's queens are photographed with affection and awe. One is immediately struck by the brilliance of the colours and the ultra-femininity of the models. Many of them have the look and image of a pin-up girl: their transsexuality is ultimately heterosexual, corresponding as it does with traditional, heterosexual notions of glamour and sexiness. In this, the queens appear to be

having the last laugh in a world such as Goldin's, where sexuality can be so difficult, and notions of togetherness and identity so embittered. The ambiguous glamour of Warhol's superstar drag queens is developed in Goldin's portraits, while there is a gentleness about some of the photographs – 'Joey and Andres after kissing, Berlin' (1992), or 'Jimmy Paulette and Tabboo! in the bathroom, NYC' (1991) for instance – which, excuse the term, is life-affirming.

While some of the transsexuals, particularly those in Bangkok, appear as natural feminine beauties, others – such as 'Misty and Jimmy Paulette in a taxi, NYC' (1991) – are truly 'third gender': caked in make-up and dressed in a kind of disco/TopShop neo-punk, Misty and Jimmy Paulette confront the lens with heavy-lidded inscrutability. They could be Jack Lemmon and Tony Curtis in *Some Like It Hot* – presenting themselves as comic and mock-heroic in their glamour; or they could comprise a Sphinx, with or without a secret.

The element of playfulness in Goldin's portraits of queens is brought to the photographs by their subjects, just as the tension and frailty within *The Ballad of Sexual Dependency* are encountered, as opposed to invoked, within the image. *The Other Side*, to this extent, might be seen as an answering hopefulness and celebration to the darknesses and illness of *The Ballad of Sexual Dependency*. So much of contemporary life is presumed illegible and beyond a single focus; Goldin, by echoing Colette, and looking hard at what gives her pleasure, and harder at what gives her pain, reclaims lost areas of compassion and humanity from the tyranny of fashionable nihilism.

[Sometime around 1993 or '94, back in London on a grey wet afternoon, Nan Goldin had been installing some of her photographs in an exhibition at the Institute of Contemporary Arts. In

the bar, someone asked who bought Nan's photographs, now that she was becoming so famous, and her druggy draggy glamorous transsexual friends were the perfect dash of gentrified avant-garde. 'Yuppie assholes,' she answered.

Later someone said that you could now buy a Nan Goldin 'Misty and Jimmy Paulette in a taxi, NYC' shower curtain. But Nan Goldin is *the real thing*.]

Then there was another definition of the gentrification of the avant-garde: when Art became a brand . . . To this extent, the 1990s was a decade when all of Andy Warhol's philosophies were proved to be right.

Because the point about the gentrification of the avant-garde, however snooty one might want to be about the debasement of radicalism by commerce and fashionability, was that it was irresistible. Aesthetically gorgeous, it flattered one's better conception of oneself as a culturally aware, urban and urbane kind of person (which was why the Paramount hotel worked so well – it put you in a post-modern movie) and, although it helped to be about twenty-one and incredibly good-looking, even if you were old and baggy and boring you could always put that original Richard Hell and the Voidoids t-shirt . . . in a frame.

In short, the whole process came through as a kind of applied Warholism – prettiness, glamour, commerce, wealth, fashionability, celebrity, but, vitally, without the content of Warhol's own dark-side moral centre. Rather, this applied Warholism was wholly at ease with being Exquisitely comfortably punky – the emblem of Surface as Depth, the card that couldn't be trumped!

(On 10 April 1984, Andy himself had recorded in his Diary: 'And little Sean Lennon fell in love with me, just madly. He said "Why is your hair like that?" and I said "Punk." He said, "What's your name?" I said, "Adam." Then I asked him to get me a double champagne and when he came back with it he said somebody had told him I was Andy Warhol, and then he went round to everyone telling them . . .')

Then in 1993, in a white-with-a-hint-of-mint room in the Royalton Hotel looking down into the baking chasm of West 44th Street – a street more suited to winter, with its nineteenth-century atmosphere of high monumental windows, and the motor-oil fumes from the low dark mouths of underground car parks – Nick Rhodes from Duran Duran, wrapped in an eau-de-nil-coloured blanket against the ferocity of the air-conditioning, had told a story of how Warhol had asked him to put his hand inside his shirt and squeeze the fabric. Doing so, Rhodes had felt something like broken biscuits rubbing through the shirt material between his fingers. 'What on earth is that?' he had asked.

'Diamonds . . .' came Andy's mumbled reply.

En Famille with Duran Duran in New York

The air-conditioned, aromatherapeutic fragrant calm of the lobby of the Royalton Hotel, on West 44th Street, was suddenly disturbed by a caravan of minders, promoters, publicists, assistants, record company officials, children and glamorous women, all of whom appeared to have descended in the same lift. At the centre of this throng, dressed in a scarlet satin jacket and Vivienne West-wood bondage trousers, his hair dyed platinum-lilac, was Nick Rhodes – the effortlessly photogenic keyboard player of Duran Duran. He was on his way to sign about ten thousand autographs at Tower Records on Third Avenue. It was a moment designed to be bathed in flashlight and, consequently, it was.

It is difficult to turn heads in the lobby of the Royalton, so used is that post-modern palace to celebrities (hence the lobby being flanked by a kind of cat-walk to the lifts), but the court of Nick Rhodes had managed to do it. Unnoticed amid all the fuss, completing a triple whammy for Eighties revivalism, Koo Stark was curled up on a Philippe Starck sofa reading a book. As the procession approached the double doors and prepared to slide

into their limousines, Rhodes paused, bringing the whole platoon to a sudden halt. The doors were opened by black-clad bell-boys with cheekbones like wing mirrors, and a few pre-emptive teenage screams shot in from the oven of the pavement. A cluster of well-informed Duranies – most notably four girls who were squeezed into one very small car – had gathered to ambush one of their idols. 'This,' said Rhodes, surveying the scene before him, and aware of the poised support team behind him, 'is going to be rather like an episode of *The Simpsons*.' He was right.

Duran Duran, the pop group, comprises three young(ish) men from Birmingham who met during the New Romantic club scene at the tail end of the Seventies. Nick Rhodes, John Taylor and Simon Le Bon were joined six years ago by Warren Cuccurullo, but with that exception have remained more or less the same unit since the departure of Andy Taylor and Roger Taylor in the mid-Eighties. There were various spin-off projects, such as Power Station, Arcadia and Rhodes's book of Polaroids, but the basic premise of Duran Duran – a pop monolith that did much to define certain aspects of the Eighties – has remained the same.

I remember first seeing Duran Duran supporting John Cooper Clarke and Pauline Murray and the Invisible Girls, at the old Lyceum Ballroom in Wellington Street in 1979. That was during the fade-to-grey days of post-punk, when futurism was being applied to pop from a basis of industrial chic; this was the time of Cabaret Voltaire and the Human League – just before the vast, glossy brushstrokes of designer pop and Soho jazz revival cappuccino cult splashed their vivid colours.

The era that produced Duran Duran was a curious mixture of art and affectation, and we can laugh about it now if we're feeling uncharitable. But when the early-Eighties superstars – Duran Duran, Culture Club, Wham! and Nick Heyward – did find fame and glory, they found it in a big way. Duran Duran, early in their confusing career, were synonymous with all things big: it was a big group with big hair and a big sound for a big decade. Later,

when the party seemed to be over, Duran Duran were dumped on in a big way – almost as though the Recession was their fault.

At their height, Duran Duran were the ultimate pop video group. Theirs was an aesthetic of excess, with monumental songs, bandanas and more sexy girls than you could shake a stick at. The band also had a reputation for being pretty boys who were riding on a wave of rather anodyne decadence. They had huge hits all over the world: 'The Wild Boys', 'Rio', 'Union of the Snake', 'Girls on Film' and 'Save a Prayer'. The middle of the Eighties was a time when video was vital to pop (new videos by George Michael, Frankie Goes to Hollywood and Michael Jackson were screened on television as special programmes, implying their status, almost, as hard news stories) and Duran Duran videos got bigger and wilder. There were rumours that a four-minute Duran Duran promo video cost more to make than an entire film by Derek Jarman. Girls screamed and pop intellectuals didn't know whether to applaud the populism or damn the sentiment.

Then, as the designer decade hurtled towards the stockmarket crash of Black Monday, Duran Duran were perceived to be losing the plot. Their finest (or worst) moment occurred when they recorded 'View to a Kill' for the Bond movie of the same name, and that was about as tastelessly big as you could get. They were critically panned, appeared increasingly irrelevant and seemed to be a kind of fast-food chain for the hyenas of the tabloid press.

'We became a soap opera in England,' Rhodes recalls. 'We called it Duranysty. Most people – movie stars, rock stars and so on – don't live in England; they go to a hide-out in Switzerland or LA. But we stayed in England; we're all very English – we like England and we don't want to live anywhere else. But because we stayed here, we opened ourselves to the press to log our lives every week: which restaurants is John going to? Will Simon have a new girlfriend this week? And I think that when you lose your mystery, you kind of break a spell.'

By the end of the Eighties, Duran Duran seemed like a spent

force. They had beautiful wives and girlfriends, some of them had children, and they were more frequently in *Hello!* than the music press or tabloids. Le Bon had married the model Yasmin, Taylor was to marry Amanda De Cadenet, families were being conceived. The twentysomethings were turning into thirtysomethings, which, of course, was a very Eighties thing to do. After all, the exchange of wreckless youth for domestic maturity even had its own cult TV show in the Eighties: the late *thirtysomething*. Thus the Eighties superstars might well have disappeared with their signature decade. 'We got the bill for the Eighties,' Rhodes says, 'on 1 January 1990 – don't you think?'

Today's young music consumers tend to want either grunge or techno. So why is it that Duran Duran, in 1993, have suddenly had two hits in the United States and are currently three weeks into a major, sold-out American tour? And why is it that while the band are touring in America, they may well bump into Depeche Mode or Morrissey – two other British artists who are marginalized in the UK but stadium-concert massive in America?

Over at Tower Records, on Third Avenue and 86th Street, there was no doubting the rehabilitation of Duran Duran as major pop stars. The queue was four deep and stretched around the block; police were called. Thousands of girls, most in their late teens or early twenties, were joined by maybe seven boys, two of whom were glaring at their girlfriends. As the limousines pulled up (Nick Rhodes putting aside his morning paper, and saying, 'Ah, yes . . .' for all the world like a City banker being dropped at his Threadneedle Street office by his driver) the crowds really did go wild: 'Oh my Gard! IT'S LIKE, TOTALLY, YOU KNOW, TOTAL!'; 'Well, there goes the neighbourhood,' said one of the Tower assistants, whom one suspects was 'into' U2.

Duran Duran look frail and glamorous: they are all fashionably skinny; Taylor has scarlet hair, Cuccurullo is wearing a gold lamé biker jacket. Le Bon looks curiously like the young Iggy Pop. You cannot help but be impressed. The group are good-natured, too,

smiling and joking with what seems to be an endless procession of tearful, hyperventilating or downright vampiric girls.

The fans are all tanned, healthy and slightly plump. They're a well-fed, first MTV generation of well-balanced optimists; they seem to represent the lighter side of American youth, even as their counterparts – the vagued-out, hurt, nihilistic and cynical X-ers – are worshipping at the shrine of Nirvana.

One girl has written a poem, 'Ode to Duran Duran', which she gives to John Taylor: 'And to the many bands I hear/Nothing compares to the music of the men right here/Insightful lyrics can undo life's harms/Especially when they are sung with Simon Le Bon's charms.' This is the second stanza; the complete work is about the same length as Wordsworth's *Prelude*.

The four girls who tailed the band from the Royalton are here, too; they arrive in a squad, two by two. Clearly, many hours have been spent in preparation for this event, precision-planned like the Normandy landings. Beyond the crash barriers, a girl all the way from Massachusetts offers Murray, the senior EMI press co-ordinator from London, a wad of loose cash to get her jacket signed. He doesn't take the money, but Rhodes decorates the jacket with Warholesque flowers anyway. 'It's rather nice, actually,' says Murray, admiring the finished work. He glances over at the pleading girl, 'Do you suppose she wants it back?'

Le Bon, the member of Duran Duran who has been most lampooned by hostile critics for everything from his weight to his hair, is the most trimmed-down of the sleek new group. He is resting his voice between performances, and he acknowledges the best wishes and greetings of the breathless fans with a series of smiles, signs and bare responses. At one point he stands up in his seat and performs a brief, hip-twisting dance, anticipating his later unchained performance on stage.

'One of the great things that we've found happening with the media here,' Rhodes says later, 'is that it's being run by people who were Duranies in the early Eighties. The rock press in particu-

lar were pretty cynical about us in the mid-Eighties, but it's like they've brought us home.' He modestly fails to mention that 'Ordinary World' and 'Too Much Information' – the most recent Duran Duran singles, are great pop records by anyone's standards.

America lacks the incisive cynicism that England can have towards pop music. 'The English are always the first on a new movement and the first off,' Rhodes says. 'The English love to see Americans succeed, they love Hollywood and they flock to movie openings, but if another English person gets a bit too successful they can't bear it. Maybe they're more interested in people's private lives than their public careers.'

Eventually, the musicians get writer's cramp and stop signing records. They have stayed for as long as possible but there are still a lot of disappointed fans. To cheer this latter mob up, the record-store manager has a free raffle for signed photographs. The winners scream with ecstasy. In London, one wonders, would such an event even raise a few eyebrows? As one girl waves her trophy in the air, one of the fans from the Royalton posse mutters darkly: 'Look at her – total slut. I mean, God . . .'

Soon the musicians are back in their hotel with their families and their private lives. 'I feel that elegant punk is right for this little cyborg society that we're currently living in,' Rhodes says. And there is something particularly potent about the coloured hair, the Westwood originals – and the intimate family groups. It's a meeting of opposed words, in which the group come across as both apologists for Eighties extravagance and born-again punks. Of all the various fates that one might imagine for Duran Duran, this friendly, effortlessly elegant yet almost cartoon-like renaissance would seem the most unlikely.

It has been argued that during the mid-Seventies, when 'serious' music was progressive rock, we actually had a secret wish to be listening to the Carpenters or T.Rex – they were just more fun and better tunes. Similarly, groups from the demonized Eighties such as Duran Duran or Culture Club wrote some great pop

songs, and now it's almost fashionable to sing along again. Duran Duran are probably not destined to be a pivotal moment in cultural history, but the group has crafted its music and its image with all the glamour of Pop Art proper. It takes the unselfconscious enthusiasm of their young American audience to cut through all the factioneering that can attach itself to pop. That night, when Duran Duran play at the immense Jones Beach amphitheatre, on Long Island, there's a lot of hand-waving going on and a lot of lighters held high.

And with good reason. It's a terrific show. The group has a new stage set designed by Stefanos Lazaridis, whose best-known work has been for the English National Opera. True, the set is so ambitious that it won't actually fit into some of the venues, but it's a grand gesture nevertheless. A red circle dominates the back-drop, with cat-walks, a telephone box, a steel fence and a tumbling globe all adding to the drama. It looks like the set of a futuristic pantomime, echoing David Bowie's *Diamond Dogs* as well as Pet Shop Boys' *Performance*. The band members play on different levelled stages, while Le Bon – with the energy of a man half his age – leaps around and kicks in the screen of a television set. It's a colourful setting for a greatest-hits/new-album package, and the kids, and their parents, love it.

There is the scent of patchouli on the humid salt breeze as the VIPs on the VIP VIP list (there are several grades of VIP on this tour) loiter backstage for a meet and greet. A security guard chews aimlessly on a straw while Terence Trent D'Arby goes through a set that sounds uncannily – due to some acoustical tricks – like Tina Turner. Amber and Saffron Le Bon, Simon and Yasmin's daughters chase one another around, their backstage passes getting caught between their legs. Yasmin and Amanda De Cadenet chat amiably, like young county mums at a private-school sports day. Cuccurullo's grandparents are sitting under a sunshade, sipping Diet Sprite and discussing the weather. On the other side of the vast stage set, 18,000 Duranies are getting restless.

The show is infectiously melodramatic, like all the best pop shows. The crowd sing along to 'Rio' and 'Girls on Film'; they punch the air during 'Too Much Information'. Then Le Bon has a special announcement: 'Mike In Row F has something very special to ask his girlfriend!'

'Thanks Simon!' bellows a beefy young man with a Sylvester Stallone accent, before proposing to his girlfriend in front of a whole amphitheatre of people who don't know him. In England they'd have booed. But the crowd here loves it – public emotion! Somehow, as the yellow half-moon gleams dully behind a steamy, heavy mist, the concert gets better and better. Towards the end, even those from England, who hate being happy, are swaying our hands from side to side and singing, 'Save it for the morning after . . .'

There are one or two technical hitches during the two-hour set: Rhodes's keyboard emits a giant crunching noise just before 'Union of the Snake', and Taylor gets given the wrong guitar for the encore. 'I'm sorry,' he says, addressing the crowd for the first time that evening. 'It's just that we haven't quite got over the fact that people want to come and see us again.'

The afternoon after the Duran Duran concert at Jones Beach, in a departure lounge at John F. Kennedy Airport, having just spent three days in and around the company of Kurt Cobain and Courtney Love (heavy drugs, mayhem, paranoia, Nirvana at their deepest darkest vortex of deafening sound), there was Jon Savage. He was swigging a Bach Flower Rescue Remedy direct from the bottle.

'And where have you been?' he asked, as though we were new boys back late from Games.

We told him.

'Oh, well,' he pronounced, 'you've been on a Pop Trip.' There

153

was a slight pause, and then, triumphantly, '*I've* been on a Rock Trip . . .'

And speaking of Pop Trips, now it was time to meet . . . Hanson's East Coast publicist: Hanson! – the three teenage brothers whose Number One single, 'MmmBop', and Scandinavian good looks had won them comparisons to the Osmonds.

On the in-room CD player, back at the Paramount, 'MmmBop' had somehow not fitted; catchy – irresistibly catchy – but too pop for the time and place. (Drifting steam from the cooling duct two blocks away; silence and minimalism; down in the lobby, ever so quietly, they were playing George Harrison's 'My Sweet Lord', which did fit, somehow.) Millions of teenage girls would willingly have given their kidneys to be on the mission this morning – to spend an hour and ten minutes with Zac, Taylor and Isaac Hanson. Zac, the drummer, was twelve years old. A pop fact he shared with Dee Generate, the former drummer with Eater.

From Times Square, across Broadway and up to Fifth Avenue, the air had seemed silver with cold. The New York of F. Scott Fitzgerald – the University Club, Delmonico's, the Saint Regis, redolent of cigar smoke, pig-skin and rose water – seem to merge in one seamless swathe and beige marble with Martin Pawson's ultra-minimalist design of the Calvin Klein superstore (one cellophane-wrapped grey sheet on a single ivory-coloured slab, the purchase of which – you imagine – will grant you the aura of the entire store) or the haute couture Baroque of Laura Biagotti and Fendi. Here was the world centre of the little treat deluxe – be it a muffin or a small Magritte.

Off to the Upper East Sixties there was a cosy little shop selling nothing but buttons, for instance – beautiful buttons with Judy Garland on them, or a perfect nugget of miniaturized Op-art; then there was the old Serendipity restaurant, where Warhol used to go,

and now a high camp wonderland for children and their infantilist parents: pure sugar, pure chocolate, and a counter decked in fairy lights selling Virgin Mary fridge magnets with costumes you could change – High School Mary with her 'Go Saints!' pennant – like the cut-out dolls that Andy himself used to cut out when he was sick in bed every summer having nervous breakdowns as a child in Pittsburgh. He used to get a chocolate bar every time he finished a page in his colouring book.

In this neck of the woods, Warhol, as the High Priest of Anxiety and Infantilism, had shown the way that little treats deluxe were your earthing wire and your armour when you wanted to explore the depths and heights of the modern city. Why else did they find all those shopping bags in his town house when he passed away so suddenly? Those shopping bags were Warhol's way home, his ruby slippers, and now we needed ours.

'Little gorgeous things, darling.' That was how the character of Edina, on the TV comedy *Absolutely Fabulous*, had summed up the infantilism deluxe of a generation. Swirls of flavoured syrup; tiny phials of aromatic essence to swab across your pulse points; a thousand things for the bath in organic-looking cardboard boxes with exquisite violet labels – things that smelled like a cross between honeysuckle and photocopy paper.

For these were the compensatory pleasures of the infantilist generation. Who were, when you stopped to think about it, the urban middle-to-upper-income bracket (gentrifiers of the avant-garde) early-middle-aged elder siblings of – whom?

By the chateau of the Plaza hotel (Fitzgerald again, but some-how a darker, older Fitzgerald than the gilded youth who was haunting the University Club or Delmonico's: his best New York short stories – 'May Day', 'A Rich Boy' – laid out the holistic relationship between debt, despair and death, rehearsing the After-life of being a Great American Novelist in Hollywood, swigging Cokes in the airless sun-baked rooms of the Garden of Allah hotel); it was the way that aspiration – glamour itself – began to

curdle when you'd run out of lucky breaks, exhausted your creditors and become 'a poor caretaker of most things in life, including talent'; when the compensatory pleasures had become an addiction you could no longer afford to support: the price of growing old as an eternal adolescent (a state of being, borrowed by Fellini from Jung, and, according to the former, vital to the constitution of a true artist – the oscillation between innocence and experience, infantilism and the head-rush of anxiety. Fellini's Plaza was the old Grand Hotel in Rimini: the unobtainable, and therefore inviolable, mecca of glamour).

The über-analysts of the zeitgeist, back in the early 1990s, had slipped out their probes as though – stealing from Robert Lowell's image of Harley Earl Cadillac tail-fins – 'a savage servility slides by on grease'. They were trying to detect the younger generation. On the surface of the alien planet, twiddling the knobs on their counter-culturometers, they picked up a reading like geigercounter clicks off space cabbage. The data processed, they came out with Slackers and X-ers – a new addition to the periodic table, but something of a compound.

These were the mall meat of north America and western Europe, whacked out under white light in fast-food seating areas on a diet of fat, salt, sugar and pixels. The Slackers, X-ers, call them what you will, hadn't seemed to need the compensatory pleasures of Nineties Infantilism. Their regression was less reactive to anxiety; it encompassed pop cultural trivia but to the tune of a kind of self-contradictory Zen nihilism, confounding and colluding with commodity culture, all at the same time.

Word got passed around that the actual culture of X-er überanalysis itself – the Slacker literature, films, and there was probably a lot of concept art in there too (Sonic Youth's song for Karen Carpenter, 'another green salad, another iced tea', the posed and poised self-portraits of Art Club 2000, or Douglas Coupland's early fiction) – would be of interest, in the future, only to . . . other über-analysts. It was all too at ease with itself, too aesthetic,

too neat, too prettily oppositional – Exquisite. It was, in fact, the absorption into actual culture practice of the gentrification of the avant-garde. 'Gorgeous little things, darling.'

A triumph of form over content had occurred (went the opposition), with the charge led by Style, which kicked into touch any idea of art and creativity (in this case, the ignited marsh gas of a slightly swampy culture) corresponding to what – for instance – Bridget Riley had described in her William Townsend Memorial Lecture at the Slade School of Art, London, in 1997, as 'an inner text which the artist needs to translate'.

Bridget Riley

In 1968, at the age of thirty-seven, Bridget Riley was the first English painter and the first woman artist to win the International Prize for Painting at the Venice Biennale. A year before, the three most famous women in Britain (not including the Queen) had been listed in a magazine poll as Mary Quant – for her cosmetics, Twiggy – for her legs, and Bridget Riley for the dizzying impact of her instantly memorable Op Art paintings. But Riley had triumphed in Venice during the months of student protest that had flared up across Europe and America, and the prize-giving ceremony could not take place. Along with the artists Marisol and Cesar – who was a member of Communist Party – she attempted in vain to get into discussion with the students who were occupying the Accademia. It was a political hot-spot, in the days when counter-cultural revolution, organized by youth, was poised to attack all and any institutions of tradition or government. The critic Edward Lucie-Smith, reporting on the Biennale for the London *Times* of 29 October 1968, claimed Riley's artistic achievement to be a simultaneous triumph for the ordering forces of culture itself: 'In choosing an individualist of this stamp, the jury in Venice has done something to rescue the reputation of the

Biennale. After the events which marked (and marred) the opening of this year's exhibition, it needed rescuing.'

Riley, as an artist for whom the demands of her own hard-won aesthetic were the cradle and crucible of all her personal beliefs, has found herself positioned as the modern representative of art's traditional aversion to all that can not be said in the language of colour, form and composition. In the deepest sense, she is an artist pure and simple. But the mesmeric precision of her work has marked her out as a radical traditionalist, advancing the boundaries of sensory perception through a rigorously disciplined application to her craft. And this, within the febrile arena of contemporary art, distinguishes Riley as a reluctant rebel, whose asserted faith in the power of painting could be seen as a cultural challenge of fundamental importance. Her approach to painting, it can be argued, performs an aesthetic audit on the volatile definition of art itself. As Lucie-Smith perceived her work in 1968: 'But the finished design is the product of inner emotion, and is meant to communicate that emotion not by means of symbols, but directly, and almost physiologically. In this sense Miss Riley's work might also be described as "anti-experimental".'

To this extent, Riley might be viewed as an outsider of long standing, as removed from the fashionability or otherwise of shifts in artistic taste as she has become, by virtue of the philosophy of her painting, a commentator upon them.

'It is perhaps not so much a determined outsider,' she says, 'as preserving an independence of mind and spirit; and I have to accept that perhaps being seen as an outsider is part of the cost of maintaining this independence. However, I am far from being an outsider in terms of how my work relates to the past.'

Fast forward to 29 November 1996, and Bridget Riley CBE is giving the 23rd William Townsend Memorial Lecture to a capacity audience at the Slade School of Art in neo-swinging London. Many of the students present resemble, in appearance at least, their anarchistic ancestors who had disrupted the Venice Biennale

in 1968. Only now, with formidable irony, the roles of rebellion and establishment have been neatly reversed. Now it is Bridget Riley who represents the voice of dissent, to a younger generation of artists and a contemporary art scene that has made the colourful shock-tactics of neo-conceptualism its champion of the hour. The experimental has become the mainstream, and Riley's 'anti-experimentalism' is about to drop a depth-charge of passionately argued opinion right under the bows of this new establishment. Her lecture is being delivered at a time when the multi-media installations of Damien Hirst or the film-works of Sam Taylor Wood have achieved a celebrity that all but consigns classical notions of painting to an oubliette of archaic eccentricity. In this context, even the title of Riley's lecture, 'Painting Now', becomes a massively subversive statement. But this is no plea for reactionary conformism to quell the riots of youthful exuberance; rather, it is a calling to account of a new conformism – the conformity of wholesale experimentalism – which Riley regards as having pushed the practice and purpose of art to a state of near pointlessness.

This lecture is a rare event, for Bridget Riley is an extremely private public figure. She is dressed in a dark blue suit that is the very opposite of her vibrant paintings. Rather than the cleverly tailored sobriety of Gilbert & George, with its blizzard of mixed messages, Riley's anti-bohemian appearance brings to mind the novelist Flaubert's stern command that 'You must be regular and natural in your habits like a bourgeoise, so that you may be violent and original in your work.' In conversation she is brisk and cheerful, approachable but business-like, but with little time for small-talk or time-wasters. She retains the intensity of expression that distinguished her striking, angular beauty in the 1960s. In *Time* magazine's photograph of her in 1970, caught in half-profile against one of her monochrome 'spot' paintings, she transmits a lean, androgynous cool that is utterly contemporary. Now, glancing at her audience, she stands to the extreme left of a long stage, almost as though she is shunning the limelight. But her delivery

is direct, getting straight to the confrontational stance of her thesis.

'The conspicuous lack of painting is certainly not because the art world has shrunk in any way. On the contrary it has grown, developed and been converted into a machine for the production of Art and its promotion. This machine is a very great deal more powerful and efficient than its forerunner in the Sixties ever was. Many, but fortunately not all, of the people involved in running the "Art Machine" – art administrators, dealers, critics and artists – are in the "Art Game" and are no longer interested in painting. It doesn't seem to fit into the present scheme of things. So – is it painting itself, that immensely cultivated activity, which is out of step? Or is it the notion of work – from which it is inseparable – that is at fault?'

Riley, who along with Lucian Freud, Frank Auerbach and David Hockney, is one of Britain's most senior and respected artists, would appear to be saying the unsayable. And, having all but named names and thrown down a gauntlet to the parliament of her profession, she then identifies the precise constitution of her artistic credo, describing a system of belief that links the early chapters of her own career to this present arraignment of the 'Art Machine'.

'To go back a little, it was very much part of the attitude of painters in the Modern Tradition that while one could and should talk and think about painting, drawing and sculpture, one could not talk expressly about Art itself. This attitude was widely held from the time of the Great French nineteenth-century artists right down to the early Fifties when I was a student. To attempt to talk about Art was regarded as trying to discuss the undiscussable. Amateurs might entertain themselves with this subject and theoreticians too, but it was seen as an academic preoccupation quite irrelevant to the much more serious concerns of practising artists. And these concerns were essentially to do with how to work – the establishing, building up and refining of an artist's metier. Just how deeply felt these attitudes to the craftsman in the artist were,

can be seen, for instance, in Jack Flam's collection of Matisse's writings and statements which he published under the title of *Matisse on Art*. But in this collection Matisse talks only about emotion, expression and painting. There is no statement or discussion of Art.'

To pronounce such certainties, about a cultural profession that takes cultural theory, the abandonment of rules and the potential for rootless reinvention as the greater part of its contemporary definition, must require a mixture of guts and faith. But it is important to remember that Riley herself achieved an early and spectacular success during a time – the early 1960s – when the local and international art scene was, if anything, considered even more controversial and open to the avant-garde than it is today. Looking back at Edward Lucie-Smith's review of Riley's success at Venice in 1968, one gets some impression of the magnitude of her achievement, and the scale of her celebrity, in the context of its times: 'The award of the main international prize for painting to Bridget Riley marks a coming-of-age for British art almost as notable as the occasion when Henry Moore carried off the prize for sculpture just after the war. Miss Riley is the first British painter to be thus honoured, as Moore was the first sculptor. Her rise to fame has been a good deal more meteoric than his, as her first one-man exhibition was held in 1962, and her work was first seen abroad as recently as 1964.'

Thus, in only six years, Riley had become both a household name – along with Twiggy and Mary Quant – and been acknowledged as one of the leading artists of her day. Only Warhol, with an artistic agenda entirely the reverse of Riley's, had achieved this double distinction of mainstream, mass-media recognition and the serious attention of the international art establishment. But what was it, precisely, about Riley's paintings that granted her such an incredible ascent to celebrity? For Riley belonged to no Pop Art gangs, was never seen dancing on 'Ready Steady Go!' – as was her contemporary Pauline Boty – and had been working solely on

the technical problems of her artistic career, with the solitary application of a classical painter. One answer to this question must lie in the singleness of intention with which she translated the complexity of her feelings – her reaction to place as a bearing of witness – into a visual esperanto which was commonly articulate.

But her work would be claimed, with an insistence which became her worst enemy, to have summed up the zeitgeist in a single abstract statement. And this assessment would be the very opposite of her driving beliefs and her artistic intention. Art, for Riley, was most definitely not a means of commenting upon society, any more than it was a simple matter of 'self-expression' – a pursuit at which, as Robert Hughes would remark in his Introduction to *Nothing If Not Critical*, 'no one could fail'. Rather, Riley's calling to art had been inspired by the need to make universal statements, through painting, out of her personal experience of Nature in its most profound aspects. And it is the origin of this calling, as perhaps the most illuminating statement she has ever made about her work, which Riley proceeds to relate in 'Painting Now'.

'When Samuel Beckett was a young man in the early 1930s and trying to find a basis from which he could develop, he wrote an essay known as "Beckett/Proust" in which he examined Proust's views of creative work; and he quotes Proust's artistic credo as declared in *Time Regained* – "the task and duty of a writer (not an artist, a writer) are those of a translator". This could also be said of a composer, a painter or anyone practising an artistic metier. An artist is someone with a text which he or she wants to decipher.

'Beckett interprets Proust as being convinced that such a text cannot be created or invented but only discovered within the artist himself, and that it is, as it were, almost a law of his own nature. It is his most precious possession, and, as Proust explains, the source of his innermost happiness. However, as can be seen from the practice of the great artists, although the text may be strong

and durable and able to support a lifetime's work, it cannot be taken for granted and there is no guarantee of permanent possession. It may be mislaid or even lost, and retrieval is very difficult. It may lie dormant and be discovered late in life after a long struggle, as with Mondrian or Proust himself.

'Why it should be that some people have this sort of text while others do not, and what "meaning" it has, is not something which lends itself to argument. Not is it up to the artist to decide how important it is, or what value it has for other people. To ascertain this is perhaps beyond even the capacities of his own time.'

Riley, as ever, makes a hugely personal statement with no reference to either herself or her work. And it is this quality of impersonality – the simultaneous extinction and translation of the self into its universal expression through art alone – that has been the purpose of Riley's life as an artist. It has been a career fixated on the difficulties of 'seeing' and the massive technical problems of communicating what has been seen, thus prompting Robert Melville, the *New Statesman*'s reviewer of the huge retrospective of Riley's work, which drew 40,000 visitors to the Hayward Gallery in 1971, to comment: 'No painter, dead or alive, has ever made us more aware of our eyes than Bridget Riley.' Similarly, during the current survey exhibition of twentieth-century British art at the Tate Gallery in Liverpool, by far the most popular work is Riley's black and white painting 'Fall' (1963). Defying its monochromatic simplicity, the painting's shimmering surface of undulating vertical lines actually generates colour, from lavender to pale tangerine across the width of its lowest quarter, as the eyes grow accustomed to the stroboscopic intensity of its composition.

Riley's pursuit of lucidity, and the existential terror, perhaps, that could be a consequence of such heightened emotional and optical sensitivity, might be regarded as having driven her to painting as a means of translating her feelings under the protection of technique. Indeed, her very insistence on the supremacy of craft within the art-making process could be taken to suggest an almost

unbearable acuity, for which painting is both a means of release and a form of displacement therapy.

Initially, at Goldsmith's School of Art, Riley found a 'key person' and 'marvellous teacher' in Sam Rabin, who taught her the value of drawing, and, most importantly: 'to order my work, to develop it in methodical stages, to see a thing as a whole, not in part. He stressed the importance of the relationships between things; how everything matters; what to accept of yourself; how to make an advance and consolidate it; make another advance; not to expect advance after advance; how to raise the level of work achieved slowly; to look at the whole movement of what you are doing. That was gold – and something I have kept with me.' This founding tuition would be of particular relevance to Riley's particular aesthetic method as a maturing and mature painter: for each painting she would synthesize a whole series of creative decisions, until, like an algebraic formula, she had 'worked out' the correct answer. This would not be a coldly academic process, but a kind of aesthetic calculus, working from a Proustian sense of time and place.

In the scant biographical notes that have been published on Riley, the period immediately following her graduation from the Royal College of Art, from 1956 until 1958, is referred to as 'the continuation of a long period of unhappiness. Nurses father following a bad accident and suffers a severe nervous breakdown. Works in a glassware shop, teaches children and eventually joins the J. Walter Thompson Advertising Agency, where her job is principally to draw the subjects which formed the basis of the photographer's work.' But importantly, in 1958, she saw the Whitechapel Art Gallery's major exhibition of the work of Jackson Pollock, and in 1959 the exhibition 'The Developing Process' at the Institute of Contemporary Arts. It was in the late autumn of that year that she made a copy of Seurat's 'Le Pont Courbervoie' from a reproduction, and this, in many ways, would be the portal to her own style and the monochromatic drama of her first mature paintings. And, in a crucial development of her work, Riley's

instantly recognizable 'black and white paintings' would be physically made by assistants – a method of working she still employs.

'In 1959/60, when my work changed, a great many conflicting forces in my life and work seemed altogether to precipitate this change. Seurat's neo-impressionism clearly anticipates abstraction, and he lays great stress on perception as the guiding principle. Felix Feneon, the leading critic of his time, in reviewing Seurat's "La Grande Jatte" praised the lack of bravura handling: "Let the hand be numb, but let the eye be agile, perspicacious and cunning." I quite deliberately laid my hands aside and placed the whole burden of the work to be done on the intricate processes of seeing. From the moment I began my black and white work, I relegated the actual execution of the final painting to others. In my terms all the real work had been done: decisions had been reached; studies and preparations completed. In a way my assistants are really part of my medium, in the sense of part of the paint.'

But this vital achievement of artistic direction in Riley's work, which would produce the great black and white paintings of the early 1960s, such as 'Movement in Squares' (1961), 'Blaze 1' (1962), 'Fall' (1963) and the maze-like surround of 'Continuum' (1965), coincided with a personal blaze of anger.

'I was twenty-eight years old at this time. I was having an extremely immature affair with a very nice man who was older than me. I was difficult and hard to handle, doing things he just couldn't be bothered with. He decided to end the affair. I was angry and hurt. I thought: "I'm not going to discuss anything with you. I can't communicate verbally with you, so what's the point in trying? But I'll paint you a message so loud and clear you'll know exactly how I feel." It was then that I started my black and whites.'

Riley's 'black and whites', which would in turn be developed to introduce greys, can be seen as creating a visual language as radical in its technical accomplishment as it is in its sensory

power. She had established a method of working through which the paintings were 'built-up', in a painstaking sequence of exponential decisions, until the finished work was ready to be made by the assistants. Hence, perhaps, the sense of sealed completion in the paintings, which makes them work on a succession of levels, seducing the viewer with their strict and complex patterning, displacing one's accustomed sense of spatial gravity and ultimately refocusing the gaze to the transmitted essence of an emotion. In answer to the critic Andrew Graham-Dixon's charge, during a radio interview 1992, that these early works were 'worrying and disturbing and aggressive', Riley replied, 'I think they were beautifully aggressive. Contrast is the clash of cymbals, the exclamation mark, the strongest possible means. That I wanted: I felt very much at the time like making an extreme statement, of something violent, something that definitely did disturb.'

With the 'violence' of these black and white paintings, Riley would suddenly find herself on the rollercoaster of international celebrity. In one of those classically bio-pic moments that can turn struggling artists into stars, she was sheltering from the rain in a doorway on her way home from work at J. Walter Thompson, when she found herself standing next to Victor Musgrave, the director of Gallery One. The following spring he gave her a first one-person show, and within three years she played a leading role in the major international exhibition, 'The Responsive Eye' at the Museum of Modern Art in New York. More than this, her unique pictorial ideas would have been appropriated by the media, retail and fashion industries of their time to represent, on a crudely commercial level, the swinging urbanity of a drug-friendly zeitgeist.

'I can see that "Continuum" could be seen as a psychedelic stimulant or agent. However, the piece came about in response to the recent purchase by the National Gallery of a large Monet waterlily painting. Like his series installed in the oval room in the Orangerie in Paris, this painting seemed to envelop one – one seemed to be "in" it. From quite another quarter some of Jackson

Pollock's paintings such as "Autumn Rhythm" (which he painted on the floor and physically stood in whilst doing) also seemed to envelop the spectator. But after I had made my piece "Continuum", it seemed to me that it was too physical, too literal, and I abandoned the work altogether and never returned to that form. Incidentally, even the word "perception", which had hitherto had such a precise meaning both in the development of painting and in its criticism, suddenly became, thanks to the popularity of Aldous Huxley's *The Doors of Perception*, linked with the drug-culture of the Sixties.

'I was surprised to be seen as a sort of representative of an aspect of the "psychedelic" culture. It was a collision between my intentions as an artist and the cultural context in which I found myself. I remember being told as though it was some sort of compliment that it was the greatest kick to go down and smoke in front of my painting "Fall".'

These dramatic consequences of her fame – which an artist such as Warhol would have welcomed with open arms – would eventually become a source of bitter fury and personal crisis for Riley, who saw a theft, debasement and travesty of her artistic ideals in this wholesale exploitation of her work. Once again, Riley's position as a modern painter can be seen to pit contemporary art's increased engagement with popular culture against itself, with her artistic seriousness requiring the very reverse of the cultural ambiguity towards which many young artists, to this day, might aspire. At the time of her simultaneous celebrity and despair in New York, Riley was told by an outraged member of the MOMA Council, who felt that she should make personal kudos out of 'Rileymania', 'So you don't like it? We'll have you on the back of every matchbox in Japan.' These days, it could be argued, there are many young artists whose idea of personal and artistic success would be the very infiltration of cultural materialism that prompted Riley to comment, on leaving America, 'It will take at least twenty years before anyone looks at my paintings seriously again.'

And there were several direct consequences of Riley's high-profile celebrity in the USA. In the first place, she wrote a response to her host culture in *Art News*, October 1965, which was published with the pull-out quotation: 'When I paid my first visit to the USA last March, I felt confident that my work, whether liked or not, would be judged with both insight and discrimination. I left three weeks later with feelings of violation and despair . . .' The core of her distress, she wrote, lay in the fact that 'I had been involved in a sociological phenomenon with alarming implications, and one which was disquieting, also, to many Americans. "The Responsive Eye" was a serious exhibition, but its qualities were obscured by an explosion of commercialism, bandwagoning and hysterical sensationalism.' In Britain, the 'look' of her painting 'Fall' had been copied by Richard Shops to include the slogan, 'Such Clever Clothes!' More significantly, with the help of Barnett Newman's lawyer, Riley tried to instigate legal proceedings against such copying of her work, only to discover that in America there was no copyright for artists. That this condition would change was due largely to Riley's defence of her work, and she remains devoutly opposed to what she regards as the misuse of her aesthetic.

'One of the consequences was that American artists and collectors realized how extremely vulnerable they were without any copyright protection of the sort which existed in Europe. A few years later the first Bill to protect an artist from this kind of exploitation was passed in New York State. Barnett Newman told me that it was nicknamed "Bridget's Bill". If I had simply accepted the flood of vulgar plagiarism which threatened to engulf my work without any sort of protest, I would have been destroyed. For this reason I continue to take legal action, as a matter of principle, if my work is abused.'

Between the controversy surrounding 'The Responsive Eye' exhibition in 1965, her equally controversial success at the Venice Biennale in 1968, and the record-breaking attendance to the major

retrospective exhibition of her work at the Hayward Gallery in 1971, Bridget Riley had achieved all of the celebrity that an artist of her comparatively young age could hope for. In the autumn of 1968, she had established the SPACE studio project in London with the artist Peter Sedgley, which would offer workspace to artists at low rental in unoccupied buildings – a forerunner of the current relationship between London's artistic community and the appropriation of redundant or reinvented warehousing and offices. As with 'Bridget's Bill', this was a direct response to a practical or even political issue that her painting had raised.

But throughout the 1970s, with a succession of extended travels to Europe, Japan, India, Bali and Egypt, Riley would be re-searching and refining the progression of her painting, from the growing into colour of earlier works such as 'Cataract III' (1967) and 'Chant 2' (1967). This fundamental engagement with colour, in 'stripes' or more lyrical 'waves', would produce a new dimension in Riley's painting that was a major consolidation and extension of all she had achieved by working in black and white. Inspired by the natural light and landscape of the countries she visited, as well as by their local art history, Riley was pursuing her formative intention to expand the emotional power of Post-Impressionism to engage directly with the senses, communicating the essence of a feeling engendered by time and place within the natural land-scape. And it is interesting to note that in her colour paintings such as 'Paean' (1973), 'Gala' (1974) and 'Entice 2', or 'Aurum' (1976), which prepared the ground for the great colour works of the early 1980s, such as 'Streak 3' (1980), she has achieved the monolithic statements in paint that uphold her desire to make paintings that defy analysis – so sealed is their intensity – save in terms of technique. Thus, through colour, Riley would make good her founding philosophy of art being undiscussable except as craft.

'Colour had defied me as too overwhelming in its potential, and I did have to "grow into colour". "Cataract III" is part of that "growing" – and it was like a landing. I achieved something in

that painting which was unique in relation to what came before and after; it was a high point of a certain sort, and then I went on. "Late Morning" was the next landing – one staircase further up, as it were.'

With a further advance to the 'diagonals' paintings in 1986, Riley's position as one of the major artists of the twentieth century was secure. She would become, almost despite herself, a senior figure within the cultural establishment, as respected for her painting as for her Trusteeship of the National Gallery in London, through which she cleared the way for the creation of the new Sainsbury Wing. Thus, in the 1980s, when the art world was engaging with the ironic kitsch of Jeff Koons or the literary morbidity of the new generation of Glaswegian painters, Riley was beginning to occupy an artistic position that was as radical, ironically, as it had been in the early 1960s. Only this time, as her observations in 'Painting Now' reveal, her radicalism had survived a generational loop in British art history that made her assertion of learning from craft almost doubly controversial.

'If a would-be artist has no form of exercising, no means of practising, no way of acquiring a language with which to make a translation of the kind of text which Beckett describes – then, aside from the tragic and shameful implications of such a situation, this person inevitably starts to look around for some indication of what they should be doing as an Artist. And it is at this point that a fundamental confusion arises. What should come from within now comes from outside. The would-be artist goes searching for Art instead of learning how to be a translator. Expressive forms and methods that once served a specific purpose are treated as a sort of camouflage to hide a fundamental inadequacy. As Stravinsky said in lectures on "The Poetics of Music" which he gave at Harvard in the winter of 1939–40: "that which is without tradition is plagiarism . . ."

'A variant of this problem – with unfortunately a very large following – is a special sort of conformism. But while the previous attitude

is rooted in ignorance and innocence, the second is street-wise. It depends on what has already been accepted as "Art" and is therefore immediately identifiable as "Art". Essentially parasitical, it cares little or nothing for the health of Art and will not invest any effort or take any risks in preserving its traditions. It is a mark of this sort of conformism that it sports a few touches of past radicalism. However, its main objective is deathly – it is to be acceptable, to pass muster, to find a niche, a position in the scene. Radicalism itself is transformed into a fashionable mode of conformism.'

The depth-charge dropped, Riley must see if she's hit her target. Her own career, founded on the honing of personal style to achieve a reactive integrity within the history of her profession, will suggest that painting, as 'that immensely cultivated activity', must revive. Ultimately, her faith in the nature of painting is as robust as her faith in nature itself. Her work describes a constancy of intention that might serve as a model for any form of artistic activity, connecting our motives for making art to the challenge of their execution. And this, in one form or another, will remain a cultural issue of the deepest importance. It was one of civilization's first problems, and it might even be the last.

'But deplorable though the disappearance of painting certainly is, it is only a phase in its renewal. It would be a mistake to think that when painting is not widely appreciated it necessarily means that it is in a bad way. Real confusion does have an advantage in that it makes one determined to try and get it right, and – more to the point – it can stimulate young artists to sort out the mess preceding generations have landed them in.'

Slacker, X-er-type cultural practitioners, through no fault of their own, but as a kind of inherited genetic disorder in their awareness of their place in the world, had become creators of the Exquisite – breathlessly stylish synthesists of earlier ideas and earlier

influences. These people weren't artists (proclaimed their detractors), they were word processors. But where had we heard that before? In 1938? 1956? Every other Tuesday?

But take a reader of the bleaps and squeaks in the zeitgeist who'd been born in the late 1950s, and much of the fizzy and fashionable modern end of culture in the 1990s seemed to be the sum of the worst aspects of the 1960s, 1970s and 1980s: a cultural materialism of bullish self-regard, presenting its political naïveté as somehow confrontational. On the other hand, to a young artist or musician born in the early 1970s, the world and everything in it could seem like one massive dressing-up box, with so many strange and wonderful combinations to try out. Nothing was real – with the exceptions of money, sex and celebrity – and anxiety or 'inner texts' were as archaic and eccentric as stamp collecting, maybe more so.

And yet, the whole point, perhaps, of the gentrification of the avant-garde was that it aimed for total superfice – for dumbness, even, in the American, Kurt Cobainized sense, of covert intelligence. Brian Eno would remark in 1997 how it had become almost mandatory for artists to present themselves as somehow inarticulate – that this was the latest badge of significance. Certainly, the rhetoric of dumbness seemed to go hand in hand with Exquisite. In Soho, just around the corner from the Mercer Hotel, an exhibition at Printed Matter bookshop of fanzines, posters and ephemera by Sonic Youth had seemed to condense the point.

Sonic Youth – such a great name for a rock group. They did Madonna Studies before anyone had thought of Madonna Studies, on a 12″ single by Ciccione Youth, covering 'Get into the Groove'. They do side projects that look like John Cage albums. And the punctum of the whole gentrification of the avant-garde thing would be the irresistible cover art of their irresistible album *Goo*, released bang on cue in 1990: a dumb-looking crude comic book illustration (dopey Campy) by Raymond Pettibon of a punky beatnik couple wearing wraparound shades and looking . . . well,

slightly pleased with themselves. This is a Roy Lichenstein painting by way of Martin Sheen and Sissy Spacek in *Badlands*: the caption on the cover art reads, 'I stole my sister's boyfriend. It was all whirlwind, heat and flash. Within a week we killed my parents and hit the road.'

The Carpenters Meet the Cutting Edge (extract)

Just when your back was turned the Carpenters have escaped from their position as classic soft-pop easy listening and are undergoing a reassessment. The release of a tribute album of Carpenters songs, *If I were a Carpenter*, with contributions from, among others, Sonic Youth, Babes in Toyland and 4 Non Blondes, seems to indicate that the brother-and-sister act from Downey, California, have been given a kind of Life Achievement award from the art punk grunge community. And it must be a new day for those good old dreams if the Carpenters are being claimed as hip.

Richard Carpenter, telephoning from Los Angeles, appears to be flattered, bemused and slightly cautious about this sudden tribute to his work from such an unexpected quarter. Officially, the record's release coincides with the twenty-fifth anniversary of the Carpenters singing to A&M, but he knows there's more to it than that.

'Well, you know the folks at A&M had told me about this project,' he says, 'and I'd heard it was a little, you know, uh, tongue-in-cheek. They wanted me to give the record my blessing and when I finally heard some of the tracks I realized that it was an affectionate tribute. There's some good work on there, with some of the acts following the map of the songs.' He pauses, then asks very quickly, 'What do you think of it?'

It's odd.

The multi-layered sound that Richard created as the luxurious

setting for his sister's extraordinary vocal richness is a pillar of American pop. In purely musical terms, it would be difficult to find a composer and arranger of Richard's age who has come close to his achievements. 'Sinatra will tell you,' he tells me, 'that arrangers are the unsung heroes of popular music – you just ask him.' I promise to do so.

But the Carpenters have suffered from an image problem since their very inception. At a time when rock was heavy and radical – Led Zeppelin, Ziggy Stardust – the Carpenters were considered little more than cloying – a joke. Ray Coleman points out, in his biography of the Carpenters, *The Untold Story*, that even employees of A&M were embarrassed to admit to their rock-biz peers that they were working for the impossibly square Carpenters. Such is the capriciousness of cool: the Spinal Tap generation poking fun at a duo revered by Sonic Youth. Delve around a little, though, and you can see a neat symmetry in this reversal of status.

Linda Perry from 4 Non Blondes proclaims her admiration for the Carpenters with unashamed enthusiasm: 'When I was a kid I thought that the Carpenters were way hip, you know? Like, way hip. I adore the cheesiness of them. I adore . . .' Words fail her. Lori Barbero, the drummer and vocalist from Babes in Toyland, who cover 'Calling Occupants of Interplanetary Craft' on the tribute album, is more specific: 'It's honest music, it really is. And that's like us. It doesn't matter how loud the drums are, or how strangled the guitar, if it's honest.' Which is where the neat symmetry comes in.

At the time of their phenomenal early success the Carpenters were considered by the know-it-alls of rock to be square white teenagers from a cosy suburban home who embodied all the apple pie and soft Republican values that rock was supposed to despise. And, as people, Richard and Karen probably were suburban conformists. Karen told Coleman that she and Richard had given their image 'an enormous amount of thought, which ended up as goody-two-shoes. The fact that we took a shower every day was

swooped on as symbolic. It is all nonsense.' Richard agreed: 'I got upset when this whole "squeaky clean" thing was tagged on to us. I never thought about standing for anything. They took "Close to You" and said, "Aha, you see that Number One? That's for people who believe in apple pie. That's for people who believe in the American flag." And boom! We got tagged with the label.'

Now consider the passage of twenty-five years – which has seen Karen Carpenter die from the consequences of an eating disorder and Richard, according to Coleman's biography, admit to a long struggle with an addiction to Quaaludes. In terms of addiction and illness, there could hardly be two more contemporary problems. White, suburban, drugged, anorexic: read cynically, as pop-cultural icons, Richard and Karen would seem to be the perfect patron saints for the mall-dwelling, vagued-out Generation X-ers of mid-Nineties America. 'Rainy Days and Mondays', as sung by the late Karen, could seem like the direct ancestor of 'Dumb', as sung by the late Kurt Cobain.

But how does this relate to fashionableness? While the Carpenters are probably consigned for ever to the world of remastered Greatest Hits and anniversary boxed sets, they have also been reappropriated by the imaginative cutting edge of new American music, partly because of a kind of kitsch value, but also because their lives complete one of the darker scripts of American Pop Art. Even the Jeff Koons-like serenity and misted edges of their publicity shots plug straight in to post-modern sampling of earlier popular culture.

Richard Carpenter, with gentlemanly good humour and a certain amount of reserve, remains baffled by the style war being fought over the Carpenters. 'Karen and I never thought of ourselves as being hip or unhip; we were just a pair of kids from the suburbs who suddenly found themselves world-famous for their music, but were having all kinds of missiles thrown at them. You know, some of those critics even used to review the audiences of our shows' (the same thing happened to Roxy Music, but for

different reasons) 'never mind the music! The point is, with the exception of "Please Mr Postman", the Carpenters were strictly not bubblegum pop, but that's the label they stuck on us.'

Despite the lack of critical generosity from certain parts of the press, the Carpenters have sold more than ninety million records – so they must have been doing something right. Subsequent to Karen's death in 1983 from anorexia nervosa-related heart failure, Richard has set up a fund to help research into eating disorders at the University of California, Los Angeles. 'I still don't understand it; I still don't know why,' he says. 'I guess that in hindsight we have 20/20 vision, and we can say now that we ought to have held back a bit from the pressures we were under, but at first we were having a ball. Then we were just too busy to stop . . .'

If I were a Carpenter, as a tribute to Richard and Karen, would be easy to place – alongside Todd Haye's *Karen Carpenter Story* movie, made with Barbie dolls – as a piece of rather knowing Camp. But however each song is interpreted, the timelessness of the originals seems to shine through, as though generations of pop consumers have grown up knowing every word to 'Yesterday Once More' or 'Top of the World' but have been afraid to admit it – like the staff at A&M in the Seventies who would joke about their dealings with the Carpenters while receiving their salaries from the Carpenters' hits. You like to think that *If I were a Carpenter* is an act of cultural liberation – 'It's OK!', we can finally admit to one another, 'I liked them all along too!'

You also get a reminder off the tribute LP just how bleak and melancholy a great many of the Carpenters' songs really were. In a classic example of the best pop working as a hybrid of opposed elements, it is the richness and warmth of Karen's voice that makes the despair in the songs appear dipped in liquid chocolate: 'Goodbye to Love' and 'Rainy Days and Mondays', as sung by American Music Club and Cracker respectively, are revealed in all their depressive attitude. Sung without Karen's pitch and tonal purity, the lyrics come across like Leonard Cohen mixed with the Swans.

Sonic Youth, the group that has contributed a cover of 'Superstar' to the tribute, recorded an earlier Carpenters-related track, 'Song for Karen' on their *Goo* album in 1990. A roaring and relentless rock track, its lyric surveyed Karen's descent into uncontrollable eating disorder. Mark Eitzel, from American Music Club, whose cover of 'Goodbye to Love' opens *If I were a Carpenter*, says, 'The Carpenters' sound is wonderful, orgasmic. It's almost pornography – and yet the music is absolutely honest. Which is why you have to be a bit heretical in covering a song like "Goodbye to Love"; you just couldn't replicate Richard's arrangements. On that song, Karen used to sing like she was almost happy, despite the tragic, heart-breaking lyrics.' Richard Carpenter himself comments: 'Some people have tried to dismiss us, but in the end they can't touch our music.'

It is almost as though there is enough strangeness and ambiguity in the Carpenters legend already: their links with Pop Art are derived from the duo's perfection as the very source material for Pop Art – Karen's obsession with Mickey Mouse, or the fact that Richard wanted every Carpenters show to present exact reproductions of the recorded songs. There is something Warholian in this, echoing Warhol's love of constant, replicating sameness. Add to this the sort of tragedy of Karen's death and Richard's addiction, and you have, in the heady mix of glamour, banality, bad luck and populism, an image irresistible to any post-modernist on Prozac or a cutting-edge American pop group with an X-er's eye for their own pop history.

But at the same time, you would like to release the Carpenters from the periodic table of cultural status – Pop Art? Kitsch? Post-Modern? – and simply admire their beautiful music. As Mark Eitzel puts it: 'To be ironic about the beauty of the Carpenters you'd have to be a real asshole.'

But anyway, here we are in the lobby – it's small, considering the size of the building it supports – of a hotel so expensive that it doesn't have a name. In fact, it doesn't seem to have anything in it at all, except for two Empire consoles on ball and claw feet and a long leather sofa. It could be the foyer of a chartered association or a private apartment block. There's a green telephone on the wall beside the sofa. Beside the telephone is Hanson's East Coast publicist. He's a tall young man, around thirty, whose fringe falls into his eyes, and whose bearing is ever so slightly rigid and aristocratic. High cheekbones, and a rather sardonic expression; he speaks in a series of sighs, with a slight lisp.

'Today ith my bed's birthday.'

The statement was thrown out, more conspiratorially than casually, during the waiting-for-Hanson small-talk.

'Tho I'm gonna throw a party for my bed. Juth me and it . . .'

You allow your features to widen in a bland, appreciative manner.

'I got a cake and everything . . . and a prethent.'

A light began to wink on the green phone. The party-thrower picked it up. 'Oh hi Taylor; how are you? Uh-uh. Yeah, ith today – you're tho nithe to remember! OK.' He turned to face you, beaming. 'We can go on up.'

Then there were young, creative, pop-drive people who ought, by rights, to be X-ers and Slackers but had somehow – by choice or error – missed the bus to Nowhere. In fact, there were millions of them, harmonizing a propagation of positivity, just as Kurt Cobain was being morphed into sainthood. Most of them probably ended up taking their place in the funky dot.com corporate workforce.

The brothers Hanson were to be found twenty or so floors above the curiously empty-looking lobby. A corridor, thickly carpeted, and yet, despite the unimaginable room rate at such a hotel, somehow still faintly forlorn, led to an outsized door, which looked as though it had been designed by and for a race of giants

from the far future. The size of the door was a major indication of the fact that the suite it opened on to had a balconied view of Central Park.

A chirpy, fresh-faced teenager (one look from whom was currently capable of short-circuiting the serotonin levels in teen and pre-teen girls around the world – which, at an average earning on Hanson-related produce of around, say, $100 per girl, represented quite an achievement) peered around its edge, before scuttling back to his cereal in his t-shirt, sports socks and chinos; entering, you expected to see discarded *Star Wars* pyjama sets, or little heaps of schoolbooks, or to hear the beginnings of a 'Did', 'Didn't' kind of fight.

The enormous, five-roomed suite – designed to imply a presidential scale of importance to the occupant, yet still elbow to elbow with the ethos of courtesy shower-caps and dusty bowls of fruit that seem to lurk in waiting at the dizzy heights of most pre-boutique-hotel-era hotels of the Chesterfield sofa and Carvery kind (no neroli-scented candles and George Harrison songs in this kind of chain) – had the cheerful, rough-and-tumble atmosphere of a middle-income-bracket, suburban family home, probably from one of those big, square dusty states, somewhere in the middle of America.

As the suite was intended for Dom Perignon on ice, corporate entertainment canapes or the rustle of diaphanous lingerie from Veronica's Secret, it had been taken over by aura of fridge magnets, cartons of juice and a plastic laundry basket. Where the Paramount encouraged infantilism de luxe in its guests of early middle age, so this imperial, slightly melancholy expanse of hotel space seemed to be imposing the values of an older, more conservative idea of luxury on its three remarkably young celebrity guests.

It made you think of Madison Avenue executive culture from the late 1970s, of successful businessmen with lined faces and silvering hair, still smoking despite their atheroma and getting ready for the second divorce. In fact, here was youth in the aura of

mid-middle age: a direct reversal of needing your almond-flavoured latte or going home to hold a birthday party for your bed.

Hanson's father (and manager) was, 'like God in His universe: nowhere seen but present everywhere'. Just every so often, directly after certain questions during the interview, you would hear him cough – a short, dry cough, halfway between throat clearance and a direct order – from some little sanctum deep in the heart of the suite. And then the subject would be changed.

Hanson, Children and Pop

'Judge us by our music, not by our age – that's what it's all about.' With a hint of weariness way beyond his years, Taylor Hanson, the fourteen-year-old vocalist and keyboard player of teen sibling pop sensation Hanson, has just put his finger on the blessing and curse of being an extremely young pop star. With the exception of seventeen-year-old Issac, who is the oldest of the three Hanson brothers – Zac, the drummer, is twelve – this is a group whose early adolescent androgyny has lent them angelic, if cracking, treble voices and a disturbing physical beauty. With a strain of Dane unleashing the genetic fizz that gives the boys that perfect shade of natural blond hair, their dark, straight eyebrows and wide mouths, the Hanson countenance oozes an ambiguity of gender that plays havoc with the hormones of teenage girls from Tulsa to Tokyo.

Taylor Hanson is not only regarded as the brains of the outfit – in terms of articulating the group – but is also routinely compared, in his appearance, to the young Kurt Cobain. On closer inspection, he resembles a cross between Lord Alfred Douglas and the young Meryl Streep. Zac, at a glance, has the full-lipped sensuality of Brooke Shields creating sexual anarchy beneath the standard white American puppy-fat of his pre-teen features. Issac alone is growing out of 'the awkward phase' and into the features

of manhood. Sitting in a somewhat bouncy row on a sofa in their hotel suite overlooking Central Park, the Hansons present a triptych of bright faces. Dressed in baggy casual clothes, they are eager to talk and extremely good-natured.

'Think of us as old guys with high voices, that oughta do it,' pipes up Zac, as his brothers begin to discuss the problems of being perceived to be too young to be in a pop group. His point, which gets to the heart of the matter, is met with a sudden brief silence. Zac shrugs, and continues to play with a miniature brass tripod and a magnifying glass. From time to time he holds the glass over his right eye and stares ghoulishly with one enormously enlarged pupil at whoever might be watching. Taylor tends to speak with a healthy degree of conviction, while Issac, one feels, is a little too ready to respect the opinions of his critics. Zac alone, imperious within the fun factory of his twelve years, does not seem to care that much what anybody thinks of Hanson, because the facts speak for themselves.

Hanson write and perform a proportion of their own material, and their debut single 'MmmBop' went to Number One in twenty countries, while the subsequent CD, *Middle of Nowhere*, has sold around six million copies. What you get is a highly polished rendition of white American soul, with musical references to early-Sixties close harmony singing as well as a reasonably sharp edge of post-grunge rock. With regard to songwriting collaborators, Hanson worked on *Middle of Nowhere* with Mark Hudson of Aerosmith, Belinda Carlisle's writer Ellen Shipley, and Barry Mann and Cynthia Weil, who wrote for the Righteous Brothers and the Crystals. The album was produced by the Dust Brothers, who also produced Beck's celebrated *Odelay*, and by Steven Lironi, who worked with Black Grape. *Middle of Nowhere* has been widely acclaimed as a classic pop album.

The Hanson brothers are middle-class boys from Tulsa Oklahoma, whose father was an oil manager before he managed his sons, and they come from a close-knit, comfortably off, quietly

Christian family. All three of the boys studied classical piano for between five and seven years. They have two younger sisters and a younger brother, none of whom is involved in music as yet. But when the latest Hanson – Zoe Genevieve – was born earlier this year, *Top of the Pops* magazine reported the news with a mischievous aside: 'Not long before she starts playing the maracas we don't suppose!'

This suggestion, that the group will expand to include other family members – like the Osmonds or the Jacksons, with whom Hanson have been regularly compared – is met with the nearest that the Hanson brothers seem to come to indignation. But even in their disagreement with the highly cynical notion that Mrs Hanson can more or less give birth to cash flow, the group manage to show not only respect for their ancestors in pop, but a worrying amount of modesty and humility with regard to their own considerable achievements.

'I really don't like comparing us with the Osmonds, the Bee Gees, the Jacksons ...' begins Zac, shaking his head in awe at the madness of such an idea.

'Right,' affirms Taylor, preparing to brandish the party line on this particular point. 'We hate to compare ourselves with those groups, because those groups were such incredibly successful groups. I mean, like, we're successful now, but who knows ...'

'Those groups had careers that lasted decades,' states Issac, 'and for us, we can only hope that we can do this for as long as possible.'

Sociologically, Hanson represent a new generation of bright young Americans who have succeeded the Prozac Nation of grunged-out slackers for whom glazed-eyed smart negativity was an ideology as well as an aesthetic. They are unironic materialists for whom the post-modern stance of slackerdom would be as irrelevant as the *Tibetan Book of the Dead*. Isaac will later suggest that one of the benefits of conformity is to be 'a more productive co-worker'. Their values are closer to the classic American ideal

– mythologized as Apple Pie America – of church, home and family being reflections of each other in a semi-rural Eden. As Dorothy remarked on her return to Kansas, 'There's no place like home!' They are, to coin a phrase, regular guys. But herein lies a further problem for Hanson as a group: that their wholesome, positive image, they sometimes feel, distracts from their musical talents even as it provides them with nearly all of their audience.

'When we were doing our latest video,' Taylor continues, in his fast, targeted manner, 'there were these punk guys in it with tattoos and stuff and earrings all over their faces, and they were saying how they'd, like, never do a video with Hanson. But once it was over, they were saying that they really liked our music. Which I guess is totally understandable, that someone would see just three guys who are extremely young and cute and say, "Oh those kids", but then they hear the music and they really like it.

'A lot of people have asked us, "Why are you in a band when you're so young?" and we say, "Well, what are we meant to do? Wait until twenty-one before we start making music?" We couldn't just not make the music.'

'Or wait until we're eighteen, and then say that we knew we wanted to be doing this ten years ago,' adds Zac.

The fact that Hanson are from a middle-class background and raised within the work ethic of business-class America has been used to explain not only their success but their very existence as little more than a carefully manufactured showbiz product. And this would place Hanson in a long line of commodified American child stars, stretching way before the unashamed rule of the Osmonds, who began as a novelty act on the Andy Williams TV show. Being a culture of public confession and public sentiment, America has a tradition of child performers that goes back, inevitably, to the child stars of Hollywood such as 'The Little Rascals' and 'The Dead End Kids' – names that sound like second-generation punk groups now. And it's a risky route to follow.

Unlike the Jackson 5, whose credibility as a pop soul band was

underwritten by their virtual reinvention of Tamla Motown's ability to place black acts in a white marketplace, the Osmonds were seen as a strictly pre-teen phenomenon and therefore something of a joke. In the documentary made about the Osmonds in 1997, a now middle-aged Donny made the perceptive and courageous observation that: 'You have to remember that teenagers, for the most part, hated us. Young kids and old people loved us. But the teenage rock fans couldn't stand us.' And this is a problem the Hansons have inherited, and which the immaculate choice of their songwriters and producers on *Middle of Nowhere* must be trying, in some degree, to solve.

'People say that girls like us, so we can't be any good,' begins Zac, 'but . . .'

'I'm sure that the fact we all have long blond hair doesn't help much, either,' interjects Issac.

Taylor is the most insistent about Hanson's musical ability within a region of pop that respects authenticity above all else. 'A lot of people, when we go to a radio station, say to us, "Do you use tapes?"' he explains, 'and we say, "No, we really play." And then they say, "Oh, so you use tapes some of the time?" and we say, "No! We're the band! We do it! It's just us!" And it's like nobody seems to understand for a single second that it could be possible that we are actually playing our own music.'

Issac is slightly worried by the forcefulness of his brother's argument. 'Well . . . I can understand their point of view,' he says, 'I can really sympathize with that. I mean, for me, it would be hard to take myself seriously. And from the point of view of a person just standing there watching all of this happen to us, I guess that I would be very, very sceptical.'

In keeping with the traditional American ethos of family groups of child entertainers, to say nothing of the showbiz mythology of the local kids who get spotted at a talent contest by the big producer – as defined by countless Mickey Rooney and Judy Garland films in the pre-dawn of the teenage musical – Hanson's

earliest success came from 'doing the show right here!' They would sing acapella, in perfect pitch, for whoever would stand still for long enough to listen. 'We wanted to be a Boyz II Men/Ace of Bass-type group where we can sing harmony and dance,' Issac announced to *Urban Tulsa* magazine at the time. Eventually, at the South by Southwest music conference at Austin, Texas, in March 1994, they caught the attention of a Grateful Dead fanatic and entertainment lawyer called Christopher Sabec, who asked to represent them.

Encouraged by his interest, the Hanson family put out an independently produced album called *Boomerang*. This, one should remember, was at a time when the big record companies were looking for the next Nirvana rather than the next Osmonds or Jacksons. But within the phenomenon of Hanson, what was important about this route to celebrity was its conformity as a modern American fable, and, to a great extent, its stamping of their image as a group with a particular morality. The Hansons were not so much rebels without a cause, as a cause without any rebels.

Central to this morality is the Hanson family's Christianity, which the group are proud to acknowledge but refuse to dwell upon. Unlike the Osmonds, whose global power as unofficial evangelists was such, between 1971 and 1974, that the Mormon Church to which they belonged was soon being besieged by teenage girls trying to join it, the Hanson brothers have no desire to foreground their faith in their music. They are unlikely to record their equivalent to 'The Plan' by the Osmonds – in which the group delivered their theological worldview – but attempt to make all of their music 'positive'. Similarly, they are extremely anxious to avoid making their faith a central facet of their image, thus avoiding – for example – the somewhat Devoesque presentation of Christianity that the Danielson Family are putting forward in their group.

'Our faith is definitely very important to us, but we don't like to make that an issue with other people,' says Taylor.

'It's just another box that people could put us in,' adds Issac. 'It's what we're about, but we don't want people to feel any segregation because of that.'

Asked what their record company would say if the group chose to record an anti-war lyric in the event of a second Gulf War, Zac replies with disarming honesty: 'They'd most likely ask whether or not the radio stations would play it. And as long as the radio stations would play it, that would be OK . . .'

'I think that Dylan did influence people back in the Sixties, with all the protests against Vietnam and stuff,' adds Issac.

'Dylan and Joplin absolutely changed things,' says Taylor, 'but I don't know if a record could elect a president or get somebody out of office.'

For the Hansons, who lived in South America when their father had to move there for his work, it was a *TimeLife* tape of Fifties rock and roll that became the primary inspiration for their own music. It can thus seem as though their musical tastes as much as their beliefs – as far as it could possibly be fair to judge teenagers by their emerging opinions – have jumped three generations to miss out all of pop and rock's principal function as protest music, be that punk, hip-hop, or the long shadow of Woodstock. Hanson's innocent brand of good-time pop is most reminiscent of the innocent age of American pop itself, when teenage TV shows – such as John Waters satirized in his film *Hairspray* as 'The Corny Collins Show' – became the rallying point for an effervescent sensibility that rode the melodramatic roller-coaster of being a teenage pop fan.

Hanson's struggle with credibility is the logical consequence of trying to be accepted as a serious band in the face of pop music's long-running incompatibility with child stars. Seized upon by the heart-throb hungry teenzines, a group such as Hanson finds their principal audience in the millions of young girls who are historically famous for their fanaticism, but for whom pop music is a kind of hormonal gymnasium in which to develop their emotional

muscles. These are the daughters, quite possibly, of women who screamed at the Osmonds in the early 1970s, and the younger sisters of girls who mobbed Bros in the late 1980s. In the late 1990s, with the rise to commercial power of children's programmes such as 'Live and Kicking' – on which every teen group should showcase if they want to get straight to the pay-load of pocket-money – there is a sense in which a significant amount of pop is being marketed and mediated to an increasingly younger audience. The term used by the record companies and media playlists is 'pre-teen', and right now pre-teen rules.

In the past, child pop stars such as Little Jimmy Osmond – whose solo recordings were as lucrative, in some territories, as those by the Osmonds as a group – were regarded for the most part as a novelty act. In keeping with the notion of the showbiz family, there was an aspect to their performance that was slightly grotesque in the same manner that circus sideshows had blurred the boundaries between cute and curio. Consequently, Little Jimmy Osmond's 'Long Haired Lover from Liverpool' was regarded as a cabaret novelty act, as was Lena Zavaroni's hit of 1974, 'Ma, He's Making Eyes at Me'. Less well-known were the Williams Twins (Andy Williams's nephews), and Our Kid – neither of whom made much of an impact beyond being test-driven – and crashed – as potential teenzine heart-throbs.

Singing acts such as these had had their equivalent at an amateur level in Britain, in the late 1960s, on a programme such as 'Junior ShowTime', which maintained the tradition of the local talent competition, but seldom saw pop as a major part of children's activities. Closer to the pop sensibility was a series such as 'The Double Deckers', which took the innocent comedy of Cliff Richard and his pals in *Summer Holiday*, and simply drained off the songs and the love interest but kept the double-decker bus. Similarly, Ed 'Stewpot' Stewart's Radio One show 'Junior Choice' – on which the Osmonds guested in 1972 – was the only radio show that broadcast music for a young teen and pre-teen audience.

Pop, per se, was still seen as an adolescent option because it was linked to post-pubertal sexuality.

The loose cannon in pop's engagement with childhood has always been the vital element of sexuality. Pop, traditionally, is built upon the translation of sexual desires into a musical form that can make the sexual element as suppressed or explicit as you want. A major aspect of the appeal of very young stars, as well as boy groups, is the projection of their safe, fun-loving, ordinariness as people. Like Hanson, whose occasional 'mad antics' could set them up as idealized pre-teen boyfriends, the mediation of young pop is more concerned with 'being mad' than with music.

But where does this leave Hanson's attempts to create a new audience for their music beyond the armies of screaming girls who have greeted them at record signings in shopping malls from Canada to Korea? On the one hand, they have been credited with producing a great pop LP that could cross generational barriers, on the strength of the music, in much the same way that George Michael's 'Faith' achieved in the 1980s – becoming a yuppie soundtrack as much as a teenage 'pash sesh'. On the other, they are staring down the barrels of the same cynicism that questions their 'authenticity' as much as their age. Taylor is swift to defend their right as musicians – not as young teenagers, or Christians or child celebrities – to sing about whatever they want provided they are being true to themselves.

'Music and songs are just a description of life – not of your age or who you are. We always say that we don't think of ourselves as seventeen, fourteen and twelve, because we're not thinking, "Let's write a song about lollipops." The feelings are the same whatever your age in life. If your girlfriend rejects you, the feelings are going to be the same whether you're twelve or eighteen or forty-five – you're still, basically, going to feel really bummed about it. And the feelings of feeling awkward and uncomfortable – like you don't fit in – they're going to be the same, whatever your age.'

'Of course, you hope that your career will last decades, but you

never know,' says Issac. 'You just have to keep on making music and hope that people will continue to find what they found in your music originally. And you hope that people will continue to expand with you, as you advance in your musical style.'

Interviewed in 1973, Alan Osmond stated, 'We try to stay one step ahead of our fans if possible. If we are good musicians, then the fans will grow up with us. In two years, we'll have an older audience – just as the Beatles took their audience right with them.' For pop groups which have first success very young, there is always the danger that they will be judged by their youth for ever – locked for life in a version of themselves that can never age. They become Dorian Grays in reverse: their pictures stay young and wholesome while they must parade their age, mistakes or misfortune. And this, in many ways, is directly linked to our understanding and assessment of teen and pre-teen pop phenomena.

There is always a sense in which we tend to judge groups such as Hanson, or the Osmonds or the Jacksons – or Musical Youth, or Five Star, or anyone who became a star very young – with an eye to their possible downfall. In accordance with some sadistic whim in the collective consciousness, there is a reflexive desire to find an animating drama in the subsequent failure or tragedy of the former child star. When Michael Jackson was accused of child abuse, the world's opinion was divided. This appears to be coupled with a desire for virtual revenge on groups and performers who present a sanitized or overly sensible view on a society which we know to be irrational and immoral. Hence, from Judy Garland's subsequent decline into addiction, through the young Karen Carpenter's coronary from bulimia, or the reduction of some of the Osmond brothers to little more than cabaret entertainers, to the decline of two of Musical Youth to stealing cars, we find an adjustment of fortune in this falling of the mighty that satisfies some unattractive but primal sense of justice.

Hanson, however, are sons of the material world. Whether it is instinctive or tutored, there is a robust logic in their polite

refusal to discuss anything about themselves save their music. As musicians, they can succeed or fail according to their talent and their luck. As vulnerable teenagers, made into interesting cases by the discrepancy between their youth and their celebrity, their every unguarded utterance could come back to haunt them. In this, their very regularity as middle-class young Americans is their last line of defence. They like to hang out with their friends and go to the movies.

<div style="text-align:center"><◇></div>

Was there a birthday party for the bed? Probably.

Beneath clear blue skies, Manhattan froze. By early afternoon, looking out over the water, you could see what seemed like little copper-coloured flares of light, bouncing off distant windows and roofs, as the rust-red sun began to set. The frost didn't melt all day. Everything seemed still, and far away, looking down from the cheesily rotating, vast but nearly empty cocktail lounge at the top of the tallest hotel on Times Square. There was a melancholy in the stretched oblongs of canvas-coloured sunshine that fell away from the tinted windows – the melancholy of empty corridors leading into vacant sun-traps, with the stifling smell of warm carpet tiles and hot metal.

Very slowly, round and round you went, the circling business tourist, chin on hand, watching the winter sun cast deep shadows down towards the docks, which, despite the cold, made you think of the city in a heat wave – Jacqueline Susann's 'New York was steaming – an angry concrete animal, caught unawares . . .', flat roofs and fire escapes. On the glow of a glass of Merlot the moment seemed eternal, as ever so slowly, chug, chug, chug, the cocktail bar went through another circuit.

Hanson seemed like dots, now. So high up, looking at the sun and the cold and the distant flares of copper-coloured light, it seemed as if you were looking back through time – through the

Eighties and the Seventies and the Sixties, just back, through an accretion of anonymous memories, eloquent through the sun on stone and concrete and metal. At heart – and here we go around again, looking towards Grand Central Station now, just there, through that – missed it! Next time . . . these sites of anonymous memory articulated the glamour of the unknowable, and of the arcane: as ancient-seeming and esoteric as Hittite carvings, or maybe more so.

Infantilism and old age – now there's a topic to toy with, as you order another glass – generous now, with amiability, comfortable and content, serene in the poetry of the moment, as chug, chug, chug, the cocktail bar rotates, and the cold clear sky begins to slip from blue to copper to pink, and the lights twinkle, and there you are in tune with the infinite, just pointlessly going round, and round, and round, soundproofed . . . Infantilism and old age, here in Manhattan . . . What was it Quentin Crisp had written in response to Liberty's 'huddled masses yearning to breathe free'? – 'If ever there was a huddled mass . . .'

Quentin Crisp on the Lower East Side

Approaching the towers of Manhattan on the expressway from John F. Kennedy airport, you might well be reminded of the moment in *The Wizard of Oz* when Dorothy and her companions get their first glimpse of the Emerald City. There is the same sense of visual fanfare as the soaring buildings announce themselves to the dazzled traveller; there is the same ecstatic tug on the imagination – described by the best of Manhattan's story-tellers, from F. Scott Fitzgerald to Woody Allen – that here is the place where dreams might just come true, but where success or failure are balanced on the fulcrum of a lucky break.

If Manhattan could double as the Emerald City, then to whom might we turn as its presiding Wizard, able to remind us that our

hearts and brains and courage were in our own possession all along? A couple of decades ago, the role would have fitted Andy Warhol like a silver wig, as he reflected America back to itself in the surface of his eerily glamorous paintings. Now, as the century drew to its close, the tinfoil crown of New York's principal seer and underground analyst surely rested on the violet coiffure of Quentin Crisp – an eighty-nine-year-old Englishman living on the Lower East Side, who had described his occupation as 'breathing', but whose life as 'a self-evident and effeminate homosexual' has entered the mythology of modern times and marked him out as their survivor. 'Happiness is the only thing which I can understand,' he remarked in a tone of voice which is halfway between the cooing of a dove and the creak of a wardrobe door, 'so I can tell people how to be happy.'

Quentin Crisp – whose name was Dennis Pratt 'before he dyed it' – was born in Sutton, Surrey, in 1908. For sixty-six years he wore a mixture of lipstick, powder and bruises as he struggled to survive – by his own admission incapable of forming any loving relationships – in a London that took his undisguised homosexuality as the justification to jeer at him, spit at him and beat him up on a more or less daily, if not hourly, basis. He worked as a commercial artist, a part-time prostitute and an art-school model before his autobiography, *The Naked Civil Servant*, was made into a play for television in 1975, starring John Hurt as Crisp. In a rare case of literally overnight success, Crisp himself became as famous and admired as he had once been obscure and despised: his 'case' was taken as the perfect temperature reading of England's social climate across the twentieth century.

By 1981, he had moved to New York, fully engaged in what he described as the profession of 'being' – writing, acting, but principally being himself for a new generation of acolytes who took the defiance of his individualism as a street-wise, post-punk, glamorous form of existentialism. Crisp's style, in this account, is of infinitely more interest and importance than his sexuality.

Within the counter-culture, gay or straight, his perseverance has made him heroic.

He lectured to packed halls – but he still lived, as he always had, alone in a single filthy room. 'After four years,' he once declared, 'the dust doesn't get any worse.' Now listening to him as he sits in his little room, aware of the peevish hissing of a scalding radiator, the piles of dusty books and the limp net curtains black with grime, one begins to realize just how Crisp's philosophy of life was derived from simply sitting in coffee shops and talking.

'I live in twilight now,' he said, leaning back on his bed to gaze up at the brown ceiling with soft, grey eyes carefully outlined with mascara, 'but the reason why I came to America is that I need a constantly changing audience, because I say the same thing over and over again. Recently, I went to Portland, Oregon, and said the same things – but it seemed new to them because they had never heard of me; soon, I shall be going to Washington and saying the same things there. In that sense, I am like Walls ice cream or Hershey Bars – always the same. I am infinitely visible; I go on to television, and television, as you know, contains a sanctifying element. People cross the road, at the risk of losing their own lives, to say, "We saw you on the telly" – and their faces are glowing. It is all that you can do not to reply. "Bless you, my child." But all I have said is this: that you should find out who you are, and do it like mad. Style is being yourself, but on purpose. And this is what I tell people, but I don't know that it's the secret of life. I don't know, in fact, if life has a secret.

'People are my only pastime, and they always have been. I used to pretend that I was interested in art or literature when I was young, but really I was only interested in people. I said that no one could be boring who would talk about himself and I was laughed to scorn by the English press. So now I say that no one is boring who will tell the truth about himself. Everyone has a story in the truth about themselves, and lives, as such, are like wonderful novels.'

There is a sense in which Crisp's own life, as it caught the public's imagination in *The Naked Civil Servant*, became a modern *Pilgrim's Progress* describing the feelings of being misunderstood, isolated or denied that can occur within us all. Written out of the experience of being conspicuously different in an era that took great pains to appear conventional above all, Crisp's autobiography revealed a mixture of pragmatism and sagacity towards the hardships of a life that was neither distinguished by artistic genius nor sweetened by money. However bohemian or eccentric his situation might have become, Crisp was forced to maintain the armour of his pose in the face of not only daily scorn but the need to earn a wage.

'When I first came to London, I lived in the very worst parts because I had no money. You see, my parents were not concerned with my sin, they were concerned with my unemployability; I never heard the word "homosexuality" until I was at least nineteen. But my parents thought, "What's to be done with him?" And so I worked as a commercial artist and I taught tap-dancing and I was a model in the art schools – but I never had any talent for any of these things. What else could I do?'

The determination to survive and find happiness, rather than the political concerns of homosexual equality, has granted Crisp's theology of 'being' a curious ontology, a place in the canon of twentieth-century literature. And yet *The Naked Civil Servant* was written only because someone remarked that it might make a bit of money.

'An art master at Maidstone said to me, "You despise art because you are a work of art," and so I smiled and lowered my eyelids. I am an autofact; I am self-creating. When people say, "What have you got against pictures?", I cannot help replying, "What have you got against the wall?" I have been asked if I have any regrets, but you can't have regrets if you never had any alternatives. Now, you could look back and say, "Why did I marry that wretched woman?" or "Why did I stick at such a boring job?";

but I knew the people who could put up with the disgrace of knowing me, and I did the jobs from which I didn't get the sack for looking the way I did, and I lived in the digs from which I would not be evicted for the same reason. And so I seem to have lived in a straight line to the present here, because I had no alternatives.'

Within his sixty-six years of struggle, prior to his celebrity, Crisp found friendship of sorts with a succession of misfits and bohemian outcasts: a disabled suburban girl who became a nun, her unfaithful Czech lover who fell in love with Crisp before hanging himself, a nagging young man called Thumbnails and a paranoid civil servant. From this unlikely cast, Crisp had to select his few companions of more than one night's standing. The frozen core of his desire he reserved for 'The Great Dark Man' of his dreams, whom he knew he would never meet because the rampant heterosexuality of this 'real man' was essential to his perfection.

'I don't know where the theory of eternal love came from, because most things are not destined to last a lifetime. But you cannot say to a woman, "I love you madly until next Wednesday." And why? Why does love have to be eternal? I am not suited to living with anybody. For one thing, I've always lived in one room. My room in London was no bigger than this one, and to be with somebody I would need two rooms, because you must have somewhere where you can go away and be your horrible self.

'Because all of the time you are with someone you are "on". I once had a relationship in which someone came to see me every weekend, and my life became a series of weekends for which I prepared and from which I recovered. I found it so exhausting. But I do love the whole of the human race; I have stretched my love horizontally, rather than disposing of it in depth.'

His literal-minded approach to personal relationships, however much it can be excused by a broader love of mankind, suggested that Crisp had no use for intimacy in a life that cannot yield up to him his Great Dark Man. You could say that Crisp has been

forced by his temperament into a kind of involuntary spirituality. As a powdered guru unburdened by partner or possessions, he can give voice to that strand of selfish individualism that exists within us all, but that he has refused to gag with compromise. Such a philosophy, in the mind of a fellow-'autofact' and existentialist such as the writer and thief Jean Genet, would lead to a moral struggle with God – whom Crisp refers to as 'You Know Who'.

'I was asked if I believed in You Know Who by the audience at a lecture when I first came to America. And I said, "I am willing to answer this question, but I would not like to say anything which shocked anybody." And a man in the audience said, "Why stop now?" But if You Know Who is the universe which encloses the universe, or if He is the cell within the cell, or the cause behind the cause – that I can understand. But I cannot believe in a God who is susceptible to prayer – that seems to me absurd.' Crisp is also mystified by the idea of a jealous God. 'I never understand why God is so angry. If I were God, I would say, "Well, shop around, and if you see anything you like better – stay with it." I mean, all that power and mean with it? So I am a bit uneasy with my relationship with You Know Who, and doubtless He is a bit uneasy with His relationship with me. Because I do mention Him constantly.

'When I first lived in London, in the Twenties, I lived in King's Cross and Clerkenwell, and the difficulty was how to get home from Soho. And I was shocked by the way I was treated; but now I know that the boys who hit me over the head were people who would push their mothers downstairs because she wouldn't give them one and ninepence to go to the pictures with. It was a physical world and I was a part of it, but I don't think that God would do anything about that because His view must be so big. We are a tiny planet on the edge of a tiny galaxy – I don't think that He can care about us.'

In the past twenty years, Crisp had also written *How to Have a Lifestyle*, *How to Become a Virgin*, and, most recently, his best-

selling New York diaries, entitled *Resident Alien*. He had also performed on-stage as Lady Bracknell in *The Importance of Being Earnest*, and in several films including Sally Potter's adaptation of Virginia Woolf's historical fantasy, *Orlando*, in which he played Queen Elizabeth I, 'the Virgin Queen'. Since losing the use of his right hand, he has taken this as a sign from You Know Who that he must stop writing, although for a brief while he dictated his diaries to an operator on the Internet.

Increasingly, despite (or because of) his age, Crisp was asked to add what Warhol defined as 'aura' to aspects of contemporary culture. Posing for a Calvin Klein jeans advertisement, Crisp took one look at the photographer's mise en scène and asked 'What does it mean?' In one of the fastest translations of a question into a catchphrase, billboards appeared all over New York, depicting Quentin in Calvin Klein jeans with the slogan, 'What does it mean?' Warhol would have been green. But to a section of the gay community, whom one might think would venerate their elderly champion, Crisp's views were considered too stereotypical and reactionary.

'Homosexuals don't have ambitions, only daydreams. In America, everything dates from the Stonewall Riots [when the police raided a gay bar in New York City on 28 June 1969, causing the bar's clientele to riot and sparking the Gay Rights movement] and weren't they lucky that it all took off in a pub called the Stonewall. Suppose you were compelled to say, "Yes, I was there on the barricades of the Pig and Whistle"? The queer populace has to move further and further forward, so as to vent its discontent; and so they look around for something they've been denied and insist on having it. The armed forces, for example! I have said to my gay friends, "Do you really want to be a killing machine?" And they have replied, "Well, I could be prepared to shoot someone if the circumstances were right." And I say, "Soldiers are not people who shoot someone if the circumstances are right! Soldiers long to kill and that is why they are soldiers."

'And why do gay people want marriage? I used to think that the hatred of male homosexuals was due to an envy of their freedom, because homosexuals are always making love to people they really fancy, whereas real men are always making love to someone they find thoroughly distasteful – for ever. And now gay men want to be married!'

From such pronouncements, you gather that Crisp was an ultra-separatist and profound romantic, who resents what he sees as the opening up of the mysterious homosexual underworld, with all its coded glamour, as much as he welcomes the gradual dismantling of prejudice, which now allows him to walk down the street in safety. And yet, throughout his reminiscences, he returns to the notion of fear as a catalyst for excitement.

'During the war, you took no notice of the shrapnel falling through the trees and tinkling on the pavement – and the war took no notice of you. But you knew that you lived in fear all the time, and it was wonderful. Walter de la Mare said that you must look your last on all things lovely every hour, and you do that when there's a war on, and it's terribly exciting. To have died in an air raid would be less grand than in a street fight, but it would do – it's still nice, it's fear. As long as I die in a significant way, that's all right. I think I had better be shot by a policeman, because if I die and people say, "Oh, and I thought that he was dead already", then that is no good. I must die and it must say on the front page, "Rogue Cop Kills Quentin!"

'Everyone in the world is younger than I am now. There is a curious relationship between the people of a country and the system. In England, the people are hostile but the system is benign. Here in America, everybody is your friend but the system is ruthless. Once you are no longer productive – a favourite American word – you will end up living in a cardboard box, where once you occupied a mansion.'

Quentin Crisp entered his ninetieth year on Christmas Day 1997, sharing a birthday with You Know Who. As the witness of

nearly a century of change – the whole span of modernism – he is more than 'the stately homo' he described himself to be. Now, making his way down East Third Street in a long fur-collared coat, with a blue silk scarf around his delicate neck, he was like an Edwardian dandy who might just survive to see the twenty-first century; the Wizard ready to retire from Oz. 'I am now waiting for death,' he said, 'and as long as it comes fairly soon, I shall be content.'

'*Pay no attention to that man behind the curtain . . .*'

Manhattan in the Nineties was the Emerald City of post-modernism – they really could dye your eyes to match your gown ('*Jolly old town!*') The issues raised by terminal gorgeousness – the gentrification of the avant-garde – are really questions of depth and subjectivity: soul issues, deep down. Merely to 'slide down the surface of things' – as Brett Easton Ellis described the society of post-modern gorgeousness, the soullessly exquisitely Koonsian – began by seeming clever and wound up, well, just missing the point.

The man behind the curtain, Professor Marvel, the Mighty Wizard, was Warhol all along. For Warhol, boredom, sameness, repetition, were pro-active: a form of meditation, to higher con-sciousness (to see the modern world from a high place) which the forces of gentrification mistook for dopy campy kitsch. Warhol seemed to know by instinct the truth of Roland Barthes' maxim: 'To get out go in deeper'; the Wiz links to the fact that McLuhan – settler pioneer of the bleeps and squeaks frontier – was a Cath-olic too. The daily bath of fire. Just look at Andy's renderings of the Last Supper, skulls and shadows, and you'll see for yourself.

One thundery humid summer afternoon towards the end of the decade, just off Prince Street, discussing William Blake with Patti Smith, the veteran poet punk shaman (it was William S.

Burroughs who'd called her a shaman) referred to the business of cultural product in relation to the ideals of art or revolution. 'You can't be a total pure revolutionary if you're an artist, because an artist produces material things,' she said, in measured, professorial tones. 'And I usually think that for me, a revolutionary is like Christ – who shed and despised all material things. Christ didn't write down His ideas, nor did He own anything, or live anywhere – and that, for me, is a pure revolutionary.'

(And afterwards, discussing the conversation with a friend, agreeing about the need to avoid the slavish cult of materialism, to respect the higher plane, but popping in to the bed linen department at Bloomingdales 'because we're passing anyway . . .')

The teenage Hanson brothers have their faith, which was rather more radical in Nineties pop than a pierced lip and a criminal record. Big up to Hanson! Quentin shared with Buddha the decision to be a wandering seeker after, and then guide to, Enlightenment (from suburban Sutton, England to the Lower East Side) – to tell people in Portland, Oregon how to be happy . . . Another of those rare elect who attained – when Quentin told people that his occupation was 'breathing', it was another example of spiritual training – the surface of things in that decade, the 1990s, when Surface was Depth – or it just didn't swing . . .

Retro: Running Out of Past

Brrr . . . It's cold out here. Right now all you can hear is the amplified sound of your own breathing – those classic deep-sea diver Darth Vader exhalations; only you're not deep-sea diving, you're out here up on the asteroid. We're yomping along across granite hard terrain, and every now and then you hear the muffled roar of whatever kind of engines it is that are driving this thing – huge great retro-burners, each one with an entrance the width of the Channel Tunnel, pitch-black up to their starlit rims. Because the asteroid's been colonized, hollowed out, motorized . . .

Coming up ahead – look, just over that ridge – with really dramatic timing (like the famous crane shot in *Once upon a Time in the West* where we follow Claudia Cardinale off the pioneer train, through the office of the one-track railroad station and into the frontier town) – there are these enormous, colossal . . . well, they look like cooling towers, only about a thousand times the size and each one is topped with a gigantic squat sphere, the colour of ready-mixed mustard. They might be nuclear reactors, but each tower's lined with what look like windows, hundreds of 'em.

You pause to look up, space reflected on the cupric mirroring

of your visor, and the colours . . . breathtaking! Like the folds of a backdrop blue velvet curtain for a roof garden midnight Revue, sparkling with pin-pricks of starlight. And then, floating along beside us, half a dozen other rocks, a whole flotilla of them, drifting silently through space as we stand here with our Darth Vader deep-sea diver breathing and find ourselves out here, on the rock, up on the asteroid.

And now there's another sound, just beneath the paced, muffled roaring of the engines. It seemed somehow familiar, a catchy little sequence of beats . . . very catchy indeed . . . Oh, you know that tune. It's on the tip of your tongue . . . Kind of thing they'd be playing at a student disco in 1978; you probably bought it. There it is again: doomy catchy bass notes, and a vaguely transatlantic, deep-sounding voice. Not Neil Diamond, but almost, a kind of Gothic Neil Diamond. It's gone now. Never mind. Things are never quite as they seem out here . . .

But where, exactly, is 'up on the asteroid'? Well, we're looking at a Glenn Brown sci-fi painting made in 1995, and it's called 'The Pornography of Death (painting for Ian Curtis) After Chris Foss' – now there's some dandy name-checking. (Chris Foss, by the way, is an illustrator who created the cover images for science-fiction novels.) The whole composition is amazingly mesmeric; you feel pulled in to the gravitational field of the thing, you get the sense of immense geological formations suspended in weightlessness. And it's glamorous, too, somehow, with that midnight-blue velvet sparkling starlight rooftop Revue backdrop curtain Space.

But the thing is, surely (and the canvas is really working its magic now, enfolding you in its weightless, slightly vertiginous atmosphere), the thing is that Space, really, shouldn't look so – Retro. And this Space does. Space in the Nineties looks very Seventies; as Retro as a copy of *Nova* magazine or a 'Magic Round-about' t-shirt. Suddenly, not only are we drifting through space – yomping along on the asteroid – but we're drifting through the

1970s and the triumph of the mutton-chop sideburn. There's nothing here to say that 'Pornography of Death (painting for Ian Curtis) After Chris Foss' is anything to do with the 1970s, but you somehow just get the feeling that the forces of Retro are at work. Glenn Brown's deep space has the same quality as a Pre-Raphaelite's idea of the Middle Ages – it's that meticulously detailed, vibrantly coloured, *flat surface of the past*.

Once upon a time, Space was traditionally connected with the future, ruled by science – Space was the last word. Then, in the 1970s, Space went all industrial and brutalist and just-another-day-at-the-office, just-another-shift-down-the-mine. (The parent company in control of the deep-space facilities in the *Alien* films – kicked off in 1979 – turned out to be a kind of Space Daewoo with sinister overtones.) In addition to which, there were all the early-Seventies progressive rock album sleeve ideas of other-worldliness, hinting at spiritual journeys in a druggy kind of way. And this seems to be the era that Glenn Brown has conjured up, perhaps not even intentionally, but as a by-product of some autobiographical, deep self-searching process that requires a particular kind of time travel . . .

So then there's the names: Ian Curtis and Chris Foss. Curtis the singer with gloomy Manchester lad band Joy Division (who killed himself) and Foss – well, there's something hugely Aesthetic about borrowing from Foss, on whose work this painting is based. Brown is an Ezra Pound of Retro – *il miglior fabbro* of pick 'n' mix high 'n' low cultural mimesis: perfect renditions of past masters, spun on pop-hip titles. So the names are Retro signage, and they seem to point up the fact that this painting, in fact, is a painting of Glenn Brown's lived experience of making the painting. Its inner space, a document of emotional and psychological process – like that album sleeve Space, which was always suggestive of interior gazing and isolation.

Behold! The 1970s! Which happened again in the 1990s – the Retro Ricochet of popular regression to the sites of adolescence.

In the 1990s, a picture of John Noakes (the children's television presenter of the 1970s) was used to sell vodka, and space hoppers (Space again, see?) became a ubiquitous symbol – tacky nostalgia telly shorthand – for a kind of funky goofy Retro comedy of recognition. As Kevin Rowland once sang, 'I'm trying to get the feeling back I had in 1972.' But why Kevin, why?

Well up here on the asteroid of Retro is where we can study the contortions of cultural time travel that happened in the temporal blender of the 1990s: the decade that puréed Retro styles like a vegetable juicer. Sixties, Seventies, Eighties . . . In 1999, it suddenly became apparent that every issue of every Style magazine had somehow looked *exactly the same* since about 1988. By 2001, cheap television would be running nostalgia shows about the year . . . 1997! Behold Retro! The past robbed of its history, the shell of age, repainted.

The Seventies (Again)

It could be said that we haven't had any new popular culture in the 1990s, we've simply had the recent past again, focusing on a selective memory of the 1970s. It seems hard to believe now, but there was once a time – around the end of the Eighties – when the first seven years of the Seventies (the uncool pre-punk bit) were traditionally described as 'The Time that Style Forgot'. My, how times change.

Attempting to predict the winds of taste, style pundits would run the occasional feature on Glam Rock styling but defend their concepts with a few pre-emptive inverted commas, denoting Irony. Trying to work out the Seventies, back then, was rather like trying to pat your head and rub your tummy at the same time – sooner or later, you got confused.

All of this changed in 1992 when a pop group from Haywards Heath (now there's a Seventies concept) called Suede (a rather

Seventies fabric) released a blistering first single called 'The Drowners', which dripped with the glam rock melodrama of David Bowie's classic LP of twenty years earlier, *Aladdin Sane*. Suddenly, a generation who were too old to rave but too young to rock took a look in their cupboards and discovered, with a dewy-eyed sigh of nostalgia, not only their complete set of Bowie LPs but also the memory of the way they were. And before you could say 'Hot Tramp', a whole field course of pop archaeology had opened up for all the slightly middle-aged dudes.

High Street fashion caught up with the trend for the kiddies, awesomely producing tiny tank tops, clomping great platform boots, clingy satin trousers and a hybrid fashion statement which was part Ministry of Sound, part vintage children's television. With the release of Todd Haynes's film of the glam rock era, *Velvet Goldmine*, and the spookily coincidental re-re-release of Mike Oldfield's classic *Tubular Bells*, those particularly awkward years, style-wise, during the first half of the Seventies, were officially rehabilitated.

Or were they? The Glam Rock gods in Haynes's film display a lizard-cool hauteur and enough phosphorescent body paint to cover a minesweeper, but when you take a look at some of the sources for their image – the documentary of Bowie's last concert as Ziggy Stardust at the Hammersmith Odeon, for instance, or the BBC 'Nationwide' report on the whole phenomenon of Bowie, screened in 1973 – you begin to get a different picture and a different set of memories. Rather than an era of androgynous super-cool, as suggested by the current retro-styling of Glam Culture, the early Seventies was a period that seemed to be locked in the damp, dismal days of tinned peas, dead-looking hair, white flabby bodies and a strait-laced older generation who thought that Mott the Hoople was some kind of tombola. (A lumpen banality that would become highly stylized and modish in the latter part of the 1990s.) In reality, the sheer potency of Glam derived from its host culture of negation: no tans, no gyms and no irony.

If we put aside the platform boots, glitter and top hats trimmed with tinsel, and take a look at some of the other mainstream popular culture that was describing or expressing youth at around that time, then we find ourselves in a curiously innocent and pasty environment. In a film such as *The Best Pair of Legs in the Business*, for instance, (which was released in 1972, and tackled the Glam-friendly issue of gender-bending through the mesmeric perform-ance of its unlikely star, Reg 'On the Buses' Varney) we are treated to the goings-on inside an English holiday camp.

Here, the supposedly fashionable youth bear no resemblance whatsoever to our post-modern idea of the Seventies. Here is a sex comedy about the embarrassment of buying condoms, and in which two young men with pudding-basin haircuts who wear their belts over their ample tummies, are greeted by two sexy young women (one of whom is Penny Spencer, of *Please Sir* fame) with the words, 'Look out Glad, here come a right pair of rice puddings.'

Freak out in a moonage daydream it isn't, but neither is it a period pastiche. Similarly, if you take yet another look at those classic Glam Rock 'Top of the Pops' from the early Seventies, you suddenly realize that the real squaddies of Glam – such as Mud, the Sweet and the Rubettes – were essentially Jack-the-lad barrow boys who were having a laugh and would have thought that andro-gyny was a medical term for athlete's foot. What really gave the game away, however, and offset the temper of the times, was the fact that there was always one member of every red-blooded, heterosexual Glam Rock group who would take the camping around just a little too seriously for the end-of-the-pier sensibilities of the rest of the lads.

Rob Gray of Mud, for example, made a spectacular appearance wearing a satinette housecoat and pair of earrings the size of cricket balls, managing to turn Tiger Feet into Tiger Mince simply by moving as though his legs were bound at the knee. Steve Priest of the Sweet mastered a particularly naughty pout while stammering out the key line on 'Blockbuster', 'We simply haven't

got a clue what to do!' in a kind of Dame Edith Evans contralto, while Mott's guitarist, Aerial Bender, simply let his stage name do the talking. These come across as the real heroes of the Glam Rock era, whose gleeful and flamboyant confusion of sexuality lent an air of real daring to what might otherwise have been a pantomime of pub rock wrapped in tinfoil.

Despite the cartoon-like element in all of this, the impudent stomping and cross-dressing of Glam Rock, at the time, was regarded by the grown-up media as a pit-bull wearing lipstick – a dangerous beast stalking the streets of decent Britain, and threatening to infect our youngsters with its depraved morals. The portentous narration of the 1973 television report on Bowie concluded with the patriarchal warning: 'It's worth wondering, though, what the Beat Age will spawn next, when someone like David Bowie isn't even freakish enough to shock us any more.' The answer, of course, was the Sex Pistols.

But the tone of this outraged concern in this questioning of teenage behaviour should be heard in the knowledge that its host culture was probably well described by a situation comedy such as *Whatever Happened to the Likely Lads?* – the point at which the ethos of 'kitchen-sink' cinema hit the New Materialism of modern UK. In this, the comedy is closer to a final recovery from Austerity Britain, rather than discovering mascara for men.

In the 1990s, as infantilist nostalgia and retro-culture has attempted to pick out the soft-centres from the Quality Street box of pop history, and left behind the chewy nougat of centre partings, NHS spectacles and no sexual self-confidence, it is worth reminding ourselves just how distant from an age of high heels, low morals and non-existent eyebrows the early Seventies was for most young people.

As an experiment in social history, it would be worth compiling a video of the 'Top of the Pops' audiences of that period, containing no shots of the bands. Here, in a nervous jigging-about of puppy-fat, bum fluff and denim waistcoats, you will see Ziggy's children,

awkwardly trying to come to terms with a pop spirit that must have seemed audacious to the point of unbelievable.

By 1977, when the young women of Britain discovered that a perfectly fashionable skirt could be constructed from a bin-liner and safety-pins, a film such as that year's *Confessions from a Holiday Camp* represented the last gasp of the saucy seaside sensibility that had dominated the first half of the Seventies and made the sudden intrusion of Glam Rock so startling. Gone for ever – for better or worse – was the mainstream British pop culture of cheeky chappies and dizzy dolly birds chasing one another around windswept holiday camps in pursuit of the frolics that had made a national scandal of a sex comedy such as *Percy* in 1972.

In many ways, the undisclosed mission of the early Seventies was to sort out Britain's obsession with sex and sexuality. When David Bowie sang the word 'wank' on his decadent music-hall number, 'Time', in 1973, he was singing it to a generation of young people who had probably only ever seen the term scribbled on a toilet wall – and who would have probably turned the colour of a Wimpy Bar ketchup dispenser if their parents had heard them using it. It was this juxtaposition of fleeting innocence and vibrant exhibitionism that made Glam Rock so exciting – and that no revival of the movement, however authentic in costume, can ever re-create.

Punk etc.

On a warm spring evening in May 1976, I caught my first glimpse of a real punk. It was during a visit to the Young Vic theatre, just a spit from Waterloo Station, and the punk in question looked about sixteen, on a school trip with the English teacher. The sheer impact of his appearance was derived from an assemblage of details that, quite simply, had never been seen before. People really did stop and stare at him – almost literally with their mouths hanging open.

Vitally, this was way before punk had become a recognizable mainstream style; this was a look cooked up in a bedroom, with customized bits of old school uniform. As a consequence the effect was infinitely more shocking than Kings Road boulevardier or picture-postcard neon-pink mohican would achieve.

Of all the younger people in the audience at the Young Vic that night, the girls were dressed in tank tops, puff-sleeve blouses and dungaree-bibbed dresses; most of the boys were wearing light brown shirts with enormous collars and brown, flared trousers. Faces were pasty and somewhat bovine, hair was still thick and under-nourished-looking.

In the midst of all of this, our one young punk was like a dropped bomb. He looked as if he'd cut his hair with a blunt bread knife and then dyed it with the dregs of school ink. On the back of his school shirt he had written the legend '1976' in biro, and beneath it –in letters that kind of got smaller and didn't quite fit, the words 'SEX PISTOLS'. On top of which, he had a safety-pin through his ear. Women were disgusted, men were openly hostile. People were saying that it made them feel sick. The effect was mesmeric in a way that would very soon – in a matter of weeks, almost – become impossible to achieve.

History, said Malcolm McLaren, was for being pissed on. And now punk rock is the new Bloomsbury Group. Anyone who stood within a hundred yards of the Roxy Club is good for another book and another documentary. But whenever I think of punk and all its works, I think of that doctored school uniform as being far more potent and redolent of the movement than, say, a pair of vintage bondage trousers or a naked cowboys t-shirt. After all, within exactly one year, in May 1977, even *Woman's Own* magazine was running a feature on 'Do It Yourself Punk for your Daughter!' We're so pretty, oh so pretty . . .

And then it was late summer in England – the first weeks of September, drowsy and golden, building to sudden freshness. Up here on the asteroid we can spot the gear-change into a different notion of Retro: a dead-drop into Georgian pastoralism, eloquent of a melancholy nostalgic yearning for . . .

Throughout the shortening afternoons, the somnambulant wasp dipped in and out of the powdery petals of a few late garden flowers; in the morning, cobwebs silver-beaded with dew made a tracery of diamante between hedgerows and railings. What a store of sensations in such a short time! Just a few weeks, a few days even, and here was a heady mingling of season and place that seemed to play tricks with time. The receding perspective of sunshine cross-hatched views, with white and silver clouds lying flat calm overhead like Colonial steamers in tropical livery; a reflection from cap d'Antibes to Morecambe Bay that here is the precious last essence of summer, refined to heavy, syrup-rich droplets – the essential oil of late August. It smells like warm grass and resinous bark, inhaled within sight of the sea.

The light and the pungency gets you; now here in this innocent amber light is a glimpse back to . . . some Holland Park mansion in the late summer of 1969, perhaps, with a clump of smouldering joss sticks filling the still air with clouds of sweet blue smoke, which drifts between Victoriana and hoards of north African bric-a-brac. The whole place – carpets, owners, joss stick smoke – as deliquescent and silent as an unnoticed windfall pear. For there's a sadness in the season, too.

Softcore

Britain in the early 1970s had the look of a country still caught in the colourless damp of the late Fifties, and the aesthetics of contemporary retro-chic are too exquisite and too self-serving to get this last detail of early-Seventies styling exactly right. It was

the drab background that heightened the impact of pop fashion's dreamy slide towards effeminacy, gentleness and the affectation (for the most part) of homosexuality.

But within its own period, the 'satin and tat' of Bowie's 'Queen Bitch' came over as halfway political; an oppositional stance towards an idea of oppression that was represented by overtly masculine ideals. It was a re-run of classic romanticism, from Keats through Wilde to F. Scott Fitzgerald – the foppishness of indolent youth. Visually, and even ideologically, the pop-fashion styling of the late 1960s had produced a whacked-out mood swing best discussed in terms of the tactile – soft for hard. The mood swing swung on gender reversal and, vitally, time travel: a modern fantasy of nostalgia for elegance – doomed elegance preferably, to add the finishing dab of romance.

All those Biba prints, peacock feathers and blue eyeshadows; Bowie in a dress by Mr Fish and Brian Eno's peacock-feather collar; Hollywood's gauzy re-creation, in 1974 – on the slender frame of Robert Redford – of Jay Gatsby's 'gorgeous pink rag of a suit', in the trend-setting film of F. Scott Fitzgerald's novel *The Great Gatsby*; Mia Farrow's saucer-sized baby-doll eyes in same, as she played the role of Daisy Buchanan like a drowsy child at a wedding reception; all those clearly heterosexual young men (even in his dress Bowie called himself 'a cosmic yob') – David and Marc and Steve and Bryan – looking limp-wristed amid bedsit Edwardiania and junk shop Art Deco. Even Elton John would swap the beard and shades of his naturalistic *Honky Chateau* phase, for the shimmering fantasy costume changes of *Don't Shoot the Piano Player*.

But strangely, the moment lacked Camp; as fashion, the softness was sincere to the point of seriousness.

At the beginning of the twenty-first century, when we live in an epoch of constant, simultaneous revivals of pop styles past, Photoshopped and remixed into baroque impersonations of themselves, it's hard to imagine a culture before sampling, and an

outlook, moreover, before irony. But take a look at the background detailing of those British films that mark the slow dissolve from late psychedelia into Glam Rock brutalism – *Performance* (1970) and *A Clockwork Orange* (1971) define the territory – and you'll find a kind of suffocating homeliness, a world, still, of institutional order fuelled on cups of brick-coloured tea, which makes the revolts into effeminate style in the foreground seem all the more impressive. ('It's a right piss 'ole in 'ere,' says hard Mod gangster Chas about soft androgynous Turner's decadent mansion in *Performance*, 'they've got drugs, foreigners, long 'air – the lot.'). The moment was summed up during the filming – in Malcolm McDowell's flat, off Kensington Church Street – of the brutal rape scene in *A Clockwork Orange*: the film's stylist had to buy false eyelash by the yard from Biba, as the ones being worn by McDowell, playing ultra-violent thug Alex, kept melting off under the lights.

If 'Swinging' London had fetishized youth, above all, as a vibrant and vivacious force of nature that could be reported upon almost as though it were a single entity, then once through the stargate of hallucinogenic drugs there had been a sudden gear-change on the cosmic trip. As the Sixties began to accelerate from innocent yet earnest youth posturing – *Vogue* models wearing two-tone vinyl caps as they stood in frozen robotic positions ('Show me love, baby!') – to the ragged edge of chemically induced reverie and political disillusionment (John and Yoko swapping the campaigns of the New Left for home-building in the Dakota) – so you could say that the styling of youth entered, in terms of its mood, a kind of Indian Summer. By 1969, the tone of the times was limpid with melancholy, and the rock music, squats, shops and bedsits seem to have produced, as though organically, a temper of stillness and nostalgia. In many ways, the freaks and the love generation had rediscovered old-fashioned English romanticism: a Keatsian softness, born of concussion from bad drugs, free love and truncheons.

It's easy now to doubt that such a moment ever existed, particularly if your experience of it comes down to you from distant memory, records and film clips. But that Indian Summer of the Sixties – the birth of a new softness (which made the hardness, for instance, of Iggy and the Stooges seem so eccentric and largely hated at the time) has been captured for us at its source, so to speak. We can now produce, as exhibits a, b and c in the court of the Crimson King, the footage of the ritualized wake for Brian Jones which comprised 'The Rolling Stones in Hyde Park' free festival on 5 July 1969.

In the first place, Jagger was wearing the softest of clothes – a bridal-white tutu, designed by Zandra Rhodes, which Lord Lichfield had been going to wear to a Biafra benefit at the Royal Albert Hall, but which his lordship felt, at the last moment, went a little too far. Secondly, Jagger chose to read Shelley in memory of Jones, rather than launching straight into 'Midnight Rambler'. And finally, in a poetically astute but technically cruel and stupid gesture, Jagger released a cloud of butterflies – the softest of creatures – to fly over, and almost immediately expire into, the hashish-clouded crowd. It was all soft: soft, soft, soft. (And history now tells us that the only hard-edged action in the park was coming from Gilbert & George, who were circulating among the flower children dressed in their grey clerks' suits and their multi-coloured, metallized heads and hands.)

Watched now, the opening scenes of 'The Stones in Hyde Park' show a rock aristocracy, glassy-eyed but all-powerful, surrounded by the high aesthetic paraphernalia of a Sixties interpretation of Wildean London: gorgeous Indian carpets, regal palm fronds – like the spoil of some Victorian conservatory – and pale plumes of incense smoke rising up into dust-mottled sunbeams. Jagger looks like some beautifully ugly girl, while his then girlfriend, Marianne Faithfull, has the look of a Dorian Gray.

In this overture to the Indian Summer of psychedelic melan-

choly (you could call it Old Romanticism, the ancestor of the New Romanticism that would follow precisely ten years later, with Japan et al.) the principal themes are gender-bending and time travel – a dress rehearsal (and how) for the early Seventies. It's a preview of forthcoming attractions, in many ways – a nod towards the waiting teenage generation who would benefit from the great rock manager, David Endhoven's brilliant decision to change the name of ultra-softy Marc Bolan's group from Tyrannosaurus Rex to T.Rex.

As all romanticism is triggered by the progression from innocence to experience, so the late-Sixties Indian Summer had a sadness at its heart. The death of Brian Jones was just one example of where this sadness was coming from. You could find the American version of this collapse of a dream in some of the best folk rock of the period: Neil Young's *After the Goldrush* (1970), for example, or Joni Mitchell's *Blue* (1971). For both these great singer-songwriters, it was the collapse of the hippy dream, and the last, plangent, lingering moments of the freak power idyll that brought about their romanticism. Here was the return to the city from the sun-soaked countryside – Young's 'Don't Let It Bring You Down', or Mitchell's despairing lines, 'Acid, booze and ass, needles, guns and grass – lots of laughs . . .'

For the contemporary Canadian novelist Douglas Coupland, in his account of 'Global Teens', *Shampoo Planet* (1992), it is his central character's hippy earth mother, Jasmine, who cuts through the chilled-out irony of her Slacker son with some gentle advice about age: 'Life at that point will become like throwing a Frisbee in a graveyard; much of the pleasure of your dealings with your friends will stem from the contrast between your sparkling youth and the ink now you know lies at your feet.'

For the son, brought up on a hippy commune, the 'ink' of his parents' generation formed the earliest memories of his own: 'I remember robes made of flags, pots of stew and candles made of beeswax. I remember adults spending hours staring at the small

skittering rainbow refractions cast from a window prism. I remember peace and light and flowers.

But let me also tell you of when the world went wrong, of hairy faces violet with rage and accusation, of sudden disappearances, of lunches that never got made, of sweetpeas gone dead on the vine, of once meek women with pursed-lips and bulging forehead veins . . . of lawyers visiting from Vancouver – the mood of collapse, of disintegration . . .'

Ultimately, Coupland concludes his account of the last gloaming of the flower-power softness with a ride through the darkness to the tract housing of a town called Lancaster. 'Let me tell you of the house that became our new home and the new wonders inside: switches, lights, grills; immediacy, shocks and crispness. I remember jumping up and down on the novel smooth floor and yelling, "Hardness! Hardness!"'

As the Sixties flipped over into the Seventies, pop fashion fused the vogue for art nouveau and art deco (high romantic forms of the decorative arts) with a whimsical theatricality. The gentleness of flower power – which, as Coupland points out, was balanced at its peril on a drug-based dream – gave way to an affectation of aristocratic decadence, sourcing its romance from the 1880s and the 1920s. As Roxy Music stormed the charts, the accompanying vogue for dance-band music brought to light a song from the Thirties, 'Masculine Women, Feminine Men', by the Savoy Orpheans, and it seemed to fit neatly with 'Ladytron' or 'Virginia Plain'.

With this in mind, the early Seventies were suffused with literary romance from the fin-de-siècle and inter-war years. The novels of Colette became freshly fashionable, and were repackaged (a little late, perhaps) in pastel covers with art nouveau framed, sepia images of either Colette herself (acting as 'the little faun') or elegiac-looking men and women from the turn of the century. Likewise Hollywood's version of *The Great Gatsby*, in 1974 (and the subsequent reprint of the Penguin Classic edition of the

novel), took 'softness' to its seeming limit, visually representing Daisy Buchanan's line in the story that she would like to place Gatsby in a pink cloud, and pat him about in the sky. Visconti's adaptation of Thomas Mann's *Death in Venice* showed a made-up Dirk Bogarde pursuing the impossibly soft Tadziu – as played by Bjorn Andressen; and even the repeated motif of the film's score – the adagietto from Mahler's Fifth Symphony – had a languor that verged on the somnolent.

These were all narratives of terminal romanticism, in which elegance was synonymous with melancholy or despair – with death, even, in the cases of Jay Gatsby, and the doomed Von Aschenbach of Thomas Mann's novella. Linked to the pop styling of the seventies – and *Vogue* featured a shoot by Jonvelle, in 'Colette' clothes in 1971 – this mythology of elegiac romance was given the fizz of high fashion, and the ceremonial flourish of pure artifice, posed as sexual ambiguity. Penelope Tree, modelling for *Vogue* in 1969, had worn 'a transparent orchid chiffon dreamshirt, turquoise buttoned and tabbed, girdled with golden chains, in the Valley of Kashmir . . .', like some doomed heroine of a terribly sad novel; and the photographs of Deborah Turbeville or Sarah Moon maintained the fantasy, not least in Turbeville's shoot for *Nova* magazine in 1973, depicting fashions by Bill Gibb as art deco arabesques, caught in the drowsy sunshine of a summer garden.

By the time that Brian Aris photographed international crumpet-chaser Rod Stewart, in 1975, with former-beatnik Ace Face Rod the Mod ('you name it, we banned it; save cats, save dogs, shag in tents', said Stewart of his beatnik youth) dressed in floppy cream pantaloons and satin blouse, with a polkadot scarf knotted about his waist, the stylized softness of an era's fashionableness would have become little more than cosmetic. Only a man as supremely down-to-earth and heterosexual as Stewart could have managed such a costume. But Rod marked the end of an era. Between 1969 and 1974 the contortions of pop romanticism had

placed a fine gauze over the cameras on which it was recorded, and for reasons that dug deeper than mere prettiness.

As the 1990s provided constant simultaneous revivals of pop cultures past, by the middle of the decade there was a general buzz that the Imperialism of the Swinging Sixties (a term coined from an article published thirty years earlier, in *Time* magazine) had been revived by a powerful coalition of hyper-mediated metropolitan personalities, from artists and art dealers to fashion designers, restaurateurs and media types. This, in many ways, would establish the ultimate triumph of the mainstreaming of the Wannabe Outsider, the Taming of the Shrewd, and would reveal itself, in a matter of minutes, to be the exchange of radicalism for obedience to the market – or, rather, the absence of any real radicalism in the first place.

As the curator and writer Francis McKee would remark on being told of the market-worthiness of Stella McCartney using prints by Sarah Lucas, 'That's a culture that's dead already – that was never alive in the first place.' Fashion was always *trying* to get rebellious (to get taken seriously within the broadband of culture) – but revealed its deep-rooted conservatism by constantly sending models down the cat-walk wearing next to nothing, to get the press shots. So the dominant sexism of the 1960s was also revived, relabelled 'sexy!' or excused as ironic sexual politics.

Alexander McQueen

A small but perfectly formed twister of hype and hyperbole informed the British public that Alexander McQueen is this country's most talked-about, most promising, and most outrageous young fashion designer. McQueen, a then twenty-seven-year-old east Londoner, was being hailed as a designer who can mingle

clever tailoring (he served an apprenticeship in Savile Row prior to studying at Saint Martin's School of Art) with 'outrageous' concepts (he titled his Autumn/Winter '95 collection 'Highland Rape' for starters) to create garments that are either refreshingly provocative or groaningly obvious, depending on your point of view. His dresses have revealed bare buttocks and breasts, his fabrics have been printed with photo-reportage images from Bosnia, and he has invented the 'bumster' trouser, with its appropriation, as a feature, of what used to be rather indelicately described as 'builder's crack'. In many ways, his combination of tremendous technical craftsmanship and confrontational aesthetics has made him to the fashion industry of the 1990s what Michael Clark, with his Royal Ballet training but bottom-baring cheek, was to contemporary dance in the 1980s. Interestingly, McQueen also bared his bottom as the curtain call of one of his collections.

Waiting for the latest enfant terrible of British fashion to arrive at Soho's Maison Bertaux – his coffee shop of choice for the last six years – it is tempting to see some analogy between this fashionable yet basic cafe and the reputation that has gone before him. Little more than a bobbin's throw from Saint Martin's, and more or less equidistant from a peep show and the Groucho Club, the upstairs salon of Maison Bertaux combines the appearance of a transport cafe with the ambience of the fashionable demi-monde. And, anticipating a vividly dressed bovver boy to crash down beside one in a flurry of foul language, one is surprised to be greeted by a slightly shy young man who looks just like any other fin-de-millennium bloke. Crew-cutted and almost stocky, he is wearing an old Ben Sherman shirt and a pair of jeans. With only the mildest of impatience he orders a pot of Earl Grey tea, makes a passing reference to the Maison Bertaux's seeming policy of employing former Yugoslav staff, and waits for questions with an understandable mixture of suspicion and weariness. When he starts talking his fast East End patter is punctuated by many sighs that turn into groans at the last minute.

'I'm a working-class kid, I stick to my working-class roots, and that's what gets me the press. At the end of the day, although I know I'm quite intelligent, I'm still quite an oik and I will say "fuck", "shit" and "piss" that people don't want to hear. Not because I'm trying to set up a cause but because that's the way I am.'

That McQueen is a genuine East Ender who refers to his own social circle as simply 'his mates', but who also enjoys a close and enduring friendship with the landed stylist Isabella Blow, has turned him into a somewhat caricatured figure in the uppity world of fashion. What is perceived as the glamorous discrepancy between his background in a large, working-class family and his success, internationally, on the cat-walk has singled him out as the stuff of legend – in rather the same way that the late Trojan was seized upon in the mid-1980s as a representative of the clubbing fashion underground by the Bodymap generation. And this is a distraction from his actual talents as a designer that McQueen has grown to loathe.

'I hate the circles that I mix in now; I really hate them. The wankers you meet; the insular people you meet. I'm a great believer in honesty and I don't think you ever find it in fashion. I'm just another boy who's trying to find what everyone else is trying to find – romance, I suppose. And I find it hard that my work's coming into my private life now. I find people giving me dirty looks for no reason – people trying to start things . . . Like, I was talking to my stylist, right, and she said that there was this boy at a party I was at, and that he said he had a fight with me. And I never spoke a word to him! So this is what I have to contend with, and it's like "Leave me the fuck alone, you arsehole, or I really will hit you . . ."' Recounting this tale, McQueen's tone swings convincingly between the compass points of outrage, confession, catharsis and bewilderment. Rubbing his eyes and shaking his head, he combines the expression of a person wrongly accused of fare-dodging with an immense vulnerability. Increasingly, the impression is that of a man at the end of his tether.

But, at a time when the ultra-laddish *Loaded* magazine and the ultra-gay *Attitude* magazine can be seen as representing a fair portion of the zeitgeist, it is easy to see how Alexander McQueen, as a gay lad with attitude, could be regarded as the perfect hybrid embodiment of his generation and his times. His reputation for yobbishness (which appears to be founded on little more than his accent and his media-friendly mooning from the cat-walk), to say nothing of the sexual bias of his designs, have somehow been authorized by his homosexuality, while his position as fashion's latest darling has been usefully informed by his working-class roots in east London. In the press, McQueen has received more or less equal parts adulation and notoriety (which are interchangeable responses in the real currency of column inches) for his confrontational designs and aesthetics, but it is difficult to tell where the canny shock tactics end and the angry ideology begins. Some of his women's clothes could be seen as sexist to the point of misogyny, with their revealing slits and panels, and McQueen's account of his design philosophy for womenswear could be described as logical only if you happen to share his peculiar point of view.

'I got into big trouble for calling a collection "Highland Rape", but I didn't give a shit. It was about the English attacks and clearances in Scotland – it was supposed to cause a fuss and it did. I like feminists and feminism and I try to design a collection thinking of a feminist's view of women's clothes. I like to make them sexy, but I like to make them sexy so they don't look naïve – not like an uplift bra and a tight skirt 'cos to me that's just crap, and it doesn't make the woman look intelligent. But I'm not a sexist, far from it. Most of the girls that modelled for me in the early days were on the lesbian side. Like there's some really, really hard lesbians and there's some really beautiful angelic lesbians, and I used to love going to gay clubs and seeing two women kiss. It was something no man could ever feel when he was with a woman, 'cos these two women together knew each other's bodies so well. I used to like just looking, and watching these two women

together and the sexual attraction there – it's a major part in my mind when I'm designing. I don't like women to be mauled over by men's eyes; I like men to be stunned by an entrance – not, "Cor, I'd love to screw that woman!", more, "She looks amazing but I couldn't go near her!" I like men to keep their distance from women.'

The originality of McQueen's designs, in the opinion of many fashion journalists, is derived from their careful tailoring and their audacious use of fabrics and prints. Their sexual aspect is considered secondary, and is justified on the grounds of that post-feminist assertiveness that claims teasing eroticism in the name of sexual independence – a debased and pointless argument that has been pushed about since Sandra Bernard stripped off for *Playboy* as a supposedly ironically political statement about lesbianism. (Not that she wanted the publicity, of course.)

Following hot on the heels of the elevation of PVC, Skin Two fetishwear and Vargas girl lingerie to both high and High Street fashion, it would also seem that McQueen's designs for women are continuing a particular trend of sexuality for a particular class of presumably wealthy women.

'I couldn't tell you what women buy my clothes. They cost anything up to £1,500, but they can go higher if it's a limited fabric. Madonna bought a jacket . . . I dunno. I hear about people buying my stuff all the time, but stars buy it cos their agents say it's the stuff to be seen in. Kylie's got one jacket. It's kind of weird, because the idea for that jacket she bought was that someone was on the road and got squashed by a steam-roller . . .'

Perhaps McQueen's success is nothing more than a timely mixture of luck, sensationalism and canny talent. His oft-cited 'loutishness' comes across as a genuine anger and impatience at the febrile world of fashion, while his unyielding demands for honesty (a word he uses as the cornerstone of all his attitudes) are aimed at a business he sees as complicit with sell-outs and sophistry. *The Face* magazine fashion editor sees McQueen as a

timely tonic for the fashion industry: 'I think he's been such a sensation in the world of high fashion because he's emerged at a time when designer fashion has been characterized by what could be described, at best, as minimalism. The commercialism of much American design has been extremely powerful, and set against this McQueen delivers innovative, influential and over-the-top designs. The sensation he's created probably says as much about the state of fashion as it does about him.'

In some ways, McQueen is the double winner from the polarities which he's seen to represent – a yob among snobs will always go far in England – but now that he's made the crucial leap from 'sensation' to 'phenomenon' he finds himself being pursued by trend-hungry advertising agencies for what he might stand for rather than his talent as a designer. In an era of rampant cultural materialism, McQueen is finding that he can be commodified in a market-led economy that couldn't care less whether he's a stand-up comedian or a pop star – so long as it sells beer. Or vodka. He has been head-hunted by Smirnoff to lend his credibility to their art-driven advertising, and by Saatchi & Saatchi for a Fosters lager campaign. Clearly, the thinking behind these lucrative offers is that arty bad boys help sell designer alcohol, and this puts McQueen on the rebellion-testing high wire between creative freedom and a big wad of cash. He's gone for the cash, so far, and clearly feels besmirched.

'I just done it with the Saatchis – it's just, real wankers! I mean, fuck me, it's not even worth talking about . . . It's like two Canadians, I mean two Australian comedians watching a fashion show and taking the piss while one really thin girl and one voluptuous girl comes on and . . . Oh, you know what I mean? It's just a load of wank, really . . . But it's fifteen grand so I'm not bothered. But they got a lot for that – we had to design a set, the clothes . . . But they didn't know me through my clothes; they knew that everyone was talking about me and so then they researched me – and so to me that's kind of a load of bollocks.'

In this fable of contemporary fame, with its cheapening of integrity in exchange for a fat fee, McQueen reveals himself as concerned about the ultimate destination that his fame, as opposed to his love of fashion, might take him to. He bitterly resents his commodification as a 'phenomenon', but he's equally honest about the lure of the cash.

'Now I just want to earn enough money so I can get out of it. It's not the reason why I started fashion in the first place, to be in the situation I'm in now . . . I started because I love clothes, purely and simply. I haven't had a lot of chance to show pure technical ability like I used to, because it would take me a week to make one jacket, and I don't have a week. The tailoring, that romantic side of my life, has gone at the moment, and that's the reason why I liked doing it. That's why I'm sitting here moaning. Now I have people above me telling me that I've got to have the menswear collection for Winter '97 ready by November – but that's how I'm paid now; I'm backed by the Japanese – I just get a percentage. You find yourself working for the press and the media at the end of the day, and not for yourself, which is what I feel I'm doing most of the time now. I could leave it – retire. I've always wanted to be a photo-journalist in the way of like, Cartier-Bresson.'

On the pop cultural map, McQueen could be seen as an island off the coast of George Michael (owned by Sony) for what he regards as the taking into wage slavery of his personal creativity. A rebel or two is always useful in any major corporate portfolio, and the speed with which big business will snap up the latest sneering sensation is a fairly accurate barometer of the times. Interestingly, McQueen's opinion of the fashion industry in 1996 is remarkably similar to Johnny Rotten's assessment of the music business in 1976, with his famous command to 'Get off your arse!' The rebel and the reactionary realist are pretty much side by side in McQueen's pronouncement that: 'I'm not like my generation because none of my generation are honest; they're all fucking

blaggers and they'll all tread on you to get further ahead. And I don't think that's like me at all – they've got it so wrong. To me it doesn't seem worth surviving if honesty doesn't come into the picture. I'll end up a fucking recluse, 'cos my brain can't handle it. I can handle fashion 'cos I know how to play the game; I can play checkmate – I worked out how to play it quite early. I knew that the boy from the East End was the bit that would get them.'

These days, for a young fashion designer (or a young anything, come to that) being seen to be yobbish is more or less compulsory; bored with smooth talkers, the Queen's English and any semblance of political correctness, the culture is hungry for young celebrities who seem to embody a laddish disaffection in their personalities and their backgrounds as well as in their work. Hence the hymning of Damien Hirst and Irvine Welsh, posing like pop blokes, as 'Bad Boy' artist and writer respectively in *Elle* magazine; hence the sneaking suspicion on the part of some cynics that mere attitude is seen to equal originality, and that we're living in a culture where the very values we disdain in the tabloid press can be cleverly gift-wrapped in critical theory and press releases to seem like the vernacular philosophies of a dispossessed generation. But Alexander McQueen probably knows exactly what he's doing. What other young designer, tipped for the very top, would say: 'It's completely ridiculous. At the end of the day it's just clothes – know what I mean?' Which is probably why he is bound to succeed.

As all empires need a flag, so the Union Jack was culturally rehabilitated by Neo-Swinging Nineties Imperialism from its former position, languishing as an emblem of nasty nationalism. Suddenly, Geri Halliwell's snappily saucy micro-dress and Noel Gallagher's guitar could be Union Jack triumphalist – the Spice

Girls were the new Vera Lynn and everyone was mad for it. Thus, for the central years of the 1990s, a whole swathe of BritCulture was placed almost, virtually, in a Neroian position of being *beyond criticism* (i.e. criticize these Imperial personalities and *you're Reactionary* — the waver or wearer of that nasty version of the Union Jack we mentioned a little earlier).

And yet only a few years before, it had been more or less a crime against the People, in pop and media terms, to dally with the Union Jack. So what had happened to make it all right again? One answer might have been that this sudden targeted mediation of Imperial Nineties London saw a kind of affectionately ironic Retro Cool in the Union Jack as a primary emblem of Imperial Sixties London — of Pop Art, sourcing from Elton Entwistle's Union Jacket or the original Union Jack sunglasses from Gear boutique.

A whole new mood! A return, in fact, to British Beat Innocence, as though all of the infantilism of Retro culture could really wind back the years. And yet this return — *a la recherche du Pop perdu*, with the Union Jack as the Proustian madeleine soaked in lime tea, triggering time travel — could only be to a theme-pub Sixties that was one part Austin Powers to three parts post-modern montage, based on a few snappy signifiers. The original Sixties — the landscape of London, in particular — was as distant as Ancient Troy from its post-modern successor, but seemed to offer an idea of style that was *the chance to have another go at Pop*.

'Sixties London': Photographs by Dorothy Bohm

The 1960s saw both the reinvention of broadsheet journalism, with the launch in 1962 of *The Sunday Times Colour Magazine* (leading with a profile of Peter Blake: 'Pioneer of Pop'), and the elevation of advertising from a staid mixture of graphic design and copy writing (as described with withering disdain by Quentin

Crisp in *The Naked Civil Servant*) to being a happening young profession for creative types with metropolitan pop tastes. And it was in keeping with these ground-breaking developments in hitherto conservative media that the decade should have been labelled with a journalistic catchphrase, 'Swinging London', that was taken from the banner headline of the American *Time* magazine's issue of 15 April 1966: 'London, Swinging City'.

The efficiency of 'Swinging London', as a historical and cultural catchphrase, has grown in strength and resonance over the three decades since its invention. Sixties London is now remembered as a unity of pop cultural activity, encompassing a network of reference points – not dissimilar, as a concept, to the map of the London Underground – in which the principal players, places and happenings were linked in intention as well as geographically. But for Dorothy Bohm, as a Jewish Lithuanian émigrée photographer, settling in Hampstead with her husband in 1956, the pageant of Swinging London took place within a city whose remaining Victorian and Edwardian constitution, and the lingering ambience of post-war austerity, were as vital and visible as its latest developments as the Pop Capital of the world. As Amanda Hopkinson points out in her introductory essay to Bohm's photographs of Sixties London: 'Dorothy's images are not the Swinging London beloved of Bailey, Duffy and Donovan, although it can be glimpsed in the small print of passing fashions. They are the story behind the banner headlines, classically presented, and infinitely more complex in content.'

Paradoxically, it is the subtle traces of archetypal Swinging London imagery in Bohm's photographs that make them doubly eloquent of the exuberant zeitgeist that was permeating and promoting the capital in the 1960s. Mini-dresses, longer hair, a Bob Dylan t-shirt or the burgeoning paraphernalia of consumer society, find their place within a city that still appears blackened and institutional, its children and pensioners maintaining a near-Dickensian countenance on either side of the new styles and new

values. Rather than a mediation of their times with an eye to fashionableness or conscious topicality, these photographs describe the reality of an accelerating urban spirit – the flight of one generation from the war-hardened but weary values of their elders – by capturing those moments of vulnerability, stillness or civic pantomime in which the subject is unrehearsed.

Thus, in their book form, we find a portrait of the coolly blonde proprietor (or customer) in a Hampstead 'Antique boutique' regarding the camera with a modish self-assurance that is mirrored in the facing photograph of an amiably clownish and top-hatted young man – reminiscent of Tommy Steele – who is minding his junk stall in Earlham Street and clearly delighted to have had his photograph taken. Both images convey the obsession with Victoriana and antique bric-a-brac that was a hallmark of Sixties London, and found its way into the plot of Antonioni's Swinging London film *Blow Up* (1966) as much as the Regency styling of pop fashions and the vogue for art nouveau. In Bohm's treatment of the antiquarian theme, however, her subjects pursue the less cosmetic strand of the reinventing relationship between youth and old age, archaism and modernity, that was pivotal to London's cultural identity in the 1960s.

Hence, in her portrait of two hip couples sitting beneath a Schweppes umbrella outside a Kings Road cafe, it is the marble bust of a stern Victorian patriarch and statesman, decoratively (and ironically) placed at their feet, which provides the animating counterpoint to the young people's unisexually shoulder-length hair, relaxed levity and bottles of Fanta orangeade. Similarly, the seventeenth-century livery of the schoolboys from Christ Hospital, Horsham, making their traditional procession through the City of London, is forced to comment upon itself by the pupils' long hair and a glimpse of a fashionably dressed young woman between their ranks. These, after all, might include the first generation of public schoolboys to be inspired by Lindsay Anderson's fantasy film of public school anarchy, *If . . .* (1968). The City street, by

contrast, with its betting office and safe fitters, is still recognizably pre-war and slow to shed its air of battered imperialism.

Bohm's photographs of London's squares, streets and hoardings, from the residential blossom of Holland Park to the (literally) totemistic height of the Post Office Tower – transmitting a fantasy of the space age above the chimneys of an end-of-terrace which bears a diptych of posters for Sovereign cigarettes and Harp lager – all possess a quietude that suggests the slow abandonment of a previous order, or, at the very least, a rearrangement of the social hierarchy. Already, the older ladies of Knightsbridge appear somewhat shabby in their gentility, while the residue of the 'servant classes' display an unshakable loyalty to an orthodoxy that is no longer in place. Time and again, in Bohm's images, which seem to analyse their times almost despite themselves, there is the sense that the younger generation are assuming the confidence of a new aristocracy, despite the obvious rigidity of London's zoning of class.

Rather than supporting the conventional mythologies of Sixties London, such as one finds in British films of the period such as John Schlesinger's *Darling* (1966), or the famous photographs of Bailey and Donovan, Dorothy Bohm's independent vision is in keeping with Norman Cohen's 1966 cinema adaptation of Geoffrey Fletcher's *The London Nobody Knows* – a documentary about the changing face of London, presented by James Mason, who picks his way from East End markets and the derelict Camden Palace to the enthusiastic popism of reinvented Chelsea.

This is the same journey through district, class and change that Dorothy Bohm's photographs of Sixties London describe. From her virtual still life of the imposing edifice of Cannon Street Station's arched wall, to her witnessing in street life of a generational desire for informality above all, she demonstrates with generous lucidity the complexities and awkwardness upon which the bright catchphrase of 'Swinging London' is so precariously balanced.

Michael Caine

It's the voice – all string vest and indignation, straight from the pubs and garage forecourts of south-east London – which works its coercive charm to beckon you into full agreement with every opinion of its owner. That its owner is Michael Caine, movie star, restauranteur and English institution, suddenly sparks the impression that you're listening to an oral cartoon. He is dressed in the yachting club chic of grey flannels, pale blue shirt and double-breasted blazer, with his famously hooded eyes conveying a mixture of triumph and conviction behind the equally famous softening lenses of his sales rep glasses. And right now, in a suite at the Hyde Park Hotel, the main room of which is somewhat larger than a branch of Boots, Michael Caine's voice is raised in a challenge that just skirts the edge of self-righteous incredulity at any forthcoming opposition. The subject under discussion is the influence of cinema and television on public taste; more specifically, the point in question is Madonna. Every third word, approximately, is stressed.

'I'll bet you a pound, right now, I'll bet you a pound that in six months' time every girl in town'll be walking around with an *Evita* hair-do and the dress. Bet you a pound right now. And it's going to be the whole *Evita* thing, with the funny shoes from the Forties and the whole look.' Certain that the point has been made, and that the argument which never even had a chance to start has been won already, Caine sinks back into the pillow-soft cushions of the enormous sofa that is perfectly scaled to his imposing frame but would reduce most of us to leg-dangling dolls, and finishes the subject off. 'Now Madonna – and I see a lot of Madonna 'cos they live in South Beach Miami – Madonna was in that costume for months before they even started the movie, and all the girls are picking up on it down there. So there you are. Pound. Right now!' As ever, Caine wins.

Caine was in London for the Film Festival screening of his latest film, *Blood and Wine*, a tautly acted vicious thriller, directed by Bob Rafelson, in which he co-stars with Jack Nicholson as an emphysemic British villain, lurking in Miami to pull off one last heist. The previous evening, amid much glitter and many superlatives, Caine was made a Fellow of the British Film Institute. But a doughnut's throw from the imperial front steps of the Hyde Park Hotel is the bus stop from which, if Caine so chose, he could travel back to the south London stamping grounds of his childhood, adolescence, and first brief marriage to the late Patricia Haines. Just south of the Thames, gentrified now but once a deliquescing mixture of workers' terraces and Edwardian villas in deep decay, is the grey belt of inner-city postal districts that shaped Caine's accent and his unyielding outlook on individual destiny. From the tail end of the Old Kent Road – where Caine was born Maurice Micklewhite on 14 March 1933, of a Billingsgate porter father and a 'char-lady' mother – through to Camberwell, where the family moved when he was six months old, and the street by the Elephant & Castle where they were reunited after the Blitz, and young Maurice's stint as an evacuee in North Runcton, Norfolk, was a short journey through the remains of Victorian London. Later, as a struggling young actor in the debris of that first impetuous marriage, Caine would live with Patricia in two rooms at the top of Brixton Hill. The need to escape, as much as a self-consciously artistic calling, was at the basis of Caine's ambition. Along with Max Bygraves and the three Charlies – Charlie Chaplin, Charlie Drake and the gangster Charlie Richardson – Caine would be one of the south London boys who would find celebrity in a big way, despite the odds.

'I'm a class warrior. I've stopped banging on about it these days, but I do believe that class is a cancer in this country, and I saw it waste so many incredible intelligences that I grew up with. I'll give you a for instance: people ask me if I ever went to drama school, and I say "no" because I didn't know there were any. We

didn't have a television, the wireless was usually tuned to the racing for my father; so where was I going to find out there's a thing called "drama school"? Cinema and television have got rid of some of the more extreme forms of ignorance, 'cos now at least you can find out what you don't know. But then a lot of people used to say to me, "Oh, when I was your age I wanted to be an actor", and I'd say, "No you didn't. You probably wanted to be rich and famous but you didn't want to be an actor – otherwise you'd have done it." It's like being gay or something; you don't have a choice. You see people of my age who've been in Rep all their lives; it's not much of a living, but they're actors, and that's what they have to do.'

The traditionally working-class experience, of life being encompassed by rigid local boundaries, would turn Caine into a human stick of rock with 'London' stamped right through him; more important, this imprint of the capital would be the hallmark of his acting style and the mythology that has grown around him: the home-grown glamour of the ordinary bloke, with just a faint whiff of the underworld. But Agent Courtenay's assessment of Caine's character Harry Palmer, in *The Ipcress File* (1965), could be seen to describe the actor himself: 'You're not the tearaway they think you are; you also like books, music, fine cooking . . .'

'That fairly summed me up, that did,' says Caine. 'And it's quite strange really, 'cos obviously Len Deighton didn't know me when he wrote the book of *The Ipcress File*. I can play the tearaway, but I don't think you become an actor in the first place if you have a tearaway mentality. You must be more sensitive than that, otherwise you'd have never done acting in the first place. Also, like in my own case, even though the Elephant & Castle in the Fifties was extremely rough, I was a big movie buff. I spent all my time in the cinema. I didn't spend my time on the streets and all that stuff. And I'd been taken off the streets by a guy called Reverend Butterworth, who had this youth called Clubland, and that's where I started acting –'cos I joined the amateur dramatics.

And so I was different from the Cockney tearaway, but I can quickly revert to it – usually as a self-defence mechanism.'

Clubland, where Maurice Micklewhite gave his first public performance as a robot in Capek's political allegory *Rossum's Universal Robots* (1920) gave Caine his first sense that acting might save him from terminal drudgery. But from the very beginning, Caine's desire was to be a movie actor – in the classic, big-budget, Hollywood sense, as conveyed by the films of the period – rather than a theatre actor. And, in perfect bio-pic fashion, as recounted in William Hill's authorized biography *Raising Caine* (1981), he decided upon his screen name one August day in 1954, having glimpsed the sign for *The Caine Mutiny* above the Leicester Square Odeon from a Fortes coffee bar.

By this time he had managed to get some stage work by serving as an electrician at the Horsham Repertory Company, then at the Lowestoft Theatre – where he met his first wife – and his new name would be credited for his first walk-on part in a TV play, 'Joan of Arc'. But Caine's particular presence as an actor would require the big screen – his first love – to catch the quality of understatement that was vital to his magnetism, and to his manipulation of ordinariness which, paradoxically, would make his style unique to the point of self-caricature.

'I always had the view of movie acting, per se, as being different to theatre acting. I thought theatre acting was what I'd call "real acting" – acting that you can see. Now, in the theatre, if you can see the wheels and the mechanism of the acting that's brilliant – and the more you see it, the better. In the movies, it's exactly the opposite. You've got to be with a person and not an actor. And, really, movie acting is behaviour and reacting. In the theatre you know it's a cardboard tree because it wobbles when they slam the door; in the movies it's a real tree, and you've got to be a real person. I just won the Best Actor award for *Blood and Wine* at the San Sebastian Film Festival, and they said it was because they couldn't see the acting!

'Very often you'll see a person get an incredible review for a performance where you can see all the wheels going round, while someone else who manages to appear just like an ordinary person – a much better performance – gets told he's just playing himself. They think it's easy, you see, when they say you're just playing yourself. No one plays himself! In a movie with sixty-seven guys standing round looking at you with their arms folded or picking their noses or with a fag in their mouths, when you're doing romance or comedy at 8.30 on a wet Monday morning, you're not playing yourself! With me it's that I've always tried to seem like a real person. In the early days, with *Alfie* and that, they used to ask me, "What sort of actor are you?", and I'd tell them that most actors held up pictures for you, but that my acting fails if you don't believe you're looking in a mirror. I hold up a mirror and I say, "This is you – not me." Which is why in the street I'm not regarded as some great unapproachable movie star – people think they know me.

'But I sometimes think it must be a bit self-defeating, because you go through life with people thinking you're playing yourself. My God! If only I knew who myself really was, I'd play him! To the hilt. But you never know who you are, do you, not really.'

Caine's big break came in 1963, when he scored a considerable critical triumph playing, ironically, the decidedly upper-class Lieutenant Gonville Bromhead, of the South Wales Borderers, in Cy Endfield's epic reconstruction of the English defence of Rorke's Drift in 1879, *Zulu*. And the celebrity rollercoaster of London in the 1960s, as a much mythologized combination of time and place that Caine would do much to personify, really began for him with the success of this role. Caine was very much a product of the new, determinedly smart, working-class aristocracy of London celebrities, including Bailey, Terence Stamp and Richard Harris, whose suits, cars, addresses and girlfriends had to be of the highest quality. These were proto-Thatcherite Mods with class – the barrow-boy yuppies of Swinging London – whose working-class

heroism was more than informed by an increasing proximity to not only glamour but royalty.

Drinking at Desmond Cavanagh's glitterati hot-spot in Great Newport Street, the Pickwick Club, or going out with a succession of largely interchangeable models, the traditionalist values of Caine and his peers, as described in part by *Alfie* (1966), would seem reactionary and suspect to their psychedelic successors towards the end of the same decade. This, in fact, would be the conflict of modern attitudes fought out by James Fox as the upwardly mobile gangster Chas, and Mick Jagger as the decadent rock star Turner, in Nicholas Roeg's psychodrama *Performance* (1970). It was all a long way from the kitchen-sink ethos of class war in the British Free Cinema movement of 1956; and it was fitting, therefore, that Caine should come to prominence playing a Victorian British officer just as the Peace Movement was getting under way.

'Well, I do think that there was an assumption on the part of the kitchen-sink writers that the working classes only existed in the north, and that the south is all full of gentry and sophisticated bourgeoise out in Surrey. The Cockney was sort of dismissed, as a comic character; and I do think that I was a part of the kitchen-sink thing, in some ways. But I just came out of the blue on an individual course, not really knowing what was going to happen. I mean, take all this thing about me and the Sixties that's followed me around: nobody was aware of the Sixties, as a specific mood or what have you, until 1968 when we read about it in *Time* magazine! There's this idea that we all sat down on New Year's Day 1960 and said, 'Right, this is the Sixties!' – but we weren't really aware of it.'

The Sixties made Caine, and Caine defined the Sixties as a timely embodiment of the class-blurring but ultimately class-conscious zeitgeist. Having signed an exclusive seven-year contract with the agent Denis Salinger, in 1964, for the then phenomenal sum of £350,000, Caine began work on the starring role of Harry

Palmer in Sidney J. Furie's *The Ipcress File*. Palmer, as a secret agent, was the antithesis of James Bond – more of a minor civil servant, plodding through the bureaucracy of espionage at the beck and call of duplicitous upper-class paymasters, rather than a glamorous jet-setting spy. As such, Caine's success as Harry Palmer could also be seen as describing the triumph of his working-class, 'ordinary' glamour within Sixties London. His Cockney lilt and thinly veiled contempt for institutional sophistication made Caine's Harry Palmer a new breed of working-class hero – holding up a mirror to its contemporary audience.

This dual success, of creating characters who described their times, was compounded with *Alfie* (1966). Based on the novel by Bill Naughton, *Alfie* offered Caine the chance to convey the charmless philosophizing of a West End Lothario. The film was blunt in its blatant sexism, which was acceptable during the vogue for 'sex comedies' such as *Here We Go Round the Mulberry Bush*; but it was also, as is often forgotten, doubly blunt in its handling of the consequences of that sexism, by way of a graphic sequence featuring Denholm Elliot as a drunk abortionist. Caine was nominated for an Oscar for *Alfie* in 1967 (which went to Paul Schofield for *A Man for All Seasons*), but more importantly he had created his identity as a 'movie star' on an international scale – by playing 'the ordinary bloke'.

'When I did *Alfie*, even though it was a success in England, I felt sure that it would never be a success in America because of my accent and everything. Then one day they told me to go over to Twickenham studios to do one hundred and twenty-five voice-loops on *Alfie* of dialogue the Americans couldn't understand. So I did it, and then the film was a huge hit in the States. But that's because every guy in America thought he could pull all the girls and screw everything in sight if he was like Alfie! And it happened the world over. So there you've got an example of an indigenous British film that will be a big hit the world over providing it's got a universal theme.

'But Hollywood cheats all the time, see? *Alfie*, of course, was different, but action films are universal. Any time they've got an actor who can't act they simply blow a building up behind him. Know what I mean? So you say, "That was a great movie; did you see the way that building blew up right behind that guy?" And that's what I call the "If You've Got Enough Money You Can Cheat" school of acting. I'll give you a for instance. Did you see that film *Independence Day*? You didn't? Oh. Well, that's got the best special effects you'll see anywhere – it's wonderful. But you think to yourself, "Who green-lighted this script?" It's appalling! One of the worst scripts I've ever read. And right at the end, I said to my wife, "I'll bet the leading lady's going to come in now with a big American apple pie." And you know what? She came in with a big plate of peach cobbler. And I said to my wife, "That just about sums up the whole script: a load of old peach cobblers!" You see we could do that in Britain, if we had the money, but no one will give us the money to throw at anything, let alone a movie.'

By the time of his first real taste of international celebrity, Caine had moved on from sharing flats at exclusive addresses with Terence Stamp, and from dating, in keeping with his epicurean appetites, Egon Ronay's daughter Edina, who had played a minor part as a sex-siren schoolgirl in *Pure Hell at Saint Trinians*. But he had bought his first Rolls-Royce (having given two fingers, in a further act of class war, to the first showroom manager who had refused to believe he could afford it), a small house near Marble Arch, and banked his first million pounds. The Sixties had made Caine a globetrotting, millionaire movie star, as underlined by his starring appearances in the two biggest films of 1969, *The Italian Job* and *The Battle of Britain*, the respective cast lists of which read like a who's who of international cinema. And, it could be argued, the epic scale of *The Italian Job*'s comedy and *The Battle of Britain*'s historical drama represented a last flowering of the exuberance and confidence that had typified Britain in the Sixties. They saw the temporary closure of Riviera fantasies and block-

buster heritage as relevant to modern taste. Broken lifts, bad drugs and brutalism had become more central to the English condition.

The 1970s, as kicked off in British cinema, would find James Fox in *Performance*, McDowell in *A Clockwork Orange*, and Caine in *Get Carter*. These comprised a triptych of films that studied the legacy of the 1960s, in their different ways, as psychopathic revenge tragedies in which the principal characters appeared to haunt the ruins of pop's first innocence. In the case of *Get Carter* (1970), written and directed by Mike Hodges, there was a reverse shunt of the metropolitan gangster – the Sixties folk hero, played by Caine – back to the reinvented northern landscape of the kitchen-sink films of the Fifties. As if by way of acknowledgement, there was even a cameo role for the playwright John Osborne, playing a lazily sadistic local villain.

Get Carter, therefore, can be seen as one of the first truly modern films about Britain, displacing not only the clichés of British social realism but also the clichés of Gangland film-noir. Soaked in malevolence as an unselfconscious fact of life, *Get Carter* rehearsed the new brutality of TV dramas of the 1970s, such as 'The Sweeney', by describing the realism of violent crime in the cold light of day, in banal, recognizable settings. For Caine, as an actor determined to reflect every nuance of ordinariness, the role of Carter was perfect. Indeed, there has seldom been a more menacing performance.

'There was an extraordinary morality in *Get Carter*, inasmuch as one of the reasons that Carter is prepared to kill everyone is that someone's put a person with his surname into a pornographic film. And that's an incredible moral judgement! But those guys, you see, within all that working-class gangster system, right through the Mafia, will follow the principle of protecting your turf and protecting your own. A gangster, more often than not, is a policeman who's taken the law into own hands, protecting his family and providing them with a criminal livelihood.

'We got an awful lot of stick for the portrayal of violence in

Get Carter. But it was only violent inasmuch that I wanted to get across that if you whack a bloke eight or ten times in the face, he isn't going to get up, shake himself down and come back at you. Just one proper hit in the face and he's going to be across the room. And you never see that in a lot of films. What you get these days, to a great extent, is a pornography of violence which is much more dangerous than a pornography of sex. I'd rather see people screwing each other than killing one another. In *Get Carter*, we were criticized because we showed the reality of violence. But just one stab in the stomach – that's all it takes. I've been a soldier; I know about the trauma of violence.

'I always remember when I did *Dressed to Kill* (1980), and this guy was having a go at me, in an interview, saying how the violence in the film was sickening. So I asked him how many people actually died in the film, and he said, "My God, it must be dozens!" and I said, "One. It's the way de Palma did it that makes it seem more violent." They showed *Dressed to Kill* in Leeds or Bradford, during the time of the Yorkshire Ripper, and a group of ladies who were rightly up in arms about all this threw a bucket of ox blood over the screen. And then when Sutcliffe was caught they asked him whether he'd seen *Dressed to Kill* and he said "no". So you see, it's difficult. Jack the Ripper never saw a violent movie. He never saw anything. He just went out and did it.

'But I was listening to Dustin [Hoffman] talking about violence in the movies, and there is a correlation. It begins with cartoons. These cartoons are nothing but violence. The anvil drops off the skyscraper and flattens Tom, and up he gets. It's not the violence per se, it's the fact that you don't see any cause and effect. And that's how you end up with the Jamie Bulger case, I reckon. They were only little boys. They just tried it out because they'd seen it.'

With the exception of *Sleuth*, in 1972, for which he was nominated along with co-star Laurence Olivier for an Oscar in 1973 – Brando receiving the award this time, for *The Godfather* – and

his extraordinary performance as Peachy in Rudyard Kipling's tale of Freemasonry in Victorian India, *The Man Who Would Be King* (1975), the 1970s and early 1980s saw Caine mixing big-budget action films best represented by the twin hits of 1976, *The Eagle has Landed* and *A Bridge Too Far*, with films such as *Beyond the Poseidon Adventure* (1977), *The Swarm* (1979) and *The Hand* (1981) – which are best forgotten. Throughout Caine's career, it would seem as though playing opposite legendary actors such as Olivier or Connery would bring out the best performance in him. He seemed to be bettering his rivals for superstardom almost as though they alone could constitute a new, energizing challenge to the south London boy who had managed to lay the world at his feet. As ever, Caine won.

In 1973, Caine had married former Miss Guyana, Shakira Baksh, in Las Vegas and started to build a mansion in Hollywood from which he would return to England, as a semi-resident, only in 1984. Openly prepared to work solely for the vast fees he could now command. Caine's return to form in the mid-1980s came from playing the slab-faced pimp in Neil Jordan's *Mona Lisa* (1986) and Mia Farrow's unfaithful husband in Woody Allen's *Hannah and Her Sisters* (1986) – for which he finally received an Oscar. That Caine should enjoy renewed critical success during the zenith of Thatcher's enterprise economy is an ironic coincidence that fuels the political ambiguity with which he is surrounded as a celebrity. On the one hand, his best films – *Ipcress File*, *Get Carter*, *Sleuth* – show him portraying the reactions of underclass or underworld characters to their handling by fate; on the other, both these characters and Caine himself (as a shrewd investor and independent businessman), possess a muscular individualism that is as intolerant of England's attempts at liberalism as it is to the traditional temperament of English society. Neither they nor Caine can countenance what Mrs Thatcher once famously described as 'moaning Minnies'.

'The same thing's wrong with England as it always has been:

we're an island and we're not aware of what's going on in the rest of the world. For a start, we invent all these bloody things and then we never back our own people. We're always negative about everything; the press is negative over here, and that's because the people are. I mean, you get the press and the police that you deserve – know what I mean? I'll give you a for instance: I'm building a restaurant out in Miami and out of the twelve guys working on it, nine of them are British! They've come over for the work! In America, when you're hiring people, they ask, "What are the wages and what are the prospects?"; in England they ask, "What time do I have to start and when can I knock off?" It's no coincidence that we've got the longest running bloody soap opera in the world and twenty-one million people have sat and watched it for twenty-five years; it's because everyone gets home in time! We've got an entire bloody population who know every word of "Coronation Street"!

'Now I don't mind people doing a thirty-eight-hour week, but who's doing the overtime? We've lost everything – cars, shipping, the lot. Would you have believed, thirty years ago, that the British car industry would be owned by the Japs and the Germans? You'd have thought I needed putting away if I'd have said that. You see with Tony Blair, now he's really going to the Right to get in – and I'm really pleased with that. I hated all that old cloth cap and "let's bring 'em down" stuff, because we had all that and it didn't work. The thing with me is that I'm not, by any shade of political opinion, a rabid socialist. But I am a free-market spirit because I just go off and do whatever I want to do. And I don't care. But, eventually, you have to have a conscience about what's going on. I do have a great deal of faith in England, and I think Blair might well get in and it won't be a bad thing. So long as he doesn't start putting all the taxes up and nationalizing everything – because we've had all that before as well, and that didn't work either.'

Over the last decade, Michael Caine has become a major personality within the iconography of English popular culture. He is

as celebrated for representing the first pop glamour of London in the Sixties, and an attitude presumed to pertain to that glamour, as he is for the films that first made him famous within that period. Hence his memorable contribution to Madness's melancholy elegy on identity, 'Michael Caine', and more recently – as British pop recycles its nostalgia for earlier British popular culture – the Divine Comedy's 'Becoming More Like Alfie', and the Sound Spectrum's inclusion of Roy Budd's haunting theme from *Get Carter* to be in the pantheon of Easy Listening revivalism. And, as London is presumed to be swinging again, with the magazines *GQ* and *Newsweek* trumpeting 'Best of British' and 'London Rules' respectively, Caine's latest return to prominence allows an original to comment on the copy.

'It's like with the Sixties, when I said we didn't know about it until *Time* magazine told us. And now it's all happening again. Nobody knew we were in the Roaring Nineties or the Naughty Nineties or whatever it is until *Newsweek* came out. But you always have a great burgeoning talent in England. Take something that I don't know much about, and seems to me to be quite superficial – dress designing. Now you've got your John Galliano and that bloke McQueen, both of them great British dress designers. Well what have they done? They've gone, that's what; they're in Paris, as the head of Dior and Givenchy. I know all this from my wife, you see, because she's into all this stuff. Mind you, now they've got these computerized things they'll be making movies with Humphrey Bogart and Marilyn Monroe instead of us lot soon! They can do it you know.'

Will Caine's next battle be with virtual celebrity? His own place, one feels, is secure: somewhere between the immortality of an icon and the everyday contentment of a movie star who owns five restaurants.

The original 1960s, taken out, dusted down and given an airing, still held a few surprises – its radicalism still intact, rather than seeming naïve. As Baby Jane Holzer, a former Warhol Sixties person, would later remark about Nineties 'cool': 'In the Sixties we didn't think it was cool to be shallow; we thought it was cool to be hip to your inner consciousness.' Retro, let us be reminded, was the Past robbed of its history.

Likewise the immediate oppositional thinking that had developed during the late Sixties suddenly seemed remarkably relevant to the cultural materialism of the 1990s. In 1970, in the issue of *Oz* magazine known as 'the Schoolkids' issue', for which its editors were sentenced to fifteen months in prison, an eighteen-year-old from Reading had written: 'The media's tactic is "take it over, package it, sell it back to itself". We haven't infiltrated them, they've infiltrated us. Now the revolution is a groovy way to sell things.'

Which, it could be argued, was a diagnosis of the cultural conundrum of the 1990s, summed up twenty years earlier. In Reading.

'Live in Your Head': Concept and Experiment in Britain 1965–75. Whitechapel Gallery

Standing in the lobby, so to speak, of the twenty-first century, we can look back over the cultural activities of the past four decades and try to see what artists and writers and film-makers were attempting to articulate in their struggle to find new creative languages. Glancing back at the year 1965, for instance – and the chronology of the 1960s art scene in London has been meticulously detailed by the historian David Mellor – we can find an uncanny rehearsal for the art scene in London in the mid- to late 1990s.

Guided by Mellor, we see Jenny Lee, of the newly elected

Labour government, increasing national arts spending in February 1965 by what was then a whacking great £665,000 – to finance 'a more cultivated Britain'. In the same month, as the direct precursor of the 'Brilliant!' exhibition of 1995, the Walker Art Center in Minneapolis hosted the British Council's 'London: The New Scene' as a showcase of Britain's 'youthful' visual culture. Bridget Riley did a light show for the T. S. Eliot Memorial performance of *Sweeny Agonistes*, and in November the first glimmerings of what we now call docu-drama were seen in the TV première of 'Up the Junction' and the controversial decision of the BBC not to show 'the documentary-fiction film', *The War Game*.

But most flamboyant of all, on Mellor's calendar of 1965, is the opening of 'the village maypole of Swinging London', the Post Office tower, by Harold Wilson. The image of the 'village maypole' is well-chosen, bringing to mind a kind of centrifugal ritual of cultural activity, the purpose of which was less to act out some arcane tradition than to bring about a luxuriously giddy sense of vertigo. This was the dance of youth to blur the cultural boundaries – way before post-modernism was a catchphrase – and to exist in a self-centred cyclone of their own audacity and optimism, partly naïve, partly heroic.

By 1965, also, the Beatles had been prised out of those awful suits and were poised to enter their greatest recording period, which would culminate in August 1966 with the release of *Revolver*. Most specifically, the closing track on that LP, 'Tomorrow Never Knows', with its backward drones and monotonal chanting ('That's me going through me *Tibetan Book of the Dead* phase,' as John Lennon later recalled) would seem to set the seal on a new way of making art. Vitally, 'Tomorrow Never Knows' made a break from pop music – in the understood sense of 'I Want to Hold Your Hand' or a TV show like 'Ready, Steady, Go!' – and, by extension, from the Pop Art that had been attendant on the burgeoning popular culture of the mid-1950s to the middle of the 1960s.

The Beatles achieved this act of liberation from the pop mono-
lith (which they had created, more than any recording artist since
Elvis) by literally dismantling the mechanics of the popular song.
When you listen to 'Tomorrow Never Knows', pretty much the
first sounds you hear are Ringo's bouncing percussion, followed
by what seem like little darts of high-pitched tones, being thrown
from the sides of the galloping composition. Famously played
on one chord (like Yves Klein's monotonal 'symphony') the track
continues by reversing every aspect of the popular song. It was a
triumph of deconstruction (involving an astonishing amount of
recording studio wizardry and improvisation on the part of George
Martin and the Beatles) and turned pop itself into a newly mal-
leable medium.

As Jon Savage has written: 'On its release, "Tomorrow Never
Knows" (as "The Void" was later known) was an explicit assault
on contemporary perception . . . If that wasn't enough ["Tomorrow
Never Knows"] also marks the moment when pop began to move
out of linear and into serial time, when directional was replaced
by circular motion, when the explicitly materialist was replaced by
the spiritual.' Pursuing Savage's interpretation of the track, as the
beginnings of pop's temporal 'looping' into a series of revivals –
in the 1960s rediscovery of Art Nouveau, followed by the Art
Deco styling that dominates the first years of the 1970s – it
is interesting to consider the practice of primarily visual artists
throughout the same period. To what extent was visual art as
capable of liberation from its inherited forms as the Beatles had
proved pop music to be?

The answer to this, in the resounding affirmative, can be seen
in the remarkable explosion of experimental, conceptual, auto-
destructive and performance-based art that gathered momentum
throughout the 1960s. Here were the dancers, if you want, around
'the village Maypole of Swinging London', conflating protest
(against political and cultural orthodoxy) and a form of celebratory
cynicism, the results of which can be seen as acts of creative

negation. In other words, as with David Dye's 'Distancing Device' (1970) – an installation of mirrors encouraging the viewer to leave the gallery – a directive in art-making that made a cultural virtue of social disruption.

When they met at the Idica Gallery in 1966, John Lennon and Yoko Ono became – to the broader public at least – the living embodiment of the avant-garde. Popular opinion has chosen somewhat to overlook Paul McCartney, who was equally, if less flamboyantly, involved with London's avant-garde at that period, and to concentrate on the works, recordings and happenings co-authored by John and Yoko.

For Yoko, as an artist in her own right, marriage to Lennon was as much an exposure of the hatred of her husband's fans towards her, as it was the sudden arrival of a global stage on which to perform. Her most enduring contribution to artistic practice would be the Zen minimalism of her 'instruction pieces' – the technique of which would be applied by the couple to their political activism. In her films, notably *Fly* and *Bottoms*, made with Lennon, Yoko would play right into the hands of British satire by producing works that trod a fine line between intensity and the sensationalism, as it was then perceived, of nudity.

A cartoon by Giles, published in the *Daily Express* in March 1967, sums up not only Britain's amusement towards John and Yoko's 'Bed-In' for world peace, but also, by extension to the political end of the avant-garde per se: 'Vibrations from the "Make Love Not War" department,' ran the caption, 'Grandma says if everyone isn't out of her bed in three minutes flat, she's coming up to join you.'

If Yoko's work made a virtue of considered literalness – a kind of Socratic method of demonstrating its argument to the audience, by inviting them to consider various propositions – then one of her most disturbing films was *Rape (or Chase) Film Script No 5* (1969). The instruction for this work was simple enough: 'A cameraman will chase a girl on the street with a camera persist-

ently until he corners her in an alley, and, if possible, until she is in a falling position.'

Ostensibly to demonstrate the invasion of personal space and privacy (which Yoko had experienced when she became involved with Lennon), *Rape* is an ambiguous work at best. Today it looks remarkably contemporary, dealing with the mediation of private feelings expressed in a public space. How this fits in with Yoko as a specifically 'feminist' artist can only be considered in the light of its historic context and the wider influence of the Beatles. More specifically, the piece highlights the significant role of violence in an epoch too frequently misrepresented by the truism 'Love and Peace'.

Back in November 1966 – one month after the release of *Revolver* – a single by the art-school rock group the Creation managed to hit the UK chart at 36, where it remained for two weeks before descending into the purgatory of Mod obscurity for the best part of twenty years, prior to being name-checked by the Sex Pistols. The single was called 'Painter Man' and kicked off with the words: 'Went to college – studied art.' As far as narrative goes, the song describes an art student's disillusionment with art itself: 'Who would be a painter man?'

'Our music is red with purple flashes,' said the Creation's Eddie Phillips, and the group's music and live performance lived up to this description. As Kevin Pearce wrote in his excellent survey of art-pop outsiders, *Something Beginning with O*: 'The Creation played way-out pop, beaten-up blues. Their first foray, "Making Time" was upfront and urgent. The song was aggressive, argumentative and articulate: "Why do we have to carry on, always singing the same old song?" The Creation's live shows were non-stop movement, climaxing with an action painting being ceremoniously set fire to. Antics on a par with the Flies pissing on the audience at the Alexandra Palace 14-hour Technicolor Dream, two people sitting on stage reading newspapers as Subway Sect played, or Einsturzende Neubauten and accomplices setting about the ICA stage with pneumatic drills . . .'

Pearce's observations that the Creation opened a new art-pop practice of auto-destruction and disruption is matched by the more celebrated relationship between the Who's ritual demolition of their stage set and Gustav Metzger's auto-destructive performances from 1961. The Who's on-stage violence – captured by Linda McCartney's photograph of Peter Townshend – caught the loop of Metzger's idea perfectly. As spotty Mods in Union Jackets, suede shoes and target t-shirts, they were following in the spirit of Metzger's pronouncements of 'auto-destructive art as the transformation of technology into public art' or 'the amplified sound of the auto-destructive process can be an element of the total conception'.

As Kevin Davey recounts in his *English Imaginaries* (1999), Pete Townshend admitted wholeheartedly to the influence of Metzger's ideas on his performance: 'At the time I considered it to be art . . . the German movement of auto-destructive art. They used to build structures that would collapse. They would paint pictures with acid so they auto-destructed. They built buildings that would explode. So I used to go out on stage thinking that this was high art.'

In July 1961, Metzger's 'Demonstration of Auto-Destructive Art' held on London's South Bank (including the supremely modern creation of the 'Acid Action Painting' which Townshend mentions, made with hydrochloric acid on nylon) had concluded the announcements on its flyer with the statement: 'Auto-destructive art is an attack on capitalist values and the drive to nuclear annihilation.' And by 1966, Metzger's 'Destruction in Art Symposium' at the ICA would be inviting psychologists (specifically) and sociologists to 'assemble the maximum amount of information' on the new destructive artforms.

Ironically, back in the world of pop, Marjorie Proops had already 'analysed' the violent tendencies of Mod in a piece for the *Daily Mirror* in May 1964 entitled 'Inside the Mind of a Mod'. Prompted by the Mods and Rockers clashes at Brighton and Margate, it

concluded with some less than useful advice from Proops: 'If only it wasn't for the blood and the pills and the broken windows, I'd be in favour of just leaving them alone to fight it out.'

In some ways, the most coherent and pervasive art statement that came out of this new, radical tendency in British pop culture in the mid- to late Sixties was the *The Beatles* album (1968). Better known as 'The White Album', from Richard Hamilton's monolithically pure white numbered cover art inwards, it was the triumphant summation of Britain's conflation of art and pop in the 1960s. It revealed the Beatles to be at odds with one another creatively (compare Paul's vocal on 'Ob-la-di, Ob-la-da' to John's on 'Yer Blues'), but somehow brought off the final evidence of the group's enduring influence on an epoch.

The double LP gave over the greatest part of its last quarter to the largely unlistenable, but historically significant 'Revolution 9'. A montage of sampled sounds and audio effects, it pushed the public's adoration of the Beatles to its absolute limit. It demonstrated the importance that John, in particular, attached to the potential of the avant-garde as a creatively disruptive force in art, despite the fact that he was urged by George Martin and the other Beatles to leave the track off the finished album. But to what extent might John have been led astray, artistically, by the cultural peer pressure of what was becoming merely fashionable dogma?

If art was perceived throughout the 1960s to have a primary function to question and disrupt, then that function would have reached its critical mass by the early 1970s. For the historian and former contributor to the two underground newspapers, *IT* and *Oz*, Jonathan Green, the period which we have grown to mythologize as 'the Sixties' began with the Albert Hall poetry reading, 'Wholly Communion' in 1965, and ended with the trial of *Oz* in 1971. Within the span of these two dates, one can see the whole trajectory of 1960s thinking with regard to the establishment and the ultimate dissolution of what became known as 'the counter-culture' and the 'alternative society'. Art, too, would have colluded

with this cultural arc, from belief to apostasy and disillusionment, between 1965 and 1971. By the time of the *Oz* trial, the idea of protest – or even the open-handed process of creative negation – would be undergoing a substantial revision.

As Green records in *All Dressed Up – the Sixties and the Counterculture* (1998), fashionableness had played a major role in much of the upward surge in counter-cultural activity, and, once that generation had moved on to jobs and domesticity, the ideals were left high and dry: 'Suddenly, after all the sound and fury, it was over and silence returned. The student anger had burned itself out. The protests stopped; there were no more sit-ins, no more excited votes, no more invasions. Where did it all go? If one believes Alan Marcuson, a drop-out from Leeds and actively involved in the more extreme actions of the London School of Economics movement, the Old Left's suspicion of their juniors had been correct: that for them "revolution" was just one more fashion, a way of enlivening the years before one finally faced up to real life.'

Even John and Yoko (whose 'Do the Oz' recording had contributed towards the defence fund for the magazine) would have left Britain for New York by 1972. Exasperated by the increasingly grim and academically hard-line agenda-setting of the New Left, for whom they had been willing propagandists on a myriad different causes, they would be turning their intentions towards the utopian sloganeering and direct media activism of their own peace campaign.

By the early 1970s, therefore, as the counter-culture of drugs that slowed you down was replaced by the new brutalist Britain (and drugs that speeded you up) there was a sense in which the visual arts had abandoned the directly political stance of its practice in favour of a more deliberated and self-aware form of discourse. A defining British work of the early Seventies would be the 'Shit and Cunt' magazine sculpture by Gilbert & George, made with prophetic timing in 1969.

Published in *Studio International* magazine in 1970 (with the

offending words censored) but also shown in a glass case to invited viewers at the Robert 'Groovy Bob' Fraser Gallery in May 1969, 'Shit and Cunt' marked a dismantling of accepted practice as absolute as that achieved by the Beatles. Here was a work that deconstructed every preconception and prejudice that could be brought to it. The simple juxtaposition of Gilbert & George, as friendly, smiling, polite young men, and the self-mocking violence of the words 'George the Cunt' and 'Gilbert the Shit' – made out of letters carefully pinned on to the fronts of their suits – comprised a statement that took control of creative violence and pressed it into service as a grand gesture of alienation and anxiety.

As with the photographs of Gilbert & George, 'off to send drawings to the 18th Paris IV Group Exhibition', in 1970, in which the artists are posed on the step of their ceremonial home in Fournier Street, east London, looking for all the world like obedient students of life drawing, the 'Shit and Cunt' magazine piece introduced the idea of an art that denounced the academic self-referentiality of modern art itself. Bruce McLean, too, would parody the poses of Henry Moore sculptures in his 'Pose Prints for Plinths' (1972) and Keith Arnatt would contribute to the sentiment with his text piece of 1970: 'Is it possible for me to do nothing as my contribution to his exhibition?'

In this declaration of art's potential to question the point of art itself, articulating the ideas that are still dominating artistic practice at the start of the twenty-first century, there is a muscular demonstration of the need to favour wit, violence and sheer bloody-mindedness over the seductive warmth of mere aesthetics and academic respectability – whatever form that respectability might be taking.

<center>◇</center>

. . . one of those raw, still, late-autumn days when the mist hangs between the trees and loud noises seem muffled. It's some time

around November 1972. And there just ahead, but somehow distinctly and obviously *apart*, sitting in a drift of leaves, and gazing directly ahead of themselves, are a pair of what can only be described as – foppish revolutionaries. It's the way they're just *sitting there*, staring directly ahead, not saying a word, that does it. When everyone, the whole school, from youngest new boy to oldest prefect, is *supposed to be watching the match*.

And then there's these two. One of them looks like the young Jimmy Page on the back of the first Led Zeppelin album, and the other looks like Ray thingy – the scholarly-looking keyboard player with the Doors who wore glasses. Between them, these lower-sixth formers, they have a certain aristocratic hauteur, shot through with that vagued-out, unblinking inner karmic could-it-be-drugs look of absolute utter vacancy. They're both wearing black greatcoats with regimental brass buttons; one has a scarf wrapped around his chin. But the way they're vagued-out so intently and just sitting there, staring directly ahead, makes it somehow worse – *far worse* – than if they were actually booing: '*Booo, booo* . . .

And that's what's really pissed off that teacher just over there, who is now marching over towards them, fists clenched, arms like ramrods, steaming along the touchline, chin lowered, eyes fixed on the starers in a death-ray glare that couldn't be more *personally affronted*. It's worse than if they were booing, much worse! It's a complete and utter rejection, repudiation, deeper than scornful, attack on the school, the school spirit, and by extension the nation, civilization and God Himself. And the teacher. That they're just sitting there staring directly ahead is a personal attack on *him* – a spit in the eye.

Thus, red-faced, middle-aged, tweed-jacketed – the teacher now has hairs coming out of his nose that are bristling with anger; his florid brow is lowered in determination. Because those two in the drift of leaves, pursuing youth's duty to piss people off, are reeking of rebellion; they have the insolence of young intellectuals who know that they're clever.

Up and away from the rugby field, over a lawn or two and up some worn, mellowed stone steps, you'd find the senior common room they generally lurk in. It's under Gothic eaves – nineteenth-century. There are heavy black drapes hanging over the windows; an Indian scarf hanging over the lamp, which sends an upward flare of scarlet light, leaving the posters of Hendrix and the slinky black girl on the motorcycle in church-like semi-darkness. Usually you can hear the light bouncing drum and sonic tones of the Pink Floyd, 'Set the Controls for the Heart of the Sun'.

Back in 1947, Cyril Connolly wrote in a new Introduction to his *Enemies of Promise*, referring to his memoir of Eton College: 'Romanticism is measured against a romantic education.' That good old Shelleyan angry young hipster thing. And the prophets of post-modernism would turn out to be Modernist romantics all along: oppositional at root. And on the facing common room wall, a poster of a young gent with a bren gun.

Malcolm McDowell

McDowell let out a short, sardonic laugh and turned to scan the traffic through the restaurant window with his famously blue eyes. 'Menacing? I've lived with that label, if you like . . .' White-haired and tanned, lost in thought, he retains in middle age the ability to slip behind that glazed-over gaze, which lent such intensity to his performances in three of the most confrontational films ever made: *If . . .* (1968), *A Clockwork Orange* (1971) and *O Lucky Man!* (1973).

It was that gaze that was the envy of teenagers and the nightmare of teachers when he played the public school anarchist, Mick Travis, in *If . . .* , spraying parents and prefects with machine-gun fire from the chapel roof on prize day. It was that gaze that opened *A Clockwork Orange*, a film deemed by its director to be so dangerous that for many years the nearest place to Britain

you could legally see it was Paris. And it was that gaze, when it filled the screen in the closing minutes of *O Lucky Man!* that seemed to sum up the fury and bewilderment of disillusioned youth.

But since this dazzling triptych of films, McDowell appears to have been marginalized by his profession and encouraged to take parts that offer little or no scope for his humour, his intensity, or his ambiguous, vulnerable glamour. While the past two decades have seen McDowell taking lucrative parts in movies of differing quality – *Aces High, Blue Thunder, Time After Time, Star Trek* – and receiving good notices for theatre work in New York, he has not played a part that offered his talent the range it deserves. Is this his own fault, or the capriciousness of an industry largely bound to trends and box-office hits? Certainly, it is hard to imagine McDowell settling down into semi-retirement, despite his commitment to his home life and children; and he is more than ready to consider film projects that would require more from him than six minutes of menace.

Exquisite Tenderness is in a long line of films to carry the ominous credit 'with Malcolm McDowell'. McDowell plays a surgeon who is strung up in his own operating theatre by a deranged research scientist. While the film has a respectable cast and buckets of gratuitous gore, it is heavily plotted and lacking in originality. McDowell plays his short scenes with effortless sang froid, but over such limited ground there is little room for him to define himself.

It would seem to be another case of buying in McDowell's iconic presence and hoping that his name alone will lend some credibility to the film. He has grown used to such treatment, however, and now prefers to set his sights on the near future and the promise of more demanding and rewarding roles. He has recently been acting off-Broadway, at the American Jewish Theatre, playing the lead in Ronald Harwood's highly acclaimed *Another Time*. It is in roles such as this that McDowell excels, and it is in this direction that he still hopes to expand his career.

When McDowell stretches out his arms in an empty embrace of incredulity, and asks, 'What changed? What went wrong?', you feel he could be talking about cinema, his own career as a menacing actor, or even England itself. McDowell's story, by his own admission, is about luck, and it begins with a bomb that hit a nursing home in Bridlington, back in the darkest days of the Second World War.

'I was born in Leeds in 1943. I had a wonderful childhood because we moved to the east coast of Yorkshire, to Bridlington. The summers were amazing, playing on the beach or driving my little pedal car around. My dad was in the RAF; he was a navigator, flying Halifax bombers and Lancasters out of Drifield. Then one day a bomb hit the nursing home at the end of our road. I remember the bombed-out building so clearly. It was huge old place, with beautifully tended gardens – they kept the gardens going and yet the building was a blackened shell.'

For McDowell's generation, who would grow up to be the first creators and consumers of modern popular culture, the childhood experience of living in the ruins of an older England, suffering the deprivations of post-war austerity while being aware of a complex new spirit of modernity, would be particularly affecting.

'After the war, my mother, father and aunt ran this hotel– so we always ate quite well. But I remember my father cutting open this ham, and seeing it full of maggots . . . But then, when we were in Bridlington, there was the theatre at the end of the pier, with Saturday-afternoon shows with dreadful comedians, although someone told me that Brian Rix was one of them. Is he Sir Brian Rix these days? And I remember coming out of movies with the light in my eyes . . . Flash Gordon, Hopalong Cassidy, all that "To be Continued . . ." kind of stuff. After that we moved to Liverpool, first to the Royal Rock Hotel at Rock Ferry, then to the Station Hotel at Ellesmere Port – the longest bar in the north west. Scary. All the seamen came in to have fights . . . right by the railway crossing. It was a pretty rough area but I enjoyed it.'

McDowell's childhood was already filled with contradictions, from his impressions of neatly tended gardens around a bombed-out nursing home, to his uncertain status in a country still minutely defined by the stratifications of class. He had been born into an era that heard the last gasp of Georgian gentility; he had been brought up in a region of Britain where the workforce of war-battered industry was about to redefine itself by finally getting a voice through music, film and expanding media. It was a volatile combination of time and place, and McDowell, about to receive the detonating addition of a southern, public school education, embodied this volatility.

'If you look over the years to my stuff, the critics made it sound as though I was working-class. But that was the thing to say in those days, because of the Beatles and so on. And I was never really working-class. I was lower-middle as Lindsay Anderson used to remind me: "Not quite working-class, Malcolm, but lower-middle, near enough . . ." My father was a publican, basically, so we had a good enough life by the standards of the time. But I don't think we had much money, even if my dad did have a Jag later on.

'So my father made enough money to send me to a minor public school, and, in some ways, thank God he did. I loathed it, at first, because I had this northern accent and I went to Cannock House School in the south, near Eltham, where they proceeded to beat the accent out of me. Do you know, I actually had a letter from the present headmaster, not so long ago, asking me to present the prizes on speech day?'

The delicious irony of McDowell returning to his alma mater to offer a few well-chosen words of wisdom to boys who would know him best as a character whose girlfriend shot a headmaster between the eyes with a service revolver, is almost too neat to contemplate. But if McDowell is ambivalent about his own school career, he has fond memories of his headmaster. 'My school was a Woolworth's copy of Lindsay's old school, Cheltenham, but the

attitudes were the same. I ended up head boy of my old school. I hated it and I loved it . . .'

As an adolescent, commuting between life as a publican's son in Ellesmore Port and life as a southern public schoolboy, McDowell began to experience, during the holidays, the new wave of popular culture in the north of England. Pop and cinema were establishing themselves as the new informants of intelligent youth, as important as books but more urgently relevant. 'I remember getting on the 28 bus and riding into Liverpool. There was this one shop we always stopped by, a pawn shop, and in the window there were these bright red electric guitars. We couldn't afford them, but just seeing them – it gave you hope somehow. The Beatles were the biggest thing in my life, and I used to go to see them at the Cavern. It was a tiny place, but when you heard John Lennon singing it was like nothing else you'd ever heard. It was "fuck this" and "fuck that" and "clap yer fucking hands". I thought this was so great – someone actually swearing on stage. But I never joined any youth cults. I'm my own man, I can't stand organization in that sense.

'I suppose that Lindsay Anderson would have called that being an anarchist, but I don't know. Of course, the conditions in the north made me very angry. I'm not after anybody's blood in particular, but all this bullshit of privilege had better end . . . Otherwise everyone'll leave, not just the actors and the film-makers.'

As James Dean and Marlon Brando were creating the classic icons of disaffected youth in their early films – *On the Waterfront*, *Rebel without a Cause* – the new wave of British cinema, which focused on the lives of the ordinary people who lived on McDowell's doorstep, was defining a new breed of working-class hero. Until the late Fifties, British cinema had been a largely middle-class business in both its subject matter and its ethos. For McDowell, the impact of kitchen-sink cinema was as electrifying as the early performances by the Beatles. And again, it was a northern phenomenon, wholly at odds with the training for life that was being offered by the likes of Cannock House School.

'For me, Lindsay Anderson, Karol Reisz and Tony Richardson were the revolution. I saw *Saturday Night and Sunday Morning* at the Odeon in Liverpool and knew I had to get involved. I suppose I was about seventeen, and here I was watching the people I'd soon be working with. Albert Finney's company Memorial produced *If...* and *O Lucky Man!*. So *Saturday Night and Sunday Morning* was the film for me, along with *A Taste of Honey*, *The Loneliness of the Long Distance Runner* and *Billy Liar* of course. We all thought that we were Billy – don't we still? – but Albert Finney was the first Billy. Albert was our hero; he was the standard bearer because he came from the north west – from Salford.'

Inspired and idealistic, the young McDowell managed to land a job as an assistant stage manager at Shanklin on the Isle of Wight, before squeezing into the RSC at Stratford. It was a period of 'actorly acting, with lots of shouting – after Olivier – and soul-searching performances'. For McDowell, it was a repeat of Cannock House School, and his ambivalence towards great British institutions was reinforced. 'The RSC? Horrendous! Middle-class theatre crap – for me. I mean, I saw some great performances – Ian Richardson and Paul Scofield – but it was, like, being ordered around and told what to do by a bunch of little shitheads. I auditioned for the RSC by reading the Prologue from *Henry VIII*, for the very good reason that nobody knew it. It begins, "I come no more to make you laugh", which was ironic, because humour has always been a great mainstay of my arsenal. I mean, *A Clockwork Orange* was essentially a comic performance. I used to loot my style from Eric Morecambe.'

What McDowell required, and what he had the good fortune to receive, was a mentor, alternative father figure and Zen master. This arrived in the shape of Lindsay Anderson, with whom McDowell created a personal and working relationship that was similar to the artistic marriage between Marcello Mastroianni and Fellini. Lindsay Anderson was an Oxford-educated intellectual who had been inspired by the British documentary film movement

(as typified by the pioneering realism of Humphrey Jennings) and whose left-wing political vision was combined with a unique understanding of fantasy and satire. Having worked extensively in theatre, and directed Tom Courtenay in *The Loneliness of the Long Distance Runner*, Anderson was to cast McDowell as the lead in *If . . .* , thus altering the course of both of their lives.

'I had to audition for the part of Travis at the Shaftesbury Theatre. They wouldn't let me out of rehearsals at the Royal Court, where I was working, so I turned up late and they were already packing up. But the stage was still lit, so I wandered on and then heard a voice commanding, "Turn around!" My hackles rose and I turned round, glaring down from the stage. It was then that Lindsay jumped up and introduced himself. He said, "And what are you doing at the moment?" and I answered, "Some piece of pretentious crap at the Royal Court." He said – "Oh, good" – and so we started work.'

If . . . won instant fame and notoriety for McDowell. David Sherwin's story of four public school anarchists touched a nerve in British society. Audiences were faced with a vision of British life that was cosily recognizable but served as a lure to explore the motivation of violent revolution. The film was glamorous and sexy, yet its message of rebellion was one of the great protests of the Sixties. The impact of its violence left audiences stunned (and caused its publicity poster to be banned on common room walls in many a school) but its position on Englishness is ambivalent.

'College was based on Lindsay's old school, but you could only make a film like *If . . .* if you loved England, and even public schools. There's a longing about it . . . But this was 1968 – the year of armed revolt. Lindsay was thrilled when we were filming the shootings at the end of *If . . .* and there was a picture in *The Times* of a guy on the roof of the Sorbonne with a sub-machine gun. He said, 'Look! A still from our film."

'After the London première of *If . . .* Lindsay got up on the stage and said to the audience, "The rest is up to you." Of course,

nothing happened, but for one glorious moment things were a little uneasy. I just wish that Lindsay had made more films, but he'd say, "Oh, Malcolm – one's enough, surely?" because he knew how difficult it was to get anything done in England.'

By 1969, McDowell was Britain's hottest young star, and offers of work were as constant as they had been previously elusive. McDowell made *Figures in a Landscape* ('not a good film') and was hailed as 'the new Steve McQueen' by the *Daily Mail*. The difficulty was to find a film of the extraordinary quality of *If*

In the role of Alex, in Stanley Kubrick's *A Clockwork Orange*, McDowell found the part that would make him an international subcultural hero and haunt his professional life for many years to come. *A Clockwork Orange*, although written by Anthony Burgess in 1962, was a story that seemed to define the massive social shifts between the idealism of the Sixties and the paranoid materialism of the Seventies. By the time the film was released in 1971, there was a generation of British film-goers for whom David Bowie's gothic futurism would be more relevant than the Beatles, urban survival would be more real than eastern philosophies and ultra-violence (as was emerging in tribal football hooliganism) would seem horribly glamorous.

A Clockwork Orange, despite being a morality tale in two halves, with as much concentration on the ethics of social conditioning as on the choreography of violence, was too potent an advert for teenage kicks of the nastiest sort. McDowell's performance ('The so deadly smile of Mr McDowell just slays them,' said the *News of the World*) became a victim of its own excellence.

'I've always had to live down *A Clockwork Orange* wherever I go, because ever since then, with the exception of *O Lucky Man!*, which I made with Lindsay immediately afterwards, I've always been cast as the heavy. It used to irritate the shit out of me, and then I just got very bored with it, you know? I just wanted to get on, maybe make a few comedies or do something else, but there was Alex . . . I know that I've said some mean things about Kubrick

in the past, but thinking back to the actual shooting of that film and trying to forget all the baggage of what happened afterwards, it was an incredibly stimulating experience, even though I got to the point where I hated the film because of the force of the reaction. For me, the nadsat slang that Alex and the droogs talk in was just like Shakespeare – fun to play with.'

Drawing on his brief experience as a trainee coffee salesman in Yorkshire, McDowell had written the outline of a film that was to become *O Lucky Man!*, arguably Lindsay Anderson's finest piece of work. By the time it was filmed, *O Lucky Man!* was a three-hour epic, best described by *The Times* at the time of its release: 'It is an epic comedy with music, in a traditional morality form. The hero of the film, Mick Travis, is a kind of modern Candide, or fairytale Younger Brother, whose innocently confident quest for success takes him through the length and breadth of a Britain of motorways, strip clubs and atomic establishments, of rich industrialists, pop singers, down-and-outs and politicians.'

By reviving the character of Travis, Anderson had created a modern Everyman to figure in a contemporary *Pilgrim's Progress*. It was a grand gesture and one that has never been repeated; to explore with Dickensian scope the constitution and temperament of Britain. It flopped, of course.

'I couldn't believe that *O Lucky Man!* wasn't better received. I couldn't believe that Warners wanted cuts. I said to them, "So you're going to cut a slice of a painting to make it fit on the wall?" No answer, of course. The critical response was stunned silence – then nothing. And it made me feel so rotten . . . It was the real rejection of total indifference. Staggering! Because we thought it was the truth. There won't be another film like it, because we don't have Lindsay any more.'

With *O Lucky Man!*, which could be seen as the last panel in McDowell's great triptych of early films, his collaboration with Anderson broke new ground, but painted itself into a corner. They did work together again, on the uneasy satire *Britannia Hospital*,

but the formula was no longer creating artistic success. McDowell had been locked into his reputation as a menacing actor, and Anderson was weary and bogged down with the difficulties of raising money in the face of critical and commercial indifference to his work.

It was as though the period of British film-making that began with Albert Finney's performance in *Saturday Night and Sunday Morning* had finished with McDowell's enigmatic gaze at the audience towards the end of *O Lucky Man!* It could also be argued that *O Lucky Man!* represented the end of a particular sensibility in British cinema; there was less interest in realism, and certainly less interest in England as a subject. Satire, in the Hogarthian sense, was to be replaced by the comedy of recognition and irony, while the cultural materialism that was to define Thatcher's Britain was too in love with its own complexity to permit the forceful moral tales in which Anderson's generation had believed.

For McDowell, this shift in attitudes meant that he was known as a signifier, and required largely to lend his iconic presence to a succession of films that ranged in quality from respectable to downright terrible. It had been his luck – good or otherwise – to embody a shift in English society. The transition made, where could he make the best use of his talents as an actor?

'After *O Lucky Man!*, I knew that in England the game was up, you know? There was nothing for me, and I remember that during 1976 and 1977, the only script that was a "go" script was a film called *The Passage* in which I played a nasty Nazi with James Mason. These days, I'm usually given six scenes to scare people – to be nasty. It's pathetic, really, but I take it as it comes and do the best I can. *Tank Girl*, I'm afraid, is not very good; the *Star Trek* film I did was OK . . . But if you're going to do contemporary pop culture stuff, then there has to be a brain behind it – there has to be a good story. I mean, the look can be great, sure, but if you've got a good cameraman it bloody well ought to be.

'I honestly feel that there's a renaissance for me, that I've got

out of that strange time in my forties when nobody was really interested in me. Maybe that was because of the whole *Clockwork Orange* thing – maybe I played the part too well. I think I was considered to be a curiosity of English culture. I don't think I was given my due as an actor, but now I'm being offered a huge amount of work, and there is a revival of interest . . .'

McDowell is one of Britain's great actors, similar in force and rarity to Tom Courtenay or Michael Caine. But like a character out of one of Anderson's allegories of England, he has made a full circuit on fortune's wheel and learned, as Anderson suggested, that there are many questions but few good answers. His subject, really, is England and the English, but there is nothing 'Little Englander' or parochial about him.

'I'm not an icon and I'm not really a representative of my generation. I'm just an actor who met this extraordinary man called Lindsay Anderson and got very lucky. And Lindsay used to listen to the Sex Pistols all the time – which is exactly what I feel like doing now . . .'

Imagining for just one minute that you really are up there on the asteroid, studying cultural time travel in the late twentieth century (whistling, perhaps, Jarvis Cocker's lyric for Phil Oakey with the All Seeing Eye, 'I was the First Man in Space on My Street' – *where was the ticker-tape civic reception? How come no one wants to know what I saw?*') you might find yourself wondering what will become of Retro – now that we're running out of Past, and the hands on the Retro-culture Doomsday Clock are standing at a minute to midnight.

Ultimately, Retro can make modernity. The last four decades of popular culture have all used Retro to create their imagery and fashions – but the best of it worked, in the Seventies strangely enough, when a stylized view of the future and a stylized view of

the past were fused together to create a tension of opposites: nostalgia for archaic visions of the future.

Roxy Music

In June 1972, seemingly sprung fully formed as a six-piece band of futuristic teddy boys and mutant matinee idols, the pop group Roxy Music released their first self-titled LP to instant critical acclaim. A month later, when the band appeared on 'Top of the Pops' to perform their first single, 'Virginia Plain' – which had not, as was usually the case, been taken from the album – it was easy to see what all the fuss was about.

Here was a group who looked as though they came from not only another era – the 1950s as they might be reconstructed in the twenty-first century – but also from another planet. Indeed, the keyboard and tape player (and who had ever heard of someone playing 'tape' before?), Brian Eno, had claimed with straight-faced passivity that he was a visitor from the planet Xenon. But having a bona fide alien in the band seemed almost less outrageous than the unholy barrage of nerve-jarring electronic squeals and furiously accelerated piano chords that the group were pumping out.

The principal musicians were a sight to behold. Guitarist Phil Manzanera, his eyes concealed behind the glittering compound-eye lenses of his famous 'bug' spectacles, was thrashing out the lead guitar with a demonic swagger. Oboist and sax player Andy Mackay, chirruping an improbable woodwind solo, had all the self-assurance of a classical maestro but looked like an esoteric rocker with a grounding in Zen. The drummer, Paul Thompson, reversed the time-honoured trend of hiding the percussionist behind the rest of the band by playing centre stage in an off-the-shoulder fake leopard skin.

And then there was Bryan Ferry's extraordinary vocal style, in which breathlessly staccato phrasing gave way to something

between a fox's bark and the leering self-preening of a high camp crooner in the throes of amphetamine psychosis. But by the time that he had reached the pivotal break in the song – 'We are flying, down to Ree-Ohh' – the bewildered studio audience of youthfully plump young people had ceased their customary expressionless jigging up and down, and were trying to work out just what manner of adult pop freakishness had crash-landed into their hitherto teenage world of Marc Bolan's glam pout and Donny Osmond's puppy love.

'If Roxy Music had been like cooking,' says Andy Mackay, sitting in the peaceful drawing room of his elegant house over-looking Clapham Common, 'it would be like the dish in Marinetti's Futurist cookbook called *Car Crash*: an hemisphere of puréed dates and an hemisphere of puréed anchovies, which are then stuck together in a ball and served in a pool of raspberry juice. I mean, it's virtually inedible, but it can be done.'

The founding members of Roxy Music – Bryan Ferry, Brian Eno, Phil Manzanera and Andrew Mackay – have all aged grace-fully in the pursuit of their solo careers since the group officially disbanded in 1982. In many ways, Mackay, Ferry and Eno resemble distinguished alumni of their art school and university backgrounds, who can reflect on their early, rampant success as avant-garde pop stars with a mixture of humour, sagacity and quiet amazement at how a project as experimental and open to the accidents of creative collaboration as Roxy Music could have accrued such massive sales and such a mythology. Glam Revival-ism, in the early Nineties, glittered like gold-dust on the surface of the zeitgeist, with groups such as Suede and Placebo redis-covering the pop power of satin and face powder. The trend would heighten, with Todd Haynes's film *Velvet Goldmine* – being more or less a total homage to the era that Roxy Music defined.

Andy Mackay, in middle age, is dressed now in a pale suit and gold tie; he has the countenance and tone of a grave but approachable lecturer. Before acquiring the heavy blue eye-

shadow and sensual quiff with which he appeared on the inner sleeve of the first Roxy Music LP, he had studied literature and music at the University of Reading, where his interest in electronic and avant-garde music had brought him into contact with Brian Eno, who was studying at Winchester School of Art from 1966 to 1969. Eno had become president of the Students' Union at Winchester, largely to appropriate Union funds in order to invite prestigious musicians to lecture there – usually to himself. Thus, between Reading and Winchester, Mackay and Eno forged a collaboration that would also include Roxy Music's future publicist and sleeve-note writer, Simon Puxley, who had been in the performance art group Sunshine with Mackay.

'One of the things about early Roxy Music,' says Mackay, 'is that we all thought that we were doing something different to the end result. When we did a supposedly "difficult" song like "Would You Believe", on the first LP, we thought that we were playing a very funky rock song. Or when we were playing live we thought of ourselves as very edgy rock and roll. We were all throwing things in, and so in that sense you do have to deconstruct the band. I was bringing a more classical influence, perhaps; Phil Manzanera came with a slightly more West Coast American style; Bryan had a strange kind of Fifties and Sixties pop influence. And so the music came out in a very particular way.

'All of us were from university art departments or art school, except for Paul Thompson, who had worked in a shipyard. And I think that it was important to Roxy Music that there was one band member who was non-intellectual, very physical and just drummed. It was a surprise to us that we were so hugely popular in the mainstream. On our very first dates, when we drove around in my father's battered and unglamorous Austin, with the gear on the roof, we were far more art-school. Bryan used to play at the side of the stage, because he wasn't quite confident enough to stand in the centre and sing; Eno was mixing the sound and also playing the synthesizer, so he would actually be in the middle of

the audience – if there was one. Then, in the middle of the stage, there was this kind of black hole, where one or other of us might venture to play a solo. And all of that changed with "Virginia Plain"; when that became a hit single, we became a pop group – which we hadn't really thought about. Bryan had maybe thought about it: he'd wanted to be a pop singer, but hadn't quite got around to knowing how to do it.'

With this fusion of classical, avant-garde, electronics and rock and roll, Roxy Music resembled their heaviest influence, the Velvet Underground, in more ways than one. For the Velvet Underground, it was the mixture of John Cale's interest in the music of John Cage and LaMonte Young (mirrored by Mackay and Eno), with Lou Reed's pop purist song-writing (shared by Ferry) and drummer Mo Tucker's ability to hit a New York phone directory for half an hour without stopping – echoed by the physicality of Paul Thompson. Out of seemingly disparate influences, both Roxy Music and the Velvet Underground honed a musical style which would become definitive – or 'seminal' – by virtue of the unique, accidental contrasts that their respective personnel brought together. Which is maybe why both groups have produced a host of imitators, and been so influential. In their time, as the Velvet Underground had touched groups as different as the Cowboy Junkies and the Jesus and Mary Chain, so Roxy Music would breathe life into Ultravox!, Duran Duran, and the Liverpool punk performance group Deaf School – who were saloon bar sand and sawdust to Roxy's Palm Court elegance, extending the bounds of homage to a near-parodic cult of imitation. And, by that time, punk rock would have authorized the audacity Roxy Music had practised in the twilight of English folk and prog rock.

'I think that we were about collaging ideas and techniques,' says Mackay, 'but it was a fairly violent sort of collage. Interpreting a piece by John Cage gives you enormous confidence to do something on a pop album that other people might think was weird.

Obviously we were all aware of the visual avant-garde, so what seemed daring in pop seemed conventional to us. What's interesting, I think, is that we were immensely influenced by the Velvet Underground – but the accidental synthesis that we couldn't control was the fact that the Englishness of Roxy Music gave it that shift towards something rather different. And I think that Bryan had a tremendous influence on people who perhaps wouldn't have been confident in going out and becoming singers, because they didn't sound enough like soul or rock singers or whatever; and then they heard Bryan – and Bowie, come to that – who both sang like Englishmen. The Beatles had sort of done that, and the Kinks, but there was always a slight acknowledgement of the American influence. Somehow, Roxy Music managed to sound both rock and roll and European – which I think was very important, about us and our influence later on.'

The promotion and appropriation of ideas of Englishness would also be a fetish in Nineties pop and rock. In many ways, it was the landscape of an English adolescence during the 1970s that would be hymned by English pop in the Nineties, from Pulp to Suede – and this, of course, was the landscape defined by Roxy Music and David Bowie, as the twin informants of an epoch. A vital ingredient of this English glamour would be its indigenous time travel – a chronological dandyism – and at this Roxy Music knew no competition.

What swiftly became evidence was that Roxy Music could combine their image and their sound in a way that hadn't been seen since the collegiate doo-wop group Sha-Na-Na had blown the longhairs away at Woodstock. But where the showbiz anarchy of a group like Sha-Na-Na had been founded in besequinned slapstick, Roxy Music's cabaret futura was unsmiling and opaque – set in the aspic of poised cool. In 1973, when the group performed their minimalist paean to luxury living and sexual fantasy, 'In Every Dream Home a Heartache', on 'The Old Grey Whistle Test', Bryan Ferry's unblinking stare would bring to mind an

embalmed Pinocchio, intoning the lament of a disconnected millionaire sleep-talking through a wet dream.

Like many of the best pop singers, from Lou Reed to Kevin Rowland, of Dexy's Midnight Runners, Bryan Ferry was more off-beat than natural as a vocalist. And herein lay his genius. His distinctive singing style was melodramatic to the point of caricature, but the effect was shot through with an impassioned eroticism and the languorous anguish of a courtly lover. And thus his singing reflected the operatic drama of his lyrics, through which he acted out the part of the archetypal doomed romantic. As futuristic dandies, Roxy Music were like a fin-de-siècle swoon into the arms of technology; as a lead vocalist, Bryan Ferry was like a Marcello Mastroianni from Mars. 'We'll make the cognoscenti think . . .' he crooned on the last line of the last song on Roxy Music's first LP. And they did.

'But I wonder whether Bryan, at the time, was really aware of what he was doing,' muses Mackay. 'The band he was in, the Gas Board, which I never heard, was basically a soul band; and it's very interesting that as soon as he got the chance to launch his solo career off the back of Roxy with "These Foolish Things", he immediately did covers of all the songs by singers whom he admired – which were soul songs. I think that he thought he was singing one thing, but because he was English it came out differently. So I wonder.'

Now, as the arbiter elegantiae of English pop, who wears his mantle of 'coolest English gentleman' with increasing weariness, Bryan Ferry is sitting in the cavernous, incense-perfumed basement of his office near Kensington High Street, and reminiscing about famous people whom he has met in lifts.

'I was once in an elevator with Stan Getz . . . ; and in one with Charlton Heston – in Newcastle of all places . . .' He begins to laugh, tickled by the seeming absurdity of his early contact with the heroes of glamour. 'And then I was in yet another lift with Charles Aznavour – oh dear . . . That was in Europe, I think. We

were kind of different heights: he looked at the floor and I looked at the ceiling. We had to go up quite a few floors as well, and neither of us spoke.'

Ferry's famous raven-black hair is greying slightly at the temples, and this touch of silver suits him. It is almost as though he has been waiting to grow into the leaner features of middle age, but his heavy-lidded eyes retain the glaze of sadness that makes their owner an embodiment of romantic glamour. His voice is quiet, and touched with the faintest lilt of Geordie intonation. He is dressed in jeans and a dark flannel shirt, discarding a loosely knotted navy-blue scarf as he settles down to talk. After years of celebrity, his natural shyness has been replaced with a sense of reserve that can make his recollections sound almost like apologies. And, like Andrew Mackay, he has a certain bewilderment at just how famous Roxy Music became.

He was born in 1945, in a pit village called Washington near Durham. He first appeared on stage when he was fifteen, playing, ironically, the hapless suitor Malvolio in *Twelfth Night*, who is tricked into wearing extremely outrageous clothes in order to be ridiculed in front of the woman he loves. You could almost argue that his entire career as a pop idol has been the precise reverse of that first leading role.

'I got a review in the *Sunderland Echo* for my Malvolio, and I remember that there was a photograph of me. That was my first picture of myself in a newspaper, and it was like a quick flash of fame. I loved dressing up as somebody else; it was much easier than going on stage as yourself. To become somebody else was fabulous, and I think that that's what I did in a lot of the Roxy songs – I simply became somebody else.

'When I was a boy I had a paper round, and I used to read the *Melody Maker* before I put it through someone's letter-box. I remember I dragged my Uncle Brian off to see the Chris Barber band at Newcastle City Hall; then, when I got a bit braver, I'd go into town on the bus to see concerts on my own – dressed in

a white trenchcoat, aged twelve! I'd probably seen the adverts for Strand cigarettes, but I was very into style. My mother used to make tea for the projectionist at the local flea-pit. It was next to the allotment where my father kept his racing pigeons, and my sister and I would sit in the cinema and watch any old rubbish. That was all you did; you didn't have television . . . Well, we got one when Newcastle were in the Cup, but so did everyone in Newcastle. It was ten shillings a week from Radio Rentals. We were very poor, you see. So I think it's fair to say that Roxy Music, from my point of view, were the reverse of this background.'

Ferry studied painting at Newcastle University, where the leading British pop artist, Richard Hamilton, was a tutor. Here, Ferry formed his first group, the Banshees, and then the Gas Board, both of which performed covers of soul and rhythm and blues standards. The Gas Board would include Graham Simpson, who would later play on the first Roxy Music LP, and John Porter, who would play bass on Roxy's second album, *For Your Pleasure*. In some ways, both Ferry's love of soul and his eventual putting together, from a northern perspective, of a soul-driven band, brings to mind the career of Dexy's Midnight Runners. In fact, you would only have to add the art school elements of avant-garde electronics and high irony to turn Dexy's into Roxy. Ferry, however, was committed enough to his art school career to leave the Gas Board when he sat his Finals, and take advantage of a travelling scholarship from the Royal College of Art in order to buy a year in London, putting together Roxy Music. Prior to their overnight success, Andrew Mackay, Bryan Ferry and their future press officer Simon Puxley were all supply teaching to make ends meet. As ever, it was the sheer diversity of elements that eventually created the Roxy Music sound and image.

'I'd become aware of Cage and the art composers,' says Ferry, 'and so my head was full of all kinds of different music which came into Roxy. I wanted to do something which was very passionate, on the one hand, and hopefully very clever as well; to try to create

something which was more than just throwaway, but hopefully not pretentious. I got a house just up the road from here, and Graham Simpson came down. I started writing songs on an old harmonium which I bought for ten quid, and which enabled me to play sustained chords. Then, through a friend from Newcastle – the artist Tim Head – I met Andrew Mackay, who also stayed . . . Whenever anyone arrived, they stayed!

'It was rather like *The Magnificent Seven* – building up the band. We made a list of about twenty names for the group; we thought it should be magical or mystical but not mean anything – like cinema names: Locarno, Gaumont, Rialto. "Odeon" wouldn't have worked! Then Andy said that he knew this guy called Brian Eno, who had a really big tape-recorder, and so Eno came to tape us. I'll never forget the sight of Brian lugging in this enormous, German industrial tape-recorder. Eno, of course, was interested in electronic music, and so he started fiddling around while Andy played, and then he stayed as well. You can imagine the scene, can't you? Andy and Brian making this extraordinary sound, and me pedalling away furiously on this old harmonium.'

Brian Eno, whose current career as a musician, producer and conceptual artist has brought him to the position of making a controversial speech at the Turner Prize awards ceremony about the role of contemporary art, has a sound installation running at Jay Jopling's 'White Cube' gallery (the professional home of Damien Hirst) as he e-mails his take on Roxy Music before boarding a steamer to Saint Petersburg. Eno is a conceptual theoretician above all else – the High Priest of neo-Swinging London's Young British Art scene – and he possesses a genius for converting intellectual ideas into their material manifestation. It is telling that a former member of Roxy Music should, in middle age, be both an editorial consultant at Faber & Faber and a visiting lecturer at the Royal College of Art.

Eno's role in the definitive line-up of Roxy Music was crucial, prompting rumours that his decision to leave the band after the

second LP was due largely to a conflict of leading personalities between himself and Bryan Ferry. His first solo LP, *Here Come the Warm Jets* (1973) was the precise opposite of Ferry's first solo venture, *These Foolish Things*, with Ferry's smouldering version of 'It's My Party' set in competition to Eno's baroque camp of 'Baby's on Fire' or 'Blank Frank'. Between them, however, they would shape the role of the English pop idol – via the shape-shifting of David Bowie, whom Eno's magic touch would reinvent almost single-handedly as a post-industrial punk icon.

'What was different about Roxy Music was that we were quite ironic, and this was new at the time,' transmits Eno. 'We came out of a context where the accepted mode for pop musicians (and most artists, actually) was to be apparently sincere, committed to one's art and immersed within it. We, on the other hand, wanted to do something that was as much to do with showbiz as with the seriousness with which rock had come to regard itself. And the other thing was that we wanted to be able to meld our interest in the Fine Arts – particularly Pop Art for Bryan and contemporary Cage- or Cardew-type music for me – with this amazing vehicle called pop music that was really starting to be born at that time. What was interesting about Roxy Music ws that it was a very unlikely combination of individuals. We never made any attempt to reconcile these differences, and we thought that they were a source of strength.

'There was a definite Janus feeling abroad at the time: looking to the past in a kitsch way, and imagining the future as it might be – but perhaps in an equally kitsch way. Our costumes were quite deliberate takes on those Fifties visions of space nobility – the masters of the Galactic Parliament and so on. But we wanted to make the world sit up and pay attention to itself, and to reflect its images back to it in weird combinations that hadn't been seen before. To locate romance and threat in strange new places – to look beautiful, but in ways that men had not thought of looking beautiful before. But we really didn't think that the music was

that radical. We were quite surprised by how people took to it, and how different it seemed to them.'

On the back of 'Virginia Plain' and the first LP, Roxy Music had gone from art school obscurity to supporting major stars such as Alice Cooper and David Bowie within a matter of weeks. And at a time of proliferating pop media, with a tremendous accent on the latest teen-zine-style music magazines that catered for a youthful audience of glam fans, as well as the more earnest rock press, the group managed to triumph in both camps. The 'accidental synthesis', as Andy Mackay described it, of melting down pop, rock and the avant-garde, then caught the rising wave of pop theatrical stylishness and gave Roxy Music a succession of best-selling records throughout the first half of the 1970s.

The departure of Brian Eno more or less coincided with Roxy Music's rise – on the strength of their chart-topping third LP *Stranded* – to supergroup status. Eno was replaced by Eddie Jobson, complete with a perspex viola, and the new single 'Street Life' became a defining moment of pop cool.

'Looking back now,' says Ferry, 'I think that we really lost something – really lost a lot – from not working with Brian Eno any more. When Eddie joined and Brian left, I thought the sound was more musical; but in an ideal world I wish that Brian had stayed and Eddie had joined.'

'Let's just say that I wanted to see the world,' says Eno, who is now in close collaboration with Bryan Ferry once more.

Stranded, *Country Life* and *Siren* each compounded the original formula of Roxy's first two LPs, defining their flamboyant image and turning their concerts into fashion statements. Indeed, the 'look' of Roxy Music was so much a part of their phenomenon that the *New Musical Express*, in 1973, ran a review of the audience as opposed to the concert: rows of boys with floppy fringes and khaki shirts; eager British girls wearing pill-box hats, hip-hugging skirts and anything at all made out of fake leopard skin. As a received idea, Roxy Music were Forties revivalism with loads of slap, for

'all the young dudes' who had left their elder siblings at home with the Beatles and the Stones. And, as Roxy Music's in-house fashion designer, Anthony Price, comments long-distance from a 'couture crisis': 'It seemed to me that before Roxy Music, fashion hated rock and rock hated fashion.'

'The audiences certainly did invent a "look",' muses Mackay. 'They dressed up to come to Roxy Music concerts, but it seemed to come from nowhere, very quickly and spontaneously. I supposed that Amanda Lear, on the cover of *For Your Pleasure*, had a kind of glam look; but these girls were turning up in mesh veils and Forties shoes ... It does seem strange that Bryan Ferry, Brian Eno and myself are all very shy people, because it doesn't come across that way. It simply became much easier to focus on the music when we were wearing these outrageous clothes.'

The Roxy 'look', from futuristic teddy boys, through gaucho chic, GI chic and Ferry's impeccable white tuxedo, was a direct reflection of the group's musical and lyrical obsession with a kind of time travelling between different notions of glamour. Roxy Music took the shock of the old as a presentiment of the future; as Simon Puxley wrote in his sleeve notes to the first LP: 'What's the date again? (it's so dark in here) 1962? or twenty years on?' Here was the agenda that New Romanticism would pick up on in the late 1970s and early 1980s, when the time-travelling dandies of the Blitz club or Hell would be acting out their formative love of Roxy's synthetic glamour to the soundtrack of 'style' groups such as Steve Strange's Visage or Spandau Ballet.

'They were pulling stuff out of the past, but constantly presenting themselves as the future,' says Simon Puxley, as he takes down vast albums of Roxy press cuttings and contact sheets for cover art from a bank of whit shelves in Bryan Ferry's office. It is interesting to note that these shelves also contain some first editions of Wyndham Lewis's novels (Ferry took the typeface used on the cover of Roxy Music's *Manifesto* LP from Lewis's vorticist magazine, *Blast*), and a few examples of Vargas girl and

Art Deco-style erotica – the point where pin-up meets the applied arts.

The Roxy 'cover girls' on each LP made a febrile statement about Roxy's mission to marry erotic romance to notions of the muse as fetishized centrefold. Kari-Ann, Amanda Lear, and – in a barely dressed pose with a suggestively positioned middle finger which earned the sleeve a ban in America – Konnie and Evelyn on the cover of *Country Life*, were all straddling the divide between a lingerie advert in *Tatler* and sophisticated pornography. But they were precisely articulate about Ferry's musical interpretation of love, lust or unrequited love. His then girlfriend, Jerry Hall, would complete the classic set on *Siren*: a come-hither mermaid washed in aquamarine, with jade-coloured false fingernails like offensive weapons.

'The cover girls were like my ideal fans,' says Ferry. 'In fact, it was rather like designing the perfect fan as well as the music. The girls on *Country Life* were the sister and girlfriend of Michael Karoli from the German rock group, Can. We wanted it to be like they were at some amazing country house party, caught in the headlights of a car as they emerged from some encounter in their underwear . . . I don't really have a fixed notion of glamour; I love the glamour of Las Vegas for instance – the extravagance of show girls with long false eyelashes, masses of hair and high heels. I think that's fabulous, even though it's completely tacky.

'Very importantly, I'd met Anthony Price by then, and as a fashion designer he was vital to Roxy Music. We didn't feel that we were a part of Glam Rock; it was different sense of style altogether, and Anthony Price made wonderful clothes – like some kind of sculptor. He loved dressing us up. I had a good talent, I think, for spotting people who could help me get what I want. I will generally try to take the credit for everything, but with Roxy it was very collaborative; Nicholas de Ville's art direction, for instance, was hugely important with its attention to details like the serrated edges of the Fifties-style postcards of us on the first

LP. But I was amazed by the extent of our popularity. I had felt that Roxy Music were like genuine Pop Art, but I was thrilled that we could get an audience way beyond the art galleries. Interestingly, Malcolm McLaren went to a Roxy producer – Chris Thomas – who has also worked with Pulp. It's that English thing. I thought that Pulp's "Common People" was quite brilliant, and very difficult to top.'

Roxy Music's manipulation of style, fashion and image was emphasized by their breathlessly glamorous practice of crediting the names of their hairdressers (Smile), fashion designer (Anthony Price) and cover girl on each LP. At a time when pop and rock, however glammed-up, were anxious to retain a street edge or the mysticism of far-out lifestyles, Roxy Music introduced the sophisticated internationalism of *Vogue* or the Sloane Square jet-set to both their songs and their image. Like the Golden Age of Hollywood cinema, which Ferry had hymned on '2 H.B.' (Humphrey Bogart as opposed to the pencil), Roxy represented a world of glamorous fantasy that brought the avant-garde to the British High Street by way of the cat-walk.

In the late 1970s, Price's shop Plaza, at the Fulham end of the Kings Road, would become a mecca for art school punks who had welcomed Roxy Music's return with *Manifesto* (1979) and studied the eerie artwork on its cover, in which mannequins dressed in Plaza clothes were caught in frozen, joyless poses as the In Crowd at a lifeless nightclub. Steeped in a potent ambivalence towards its own image, this was pop for poseurs and a Fitzgeraldian comment on the vacuity of the high life. Roxy Music's relationship with English punk rock was very much a matter of mutual, if ambiguous, acknowledgement.

On the one hand, Siouxsie and the Banshees all met at a Roxy concert at Wembley, and the fashion-conscious end of punk styling owed much to Roxy Music's theatricality as its spiritual kindergarten; on the other, Ferry's solo career and the group's subsequent shift into their beautifully crafted, softer and more

opulent sound in the early Eighties – with *Flesh + Blood* (1980) and their final LP *Avalon* (1982) – showed a polished maturity that had its best equivalent in ABC's luxurious album *Lexicon of Love* (1982), with singer Martin Fry paying homage to Ferry's doomed romantic.

'I liked the energy of punk,' says Ferry, 'and the hair – but not much of the music. I was trying to be more musical at that time. When I recorded *The Bride Stripped Bare*, which was edgy and by far my most mature musical statement, the single off it, 'Sign of the Times', was an essay on punk from my perspective at that time. I think that John Lydon actually liked Roxy Music . . .'

'I remember talking to John Lydon, and he was totally dismissive of Roxy Music for being too bourgeois,' says Mackay, 'but Sid Vicious was positively gracious to me. I think that *Siren* was our least satisfactory album, in my opinion, although it did give us "Love is the Drug". I think that certainly those last three albums were different. It was also the point when Paul Thompson left, and Bryan, by then, had a very fixed idea of how he wanted things to sound – some of which was brilliant, and some of which wasn't. There was very heavy pressure on us to break in America, and somewhere along the way the more experimental material got squeezed out. If young people were to listen to the Roxy canon now, I suspect that they'd be more likely to listen to the early records, because the Seventies are rather fashionable at the moment.'

In 1982, subsequent to the release of *Avalon*, Roxy Music ceased to exist as a working group. But they left with customary style and two Top Twenty singles, in a kind of evaporation that scented the air of rock and pop for a long while after the group had disbanded. Now, in an era of constant pop revivalism, it would be easy to imagine a Roxy Music reunion. But, as the Sex Pistols and Velvet Underground re-formations suggested, such a seductive transaction with nostalgia can often flatten the cultural legend that seminal groups enjoy in retirement.

'From my point of view, there's every chance – but I have the feeling that it's unlikely to happen,' says Mackay. 'It may be that the key moment for that has passed. There were some very serious discussions around the early Nineties, but obviously it would be down to Bryan, really. But I can't help thinking that if we did re-form it would be fantastically good. There would be no problem coming up with our late-Nineties solution to the same set of problems.'

When Roxy Music finally did re-form, in the summer of 2001 – with Mackay, Manzanera and Ferry – they managed to do so with stadium-filling triumph, rather than within the neutering confines of those merely retro re-formation tours that had become Pop's answer to 'The Good Old Days' throughout the 1990s. (So often, interesting groups who hadn't recorded for a decade or more would reappear with their greatest hits as glaringly irrelevant, transposed from the archival medium of CV or DVD to the live element of performing. Novelty nights with Eighties chart-toppers, singalongaCultureClub: although you could never blame anyone for cashing in the pension of their legendary reputation, here was a kind of admission that we can laugh about it now . . .) Roxy Music, however, stormed the stage as a contemporary group, as opposed to the souvenir of a legend. One look at Andy Mackay's drape-coated form, Ferry's silver suit, told one that they had indeed found new solutions to the issues of performance.

Ultimately, Roxy Music's greatest achievement was to authorize a cult of pop glamour in provincial British discotheques and nightclubs that was a brave imitation of the jet-setting international chic that the group had come to represent. Inspired by visions of Roxy Music's starlets, Joanne and Susanne of the Human League could click their fingers and swing their hips as the sirens of Sheffield. Roxy brought the heady whiff of sophistication to High Streets and precincts, launching a thousand haircuts.

As Brian Eno signs off his e-mail: 'I thought, and still think, that pop music isn't primarily about making music in any trad-

itional sense of the word. It's about making new imaginary worlds, and inviting people to try them out.'

By the beginning of the twenty-first century, catalysed by Retro, the principal function of cultural production would be, in one way or another, archival. A modernity comprised of highly sophisticated time travel to many different ideas of the past, from simple nostalgia to full-blown cultural archaeology. Re-enactments would become modish (Jeremy Deller restaging the Miners' Strike as an epic piece of performance art, the West End staging a musical about Leigh Bowery and the Taboo club), answering the need to return to some ... more energized state, when *modernity seemed possible*, and the pores seemed open. Deeply romantic, as seductive as the Exquisite (particularly in the heady cocktail of Retro-Exquisite) the flotation tank of Nineties Retro was perhaps a visceral distraction from the greater sense of that decade's cultural voids – lost direction and critical mass, with us just hanging around, the first persons in Space, above the asteroid, and waiting for Hal to open the pod bay doors ...

Post-industrial/Auric Food

If Space in the 1990s somehow seemed very Seventies (and fantasists and futurologists had always supposed that by the end of the twentieth century humankind would be very intimate with Space) then what type of environment might actually have managed to articulate the Nineties as a kind of allegorical landscape – the zeitgeist made eloquent as ambience and terrain?

One answer to this question, and quite a good one, too, would be Nowhere – as in Nowhere Space and Non-space, summed up by the blank functionalism of the service areas, support systems, retail engineering and hinterland of the total consumer and information age. More specifically, we might look to the edges of motorways, warehouse-scale superstores, retail and business parks as somehow defining the subconscious of the closing years of the twentieth century.

It was Marshall McLuhan, interviewed by Willem L. Oltmans in 1972, who got the hang of Non-space and first looked beyond the activity of driving and the technology of the car to what he called 'the ground' of any cultural 'figure'. Read now, McLuhan's analysis seems to fit the bill for all those modern projects that engage with the additional idea of a romantic relationship with the

landscape of service, functionalism and nowhere space hinterland. With this in mind, it is worth citing McLuhan at length.

'It ["on ground"] is a term from Gestalt psychology. Look at the ground around the figure of the automobile or the ground around any technology, which necessarily has a large ground of services and disservices associated with it. With a motor car, most people are interested in changing designs or patterns of the car. They pay only incidental attention to the huge service environment of roads, oil companies, filling stations and other allied services of manufacturing that are the ground of the car. It never occurred to them that this figure of the car might generate a huge ground of new services far bigger than the figure was ever thought to be. In other words, the car created a totally new environment of services.

'By not looking at the ground around the automobile you miss the message of the car. For it is the ground of any technology that is the medium that changes everybody, and it is the medium that is the message of the technology, not the figure.'

Throughout the 1990s there was a growing interest in documenting – as a sub-strand of artistic practice – what McLuhan calls 'the ground' of technology. Most notably, the ground of New Media, in which the idea of a computerate, on-line world was used as a multi-purpose definition of modernity.

(In many ways, the German synthesizer group Kraftwerk's track 'Autobahn' was a pioneer of these activities, deriving as it did from Hutter and Schneider driving around Dusseldorf in Hutter's Volkswagen, recording the sounds of the engine and the passing traffic with a microphone hanging out of the passenger window. Later, to 'promote' the single, they offered to drive journalists around the industrial areas of the city – like some sort of ready-made performance piece, standing in for a pop video – in just the same way that they would take journalists on a train journey to promote their 'TransEurope Express'. Here was yet another early example of Non-space aesthetics – no hedonistic launch party, just a drive around the boring parts of town.)

As McLuhan's 'ground' becomes Nowhere Space, offering up a new interpretation of modern, information- and systems-based experience, it could be the landscape as seen from InterCity trains or the slow lane of the M6 – places where the raw, barely designed casing of advanced capitalism seems to have been dumped in semi-industrialized countryside. We might call the aesthetics of this functional environment, as they have influenced other areas of contemporary culture, the school of Nowhereism or maybe Banalism – a noble tradition, in fact, with roots going back to the Sixties, with the building-rearranging art of Gordon Matta-Clarke, for instance, or Dan Graham's 'Homes for America' magazine piece, which simply listed names of American suburban housing estates.

In a Nowhereist perception of the Nineties, an idea of virtual space as a real space would often be regarded (despite the rather difficult puberty of new media, still struggling to live up to their rhetoric) as more tangible than any actual place. Brands and logo would whirl around a similar plug-hole in the culture, with the destination of branding by the end of the century being brands that stood for nothing save the brand: no product, no service, just the brand, as with the 'No' brand, or viral advertising campaigns that became indistinguishable from counter-viral 'ad-busting' intervention, thus cancelling each other out.

Although there was indeed 'so much of everything' – suggesting a cultural Wonderland, where the happy customers of Cultureberg had never had it so good – there would also be a growing sense that more was somehow less, as formatting and the centralized control of both cultural and retail production – in everything from book-selling to multiplex cinemas to radio playlists – began to take effect. It was another of those patterns in the desert that you can see only from 37,000 feet.

In addition to this, the ubiquity of the major shopping chains, coupled to the anonymity of much new office space, created a mono-environment that even the most extravagant of shopping

malls could do little to enliven. Shoppers arriving at monoliths such as BlueWater or the Trafford Centre (the latter looking as though Pugin had tutored in Las Vegas) were being presented with both the Benign Corporation (shopping as the new family morality, with retail itself as statements about warm, human unity, as though the brand was a part of the family) and the latest version of the People's Palace. (To be compared with the Russian metro system or the Tower Ballroom in Blackpool.)

At the Trafford Centre, sited just off the Manchester orbital motorway to the west of the city, the illuminated turquoise domes of the curving, marbled and fountained Milanese-looking mall were joined by a truly Imperial ceremonial entrance, reminiscent perhaps of a re-creation by a Hollywood director of the 1920s of the splendours of Ancient Rome. With a food court designed to look like the deck and bridge of an ocean liner (complete with rust stains painted around the liner's bolts) and a quasi-Renaissance/ Empire/Classicist central atrium (where lifts like gold carriage clocks added a nursery rhyme element to the architectural mix) this was applied post-modernism on a scale of which Jeff Koons could only dream.

When Selfridges department store were considering whether or not to open a branch that would, in effect, be the jewel in the crown of the Trafford Centre's shopping, they commissioned an independent report from the Manchester Institute of Popular Culture, which summarized in a sentence the ambiguous status of not only Manchester, but the majority of post-industrial provincial cities in the UK: 'There has been a clear shift away from the city as a site of production and work, towards one of consumption and leisure.' Where in the past the city had been held together by its purpose – work, community, identity – it was now fulfilling Jeff Noon's remark that 'Manchester will soon be just one big shop.'

In many ways, many provincial cities in the UK had their 1980s in the 1990s. Where was the economy, for instance, to drive all

this consumption and leisure? It all had the ring of a classic Eighties scenario, of social and economic agendas pulling in opposite directions. The reach of Nowhereism and the new ambience of functional non-spaces, would extend throughout the 1990s as a kind of process of urban pasteurization, sweetened with the notions of sophistication that kicked off in the 1980s, and which created the impression that last century's industrial grandeur would be next century's loft conversations – and, of course, frothy coffee shop. But what would be the option? To preserve chunks of industrial, pre-Lifestyle city space as either memorials or working museums?

Ironically, what would end up being revived in the regenerated city centres and more expensive suburbs was a scaled-down version of mercantile bourgeois good taste; beyond this, the ruins of an industrial landscape, deliquescent estates and struggling communities, maintaining a subsistence economy beside the strange, science-fiction presence of hyper-market hinterland. Spreading estates of post-modern artisan cottages or executive housing completed the picture. Those critical theorists of the mid-1980s who had seemed to double as landscape poets would find their futurology concretized.

Motorways

There is something about the minimalism of the motorway that both refines its aesthetic appeal, and – less enjoyably, perhaps – informs the experience of using it. On joining the motorway, we enter a territory stripped of everything save function: the whole environment is designed to facilitate and control safe driving – the human element exists only as a variable in the formula. You are the inhabitant of a non-place, serviced every twelve miles or so by little homoeopathic doses of the real world, called service stations. But even they seem to exist outside real time. When you

try to pin down the status of the motorway, the service area, and their vague, indeterminate hinterland, you are faced with a version of Gertrude Stein's pronouncement: 'there's no "there" there'.

In Britain, the cultural status of the motorway remains ambiguous, to say the least. Whereas America has hymned the romance of its highways and freeways in a national history of generic, iconic artforms – from Kerouac's *On the Road* (1958), to Bob Dylan's *Highway 61 Revisited* (1965) – there is no such tradition in Britain. This country's experience of the motorway is comparatively young – the first was an eight-mile stretch of the Preston bypass, which opened in 1958 – and rooted, unwaveringly, in the very opposite of America's road-movie romance with the highway.

The fact that the first British motorway was a bypass could be said to sum up our national relationship not only with the motorway, but also the entire world that word suggests. Eternally modern, yet dreary and functional, a necessary evil perceived to be synonymous with bad weather, tailbacks and stewed tea, the ambience of the British motorway has usually been described through varieties of Social Realism, or sudden flashes of disturbing psychological allegory – most notably in J. G. Ballard's novel *Crash* (1973).

If British banality could be said to have a heart – an inner core of pure boredom – then the motorway and its environs might be expected to occupy a cosy place within it; alongside the carpet showrooms in out-of-town retail parks. Now, however, it would seem that this very quality of amplified 'ordinariness' is being taken as a catalyst in the depiction of primarily functional territories as potent psychological spaces. Increasingly, as the motorway features in the reclamation of shared and formative memory for successive generations, so its initial cultural status as a non-place is being exchanged for a new measure of significance.

You could say that the phenomenon of the 'non-place' is beginning to carry a romance – as a portal to nostalgia, and as a quasi-ironic metaphor of some lost state of innocence – that in Britain

has been formerly ascribed to the Victorian suburb and the Edwardian seaside town. The British fetish for identifying the ghosts of its past is in a state of reinvention: it has become a generational identification with a certain kind of blankness, and a search for other-worldliness within the history of the common-place, the domestic and the downright dull. Beyond post-modern contortions of rhetoric, Ballard has deposed Sir John Betjeman in a sudden return of Modernist narrative. The basis for this exchange derives partly from modern functionalism's steady accumulation of social history, but also, more importantly, from our changing reaction to that social history.

Over the last twelve months, with the publication in Britain of Pieter Boogaart's pictorial history of the A272, *A272 – an Ode to a Road* (2000), Martin Parr's astonishingly successful book *Boring Postcards* (1999), which features many images of early British motorway travel, Edward Platt's *Leadville: A Biography of the A40* (2000), and David Lawrence's *Always a Welcome: The Glove Com-partment History of the Motorway Service Area* (2000), a survey of the cultural status of roads, hinterlands and service areas appears to have begun. Astute and poeticized, this survey is largely founded – despite Martin Parr's heavy armour of irony – upon a repos-itioning of the nostalgic impulse.

Christopher Hawtree, reviewing *Leadville* for the *Independent*, began with an amusing prediction of a forthcoming literary trend, in which publishers would be battling with one another for increas-ingly lucrative biographies of boring roads: 'No sooner has a book on the A272 appeared, than one about the A40 arrives, another on the A1 is imminent. Where will it all stop? "Jeez, I know it's Martin [Amis], but half a million for the B4009? Come on . . ." "But look at his riff on the traffic-light phasing in Watlington . . ."'

Even in this favourable and supportive review of Platt's book, one can see the curious territory the current reassessment of British 'arterial culture' is beginning to occupy. The reflex for nostalgia is being refracted through a matching interest in what

might be termed 'the anthropology of boredom'. For every seem-ingly banal archive photograph of Britain's motorways and ring-roads – the Washington-Birtley footbridge in 1970 is one example from the treasure trove of pictures in Lawrence's book – there is now an accompanying frisson of significance, derived from a fresh reading of those images. In their latest anthropological context, these images articulate both social or architectural history, and, it would seem, the poetics of a state of mind.

These poetics might be taken as a generational recollection of childhood and adolescence: the time travel triggered for Proust by the sight of rose bushes or hawthorn blossom in his 'deep moments' can perhaps be re-created for the children of the 1960s and 1970s by Parr or Lawrence's meticulously positioned images of the Fortes restaurant in the bridge across the M6 at the Charnock Richard service station, or a Motorchef sugar sachet.

For Edward Platt, the residue of childhood experience was at the forefront of his decision to revisit the territory of the A40, and to speak to the people who live along its polluted edge: 'In my mind, London is mapped through the roads that connect it to parts of England where I have lived: the A11 to Essex, where I was born; the A1 to the north, where I grew up; the A3 to Hamp-shire, where I finished school; the A4 to Bristol, where I went to university. The fact that I now live in west London, close to Western Avenue – the A40 – completes my map of city roads' (Edward Platt, *Leadville*, Picador, London, 2000, pp. 1–2).

Importantly, Platt concludes his following paragraph with a description of the houses he saw on his childhood trips to London: 'It seemed incredible that there were people living within ten yards of the car in which I was sitting'. It is this sense of childhood incredulity – in Platt's case towards the 'dirty and anonymous' houses he could see from the car – that has lingered like a residue in his mind, prompting his ambitious and challenging plan to revive George Orwell's search for 'the future England' along 'the arterial roads'. The present generation are studying the imagery

of Britain's motorways for an equally liberating vision of the past. As Platt interviews residents of the houses along the A40, he discovers an oral history that could be read in much the same way that we might study one of Martin Parr's boring postcards. Within the apparently ordinary exists a compelling narrative of daily life, the sheer oddness of which is eloquent of our social and human condition: 'One morning,' writes Platt, 'the Shaws woke up to find that the low brick wall at the front of their garden had collapsed – as had all the wall in front of the next-door house, and the next, and the next. They soon discovered that every other wall along the road had collapsed overnight, though they still do not know why'.

The cover of *Leadville* depicts a computer-manipulated photograph of a boarded-up block of white-gabled 'Tudorbethan' houses. Created by Gigi Sudbury and Catherine Platt, the saturated colours of this image – vivid reds and oranges offsetting the stark silhouette of the rooftop and the delicate pale blue of the sky – appear to echo the saturation that one also finds in many of David Lawrence's archive images from motorways: a terrifying spread of a sweet counter, for instance, or the Corley Grill Room in 1976. It is as though an entirely unofficial colour register has been established for elegiac images of British banality: while sepia was the clichéd signifier of faux-Edwardiana, and pastels the signage of 1950s Americana, so saturated orange appears to articulate the memory of a buried Britain – the civic or service aspects of British social history from the late 1960s to the end of the 1970s, just before the major regeneration projects of the 1980s.

This conflation of testimonies, drawn from memory, reportage and archive, comprises a new perspective of our perception of the 'commonplace' in recent British history. Confounding academic methodology, it is a perception based largely on the expression of a particular sensibility. Linking, on the one hand, a form of pop-cultural nostalgia (as in Morrissey's early laments for a 'changed' Britain – 'I lost my bag in Newport Pagnell . . .') and

on the other a sense of the post-industrial wilderness. This new concentration on the history of 'boring' places is linked to the emotional requirements of a generation out of patience with post-modernism.

Twenty-five years ago, the German synthesizer group, Kraft-werk, released their recording 'Autobahn' (what would you call it – a soundtrack? a song?) as a seven-inch single in the UK, on the old Vertigo label. It was this release that defined the Kraftwerk sound, where robotic harmonies were synchronized to minimalist beats – the doo-wop of the German Economic Miracle. In Pascal Bussy's biography of the band, *Kraftwerk: Man, Machine and Music* (1993), he uses the term 'industrial folk music' to describe the group's mission to express the industrial and technological world solely through industrially and technologically generated music (Pascal Bussy, *Kraftwerk: Man, Machine and Music*, SAF Publishing, London, 1993). At the heart of this mission is an engagement with the ambiguities of nostalgia that we also find in *Boring Postcards*. Indeed, Parr has also compiled a collection of boring German postcards – thus completing a cultural circuit.

For Kraftwerk, most of their music – not least their hymn to the motorway (which exists as an epic, twenty-minute track in the album version) – is inspired by archaic visions of the future: their robots, railways and radioactivity are always depicted with an eye to the past, as well as a sleek, dehumanized future. The irresistible precision of their electronic percussive effects (now themselves an anachronism in an age of digital sampling, yet never bettered in terms of their purity) is matched by what the novelist Jeff Noon has described as 'the melancholy of dance music'. In Kraftwerk's case, to judge from their choice of back-projected images during their live shows, this melancholy seems to stem from nostalgic recollection of an earlier idea of Modern Europe, defined by a romance within the ordinariness of motorways, show-room dummies, power stations or early computers.

As demonstrated by the enduring importance of Ballard's

fiction, or by the themes explored in Julian Opie's 'Imagine You Are Driving . . .' paintings, the supposedly dull 'non-places' of Britain exist in a complex position between psychology and sociology. To return to Orwell, these places seem to offer, in their very emptiness, an idea of the future that constantly reinvents itself – even as they speak to us from the past, in saturated colours or monochrome. Ballard, writing in the catalogue for the Photographers' Gallery exhibition 'Airport' in 1997, repeated his claim for the ideal of the non-place: 'For the past twenty-five years I have lived in the Thames Valley town of Shepperton, a suburb not of London but of London Airport. The catchment area of Heathrow extends for at least ten miles to its south and west, a zone of motorway intersections, dual carriageways, science parks, marinas and industrial estates, watched by police CCTV speed check cameras, a landscape which most people would affect to loathe but which I regard as the most advanced and admirable in the British Isles, and a paradigm for the best the future offers us' (J. G. Ballard, 'Airport', the Photographers' Gallery, London, 1997, p. 120). Not many people, perhaps, would agree with Ballard's vision of a service area Utopia – as most of the interviewees in Platt's *Leadville* testify – but the eloquence of its 'not-thereness' epitomizes the strange poetry of boredom.

Ian Davenport's Paintings

The surfaces of Ian Davenport's poured paintings are satisfying to contemplate. They present themselves complete, as it were, with a neatness of presence that brings to mind the pristine newness of freshly machine-made components. The artist has often said that he derives tremendous pleasure from the physical process of making his paintings. 'I am really good at pouring paint,' he once stated. And he compares the pleasure of getting a painting right to the pleasure of scoring a goal.

Davenport sets up systems for making successful artworks. The artworks are successful because they are fully realized on their own terms; they require no interpretative skills to trigger their meaning. They exist as physical objects, literally defining the term, 'What you see is what you get.' For these poured paintings, he has become expert at pouring household paint on to a prepared surface, allowing it to dry and then pouring a second layer. Vibrant with the colours from commercial colour charts, the depth of these paintings is in their surface.

More recently he has been making multi-panelled works on a large scale. He has now refined his technique to the point where he can create a sequence of panels simultaneously, thus revealing the sheer precision of his practice. If a painting does not work for the artist, the board is wiped clean and begun again. The haunting subtlety and mesmeric sophistication of these paintings are the consequence of a distinct configuration of timing and rhythm, through which he recomplicates the composition. If the sequence of these multi-panelled works is disrupted, their effect is altered. Thus, the entire sequence must be made at the same time, releasing the particular mood of the paintings and harmonizing the finished effect.

The results, in keeping with the signature of Davenport's aesthetic, are remarkably tactile paintings that look as though they could have been computer-machine-generated, but not quite. They have become encoded by the presence of the artist, at a highly subtle level.

It is this encoding, acknowledged in the very individuality of each painting, that reveals the fallibility to chance of Davenport's art-making system as one of its greatest strengths: it elevates his system above the mechanics of mere process, and allows him to explore the dimensions of painting as a medium.

Importantly, Davenport's paintings do not collude with theory. They remain fixed in their own aesthetic, neither confounding, nor accepting speculative interpretations. Being the consequence

of a process, rather than honed into shape, even their relationship with the artist is based on selection and approval. On one level, the paintings pursue – at a level of extreme intensity – the aspects of Warhol's aesthetic practice that draw together intuition and instinct with system-making: deep subjectivity objectified as surface.

There is a profundity in Davenport's paintings that seems to communicate directly to viewers. When viewers attempt to identify and label these communications, however, they tend to find that their enquiries are drawn in to the surface of the paintings, and that the process of identification breaks apart – like trying to put your finger on a drop of liquid mercury. To this extent, the paintings perform the philosophical and psychological function of demonstrating processes of perception.

The artist has often remarked that his choice of colours can be inspired by the manufactured materials in the modern world. Certainly, his use of household paints on MDF brings to mind the practically minded, commercial world of DIY hyper-markets on the edge of urban conurbations. Similarly, his working methods are wholly open to the decision-making capacity of computers as problem-solving tools. And this, too, could be regarded as another contributing strand of his aesthetic.

In itself, this approach to making art could be seen as a simple post-modern tactic. But Davenport then confounds that interpretation by rejecting with equal certainty the irony that has become a regular feature of post-modern culture.

Rather, in a manner highly sympathetic to the ethos of Warhol, Davenport sets about seeing what happens when you try to repeat a particular process and discover the internal characteristics of that process. When he talks about a painting 'going right', or the interest he derives from some unexpected glitch in the dripping or pouring process, you get the impression that he is fascinated by what goes wrong, within a system, as much as by what goes right.

Ian Davenport's paintings address the fallibility of a techno-logical age. They do this, not by making a conscious commentary, but by the demonstration of their own example. His concern, as an artist, is to derive and donate a pleasure from his process. His paintings are thus extraordinarily generous to the viewer – not at all the tight-lipped protagonists of unexpressionism.

And yet, when one considers the impact of Davenport's poured paintings, as intensely coloured shapes like the imprint of a portal, and when one studies the way in which he has explored this process, into new, large-scale works, it is hard not to think of them as wholly eloquent of their times. They concretize the tension of opposites, being at once redolent of stillness and of perpetual motion, silence and noise, activity and stasis.

These paintings refuse to exist as symbol or allegory, and yet they share the enigmatic intensity of the famous black 'monolith' in Stanley Kubrick's film, *2001 a Space Odyssey*. In many ways, they articulate the new society of information technology, periph-eral industrial space and mass production more fluently than any figurative photograph. As social objects, Ian Davenport's paintings achieve parity with their aesthetic significance. In fact, those two functions are entwined within the painting process itself.

As projects such as Martin Parr's phenomenally successful pub-lished selections of *Boring Postcards* would imply, there was a point at which the banality of Nowhereism went right through the back wall of irony, nostalgia or kitsch, and became an exercise in pop cultural Gestalt: to what extent were these comically dull, blank, archaic spaces actually describing a generational melan-cholia – that yearning, as Graham Greene once said of 'seediness', for 'a stage further back'? Another shuffle of the deck, and the ethos of Parr's *Boring Postcards* – the banality of suburban and provincial Britain (he would tackle Boring Germany and America

293

in subsequent volumes) in the 1960s, primarily – would seem breathlessly fashionable, more in keeping with the sharp end of interior design than nostalgia for a comic dullness.

There was also a whiff of pure Dandyism in all of this, as well; that integrated Nineties pattern in which the tastes of the ultra-refined aesthete become responsive only to the bland – all other sensations having become too predictable. In the Banalism of Parr's postcards, there is the sense that *Boring Postcards* is the most fascinating book to be published in the 1990s, which one consumes in a single, appalled but mesmerized sitting. Despite or because of the dreary subjects – try a colour postcard of the National Giro Centre, Bootle, for example – a strangely modern empathy was triggered, which tied in the time trips of Retro culture and the infantilist reflex to revisit the world of a Seventies adolescence. As such, *Boring Postcards* pretty much defined a whole swathe of Nineties styling.

Concurrent to this, the portraits of the Dutch photographer Rineke Dijkstra, in which young people of many different national-ities were photographed or video-taped confronting the camera with an unblinking gaze – at once indifferent and self-conscious, but wholly unsupported by any further narrative meaning, like subjects in a directory – would catch another aspect of Nineties blankness. Schoolboys and young mothers with their new-born babies, vacant-eyed clubbers, teenagers on beaches and youthful Spanish matadors (fresh from their revolting attacks on distressed bulls), would all be caught, visually democratized with near clinical clarity: faces caught between obedience to the process of being photographed, the ubiquity of surveillance culture and a kind of 'What now?' bewilderment. Dijkstra's subjects look as though they are caught on a conveyor belt of lived experience, running through a void.

Were these, then, blankness and bewilderment, boredom and banality, fin-de-millennium statements about post-modern subjec-tivity? Young, staring faces, or old pictures of the dullest places

on earth? Brought together, did these high-profile visual projects suggest a generation prematurely aged – or did they mean nothing at all, save modish documentation and ironic humour? Either way, once the decade had passed through its febrile dalliance with a re-enactment of nineteenth-century Decadence, there seemed to emerge a new quietude within the visual arts, like the random findings of some ethnographic research team who were uncertain as to their own purpose.

The Dome

On 5 February 2000, less than six weeks after the Millennium Dome's official opening, the chief executive of the Dome, Jennie Page, was forced to resign due to what one broadsheet summarized as 'the opening night fiasco, poor attendances and a revolt by the sponsors'. By the time she had been paid off, Ms Page had received £500,000 from the New Millennium Experience Company, which runs the Dome. She was to be replaced by a fairly junior member of staff from the Disney Organization, an unknown Frenchman – en route, it has transpired, to a post with Club Med – called Pierre-Yves Gerbeau.

That Britain's Millennium Dome had been handed over to a French corporate trouble-shooter, formerly employed by an American cartoon company, is nothing short of a self-scripted satire – with the kind of plot-line favoured in the comic novels of David Lodge or Tom Sharpe.

But it is the precision with which the Millennium Dome had managed to satirize itself that verged on the extraordinary: the speed and efficiency with which the Dome as a phenomenon had been translated into a political commentary of its cultural context. To the majority of British citizens, the Dome did not exist as a real structure on the Greenwich peninsula; it existed as an idea, filtered and refracted through the trick mirrors of mass media, to

become a kind of allegorical site – a tabular rasa on to which the nation projected or dumped its sense of self. To this extent, the Dome had exchanged its reality for the gaseous status of metaphor – a function encouraged by its form as much as anything.

Forgetting the intellectual gymnastics of post-modernism, the Dome was primarily a late symbol of Modernism. Even its site, coincidentally, is on a stretch of the Thames that figures in T. S. Eliot's *Waste Land*, and in that poem's precursor, Joseph Conrad's novella *Heart of Darkness*. And as those modernists regarded the Thames as a river of consciousness, heading towards the unknown future of the twentieth century, now the Dome seems to stand as a monument to their fearful apprehensions.

As ever, the fundamental questions posed by literary modernism between 1914 and 1925 – with regard to such 'millennial' concerns as faith, destiny, time and Civilization – remain for the most part unanswered. In fact, the Dome is as much a symbol of the failure of post-modernism, as it is an affirmation of modernism's specu-lations. Strip away the mere cleverness of the designs, and you're left with a vacuum to contemplate.

The contents of the Dome seemed to reinforce the problem: like giant-sized models of the illustrations in a school science project, the theme-rides of human evolution hit a duff note between edu-cational, edifying, and . . . well . . . big. They were neither whizzy enough for children to be impressed, nor substantially original enough to offer a new addition to the tradition of industrial and cultural fairs. Were they somehow allegorical of Ninetiesness itself, and the triumph of a culture of superlatives? For the con-tents of the Dome seemed straight from Pope's Essay on 'The Use of Riches': 'Lo, what huge heaps of littleness around!'

As the material existence of the Dome was translated, piece by piece, into political journalism, so the vocabulary for that trans-lation was sourced from the oldest prompts of satire: the vanity of government in relation to the temper of society. With this in mind, the Dome was compared from the outset to 'The Skylon'

structure that was a show feature of the Festival of Britain in 1951. This was a ninety-one-metre-high mast, shaped like a vertically stretched ellipse, the function of which was to convey an abstract yet forceful symbol of triumphant modern progress. Unkind critics of the time commented that 'The Skylon's' almost invisible means of support could be seen as symbolic of the State of the Nation.

With history repeating itself as though to a script, the *Guardian* newspaper ran a supplement cover story entitled '101 Uses for a Dead Dome' on 25 January 2000, while a nationwide advertising campaign for Heineken lager suggested 'how refreshing' it would be to use the decommissioned Dome as a giant NCP car park. If it was the very precariousness of 'The Skylon' that lent its form so readily to satire, then it was the presumed 'void' of the Dome, as a container, which up-dated the intentions of journalistic critique.

Where the form of the Dome has been pilloried as a literal 'waste of space', and an easy symbol of vacuity, due to its social and political context, so this cynicism has chosen to take a very specific reading of the Dome's architectural significance. In this, the real presence of the structure was utterly occluded by the received idea of its presence: what the public thought that the Dome stands for, in relation to what it is supposed to represent. And in this there are some interesting reversals of the relationship between the 'signifier and the signified' – as we used to call them back in the twentieth century.

This can be seen from the fact that the Dome was designed, primarily, as a weather-proof shelter, the strength and dimensions of which were engineered to be protective. To mediate the Dome as a 'void' is thus already to misread its founding, architectural statement. Any idea of seeing its form to be parental in the most benign sense has been utterly repudiated.

Similarly, the Dome was accused – again with justification – as geographically inaccessible, and hence (pursuing the line of the Dome as a self-scripting satire) the perfect symbol, on Millennium

Eve itself, of the remoteness of Government to the people. And yet the siting of the Dome on a 300-acre site, bounded by the sweep of the Thames, was decided on the basis of environmental, demographic and aesthetic considerations, all of which were meant to denote a modern respect for the ethics of building.

In both of these cases, the Dome's misfortune resided in the statement it triggered, as symbol and allegory, when seen in relation to its broader cultural context. Ironically, the success with which the British Airways-sponsored big wheel, further up the Thames, has been greeted, can be seen to reverse, point for point, the accusations levelled at the Dome. And it is worth comparing these two structures, as 'functional icons', to see how their form has informed their reception into the host culture.

Seen from a distance, the aesthetic impact of the Dome stems from the way it responds to the light and the weather. Brooding and glowing on a clear winter's night, the Dome achieves an essentially 'space age' mystique, bringing to mind the science-fiction fantasies of the future that were so popular during the 1950s.

A 'space age' structure in the popular sense, somewhat enigmatic, the building has the appearance of having 'landed' on its site. Its twelve protruding masts can almost be seen to be performing their mechanical task, calling into play the language of superlatives on which the Dome is advertised. The tension in the Dome's roof, for example, is equivalent to the pull of twenty jumbo jets at full thrust. And, once again, these facts are translated within the phenomenon of the Dome to do their work as symbols.

It is only when you discard the rhetoric that has been central to the promotion of the Dome – the language of superlatives, ironically – that you begin to liberate the structure from its imposed role as a self-satirizing symbol.

As a baton handed on from one government to the next, the Dome was always meant to be a showcase for British expertise, demonstrating the ingenuity and panache with which Britain could

298

dress its identity for the global millennium party. To this extent, the Dome was being called upon to suggest Britain's subjective core – a concretization, supposedly, of our collective response to the summation of an epoch. And in real terms, this meant that the Dome was designed and constructed without its builders and administrators knowing what, precisely, it was meant to be housing.

In a neat slippage between irony and intent, this factor of the Dome's uncertainty of purpose – its ignorance of its own destiny, almost – can be seen to translate the actual structure and fittings of the building into a kind of abstraction. In many ways, the Dome is at its most beautiful when viewed as its unassembled components, rather than as the sum of its parts. The pristine newness of the yellow steel support columns brings to mind the monolithic metal sculptures of the late 1960s – Caro, or King, for example – while the steel pods, cowlings and pipes of the many infrastructure service systems have the enigmatic sheen of works by Judd.

Viewed in isolation, fresh from their wrappings, so to speak, these component parts became strangely eloquent of their times: a kind of alphabet or algebra of abstract signs, the purpose of which was to solve equations, or spell out statements, relating to their social, protective or curatorial functions. In an equally curious way, the Dome's components seemed to make less sense as they were assembled: their poetic abstraction has been circumscribed by the comparative banality of their completed form, and the faltering function of that form.

The same could be said about the architectural drawings and the computer simulations of the predicted 'dynamic relaxation' (as the engineering term is known) of the Dome's structure. In the case of the latter, the computer generated what look like thermal photographs of the Dome's total area. To non-engineers, simply seeing grids of tessellating, primary-coloured triangles, these simulations look uncannily like a satellite photograph of Earth, taken

from directly over the North Pole. Once again, the Dome seems complicit, as a phenomenon, with its misreading into allegory and symbol. Is the bottom line that the Dome resembles some sort of sixteenth-century depiction of the universe – with concentric rings of man, matter and God? The universe sponsored by Boots?

The future of the Dome remains uncertain. For the present, the structure remains locked in its role as a metaphor for free-floating satire and disaffection. As an allegory, however, and as a self-scripting narrative, the Dome can hardly fail. Whether its fortunes revive, and it becomes reborn as a national monument, or whether it is finally dismantled, to become nothing more than a raw site on the chilly Greenwich peninsula, it will have told its ancient tale about the vanity of governments, the fragility of monuments and the unflinching indifference of time towards pride.

In the midst of all detections that culture in the 1990s had been entertaining a void, so there was the sense that all of the fashionable posturing vacuity and pseudo-nihilism, far from making eloquent an overload of cultural commodification, was in fact a colossal failure on the part of contemporary culture to synthesize or articulate what was once called 'the anxiety of influence' – in other words the artistic process in relation to the accretion of its precursors.

Living in a business culture of communication technologies, marketing, new media and professionalism, the sense that creativity had to respond to its context – to deal with issues of pre-mediation, above all – was greatly enhanced. In the face of 'everything's just another look nowadays' culture was faced with a *crisis of presentation* that could almost seem overwhelming. How to reclaim one's subjectivity in the face of the near simultaneous translation of culture into received ideas of itself?

Brian Eno

When you try to describe Brian Eno's career, you find yourself faced with a job description that would suit a present-day Leonardo da Vinci. In the true spirit of Renaissance thinking, Eno is an inventor, conceptualist, musician, artist, diarist, ideologue and philosopher for whom the social application of his ideas – how art integrates with the way we live – is the basis of his creativity.

A founder member of Roxy Music, in the early 1970s, Eno is also regarded as the popular embodiment of the avant-garde. Now in his early fifties, he has worked as a collaborator and producer on landmark LPs by David Bowie, Devo, Talking Heads and U2. But more importantly, as regards the development of his own career as an artist, Eno has invented whole new ways in which recorded music is both made and heard.

Currently, Eno is working in his London studio – a light, airy suite of rooms tucked away down a quiet mews – on a major audio-visual installation piece for the forthcoming exhibition 'Sonic Boom: The Art of Sound' at the Hayward Gallery. Dressed in a simple grey suit – in the Roxy years it was pale blue eyeshadow and a collar made of peacock feathers – he radiates youthful energy and generous good humour. He also has the ability to speak in what seem to be perfectly formed paragraphs, articulating complex ideas almost as though he were reading from a script.

'I can have a very authoritative voice,' he remarks at one point, laughing. 'It sounds awful, but I can convince people to believe in almost anything. Like I can persuade them that the Belgians invented water – as I did last night at dinner.'

Back in 1975, Eno released an album called *Discreet Music* on his own Obscure label. This was a thirty-minute piece of instantly mesmeric, but seemingly simple tones, and it demonstrated how a recording system could be made that would literally 'create' its own music. Described by Eno as 'ambient' music, the ramifications

of this process were rather like the intention of oil painting or Cubism: they opened up whole new areas of cultural practice, rooted in a dialogue with technological thinking. In fact, it was Eno's firmly held belief that the arts should make themselves as answerable to public debate as the sciences that formed the basis of his highly controversial speech at the Turner Prize dinner in 1995, prior to Damien Hirst being announced as that year's winner.

'I don't see why it should be considered incompatible with being a good artist, that you might be articulate as well. I take that as a part of the job. If you ask me a question about what I'm doing, I want to be able to tell you, at least, "This is what I think I'm doing, this is how I'm doing it, and this is why I'm excited about it."'

Eno expanded the concept of ambience, through new applications of technology, to pursue wholly generative – or self-creating – artforms. A precursor of these was his Oblique Strategies set of cards, developed with the painter Peter Schmidt, back in 1975: like a Tarot deck for creative decision-making, these cards offer directions within blocked (or questioning) artistic processes – 'Do we need holes?' reads one, for instance, while another, more simply, commands, 'Take a break'. The point is to trust the card – however strange its advice might seem. When Eno was at Winchester School of Art, a tutor suggested that all the students become the opposite of themselves for a period of time; Eno, endlessly agile and motivated, had to work from a wheelchair to reverse his natural energy.

Eno's subsequent generative pieces of music and sculpture are conceived and designed hardly ever to repeat themselves, but endlessly to 're-mix' their own particular effects. Over the last few years, he has been invited to instal such works all over the world.

'But this'll be the first time that I've made one of these types of pieces in England,' he says, having set running the ten CD players that combine to create the hauntingly atmospheric min-

imalism of the new work's musical element. 'These are pieces which use slide-projectors that are computer-controlled to do very slow dissolves from slide to slide. In fact the images are made up of overlays of many slides, which I have either painted directly on to, or etched through a varnish. There are other objects in the room as well. Pieces of "semi-three-dimensional" furniture which I make, and of course the music.

'What nearly always happens with these shows, because they move at a very slow, hypnotic pace, is that people come in and settle down. I always have chairs in there, actually, and this provides the only ergonomic problem that we encounter – how to get rid of people!'

Whether heard as recorded music, or experienced as installations, Eno's generative projects are far more than simply refined aesthetic experiences. They demonstrate the ways in which his genius for conceptual thinking – the ability, above all, to test ideas across a wide range of social and artistic phenomena – have singled him out as a kind of moral philosopher whose ideas about music can have a far-reaching effect.

'If you can get used to the term "generative", and start to think of yourself as a generative being, so you stop having the notion that there is a perfect, Platonic version of yourself which you'll finally achieve. You begin to think of yourself as a continual "mix", with some things added, and some left out. Sometimes this mix is going to produce brilliant, beautiful surprises, and sometimes it's going to be a bit dull.

'Every kind of music, actually, embodies a social philosophy. What it requires of the listener is an embodiment of their participation in that philosophy. And the implications of this are quite profound.'

Eno's artworks can be seen as practical demonstrations of his philosophies, and in many of the cities where he has shown these works there has been the response from the public that such meditative, peaceful environments should be a permanent fixture.

In London, Eno would like to site his installations in both public waiting areas – such as airports or stations – and in places used a lot by elderly people.

'With these generative pieces, I think that I've hit upon a territory which people really like and instinctively understand. Because a lot of our reflective spaces have disappeared, in modern city living, there are fewer chances in everyday life to just sit and let your thoughts go by without being particularly pushed or pulled in any direction. I think that as much as anything, these pieces give people an alibi to do just that. Because they give the impression of something happening, you can say to yourself, "I'm not wasting time, I'm looking at art." In fact, they allow you to just sit still for a while.'

In a neat rearrangement of priorities, business culture itself during the Nineties – the whole kit and caboodle of how to survive in the workplace – would become as correspondingly interested in subjectivity and psychology as culture had become in matters of marketing and presentation. Had the universe become an office, with the career ladder assuming the role of a spiritual journey?

Executives

Released in 1960, Billy Wilder's moral comedy of corporate manners, *The Apartment*, begins with an opening narration from C. C. Baxter, Jack Lemmon's classic Manhattan office worker. With a mixture of cynical confidence and caffeine-wired anxiety, he announces: 'I know facts like this because I work for an Insurance Company – Consolidated Life of New York. We are one of the top five companies in the country. Last year we wrote nine point three billion dollars' worth of policies. Our home office

has 31,259 employees, which is more than the entire population of Natchez, Mississippi, or Gallup, New Mexico. I work on the nineteenth floor – Ordinary Policy Department – Premium Accounting Division – Section W – desk number 861.'

The urban comedy of *The Apartment* made a definitive advance on the nightmarish, Kafkaesque symbolism of office life that had begun with King Vidor's 1928 *The Crowd*. In Baxter's dilemma – how to accelerate his progress from second administrative assistant to executive proper – we find the template for many a sitcom's modest plot, spanning the social embarrassment of Samantha's corporate husband in *Bewitched*, to the existential crises of Britain's Reginald Perrin as he questions the point of his job at Sunshine Desserts.

In *The Apartment*'s portrait of corporate America, the office becomes the universe and one's position within it as a consequence of profound and complex factors. Here the status of executive – the summit of Baxter's initial ambitions – carries a glamour that belies its etymological roots: traditionally, 'to authorize' (and, tellingly, 'to punish'). The Sixties and Seventies saw the currency of 'executive' as a social term expand to encompass an entire mythology of the urban – but specifically metropolitan – officer class. Coinciding with the rise to power of Hugh Hefner's Playboy empire and the subsequent expansion and reinvention of the men's magazine market, this mythologizing of the executive would be marketed to suggest a specifically male, virile, sexually dominant, sophisticated connoisseur of fine living. By the mid-Sixties, even our secret agents and super villains were glamorized members of the executive lifestyle, as could be seen in such films as *The Man from U.N.C.L.E.: One of Our Spies is Missing* (1996) –with its subterranean office reflecting the quiet efficiency of IBM rather than the grim austerity of the Pentagon – and even *The Thomas Crown Affair* (1968), in which Steve McQueen's Crown reflects on bloodless crime as the ultimate executive toy.

The thick gloss of glamour attached to the early years of execu-

tive mythology succeeded in focusing the aspirations of several generations of middle managers, but later it began to prompt a sense of crisis that had been prophesied in the founding theology of *The Apartment*. As early as 1956, in fact, the neuroses within the executive type had been identified by the American revisionist sociologist, William H. Whyte, in his study of corporate life, *The Organization Man*: 'Executives admit that they impose exactly the same kind of pressure on their own subordinates,' states Whyte in his chapter entitled 'The Executive: Non-Well-Rounded Man'; 'Some lean toward praising men pointedly for extra work, others prefer to set impossible goals or to use eager-beaver as a "rate-busting" example to others. "What it boils down to is this," one executive puts it, "you promote the guy who takes his problem home with him."'

In these few lines, Whyte would set in place the principal concerns of management practice, as they have come to dominate the proliferation of business studies publishing in the late Nineties: that the executive, as a modern type, should attempt a quasi-mystic personal training in order to manage corporate ambition. Whyte puts his case even more clearly: '"The ideal," one company president recently advised a group of young men, "is to be an individualist privately and a conformist publicly."' The management of such a necessary compromise, which began with C. C. Baxter, lies at the heart of the contemporary executive's neuroses.

Thus *The Apartment* can be seen as a monochromatic premonition of the yuppie fables of the late Eighties, such as Oliver Stone's *Wall Street* (1987) and Mike Nichols's romantic tale of self-promotion, *Working Girl* (1988). Ironically it was Nichols who had described, precisely twenty years earlier, a hatred and mistrust of the executive promise of fulfilment in his film *The Graduate* (1968), mythologizing 'dropping out' with even greater potency than *Working Girl* glamorized the yuppie ideal. 'I've got just one word to say to you, Benjamin,' confides a neighbour of the young graduate: 'Plastics.' Benjamin's subsequent rejection

of the corporate dream would be echoed on Joni Mitchell's LP of 1975, *The Hissing of Summer Lawns*, in the lyric of an executive wife's disaffection, 'Harry's House/Centerpiece': 'To tell him like she did today, just what he could do with Harry's house – and Harry's take-home pay.'

In *Wall Street*'s presentation of cultural materialism as a Faustian struggle between good and evil, and *Working Girl*'s triumphant closing shots that describe 'getting one's own office' as the pinnacle of human achievement, the dynamics of executive empowerment were temporarily rehabilitated for an era of bullish ambition. The literary equivalents of these quests for status could be found in the 'brat-pack' fiction of the late Eighties – Brett Easton Ellis's *American Psycho* and Jay McInerney's *Brightness Falls* – the former translating advanced capitalist greed into psychopathic serial torture and the latter proposing a Fitzgeraldian moment of collapse in the sealed pressure cooker of Manhattan's ventures in the investment market.

By 1988, the seismic Black Monday market crash of 19 October 1978 had created an enduring tremor across not only the daily practice of global business but also the mythological world of the executive handbook. In addition to this, as Peter York has pointed out in his personal thesis, *The Eighties* (1997), the decade that saw the cultural fetishizing of 'professionalization' in everything from contemporary art to retail engineering suddenly became culturally demonized. '"How was it for you? What did it feel like?"' writes York. 'What emerged was that many of them were in denial, as our psychological friends say: they didn't want to think about it and they almost didn't want to admit that they were there.'

In terms of executive stress-management, the business evangelism of Tom Peters had given way, temporarily, to the business dystopia of Tom Wolfe's *Bonfire of the Vanities* (1987). Caught between a vogue for Japanese management techniques and occidental 'doomsday theories', the executive began to search for enlightenment in a neurasthenic business community that was

adjusting itself to a recession economy and political revisionism, as even Homer Simpson would discover during his accidental promotion to executive status at Springfield Nuclear Plant: 'I can't work any harder – I'm a natural under-achiever.'

It was in this climate that Robert Heller wrote *Culture Shock: The Office Revolution* (1990), in which he suggested the survival of the most computer-literate. The book could now be seen as a precursor to the current trend of 'millennium bug' publications, where the business world's contract with Information Technology is described in virtually Faustian terms – and it's time to pay back the loan. Heller's analysis of the high-tech office had the portentous prose style of an apocalyptic short story: 'In 1989, every computer supplier, from mainframes to minis, was committed to alliances that would make the complete corporate system possible, and with it the transformation of the office. That commitment means that, in a future that is almost upon the industry as I write, users will take it for granted that their information systems will be totally cohesive. That, in turn, will exploit the powers of networks to the full – and networking is the key to the third computer age.'

The late-Nineties definition of the executive can be seen nowhere more clearly than in the contemporary boom in business and management handbook publishing. The morass of books now being published reveals the development of not only a new language – a kind of Zen techno-speak underwritten with the objectivity of an army training manual – but also the reinvention of the old mythological character of the self-made tycoon, whose rise to power in the tradition of a Rockefeller, or even a Branson, can be studied, absorbed and cloned.

The touchstone of the executive manual is the salesman's promise that you are buying into a secret formula for success – or, if not a secret formula, then a precise way of looking at your position within the office as universe that will empower your status, sales and profile. In most management handbooks, the

objective points of each particular executive method are animated by mythological parables of success and failure, the collective power of which creates a land of business fable in which the terrors of redundancy and bankruptcy are countered by the possibility of living happily ever after in a fiscal turnaround. Narrative is the spoonful of sugar that helps the medicine go down, while fear, in fact, becomes the motivating force behind much executive counselling.

In Tim Drake's *Wearing The Coat of Change: A Handbook for Personal Survival and Prosperity in the Unpredictable World of Work* (1998) or *The Age of Insecurity* (1998) by Larry Elliott, the reader is confronted with an essentially treacherous world of business back-stabbing and office politics, in which only the carefully trained will survive. One is being presented with a classic piece of executive infantilism: the office as universe as computer game – the Mortal Kombat of Middle Management.

As a response to the infinite practical and psychological complexities of office life – to say nothing of the stresses and financial pressures of running a business – one witnesses an unlikely marriage between self-help therapies as the practice of self-empowerment, and the more traditional concerns of how to make a great deal of money. In executive-speak, if individuals are their own corporation, then this conflation of spirituality and pragmatism – an objective and subjective mix – is the exercise of 'individual turnaround'. You are bringing your entire being back from the brink of collapse; you are trouble-shooting your own self-concept. And that, in a concentrated form, is the historic 'spirit mission' of the executive as a modern type: in order to succeed on the material plain, ambitious executives must be able to create the circumstances of their own advancement.

But this is also a period of high insecurity for the executive classes, and many of these new titles reflect a sense of crisis to which various analyses, mindsets and psycho-therapeutic 'programming' can be the reactive response. This movement could be

seen as a partial consequence of the ethos for spiritual hygiene that has typified aspects of social and corporate culture of the Nineties. Prevalent among these therapies is Neuro-Linguistic Programming, which began at the University of California at Santa Cruz in the early Seventies, when John Grinder, a professor of linguistics, got together with Richard Bandler, a psychologist. In Joseph O'Connor and Ian McDermott's *Principles of NLP* (1996), there is a concise list of 'presuppositions of NLP' that contains a working definition of NLP itself: 'Modelling successful perform-ance leads to excellence. If one person can do something it is possible to model it and teach it to others.' This 'modelling' of achievement or behaviour is attempted in NLP by deconstructing our presuppositions about language and behaviour in order to rebuild those suppositions within a positive and targeted outlook.

The attraction of Neuro-Linguistic Programming to the business world, and to the pressurized executive in particular, lies in its mix-ture of serenity and logic. NLP is the basis for the teachings of Anthony Robbins, the business and personal development guru, who typically created his own version, Neuro-Associative Con-ditioning, trademarking the term en route. In many ways, Robbins represents the latest phase in the conflation of personal and cor-porate skills. He corresponds precisely to the mythological con-struction of the self-made tycoon, and his extraordinary success as a management consultant – to AT&T, American Express and, spookily, the United States Army – is underwritten in humanist terms by the 'Anthony Robbins Foundation' – a charitable trust working in prisons, schools and old people's associations. His personal development handbooks, *Unlimited Power!* (1998) and *Awaken the Giant Within* (1992) have become bestsellers in thir-teen languages; his brand of positivity and social responsibility represents a kind of secular mysticism, in which belief in oneself will one day network outwards, via a global belief in the corpor-ation, to a collective belief in the planet and the whole of the human race. The Michael Jackson of the business community –

and twice as successful – he concludes *Awaken the Giant Within*:
'Till then remember to expect miracles . . . because you are one.
Be a bearer of the light and a force for good. I now pass the torch
on to you. Share your gifts; share your passion. And may God
bless you.'

Sexual Intrigue in the Office

'ABUSE OF POWER COMES AS NO SURPRISE' (Jenny
Holzer – American artist, 'Truisms 1977–1979')

For the white-collar worker, the office is a parallel reality to home
and family, a place at once accepted as the norm – it's how you
earn your money – yet crammed with an inner strangeness. The
wide-eyed wonder with which Dorothy first set foot in Oz, or Alice
took her first peek at Wonderland, is as nothing to the sheer
peculiarity of the office as a psychological landscape. So much
arcane ritual, and so many baffling posts and personalities, are
stitched into a kind of living tapestry, describing a monolithic
mythology. Once through the swing doors into reception, your
identity card flashed to a guard who already knows perfectly well
who you are (it wasn't for nothing that the illustrator Ralph Stead-
man, in his edition of *Alice in Wonderland*, showed the Walrus
first as a dozing commissionaire), the office worker has entered a
whole new universe, filled with contradictions and reversals of
personal status.

Make it to the lift and you begin to assume your working
identity – you could compare it with the avatar forms people take
on in virtual chat-rooms, advancing masked within an alter ego.
Of course, these new identities are there for a purpose, to make
the business of teamwork and interpersonal relationships – all
those voodoo arts of the training course – come a little more
easily. But once to your desk and the coffee machine, the prospect

of another eight hours in an essentially unnatural habitat will begin to play strange tricks with your brain. For despite the cyclone of New Professionalism that has swept the world of office work since the enterprise economy ethos of the 1980s, the fundamental oddness of office life has remained unchanged.

What has always been required by the office worker, and what has fixed itself within the index of institutional employment, is the semi-official code of the compensatory pleasure. These are the little rewards the workers negotiate to make it through the day – no matter how dedicated they might be to their work. As such, these pleasures describe a spectrum of social acceptability, from joining a fitness club in the lunch hour to developing a habit for crack cocaine. Somewhere in midstream of this register lies the grey area of sexual speculation, itself a perilous region bounded at one extreme by the welcome laws relating to sexual harassment, and at the other by adventures pursued with mutual consent.

Brought together by chance, frequently in states of competitive hostility, subject to the usual mood swings, the majority of office workers have to wage a constant battle with themselves to retain the balance of their identities. Plumage first, the modern office worker is bombarded by images of sexuality and gender, restated through dress codes and fashion. According to the rhetoric of advertising, despite the New Informality of funky dot.com office casuals, people should dress in the workplace with an eye to social authority and personal empowerment. Needless to say, the majority of office workers struggle through the daily commute in a battered approximation of these codes, their early mornings under attack from the cool sexuality of men and women in print advertisements, suggesting a further parallel universe of perpetual coded erotica and romance. Office workers are harried to their desks by the taunts of what they might be missing. Hence the compensatory pleasures: recompense for drudgery; placebos for disaffection; at times, importunate dashes into unguarded

behaviour – the drunken snog at the conference disco, the rash Bacchanal.

In the office, the private self is on public display – whenever somebody gets angry or goes off to cry in the loo; but stir sex into the mix – and the majority of Eastern religions accept the sex impulse as a primary life force – and the emotional soup of office life is a highly volatile chemical. And sex, in the office, is the Joker in the pack, ever present (most offices, at one time or another, become pressure cookers of lust) but a somewhat covert card to play.

Perhaps it is the very banality of the office environment – all those dreary houseplants, veal-coloured desktops and brushed steel framed partitions – that first serves as the trigger for erotic speculation. Like the bland hotel rooms traditionally used as the locations for pornography shoots, the office presents a 'nowhere' space – little more than function and form – that suggests an abandonment of the usual behavioural rules. It is rather as though – in terms of archetypal sexual fantasy – the sheer impersonality of office decor permits libidinal anarchy. Detached from their personalized environments, people can imagine themselves as free sexual agents, equally detached from morals or conscience.

The American author Nicholson Baker has described the connection between living environments and erotic speculation. In his first novel, *The Mezzanine*, Baker offers a minute deconstruction of office life, offering lengthy footnotes as to why, for instance, the bubbles collecting around a paper straw in a carton of soft drink cause the straw to push itself out of the carton. But if *The Mezzanine* established Baker's signature as a writer – as an anatomist of self-consciousness above all – then his subsequent (and fiercely criticized) investigations into sexual fantasy seemed to prove the lines of connection within his fiction. In *Vox* Baker offered an epic telephone conversation – on an adult 'contact' chat-line – of two tired office workers, resulting, somewhat implausibly – in their mutual telephonic climax. In *The Fermata* – an uneasy book,

due entirely to the dangerous ethical territory it described – an over-educated male office temp exploited his power to halt time in the universe, simply to undress women he had seen in the street, on the beach and, most importantly, in the various offices where he worked.

These miniatures of sexual fantasy within the workplace draw their narrative force from the bland semantics of top-shelf pornography fiction: a story form built entirely on conjunctions, leading the reader to increasingly bizarre sexual action. Arguably, this method of sexual fantasy (and there are many critics who take Baker's writings on sex to be little more than literary porn) is a subtle reflection of the relationship between boredom and erotic speculation, such as we know has its place within the office workplace. As the office suggests a moral vacuum, where sexual gravity rearranges itself, to a kind of libidinal weightlessness, so the single-minded trek of Baker's central characters towards nothing more than ejaculation is in itself an epic of boredom.

Within all of this there is a central melancholy – if not despair; and within the office as a field of sexual speculation, crossed by grids of gaze and fantasy that could be likened to the infra-red beams of a complex security system, there is the deeper sense that sexual intrigue within the office is shot through with a quality at once sordid and pathetic. One could look to the sun-drenched scenes of furtive suburban sexual activity described in the paintings of the American artist Eric Fischl as the equivalent of these intrigues: sexuality is seen as both yearned for and feared, wantonly pursued through fantasy yet hidden from private view. (A boy masturbates in a bland, tract housing bedroom when the house is empty; the respectability of a suburb is nothing more than a shabby covering of repressed libido – the consequence is spiritual emptiness.)

As every office creates and maintains, through typically folkloric codes, a constantly self-annotating mythology of sexual behaviour, so these legends (the couple found fucking on the photocopier, the married man pursuing the junior temp) convert themselves

through time into an archive of human failure. This is not the consequence of moral censure, however; rather – as we can see in Billy Wilder's great comedy of sexual politics within the office, *The Apartment* – the translation of fantasy into reality is due to the sudden violation of human feelings. Lies and shame dog the progress of an office affair, neither romantic nor erotic; when people who work together fall into a real relationship, their behaviour avoids the psychopathic nature of coldly emotionless sexual pursuit.

In all forms of fantasy – from the syrupy girlishness of *Bridget Jones* (as the contemporary re-creation and translation of the themes once trodden in the bodice-ripping romances of the 'Mills & Boon' publishing imprint) to the self-defeating sexual anarchy of Nicholson Baker – the point where speculation meets realization is generally marked with crisis. Within the world of office politics – more complex than the intrigues at Hampton Court under Cardinal Wolsey, or Uganda under Idi Amin – there is usually a subtext of exploitation; what might be 'got away with' is played off against the algebra of status, with one player standing to lose far more than the other. Hence, despite its feel-good yuppie fable, Mike Nichols's film *Working Girl* is essentially a patriarchal myth, in which a sexy secretary – Melanie Griffith – is allowed by comic and erotic means to enter the male executive world defined by Harrison Ford. The fact that her boss is female – and ridiculed, sexually ('move your bony ass' says the boss of bosses when her corruption is finally revealed in the romantic dénouement) simply makes the myth more patronizing.

To escape the circumnavigation of sexual fantasy by behavioural codes – what the young Erica Jong more succinctly described as 'the search for the zipless fuck' – is both the generator of erotic speculation and, paradoxically, its in-built self-destruction. Studied now, the 'sex comedies' and pseudo-sophisticated 'men's' soft-porn magazines, which were fashionable between the 1950s and the 1970s, when the American cult of the executive as male

315

hero was passing through its Golden Age, reveal a concept of maleness that is ultimately neurotic. In an era pre-HIV, about to face the development of complex sexual politics (the conversion of feminism out of theory into law and practice), such championing of male potency remained locked in a kind of perpetual – and ultimately joyless – adolescence.

Within this archaic cult of the executive, the workplace was shown as an entirely sexual universe, in which all flesh is ultimately obtainable. By the early 1980s, however, when a first wave of social changes had begun to challenge overt sexism within the world of work, the daily experience of many office workers was that sexism – and predatory sexual behaviour within the office – had simply become more covert, but always present. The rise of e-mail as the principal means of an office creating its sexual subtext – erotic speculation as the grubby note passed around in school – was only a decade away. Today, as more and more demographic studies reveal the high stress of the contemporary workplace, so the workers themselves must negotiate their own means of survival – a long-term choice, in the absence of a brave new anything.

As Cyril Connolly had identified Flaubert as a principal influence on Modernism, so it might be added that Flaubert was a principal prophet of post-modernism, most directly in his 'technically endless', unfinished novel about two Parisian office workers, *Bouvard and Pécuchet*. By identifying the idea of bored clerks as frustrated seekers after truth, Flaubert put in place a paradigm of the postmodern conundrum of 'meaning' in relation to cultural and intellectual signage. As his two office clerks attempt to discover the truth about the universe, so knowledge itself recedes as fast as they can pursue it, leaving only a sense of bewilderment, weariness and frustration, until, 'Everything annoyed them, even the advertisements in the newspapers.'

As a prophetic work of post-modernism, attempting to reconcile human failing with systems of knowledge, *Bouvard and Pécuchet* explored the relationship, finally, between the individual and the organization – those same questions which William H. Whyte would examine in his classic study of office sociology, *The Organization Man*. (The 'Us and Them', in fact, whom the teenage scribe in *Oz* magazine saw as prompting the take-over of the Revolution as 'a groovy way to sell things'.)

Bouvard and Pécuchet was developed by Flaubert in parallel to his *Dictionary of Received Ideas* – an index of truisms and clichés that pretty much identifies the subordination of signified to signifier in the post-modern period. The two principal characters – sympathetic for their vulnerability, and their perseverance in the face of endless failures – appear to establish a comic model for bosom-friends as searchers for enlightenment, their very domesticity and ordinariness somehow marking them out as heroic.

The Power of the Double Act

In one of their funniest sketches, Ronnie Barker and Ronnie Corbett are dressed as Kenneth McKellar and Moira Anderson, singing a jaunty music-hall number about being a famous double act. Performing a dainty two-step between each verse, they managed to combine the louche appeal of a drag act with a sense of glee at the hilarious absurdity of their impersonation.

'Well, we're not John and Yoko, and we're not Bill and Ben,' they chorus to a camp little tune which sounds as though it were written by Gilbert and Sullivan, 'Marks and Spencer isn't our name, we're Moira and Ken!' For one of Britain's most famous double acts to impersonate another famous double act, singing about the celebrity of double acts, has all the logic of the plot of a post-modern novel.

The layers of parody and punning become increasingly en-

twined, positioning the Two Ronnies in that grand tradition of comedy duos who play, primarily, on our perception of their relationship. Safe in the mainstream of British television comedy from 1971 to 1986, the Two Ronnies described a Britain of nervous bridegrooms and grumpy plumbers, but could satirize almost anything by simply placing it within the comic world their names had come to define. To this end, during the height of New Romanticism in the early Eighties, they performed a number in which Ronnie Barker was dressed as Kid Creole and Ronnie Corbett was made up as Boy George.

Another shuffle of their creative intentions and they could have done it at the Institute of Contemporary Arts. But what with Ronnie Barker's multicoloured blazers and Ronnie Corbett's pink cardigans, the Two Ronnies seemed to come from an age before irony, from the era of saucy postcards (Barker, in fact, owned 55,000 saucy postcards) when social caricature was played without conceptual spin.

Towards the end of the Eighties, Vic Reeves and Bob Mortimer reinvented the double act, creating a notion of comedy in which being dressed as Kenneth McKellar and Moira Anderson was still OK, providing they were performing a song by T.Rex or the Human League. The comedy was derived from a new way of juxtaposing opposites ('What's on the end of the stick, Vic?'), in a way that didn't have to make any sense at all to be funny. The Two Ronnies delivered a comic world that was uncompromisingly suburban – a known, comforting world – while Ronnie Barker, individually, was drawn to slightly experimental projects such as *His Lordship Entertains* – which has parallels with the late Vivian Stanshall's comedy of aristocratic decrepitude, *Rawlinson's End*. Indeed, Barker's fascination with English social types led to the brilliantly realized characters he went on to create for TV in *Porridge* and *Open All Hours*.

But within the Two Ronnies, he dreaded having to play himself. In Bob McCabe's biography of Ronnie Barker, Corbett explains

how Barker had to invent a character who was Ronnie Barker: 'Once he found a way of doing it, like an actor, it remained the same more or less each night. I would see him remembering to put his hand in his pocket at a certain time and so on. On his own admission, he can't go and open a fete or something because he doesn't know who to be.' This hugely empathic relationship with character also won continued admiration – and offers of work – from Sir Peter Hall, the former director of the National Theatre, who said of Barker: 'His scripts are very precise. I think the writer and the actor kind of coalesce in their precision, because although he's an anarchic comedian in some respects, as a performer he's about precision.' In terms of television comedy, that was pre-ironic anarchy.

Eleven years after their last show together, the Two Ronnies were given their place in the cathedral of light entertainment. With tributes from John Cleese, Ben Elton and Neil Morrissey, the duo received the televisual equivalent of canonization in a Two Ronnies theme night, and a BBC Comedy Greats video. Described by Ronnie Corbett as 'a scrapbook of our lives together', the theme night was a retrospective celebration of the duo's achievements. But Corbett's phrase, 'our lives together', seems to touch on a common denominator of double acts within a broader cultural tradition.

Best exemplified by the sexless yet cosy manner in which More-cambe and Wise shared not only a bedroom, but also a bed, there is a soft core of domesticity at the heart of most double acts – particularly when the odd couple in question are the same sex. Within the supposed domesticity of their relationship, a double act can present life together to the audience as the basis of their comedy.

The Two Ronnies made far less of this than Morecambe and Wise, preferring to play characters than suggest that their real selves were living in the world of their comedy. But the notion of a comedy duo sharing a bit of their world with the audience was picked up by Vic Reeves and Bob Mortimer, who played on the

supposedly domestic relationship between themselves as a mutually dependent but frequently arguing couple.

For Morecambe and Wise, there was never any question that there might be sexual ambiguity in the domestic world that they presented. From kitchen to bedroom and back again, Eric and Ernie based an entire comic formula on the idea that we got to see how they lived when they weren't actually on the stage.

It was like the Beatles' house in *Help!* all over again. And in their autobiography, *There's No Answer to That!*, Ernie Wise gets straight to the point: 'The great thing is to be able to do sketches in that flat without anybody having any ideas that we might be queer. We even used to share a double bed at times, but no one has ever suggested that there was anything immoral in it.' Questions of morality to one side, however, Eric Morecambe recounts how the BBC was sensitive to the ambiguity of the double bed, even if its occupants were not: 'I always smoked a pipe in the bed for the masculinity. I'll tap him on the head with it. But the hierarchy at the BBC once said: "You can't get into bed together. You have to have two separate beds." But we thought that would have made it worse. In fact, we never had a single letter of complaint. Nobody else could do that. Little and Large couldn't. In any case, I think we've made it our own domain now.'

The founding examples of a same-sex double act, living together in the universe of their own comedy, are the eponymous heroes of *Bouvard and Pécuchet*, which was published a year after Flaubert's death, in 1881. The two disaffected office workers, released by a sudden legacy to pursue their quest for total philosophical knowledge, *Bouvard and Pécuchet* set a model for comic couples that has its contemporary equivalent in the cartoon, *Ren and Stimpy*. Just like Ren and Stimpy – the bad-tempered chihuahua and his doting friend, the goofy cat – Bouvard and Pécuchet live together in their own bizarre house, preyed on by society, and are continually thwarted in their attempts to find happiness by the limits of their own intelligence.

In a single line, Flaubert explained the relationship between Bouvard and Pécuchet: 'The friendship between them was profound and absolute.' There is neither sexual ambiguity nor distracting sentimentality, so this comic universe can be presented ready-made. And this comedy is maintained by the manner in which the heroes become comic victims, retaining our sympathy because much of what they endure is due to the stupidity of a bigoted and complacent society.

Culturally, we can use the double act to become mirrors of society and social change. We observe the double act as pioneers setting off into the wilderness of fate and circumstances. They seem to demonstrate our collective vulnerability to the temper of the times, primarily through struggle and suffering made palatable by comedy. Laurel and Hardy, for example, become the victims of bad-tempered bosses and bullies, as much as the victims of their own incompetence, and their struggle was usually to find a lucky break in the midst of depression or poverty.

For Bouvard and Pécuchet, the search for happiness ends when they decide to become office clerks again. And as for Ren and Stimpy, their mantra of 'Happy, happy, joy, joy' is arguably one of the saddest lines ever written. But what happens when the potential of the double act is extended beyond comedy, into other areas? In the art of Jane and Louise Wilson, as twins who work together as one artist, there is a sense that the viewer is witnessing an experience of detachment and solidarity. But the authority of this vision is heightened, to some extent, by the fact that it has been created by two people working as one.

There is the strong sense that we are seeing a glimpse of Wilson World, particularly in the pieces that feature the twins themselves. For their installation, 'Hypnotic, Suggestion 505', the twins were filmed being hypnotized in matching office chairs, against what looks like a blue-screen backdrop – two young women, trusting to the power of suggestion. More disturbingly, they have photographed themselves in what looks like the preparation for a suicide

pact, with one twin wearing a noose while the other lowers her head into a tank of water.

As with the World of Gilbert & George, the stage shows and videos of the Pet Shop Boys, or even Jake and Dinos Chapman's Chapmanland, the double acts who work within the broader arena of contemporary culture are usually presenting an idea of survival from a position of isolation and melancholy. In the most famous double act of the grunge operation, Beavis and Butthead, there is the overriding impression that their boredom and nihilism is the result of living in a junk civilization, ruled by bad rock videos and peopled by corrupt sophists.

What the double bed was to Morecambe and Wise, and the news desk to the Two Ronnies, so Beavis and Butthead's television is the centre of their comic universe, and the label of their domestic relationship. Stage-diving off their smelly sofa, Beavis and Butthead occupy a limitless suburbia which is so dull that when their television finally breaks, they can think of nothing better to do than throw a dustbin at one another. A more potent symbol of the power of the double act would be hard to find: in the end, they have nothing to lose but each other.

Gilbert & George

In the thirty-four years that they have been working together as a single artist, Gilbert & George have never wavered from 'The Laws of the Sculptors' that they wrote in 1969 to accompany their 'singing sculpture', 'Underneath the Arches'. Interviewed thirty years later at the Institute of Contemporary Arts, they remained the embodiment of their First Law – 'Always be smartly dressed, well groomed, relaxed, friendly, polite and in complete control' – and reasserted their commitment to their Third Law: 'Make the world to believe in you and to pay heavily for this privilege.'

As the 1990s found Young British Art – of which Gilbert &

George have been described as 'the godfathers' ('Although maybe we're the fairy godmothers,' says George) – to posit notions of cultural spin, aesthetic irony and personality cults, Gilbert & George remain utterly unironic, artistically sincere and morally serious within their work and beliefs. This is the intention behind Gilbert & George's founding slogan, 'Art for All'. They have always been committed to accessibility in their art, to the point of still listing their private phone number. 'We're in the Yellow Pages,' says George, 'under "Artists". We are making work, we imagine, for the viewer out there. Artists fall in love with art; we fell in love with the viewer of art. That's the difference.'

'We are moral artists,' says Gilbert, 'and moralistic. We want to change morality, what's good and what's bad, in a better way.'

'We believe that in a voting society, culture is in advance of politics,' George continues. 'Because what books your parents did or did not read, what gramophone records your grandparents did or did not listen to, is all part of how you are, and how you feel in the world. We are all cultivated beings. And politicians have to respond, roughly speaking, to people's feelings and thoughts. Governments are dragged by the general public into changing laws.'

Gilbert & George have a reputation as shock-brokers, but the potent imagery (and they readily admit that they often feel 'completely stupid' during the process of actually making images – photographing body fluids, or chewing gum, for instance) within their art is often the Trojan Horse in which they deliver strong polemics on identity, individualism, human frailty and mortality. These are 'the main messages' of their work – to borrow Gilbert's term, and the pair are always in total agreement about the content of their messages.

'I don't have to ask him what he thinks,' says Gilbert, about their creative union. 'I know what he thinks.' In this respect, Gilbert & George also hold strong views on the relationship between government, culture and ethics, and regard their art as

a means of articulating the complete human experience of modern, predominantly urban, life. And this includes the administration of culture. On the rearrangement of the Tate Gallery into 'Modern' and 'Britain', for instance: 'It's so twisted. No other country in the world today would split a national collection by nationality and race. We have spoken to museum directors all over the world, and not one thinks that it's a good idea. There would be a scandal.'

The single-minded constancy with which they have maintained their career, establishing their besuited appearance and calm demeanour as an exponential extension of their art, has both distinguished them as pioneers – creating a consistently modern identity (you could almost call it a brand) for themselves – and confounded the perilous shifts of fashionability. Like Oscar Wilde, James Dean or the Doors, they fascinate each new generation of young people. Along with Warhol and Beuys – the former of whom they found to be too interested in rich people, and the latter too concerned with German mysticism – they are the only contemporary artists to possess an iconic status, on an international scale, comparable with that of rock or movie stars.

'Ninety nine per cent of the people involved in looking at our pictures are not collectors and would never think of being,' says George. 'They go to exhibitions of our work and buy catalogues and videos of us. When we say "Art for All" we mean more an art which is addressing the issues that are inside all of us.'

'An art,' says Gilbert, 'that is not elitist, and that is not based on the inner circle of the art world; that ordinary people are able to come in and get something from.'

Having changed dealers – in a move that was reported as a news story in the national broadsheet newspapers – from the Anthony d'Offay to Jay Jopling's White Cube gallery, Gilbert & George showed a monolithic and austere group of enormous pieces entitled 'The New Horny Pictures'. Presenting a directory of personal advertisements – in which the very act of naming seems to double as a statement of fathomless anonymity – these works

appear like war memorials for dead sexual encounters, fusing mel-
ancholy with speculation.

'We say that there are many maps of the city, and this is a
sexual mapping of the city. Just as the "maps" we found in blood
could show perhaps the moral dimension which exists in us'

'All the men will be totally terrified,' adds Gilbert. 'And all the
women will love it.' The couple have managed to remain supremely
confrontational, even during the fashion for artistic shock-tactics
that dominated the last decade. With time, their art is achieving
a deeper quality of timelessness. At their public interview, when
asked for their advice to young artists ('baby artists' as Gilbert &
George call them) they replied: 'When you get up in the morning,
sit on the edge of your bed, and don't move, and don't do anything,
until you know what it is you want to tell the world today.'

'And fuck the teacher,' adds Gilbert.

... it's a windy evening down here on the South Bank; one of
those sudden dusks when the sky over the river, looking up towards
Charing Cross and above the Peter Pan Gothic of the old Savoy
buildings, seems suddenly shadowed blue, reflecting the peach-
coloured gleam of the streetlights.

The buildings over on this side – the brutalist hulks of the old
culture bunker, the colour of cold office coffee – they're probably
bringing back a few memories for some of us. It's their utter
indifference to being loathed by the general public that we, as a
tribe, can appreciate; that and their demand that new ideas should
not necessarily be easy to understand.

But here we all are and it's just after seven o'clock in the
evening and there's a steady hum of noise, but not as much as
you might think. A chilly spring evening towards the end of the
1990s ... Who are these people? Couples and loners, a lot of
them with grey hair, horrible jackets – quite a few with obviously

false teeth. Never, ever, has there been such a gathering of potatoes . . . of socially awkward people – all that *shuffling and grimacing*, the sound of the odd bottle being smashed. Then there's a really wild bunch of women – half of them look like elderly strippers, the other half like librarians – and they've taken over a whole table, and there's a rising pyramid of lager bottles, its summit wreathed in clouds of cigarette smoke . . .

Then there's a chap on his own – friendly-looking, slightly wobbly on his pins, wearing a long green mac and a beret. He's swaying slightly and laughing to himself as he peers forward to study – with all the concentration of someone seeing something they've known very well, but now feel to be seeing for the first time, as if they're checking that it hasn't changed – one of the many exhibits at the back of this cavernous hall, which are fastened in plastic sheets and mounted on boards. What is he looking at? From this distance, it almost looks as if he's crying – or laughing.

You push your way past some people looking at their feet, and some more people looking like bored parents at a school meeting. One or two very spooky-looking individuals, dressed in grey camouflage trousers and glaring at people. But now you can see what the chap in the beret was peering at: it's an old matchbox, the green, red and yellow 'Puck' brand, only the 'c' in Puck has been replaced by an 'n' and so the matchbox now says 'Punk'.

This is the opening of 'Destroy: Punk Graphics' at the Royal Festival Hall, and as you look around it somehow feels like the last party ever in the history of the world. These dowdy clothes and this grey hair, the blank, the awkward and the completely drunk, they still seem to have some kind of aura of energy (yes, we know we're not supposed to say this about punks) that turns negativity into creativity, like some alchemical process.

. . . And a Nineties *thought*: 'Oh! What it must have been – or was – to be alive and culture-vulturing in 1977!' For a constant had emerged in Nineties culture, running its pink nylon thread through Retro, New Authenticity and Cultural Infantilism – and

that was: that the First Wave of British Punk Rock – the real school trousers and cheap guitars and badly dyed hair springtime of Punk – was *the card that couldn't be trumped*, the soufflé that couldn't fall (as Warhol said of people's expectations of love), the one bit of cultural and creative status that no one could argue with. *They wouldn't even try.* Artists and writers, critics, film-makers and musicians, the whole gang, throughout the Nineties, would attempt to source from, name-check, replicate, bask in the reflected glory of, or reinvent – Punk. But they couldn't.

In the light of this, the male reflex would predominate, with the king boys in the playground trying to own the experience of punk. But what was it about punk, which, with the possible exception of Warhol's Silver Factory, seemed to be the most effective and glamorous modern cultural process? Now Punk is the new Bloomsbury Group, and a thriving cultural industry. The answer seemed to lie in its ability to create *Newness* – that touchstone of contemporary culture – as a practice, and as a creed.

Patti Smith

Patti Smith's return to the British stage after a gap of eighteen years bore the comic timing of Tommy Cooper. Having struggled to find the gap in the backdrop curtain that would deliver her face-to-face with the 200-strong audience crammed into a smallish room in the Serpentine Gallery in London, she took a half-step backwards, peered suspiciously at the rows of expectant faces, and demanded, in the tones of a crotchety suburbanite who has found a gang of strangers helping themselves to drinks in her front room, 'Who the hell are you?'

And, given that it has been eighteen years with no hit records and no one-off appearances, we could have been forgiven for asking her the same question. That we didn't, of course, is testament to the fact that Patti Smith is still considered to be one of

327

the most radical writers and performers to emerge from rock and become a leading figure in the much broader arena of contemporary culture. Historically, she embodies the second wave of New York's pop avant-garde: the punk scene of the early Seventies, based around CBGBs, that took over the underground after Warhol had been forced to close the doors of his Factory. This was a world where art, poetry and music were all plugged into the same circuit, creating a fledgling society that would produce, under the inspiration of the Velvet Underground and the New York Dolls, smart young groups such as Richard Hell and the Voidoids, Tom Verlaine's Television, Alan Vega's Suicide and, foremost, the Patti Smith Group.

Regarding her role in that much-mythologized era, Smith wrote in her dedication 'To the Reader' in her *Early Work 1970–1979*: 'The Seventies. When I think of them now I think of one great film in which I played a part. A bit part. But a part nonetheless that I shall never play again.'

But Smith's 'bit-part', fronting the Patti Smith Group, was more of a starring role. Her one hit single, 'Because the Night' (1978), has been largely eclipsed by the enduring respect, closer to reverence, for her first three albums: *Horses* (1975), *Radio Ethiopia* (1976) and *Easter* (1979). In addition to this, she has published four collections of her poetry, and started work on a novel. She retired from performing, although not from writing, in 1979. Now, fifty years old, the mother of two children, and widowed last year, after fifteen years of marriage to Fred 'Sonic' Smith of the seminal rock group, the MC5, Patti Smith has a biography that contains all the tragedy and romance that marks out a bohemian legend. She's been described as a visionary and an iconoclast, but she has no interest in playing the high priestess of punk rock – which was a role she never really wanted in the first place. Rather, she is a realist, intent on dismantling the myths that surround her and replacing them with a less heated assessment of her worth and presence as a primarily literary figure.

'Fitting people into a formula is just another act of jerking off, but I can't say I don't find it interesting. I used to be a lot more rebellious about all that stuff. If you'd asked me about it in the past, I'd have said it was all bullshit, but one thing I learned in the Eighties, mostly through the breadth, compassion and intelligence of my late husband, was how to appreciate, even with humour, all the different ways people conceive, translate or digest things. And so I guess it's all interesting, it's all good – it all keeps the planet going. But I have to tell you, some girl sent me her doctoral thesis, relating my work to Rimbaud, and I didn't understand a word of what she was talking about. I was honoured that she'd spent all that time analysing and considering my work, and even considering it next to the work of someone I greatly admire – but it's not really my beat. It's just great that people keep on pursuing things. I mean, I'd rather see someone write a worthless, 900-page dissertation on CBGBs than see them take their own life. Then again . . . I might want to shoot him after he wrote it.'

With her high cheekbones, her greying, Indian-plaited hair, and her severe, angular beauty, Smith can make her features and her stature convey rustic humility or formidable strength from one moment to the next. Her androgynous glamour is entirely uncontrived, with a tribal elegance that confounds fashion and politics. Dressed in a ripped jacket, combat trousers and loosely laced boots, she could have walked off a Paris cat-walk – or across a ploughed field. She appears to be neither of the country nor of the city, and her voice, too, drifts between hillbilly whimsy and tough, New York street talk. Her roots are suburban, but only inasmuch as suburbia was a transit camp for her questioning and rebellious spirit.

'I was moved from Chicago to Philadelphia when I was about three or four years old, and then to southern New Jersey when I was about nine or ten. I wasn't really raised so much in the suburbs as in a fairly rural community – a sort of lower-class rural suburbia. Even though I felt very alienated there, I don't really feel that

people who have a certain calling will feel any less alien anywhere else. I don't think it's the suburbs' fault, or the square dance community's fault, or the farm community's fault – I just think that certain people are born with a very specific calling. It could be that their sexual preference is away from the mainstream; it could be that, whether scientifically or artistically, they have a calling. Albert Einstein never fitted in wherever he was and Mother Teresa didn't fit in where she was. I don't think you can blame your surroundings. It's more that some of us are born with a certain burning and we have to live with it, nourish it, and produce work and then be grateful for it.

'I think that the things that produce poets, that internal things that produce Genet, or Artaud or Michelangelo – and I'm not comparing myself to those people, of course – has more to do with God and less to do with the suburbs. I think we have to be grateful to the middle classes and the suburbs for keeping the planet going, and we can't blame them for producing a bunch of crazy alienated artists. I think God does that; I don't think the suburbs does it. There. Ain't I brilliant? Well, not brilliant, just fairly intelligent.'

Smith's mother was a Jehovah's Witness, and her father a non-believer. Herein, perhaps, lies the basic pattern of conflicting influences that prompt creative activity. And, for a child with a highly developed imagination, being brought up in more or less the middle of nowhere, a heightened awareness of God was bound to stir a powerful ingredient into the chemistry of her formative years. The distant horizons of the country suburb and its community would make for a world in which the local became universal, and the interior world of the child's thoughts and fantasies would achieve a vivid colouring that linked consciousness to conscience. And God, in whatever sense one would like to conceive of a higher power, has played and still plays a vital part – arguably the most important part – in Smith's life and work.

'I think I was really lucky in my parents to be offered those

totally opposed poles. My mother taught me to pray when I was, like, two-and-a-half years old, and it expanded my world totally. It was the greatest gift she could ever have given me. It was the idea that no matter how bored you may be, you can still go to bed early and you can pray – which means that you can talk to the Ultimate Place all you want: tell your troubles, ask for stuff, and receive. And then I was raised a Jehovah's Witness. It's an extremely disciplined faith. They have their own philosophies and their own dogma, which I don't fully agree with, but that's the beauty of that particular religion.

'My father wasn't necessarily an atheist, but between him and my mother there was a lot of expansive territory, and so the idea of God was constantly being discussed in our household. And so it was a very stimulating household. And now my father's a Jehovah's Witness! He's nearly eighty years old, he explored nearly every arena, and he's wound up agreeing with my mother!'

Within the mythology of Patti Smith, it has often been said that she had hallucinations, whose form and residue enabled the stream-of-consciousness Babel that has marked her performances and writings. And, opened to the written and spoken word, Smith's adolescence took a classic literary turn in her discovery of Rimbaud, the nineteenth-century French poet, as both a vagabond writer with a violently heightened sense of beauty, and an icon of romantic rebellion. Indeed, if a strong awareness of God was to inform her vision of the world, then Rimbaud was to be her muse, inspiring such later lines as 'Rock 'n' Rimbaud' (the title Smith gave her performance with guitarist Lenny Laye at Le Jardin in 1973) and the oft-quoted 'Go Rimbaud Now Go Johnny Go' on the album *Horses*. But Smith makes no claims to early profundity or intellectual precocity in her teenage love affair with the great French poet; rather it was a crush that turned into a creative marriage.

'When I was sixteen, I really wanted a boyfriend. And I didn't like the way the boys looked in our neighbourhood: they didn't

really appeal to me. And so then I found a copy of *Illuminations* and he was on the cover and he was just my kind of guy. So I really got the book because I looked at him and it was love at first sight. I opened it up and I read it and I have to admit that I couldn't really comprehend or decode what he wrote. But my instinct and whatever ability I have to feel knew that the writing was beautiful. Even in translation, I was seduced by the language.

'And you know, I really think that great art is seductive on various levels. You don't have to be able to understand it; I mean, if you're touched by it or you feel any kind of cerebral response, it's done its work. I couldn't tell you what Pollock meant in "Blue Poles" – it's not necessary. I don't really know what Bob Dylan was talking about in "Desolation Row", but it doesn't really matter. I'm not an analysing type. But an artist's gifts have nothing to do with external factors like drugs or alcohol or anything like that. You can have a great night or a weird night, or some kind of experience through drugs or alcohol, and you can write about it – but it ain't going to make you nuthin' but a physical wreck.'

Having majored in Art at Deptford High, Smith was offered a partial scholarship to the Philadelphia Art Museum. Her parents were unable to make up the shortfall in the fees, so she went off to the Glassboro State Teachers' College to study to become an art teacher. It was here, according to legend, that she found a tutor called Paul Flick who instilled in her (or authorized, with the benign superiority of a trusted teacher) the deeper Rimbaudian values of the relationship between outcasts, criminals and artists. Working through her vacations at a factory, prior to dropping out from Glassboro, Smith was faced with a choice – emphasized by the brutal cul-de-sac of local employment – of either following in Rimbaud's footsteps as a vagrant poet or accepting the tyranny of minimum-wage work. Her experiences in the factory gave rise to 'Piss Factory', one of her greatest pieces of writing.

Written in 1970 and later recorded as a B-side, 'Piss Factory',

with its powerful line, 'Sixteen and time to pay off, I got this job in a piss factory inspecting pipe' was both a cri de coeur and a de profundis; it drew its strength from social realism as opposed to romantic poetry.

'"Piss Factory" was written in reaction . . . Where I was brought up in South Jersey, there wasn't much work. In terms of getting a job you either worked at the glass factory or you went to this other factory – that I wound up in – where you made mattresses or children's buggies. It was non-union, so you had really low pay; the conditions were terrible and it was, so I perceived, a really rotten way to live. But most of the people who worked in this factory had worked there all their lives. I only worked there for two summers but in that small glimpse I had of what some people considered a life, it was a real prison. I was at a time in my life when there was really no way out: my parents had no money, and while I'm not speaking against the local community, it wasn't a very culturally developed area. People were happy just to have this crappy job and live under the worst conditions – and that probably produced the most rebellion in me.

'But in "Piss Factory" I wasn't trying to represent any punk-rock point of view. I was just representing the fact that we all have a choice. I perceived I would rather live on the subways and sleep on the streets of New York and try to find something better to do with my life, than choose living in a cheap little place – trying to divide my pennies between a little bit of food and a little bit of clothing. Working in this hot, sweaty, shitty factory – to me it was all a matter of choice and imagination. It felt like a lot of people were happy to be like cattle in the factory, and never rebel against the fact that it was 110 degrees and there were no windows. It was unhealthy, they were being paid minimum wage, they just sort of went along with it. So "Piss Factory" wasn't anything to do with punk rock. I mean, what is punk rock anyway? Is it like, I'm writing something just to make a bunch of people with weird hair happy? I wrote that because I was concerned

about the common man, and I was trying to remind them they had a choice.'

'Piss Factory' closes, prophetically, with the desperate avowal: 'I'm gonna get on that train and go to New York and I'm gonna be so bad, I'm gonna be a big star and I will never return never return no never return to burn out in this Piss Factory.'

Both Lou Reed and Robert Mapplethorpe were children of the suburbs, and 'Piss Factory' can be seen as echoing the brittle determination of countless provincial and suburban romantics. Smith's flight from Woodbury, New Jersey, to New York City in the late Sixties, sleeping rough until her Cocteauesque relationship with the young Robert Mapplethorpe, during which they struggled against desperate conditions to realize their respective dreams as a poet and photographer, has all the qualities of a nineteenth-century novel from the Bildungsroman tradition, in which the young poet comes to the big city and learns about life, love and ambition the hard way. Importantly, as a woman, Patti Smith reversed the Bildungsroman's accepted formula – that the poet hero was always male. At this point, living between cold lofts and the cheapest hotels in New York, Smith's second great literary passion, for the French criminal, political activist and novelist Jean Genet, began to define her writing and describe her own experience in attempting to write in and about a state of near vagrancy. Genet's writing, like Smith's, was driven by a desire to live in opposition to social orthodoxy, and to confirm an outlaw status through a life of degradation. His criminality, as well as his prose, articulated a deeply moral view of society, in which his homosexuality and his sexual fantasies became parables of personal, artistic and political freedom. As such, he was the perfect patron saint for Mapplethorpe and Smith's artistic union.

'I think that we're polarized people, raised to be polarized – good and evil, life and death. With my earliest writing . . . Well, I aspired. I remember reading *Little Women* when I was a kid,

and the character Jo, she was the rebellious sort, y'know, and she writes in the attic all day instead of cleaning, and that appealed to me. And I did dream of being a writer, but it's a lifetime's work and some people have to work a lot harder. I mean, some people, they have gifts that immediately flower, you have someone like Rimbaud or Genet and they just . . . they find out that they're gifted on Monday and write a masterpiece on Tuesday; but others of us have to really plug away and I guess I'm one of those.

'Genet was obviously a man who was so gifted, and born with a certain calling. We don't know who his father was, we don't know, genetically, where his gifts might have come from; we know very little about his mother, and so we can't trace certain things. So they came from within him, from God, and when I say God I'm not discounting Buddha or Allah or any of 'em.

'But he was a crappy thief. He wanted to be on the outside of society but he was actually very intelligent and very aristocratic – I think he was like the son of Proust. He liked to romanticize himself and think he was one with the brotherhood of thieves – but what did he steal? He stole some rare books and some silk to make fancy shirts, and he got caught and got life in prison. And the thing with Genet that tormented him most was that he never really knew where his gifts came from. One day he's writing a letter on this beautiful piece of paper and instead of just writing, "I'm in prison in Spain; wish you were here," he starts elaborating about the texture of this white paper, and all of a sudden he's really writing, and he realizes he knows how to write. I think all artists seem to have a lot of conflicting values. With Genet, a part of him loved luxury and fancy silk shirts; the other was a complete bum.'

In the young Robert Mapplethorpe – then sexually confused and seeking his artistic identity within that sexual confusion – Smith had found her soul twin, spiritual brother and part-time boyfriend. They supported one another's artistic ambitions and evolved a relationship that was strong enough to see them through

the poverty and squalor of their earliest attempts at forging careers in a city already weighed down with aspirant poets and artists. In 1997, Smith published *The Coral Sea* – a sequence of prose poems that chart her love and mourning for Mapplethorpe, who died of Aids in 1989. She is disappointed by the appropriation of some of Mapplethorpe's more explicitly sexual images by lobbyists with specific sexual agendas.

'Robert was really a true artist, a pure artist. He had a true artist's calling, and I can say that with some authority since I knew him from when he was twenty and saw the history of his development. If he's being used politically right now, that won't endure – his work is being perceived in a narrow way. Robert's concern was always with composition and light. This was his pure motivation. Whether it was a picture of a man pissing in another man's mouth, or of a flower, or a portrait, Robert had the same motivation – he was looking at the composition and the lighting. He always considered all of his work to be of equal merit and strength, no matter what the subject.

'When all the controversy happened after Robert died, people often asked me what he'd think about it. And I know, knowing Robert the way I did, that if he had a photograph on the wall that offended most people – of the distended organ of a black man, for instance – he would say, "All right, take it down," and put up an equally offensive portrait of a rose. Because all of his work was interchangeable. He was an artist, not a politician.

'When I started writing these sets of prose poems [*The Coral Sea*], I drew on all of the different things I knew of him as an artist and as a human being. It wasn't hard to write it because Robert had a very strong work ethic and our friendship was very work-oriented. So to grieve for him in the form of work was a very blessed experience.'

A chance meeting with Lenny Kaye (then a music journalist who worked in a record shop) and the recruitment of Richard 'DNV' Sohl gave Smith the basis of a group to support musically

her readings and improvisations. In keeping with the informality of the underground, there was no formal decision to start a group, but they did produce the single, 'Hey Joe', in 1974, backed with 'Piss Factory'. Smith used 'Hey Joe' to retell the story of the Patty Hearst kidnapping, and the whole project was funded by Mapplethorpe.

After a stint at CBGBs and a brief mini-tour of California, the basis of the Patti Smith Group returned to New York, where they brought in Ivan Kral and Jay Dee Daugherty. The buzz buzzed and they were offered a deal with Arista, their first album, *Horses*, being produced by the former viola player of the Velvet Underground, John Cale.

Reviewing Tom Verlaine's group Television in the October 1974 issue of *Rock Scene*, under the title 'Learning to Stand Naked', Smith had written, 'In the Sixties we had the Stones, Yardbirds, Love and Velvet Underground. Performers moved by cold images. They didn't hide behind an image, *they were the image*.'

Now, with Mapplethorpe's stark, self-assured portrait of her on the cover of *Horses*, the same could be said of Patti Smith. This cover image was seen to shake rock's perceptions of gender, and – as much, almost, as the record – came to define a super-cool punk androgyny. 'People have made a lot of stuff about the *Horses* cover, but a lot of what we do is bred on innocence. How people interpret it is up to them. I thought of myself as a poet and a performer, and so how did I dress? I didn't have much money; I liked to dress like Baudelaire. I looked at a picture of him and he was dressed, like, with this ribbon or tie and a white shirt. I wasn't thinking I was going to break any boundaries. I was just dressing like Baudelaire.

'And Robert liked taking pictures in natural light and he had very little equipment then. The *Horses* cover came from twelve photographs that Robert took. He thought it had dignity, but he was also trying to take a picture of a triangle of light that you can see on the image. He wanted me to look good, of course, but he

was a photographer first and foremost, and he was trying to get the best picture of that triangle. Me? I just wanted to look cool. I wasn't trying to do anything. I know people would like to think that we got together to break boundaries of politics and gender, but we didn't really have time for that – we were really too busy trying to pull enough money together to buy lunch.'

The rock industry (as much as any other more conservative industry) had been notoriously sexist throughout the Sixties and Seventies, expecting women to be the passive squaws of patriarchal hippy men, and content in their roles as either 'chicks' or 'ladies'. Smith, light years away from either the West Coast introspection of a singer-songwriter such as Joni Mitchell, or the dirty blues trad-itionalism of Janis Joplin, reinvented the role of women in rock by bringing a new muscularity and mysticism that was possessed of a confrontational glamour. This was summed up by the rumour that record company executives at Arista were outraged by the visibility of a light hair line above her lip on the cover of *Horses*, and were doubly outraged by her steadfast refusal to allow the offending facial hair to be air-brushed out. This was a woman as warrior and mystic – your average marketing man's worst nightmare, when his ideal was the soft or the pornographically sexy.

In this sense, Patti Smith's rebellion through honesty – in terms of denying the male control of her body as an image – resembled the bravery of the body-builder Lisa Lyon, whom Mapplethorpe also photographed extensively, and who revolutionized the world of body-building by kicking off the high-heeled shoes that women competitors in body-building had always been made to wear to leaven their 'unfemininity'. 'That collaboration between Lisa Lyon and Robert was brilliant. It was kind of different to how I worked with Robert. I wasn't a very generous model, and our photographs were based on a different kind of trust. I wouldn't dress up for him; I wouldn't lie naked on a rock, covered with clay, like Lisa Lyon did. We took very direct photographs, almost completely based on friendship. And the collaboration between Robert and Lisa was

about a different thing: him as an artist and her as a body-builder, and that being her art. Being comfortable displaying her body, she was like clay for him, dressing up in veils or fancy hats.'

Smith's particular brand of punk rock was a form of mystical theatre in which, as she famously put it, 'three-chord rock merged with the power of the word'. While the Patti Smith Group could play the fastest, most violent form of white-noise speed punk doing the rounds in 1977, Smith's performances ranged from covering the Who's 'My Generation' to virtually speaking in tongues – thus mutating the extremes of her religious upbringing to a kind of punk shamanism. Her sexual ambiguity – singing Van Morrison's 'Gloria' from the point of view of the predatory male, or describing a suicide on the lesbian beach at Redondo – was always secondary to her immense romanticism as a poet. Her most impassioned monologues across the group's 'field of sound' – captured on *Radio Ethiopia* and later *Easter* – resembled a one-way shouting match with God. She used the language of ecstatic religion within the theatre of rock and roll, crunching visions of teenage rebellion into snarled prayers, or cooing accounts of spiritual communion through a cast of misfits and outlaws. This was closer to Genet than Generation X.

Pitched between bearing witness to a living God and proclaiming her violent apostasy, Smith's records and performances can be seen as a struggle with the faith she'd learned as a child – an acting out of the 'expansive territory' between her Christian mother and doubting father. As the American conceptualist and critic Dan Graham was to write of her in 1979, in his essay 'Punk: Political Pop' for the *Southern California Art Journal*: 'She speculated on a new definition of "female", redefining women's subservient position in rock. Variously, she projected herself as lesbian, androgyne, martyr, priestess, female God.'

On the night of 26 January 1977, Patti Smith fell twelve feet from the stage during a performance in Tampa, Florida, cracking two vertebrae in her neck. In Clinton Heylin's book *From the*

Velvet to the Voidoids, she is quoted as describing her fall (and the word becomes a pun on its Christian usage): 'I was doing my most intense number, "Ain't It Strange", a song where I directly challenge God to talk to me in some way. It's after a part where I spin like a dervish and I say "Hand of God I feel the finger, Hand of God I start to whirl, Hand of God I don't get dizzy, Hand of God I do not fall now." But I fell . . .' For a woman whose first album had begun with the line, 'Jesus died for somebody's sins but not mine', it seemed as though Patti Smith had finally got her answer from God. The fall marked the beginning of her retirement from rock, and in June 1980, at a final performance in Detroit's Masonic Temple, she bid her adieu by reading Chapter 25 of the Gospel according to Saint Matthew, which deals with Christ's resurrection. And, even if one dismisses Dan Graham's esoteric line that Patti Smith combines the trance-like communing with God that was advocated by Ann Lee, the founder of the Shaker movement, with the evangelical possession of Jerry Lee Lewis, her role in punk rock is a long way from the English experience of the Sex Pistols.

'I don't know if I'm real conscious of what I'm doing when I'm doing it. Take a song like "Rock 'n' Roll Nigger", for instance. Consciously, I was trying to give a new meaning to an old word whose meaning had become unacceptable. It's like the word "punk". When I was a small girl, "punk" was a very negative term. If you called someone a punk it meant that they were stupid or a jerk. Then, in America at least, in the Seventies, punk translated into something very intelligent and philosophical. I'm not talking about the trappings and the clothing, but the actual meaning of the word. Whoever invented the punk movement – which certainly wasn't myself – shifted the old meaning.

'I remember quite clearly, in 1977, when I had fractured my neck and was out of action for a while, some young people from CBGBs dropped by with a magazine to show to me. They'd put me on their cover as their get-well present to me, and the magazine

was called *Punk*. And I said, "What d'you want to call a magazine *Punk* for? It's such a stupid word – it means like an asshole." And they said, "No, no, no, it's changed." And that's what I was trying to do with the word "nigger" – to turn it into a label you had to earn, like a positive badge.

'I thought the Sex Pistols were great dressers who had great energy but were really spoiled kids. I liked them though. When things look pretty fucked-up around you, which they do, it's the young people that really get it. They look around and see a world full of shit, full of war, full of materialism and pollution. But I think that their next duty is to do something positive about it – to see what they can change. They have to make their complaints, spit on it all and transform it into something positive. I don't know if the Sex Pistols have transformed anything into anything positive.

In the eighties, happily married to Fred 'Sonic' Smith and raising her children in a suburb of Detroit, Smith continued to write, but withdrew almost completely from the limelight. She released an album, *Dream of Life*, in 1988, but most of her creative energy was spent preparing her *Early Work* and *Woolgathering* collections of poetry for publication. For the best part of a decade, she enjoyed a comparatively quiet and private life, until a rash of harrowing bereavements took away her best friend Robert Mapplethorpe, her brother Todd and her beloved husband Fred.

Fred died of heart failure on 4 November 1994, having co-written much of the new album, *Gone Again*, and Patti Smith had to adjust to what amounts to a new life – artistically, spiritually, and as a single mother with two children.

'I am definitely on another plane, but I don't know how much of that can be attributed to mysticism, or even intelligence. A lot of it's to do with grief. So part of my elevation, if it *is* an elevation, is to do with that. I think of my new songs as gifts from Fred – his last gifts to me. When he died, my abilities magnified through him. At this point in my life, I'm trying to rediscover who I might be. I'd been a wife for fifteen years, and my husband and I were

very entwined; a lot of who I perceived myself to be was an extension of him.

'And now he's gone. He's with me spiritually but I'm here on physical earth, and it's been along time since I talked about myself. When I was younger I used to either joke around with journalists or really try to articulate my presumptuous philosophies. But now it's different; I'm not as fascinated with myself as I was then. I'm very proud of my new record, and I wouldn't put it out unless I was. The last thing I want to do is inflict a piece of mediocre art on the planet. But I've also, as a single mother of two children, got practical reasons I've never had to consider before. I still have a part to play in rock and roll, and I'll do that, but I'd love to write a book that people would read and say was good.'

Gone Again, and Smith's return to performing, showed a woman who is all of the things that her legend claims – almost despite herself. The myth remains intact. She is a transmitter, a shaman, and an artist with a violent calling. And she's fifty years old. Watching her again after fifteen years, there is no sense that this is simply another professional pension plan. Rather, she is bound to a spiritual path that gives her no choice but to continue her conversation with God. Less heated, perhaps, but still with some business to settle.

'It's my romance with the New Testament. Who was Jesus out to get? The thieves and the whores. He was looking to get the lowest of the low; he was looking to help the lepers to pray for themselves. They didn't need to go to these fancy scribes and Pharisees, and, like, bring a lamb or a gold shekel and say, "Will you say a prayer for me?" He was saying, "If you want to talk to God, you can talk for free: mention my name – you're in." And, of course, I'm not saying I have that directive, but I was really looking to inspire a cast of people – and that cast was the miscast.

'And there's a lot of people who feel alone, and I know how that feels. I was like the joke at school: I was real skinny, people made fun of me all the time. I didn't have nice clothes.

But I learned to turn that around, because I had one thing that those other kids didn't have, and that was a pretty good self-concept. Because my parents had raised me how to *feel*. And, if you feel, that can be real painful. But don't crawl into a hole. Don't suppress it.'

In 1999, the acclaimed video director Chris Cunningham – the Mozart of robotics, and an image-making star by his early twenties – was commissioned by the advertising agency TBWA to make a television advert for Sony PlayStation. Employing extraordinary digital imaging effects, Cunningham came up with 'Mental Wealth' – an advert shot in the style of a video-diary, which featured 'Fi-Fi the Celtic cyber-pixie' holding forth about the need for a new kind of ambition.

'It's not about what they can achieve out there on your behalf,' asserted Fi-Fi, with bags of late-Nineties advertising culture Attitude, 'but what we can experience up here in our own time.' Tapping her digitally expanded forehead as she got to the 'up here' part of this pronouncement, the Celtic cyber-pixie was being put forward as the latest embodiment of Sony PlayStation's socio-cultural aura.

And Fi-Fi's look was . . . pure Ninetiesness: her look being part rebel, part free-thinker, part post-modernist urban mystic, with the mission to suggest that 'mental wealth' lay in the power of your imagination (*good* word, Fi-Fi!) 'Land on your own Moon,' she concluded, before cutting through the solemnity of the moment with a sudden – and faintly irritating – giggle.

Sadly (and to the equally imagined accompaniment of those comical wah-wah-wah-wahhhr trumpet notes denoting deflated hope and collapsed promise) this rebellious, free-thinking, post-modernist urban mysticism was to be considered the sole property of Sony PlayStation, which you had to buy into to achieve. So

much for really giving two fingers to the tedium of the 'real' world – let's go and buy a PlayStation! As an advert geared towards the ever-expanding demographic tribe of 1990s Youth (a market sector connecting the mid-teens to the early fortysomethings, by way of Glastonbury, Internet banking, Damien Hirst and twisted Levi's) 'Mental Wealth' used the idea of resistance and non-conformism to push the cultural identity of its mass-market product. (Remember that teenager from Reading, back in smelly old 1970, writing in Oz about the revolution becoming a groovy way to sell things? Told you so.) The spirit of individualism embodied in Fi-Fi – her very claims to deep subjectivity, mind gaming and reclaiming of the imagination, her clarion call to the Inner Life – was of course nothing more than the pixellated voodoo of a corporate monolith.

The Nineties, however, could never escape the demands of the inner life, however mashed and mangled, fiddled-about-with and conceptualized subjectivity became. The Koonsian yellow brick road seemed to lead from the mass demand for the magic bullet of Prozac in the early 1990s, to the demographic up-swing, at the end of the decade, in people seeking spiritual retreats across the broad band of religions, life-coaching and therapeutic practices. We did indeed want to land on our own moon – but it had to be our moon, not Sony's.

In Buddhist philosophy, the term 'hungry ghosts' can mean a kind of joyless consumption – consuming for the mere sake of consuming, but never feeling any real nourishment. In contrast, they've now identified 'auric food' – food prepared perhaps with mindfulness, the positive energy of which you can actually feel when you taste it.

So is this, then, where one generation takes leave of the 1990s: through the pursuit of the spiritual, and an attempt to protect or reclaim subjectivity from the seemingly entropic systems of post-modernism? Could be. Or do they just feel old in a young world? On a Fine Arts Department noticeboard there's a poster with a cartoon of a lavatory on it: 'Career down the pan?' says the

slogan; 'Looks like it,' someone has written underneath, in shaky biro letters. And beneath that: '*Art is not a career.*'

All the old punks, all the old culture-vulturing city slickers – they seem to have begun a coastal drift . . . moving to strange seaside towns in out-of-the-way places: Morecambe, Frinton-on-Sea, Beaumaris. Allegorical sites of self-imposed exile. Perhaps, like Bouvard and Pécuchet, 'Everything annoyed them, even the advertisements in the newspapers.' Perhaps it was more a question of identifying new ideas, or reviving old ones, to make sense – intellectual survivalism – of the post-modern world of '*So Much of Everything . . .*'

The artist Linder, who had once made the photomontage which the Buzzcocks used for their 'Orgasm Addict' single, writes down a few slogans: '*The Ironic Shall Yield to the Mythic*'; '*Reactionary is the New Radical*'; and of watching Howard Devoto performing 'The Light Pours out of Me' with his group Magazine in 1978: '*The last great radical act of twentieth-century art is to declare your own divinity*'.

Paul Laffoley and the Boston Visionary Cell

Paul Laffoley is an artist, architect, polymath and idealogue who both embodies and has translated into diagrammatic art a perception of time and space broad enough to accommodate those areas that are described as magic or parapsychology, yet so coherent and socially aware in its propositions that it suggests the thinking of a new, revisionist school of liberal humanism. Laffoley occupies the role defined, historically, by the tradition of esoteric scholarship connecting the experiments of medieval alchemy to the philosopher scientists of the eighteenth and nineteenth centuries. He brings the study and practice of lucid dreaming, dimensionality, mind physics and psychotronics to a schema of visionary architecture. He has also designed a time machine and a prayer gun. Put

simply, his practice could be defined as the conversion of mysticism into mechanics.

Since 1968, Laffoley has lived in an eighteen-by-thirty-foot utility room on the first floor of a former commercial property in downtown Boston, not far from Filene's department store. This room – Laffoley calls it the Boston Visionary Cell – is the core of his research and practice. It is reached up a featureless staircase, from a hallway that has the shabby anonymity, tinged with melancholy, of decommissioned functional space.

On entering this building, the sounds of the street are suddenly silenced. It is rather as though one had passed through a heavy, invisible curtain, on the far side of which the daylight, filtering through the street-door glass, is thinned to a dust-coloured twilight. Glimpsed from the stairwell, where the pallor of daylight falls away, the remainder of the property appears tall and narrow, with the semi-industrial air that one associates with caged service elevators and silent, institutional corridors.

From the stairway landing, the lamplight inside the Boston Visionary Cell appears warm and golden, as though the room is lit against the blackness of the winter's evening. Piles of books (a library of history, philosophy, science and occultism) and papers, charts and drawings, reaching to elbow or shoulder height, make an island of information in the centre of the room, moated by a narrow pathway and rising to a pyramidal summit. Here Paul Laffoley sits at his drawing desk.

In middle age, with a frank, engaging expression and an enthusiasm, above all else, to communicate the validity of his ideas within their broadest context in the history of science and philosophy, Paul Laffoley could be said to administrate the function of the Boston Visionary Cell as the curator of his own thinking. He supports himself with a job at the Boston Museum of Science, returning to live and work at the Boston Visionary Cell – sleeping on his drawing board. He can entertain friends at the Harvard Faculty Club, and keeps spaces in other buildings for the require-

ments of daily living. 'I have all the parts of a house,' he explains, 'but they are not in one place.'

With his pale, delicate hands pressed palms down on his drawing board, as though about to shape the meaning of his words in simple gestures, he gives the astrological explanation for his life and work in two spoken paragraphs, the syntax of which is so precise that he could be reciting from a script. Planets, their houses and aspects – a complex geometry of mathematical configurations – seem to fall into a perfect pattern, articulated by his deft recitation.

'My horoscope is essentially a grand cross: Leo sun, Aquarius moon, Mars in Scorpio and Taurus in Uranus. But the sun sign is in the twelfth house, the Moon is in the sixth house, the Mars and Scorpio in the third and Taurus in the ninth. A fixed grand cross means that your energy is completely blocked: it is exactly what happened with the eclipse of the eleventh of August – that was a grand cross in the sky.

'Now, how I am able to operate is as a result of the fact that I have Virgo rising, as a consequence of having my sun in the twelfth house; I also have an unaspected Neptune in Virgo in the twelfth house. And that means that I am able to take cosmic themes and turn them directly into finely detailed work, with the rest of my life having nothing to do with it.'

The clarity of Laffoley's thinking is served by the stresses his accent places on the different items of information. To a European, his accent seems New York colloquial – 'I did eleven years of Latin – coulda beena priest.' He communicates his own amazement at the way in which his whole life could be recounted as a lived example of the 'finely detailed work' which comprises diagrammatic artworks. In Laffoley, there is a convergence of influences, circumstances and reactions that lend his autobiography, no less than his paintings, a cumulative, holistic harmony – the functional symmetry of scientific formulae.

This convergence lends his account of himself a kind of

narrative perfection: a neatness of imagery and a fluency of themes, empowered by a form of synchrony that seems to convert the effects of coincidence within his life into a realized biographical structure. As related by Laffoley, the esoteric, the bizarre and the mundane coexist with the allegorical and the supernatural. At times, he seems like Prospero with the comic timing of Woody Allen.

Books dominate the Boston Visionary Cell– filling its shadows with a particular aura, and drying out the air-conditioned atmosphere with the combined absorbent power of their pages – but their presence is augmented by various arcane instruments. In appearance, these instruments can be seen to double as either sculptures or mystical artifacts or both; they have the air of tribal or folk art, merged with the demonstration equipment that you might find in a physics laboratory. The utility room allows no natural light, and the light from the room maintains its nocturnal ambience twenty-four hours a day. You could be reminded, with regard to the lighting, of one of the rooms in the suburban villa customized by des Essientes – the aesthete-philosopher-hero of Huysman's 'decadent' novella *Against Nature*: an environment controlled entirely by intellectual needs.

The Visionary Cell is both a muniments room, containing the research acquired in a long career of scholarship, and a working laboratory. In relation to Laffoley's extraordinary artworks – which could be said to have the high aesthetic status of technical drawings, and to supply their compelling pictorial energy as a kind of unintentional by-product, like the enhanced calligraphy of illuminated manuscripts – the function of the Visionary Cell is closer to housing scientific research than containing the traumas of artistic inspiration and creativity.

'A lot of my work has to do with psychotronic devices – mind/matter interactions – because they appear to be artworks in the same way as what the alchemists did appeared to be artworks. The important point was that what appeared in the mind was as

efficacious, in what we could call an experiment, as anything else. As opposed to science, which you could say is methodological sensation, alchemy or magic is methodological revelation. But if you can make a statue cry, then people are going to be very suspicious. Like the alchemists could do miracles on demand, and that made the Catholic Church suspicious.'

Laffoley's artworks, read as signage, have the intellectual intensity of Talmudic writing; they mingle the questions raised by quantum physics with the history of comparative theology and parapsychology. In formal terms, his paintings and drawings have the assertive, descriptive beauty of scientific formulae, touched with a poetry of mysticism that you can detect, for instance, in some of the assemblage pieces made by Robert Rauschenberg. That Laffoley is a significant American artist seems beyond doubt; he resolves questions of influence, form and integrity that are central to not only the history of art, but also to the possibility of art being as answerable to its conclusion as science.

What prompts the conviction of this assessment, beyond the pleasures of symmetry and line, image and gracefulness, which distinguish the best of Laffoley's work, is the unimpeachable honesty of intent in his entire project. Far from being some theoretical adjunct to a pop cultural romance of quasi-occult, pseudo Gothicism – 'the post-modern reclamation of Bram Stoker', as he puts it – Laffoley's ideas are rooted in a pragmatic and clearly documented presentation of their inspiration, cultural history and intellectual origins. It is more a question of the viewer having to reframe contemporary prejudice towards the use of certain terminology – 'alchemy', 'magic', 'extraterrestrial' – than it is a matter of Laffoley attempting to coerce a sensationalist aesthetic.

'Anyone dealing with magic today does not ignore the history of science in what they are presenting. And so we have a revival of what you could call ancient wisdom, but placing it in a future context, so that it isn't simply reviving something out of the past – it's recognizing that what has gone on, in between then and

now, has as much value and needs to be in the mix. But it's the old story: tell somebody something new and you've probably got an enemy.'

The futurology in Laffoley's thinking relates his charting of the evolution of consciousness, from the pre-Classical models of civilization, to the successions of social and spiritual stages he believes to be awaiting humanity beyond the mezzanine, so to speak, of post-modernism. Thus, as he recounts in a published statement entitled 'Disco Volante II', for the 'Building the Bauharoque' exhibition of his paintings at Kent Gallery, New York, in 1998, he has found himself to be connected, by a series of events and circumstances, to the uneasy relationship that exists between research into extraterrestrial phenomena, and the framing of that research within the popular culture and the broader substrands of esoteric study.

In 'Disco Volante II' Laffoley tracked the synchronic trajectory of his relationship with the science-fiction film *The Day the Earth Stood Still*, directed by Robert Wise and released in 1951. This statement recounts his three-tiered engagement with versions of extraterrestrial phenomena: the set designs for Wise's film, the significance of those designs to Laffoley's concept of architecture, and Laffoley's own relationship with what are known in popular culture as 'close encounters'. The concluding entry, dated 5 January 1996, conflates these three narratives to present a defining account of Laffoley's perception of visionary architecture; it also helps to explain the man: 'What Robert Wise created is literally a new "Jungian Archetype – a Tulpa". The Tulpa is the Hindu concept for a "degree of embodiment" from Brahma [true reality] to the Maya [our world of physical illusion]. We might say it is a point on the continuous spectrum from consciousness to mass. *The Day the Earth Stood Still* is, therefore, a "Tantric" film and a "built piece of architecture", whose existence is verified, not by walking up to it and giving it a kick, or constructing it within "virtual reality", but by means of lucid dreaming. I have seen this

movie, now, over 750 times, most of which were not on the silver screen but in the "Lux Theatre" of the mind.'

And extraterrestrial contact, it appears, may not have been achieved only through the movies. According to one of Laffoley's autobiographical notes, dated 17 February 1992: 'During a routine CAT scan of my head, a miniature metallic "implant" is discovered in my brain, near the pineal gland. A local chapter of "Mufon" [Mutual UFO Network] declares it to be a "nanotechnological laboratory" capable of accelerating or retarding my brain activity like a benign tumour. I come to believe that the "implant" is extraterrestrial in origin and is the main motivation of my ideas and theories.' To this day, Laffoley is resisting neurosurgeons who insist he should have exploratory surgery to identify this implant.

On the far wall of the Boston Visionary Cell, Laffoley has hung a work he made in 1964, part of which consists of the following text: 'Beware the end of the world; it will end not by fire or water or disease or aliens from space, but from a paroxysm of kitsch; the conceptual non-form that separates that which has no history from that which has only history – eternity from time.'

If Laffoley's work within the Boston Visionary Cell can be said to have one principal preoccupation – a common denominator of his eclectic scholarship and practice – then that preoccupation would be to understand the process by which one goes from becoming to being. Like Kierkegaard attempting to prove to himself, through his many pseudonymous writings, the certainty of his faith in God, so Laffoley is concerned above all with actually proving one's progress through the levels of being described, for example, by Plato.

'What was the mechanism to be able to convert the physical to the metaphysical? Because if you simply assume, verbally, that these two realms exist, then how do you prove it to yourself? And there has to be a way to do it. All the experiences that people call mystical have to go through stages, and I think that that is exactly what Plato was describing.'

The defining directive in Laffoley's art could be summarized as an analysis of the way in which society, science and culture are encoded with predetermined directives that connect the past to the future on an epic evolutionary scale: the point where prophecy meets prognosis. As an artist, Laffoley both translates the data of these directives into anthropological charts and also provides diagrammatic revelations (incorporating design solutions) of the means by which history can not only be read, but also described in visual signage – text, image, pattern.

As a character, however, Laffoley has no interest in positioning himself as a guru, iconoclast or counter-cultural folk hero. Rather, he resembles the philosopher-scientist, whose experiments generate a by-product of extraordinary art. The Boston Visionary Cell, as a concretized manifestation of its inhabitant's work and preoccupations, describes the way in which a chaos of data – no less than a chaos of marble – can be sculptured by research to release the perfect forms within it.

It seems interesting to me that in Britain, at least, we would probably accept the reasoning that leads an artist to suspend half an animal's carcass in a tank of formaldehyde with greater readiness than we would consider the genuinely radical thinking behind Laffoley's diagrammatic explanations of anthropological and 'magical' propositions. 'Nature has a tendency to be habitual, and miracles are a non-habitual event. So placing higher meaning on the things that don't occur very often, and saying that because a thing only occurs maybe once we should simply revere it and not try to understand it – that is not what a magician does. In other words, a magician says, "Well, this is a part of nature, as much as anything else, only it has different characteristics." Put this simply, there is a muscular rigour in the patience with which Laffoley relates his understanding of himself to the experiments and research which he carries out within the Boston Visionary Cell. In many ways, he can be seen as classically romantic, in the tradition of William Blake, Jules Verne or H. G. Wells – with

whom he shares an essential humanism. His work suggests that you consider certain alternatives to orthodox reasoning and conventional understandings of history; it rejects the imperial despotism of certain forms of conceptualism, preferring to attend, with courage and humility, to its own pressing business of explication.

It's a clear night, and very still. The big grey apartment is empty now, with all of the furniture moved out. All of the lights are off, but the enormous room doesn't seem very dark. You can just make out the little indentations in the carpet left behind by castors and chair legs. There was never much in here in the first place.

The big sash windows cast slanting shadows. Do you remember when they were streaming with angry rain, rattling and buffeted by the wind? Now it's so still . . . a little after two in the morning. No more Pierre Boulez trapped-snooker-ball chords . . . Over there is where the chair was . . . The grey vinyl cube . . . And on that wall a painting made in the early Nineties of layer upon layer of household paint . . . All gone.

But if they're anywhere, they're here, the hungry ghosts of the culture-vulturing city slickers. When you peer into the grey half light, the middle distance seems to shiver and sharpen, and you think that maybe, just for a second, you can make out a figure, very still. But then you look again and there's nothing there – just an up-turned packing case and a couple of empty plastic cups.

Index

Moors murders 119
Morecambe, Eric 5, 257, 319–20, 322
Morgan family 130
Morley, Paul 23, 116
Mormon Church 185
Morrison, Blake 44, 45
Morrissey 14, 23, 114–20, 149, 288
Morrissey, Neil 319
Mortimer, Bob 5, 47, 86, 88, 318, 320
Mosley, Walter 112
Moss Side, Manchester 108–10, 114
Moss Side Story 109, 110, 112, 113
'Most Important Man Alive, The' 23
'Motorway Life' 68
motorways 284–90
Mott the Hoople 205, 207
'Movement in Squares' 165
MTV 38, 150
Mud 206
Mud Club 105
Mueller, Cookie 140
'Mufon' (Mutual UFO Network) 351
Muggeridge, Malcolm 44, 45
Murray, Pauline 147
Museum of Modern Art, New York
 (MOMA) 166, 167
Musgrave, Victor 166
Musical Youth 189
My Generation 100, 339
'My Major Retrospective' 77
'My Sweet Lord' 154
Myers, Mike 46

Naked Civil Servant, The 192, 193–4,
 226
'Nan after being battered' 143
National Gallery, London 166, 170
National Giro Centre, Bootle 294
National Lottery 14, 68
National Sound Archive 27
National Trust 85
'Nationwide' 205, 207
Natural Shoe Store 53
Naughton, Bill 235
'Necrocard' 31
Negro Inside Me, The 109, 110
'Neighbours from Hell' 68
Neoist Alliance 30
Neophiliacs, The 45

'Nessum Dorma' 5
Neuro-Associative Conditioning 310
Neuro-Linguistic Programming 310
'New Barbarians, The' 61, 62–3
'New Horny Pictures, The' 324
'New Image Glasgow phenomenon' 12
New Labour 18, 84, 124
New Millennium Experience Company
 295
New Musical Express (NME) 102, 273
New Romanticism 9, 11, 14, 36, 37, 38,
 101, 147, 214, 274, 318
New Statesman 163
New York 122, 129–30, 132–3, 137–8,
 154–5, 190–2, 199–200
New York Dolls 328
Newcastle City Hall 269
Newman, Rob 5
Newman, Barnett 168
News of the World 259
Newsweek 241
Nichols, Mike 306, 315
Nicholson, Jack 230
Nicola Jacobs Gallery 12
Nietzsche, Friedrich 31, 61
Nil by Mouth 49
Nirvana 185
Noakes, John 204
Noble, Tim 56–62
Noon, Jeff 10, 23, 55, 283, 289
Norman, Nils 33
Northey, Prof. Eric 40
Nothing If Not Critical 162
Nova 202, 216
Nowhereism 280–4, 293
Numan, Gary 62

O Lucky Man! 252–3, 257, 259–60, 261
Oakey, Philip 9, 262
Oasis 6, 14, 15–16, 17, 18, 19, 47,
 116, 117
'Ob-la-di, Ob-la-da' 248
Oblique Strategies 302
Obscure 301
O'Connor, Joseph 310
Odelay 181
Oedipus Schmoedipus 109, 112, 113
offices 304–16
'Old Grey Whistle Test, The' 267